Printmaking

BOOKS IN THE CREATIVE HANDCRAFTS SERIES

Dr. WILLIAM C. MAXWELL is a Visiting Assistant Professor of Art and Education, Teachers College, Columbia University, and Assistant Professor of Art, Graduate School, College of New Rochelle. He has had much experience as a printmaker working in many professional shops throughout the country as well as teaching the subject since 1968. As a professional artist, he has exhibited widely both paintings and graphics throughout the United States and abroad.

The Creative Handcrafts Series

Printmaking

A Beginning Handbook

WILLIAM C. MAXWELL

Photographs by HOWARD UNGER

A SPECTRUM BOOK

PRENTICE-HALL, INC., Englewood Cliffs, New Jersey 07632

Library of Congress Cataloging in Publication Data

Maxwell, William C
 Printmaking, a beginning handbook.

 (The Creative handcrafts series) (A Spectrum Book)
 Bibliography: p.
 1. Prints—Technique. I. Title.
NE850.M385 1977 760'.2'8 76-49888
ISBN 0-13-710699-8
ISBN 0-13-710681-5 pbk.

A Spectrum Book

Printed in the United States of America

10 9 8 7 6 5 4 3 2 1

Prentice-Hall International, Inc., *London*
Prentice-Hall of Australia Pty. Limited, *Sydney*
Prentice-Hall of Canada, Ltd., *Toronto*
Prentice-Hall of India Private Limited, *New Delhi*
Prentice-Hall of Japan, Inc., *Tokyo*
Prentice-Hall of Southeast Asia Pte. Ltd., *Singapore*
Whitehall Books Limited, *Wellington, New Zealand*

To all the artist/printmakers, past and present, who have provided me with the process means to pursue an extremely rewarding fine art, and the chance to pass my enthusiasm on to others.

Contents

Introduction
Workshop, Equipment and Supplies: Initial Preparations
Hard Ground Line Etching

Plate Preparation / Placing Ground on Plate
Creating the Line Drawing Through Hard Ground
Etching the Drawn Line and Preparation of the Acid Bath
Cleaning the Plate: Preparation for Proofing

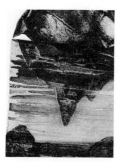

II PRODUCING A RELIEF PRINT

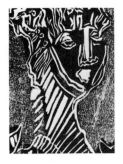
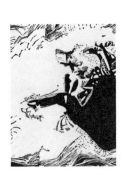

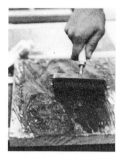

13 *Metal Plate Lithography*

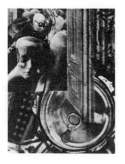

Preface

Since the early 1950s, the United States has been experiencing the growth of a small renaissance in the field of fine art printmaking. Following World War II, increasing numbers of European printmakers found their way to America. Additionally, the art world in general was experiencing a new capital, New York City. Workshops began to spring up all over, from Hollywood, California to Long Island, New York, answering the needs of artists who wished to explore the possibilities of printmaking and dealers who saw the increasing value of this expanded market for art. Correspondingly, colleges and universities began increasingly to incorporate printmaking into their art curriculums. And, of course, the reinforcement to all this was a very interested viewing and buying public, who found it financially more agreeable to purchase a print rather than a painting or sculpture, which usually cost considerably more. Today, this renaissance is at its peak. There are now numerous galleries devoted only to prints and multiples. Every major art museum possesses its own curator and collection of prints. It is possible to find a fine art printshop in most major American cities. And there are very few educational institutions not teaching printmaking, including the secondary school art programs.

Out of this ever-building interest in printmaking, one significant result has been an emergence of a considerable amount of published material dealing with both the craft and art. The most significant books, by Hayter, Peterdi, Gross, Antreasian, Ross, Romano, and other well-known printmakers, have dealt with the skills of printmaking *primarily* on an advanced level, usually with extreme expertise. These books, and many more like them, have assumed that the literature was addressed to a somewhat "educated" audience. Accordingly, the novice printmaker found his or her only complete source of *initial* learning in the institutionalized workshop, depending solely on the instructor's knowledge, and more importantly, availability. Often, without the printmaking instructor's presence, the beginning student found him- or herself temporarily blocked from proceeding further. And, of course, those interested in pursuing an interest in making fine art prints, who did not have access to formal instruction, never got started.

For this reason, it is the intent of this text to address itself to the beginning printmaker, whether he or she is beginning instruction in a formal workshop or intending to learn printmaking "on his or her own." The student within the formal structure of a printmaking workshop in a school, college, university, or similar institution should find this text complementary to the instructor's teaching. When working out a particular problem that results in "blockage"-type questions, the beginning printmaker should be able to find or reinforce the answers with little difficulty in this handbook. And the novice printmaker, independent of formal instruction, should be able to proceed from beginning to end, effectively and systematically, without the burden of deciding what material is extraneous to a foundational understanding of media.

This handbook assumes nothing. Familiarity with a printmaking vocabulary will develop out of the commitment to following the individual printmaking processes covered through a step-by-step method. It is believed that through this method of imparting a body of information that has traditionally inhibited the layperson, a foundation of process knowledge will be developed that will become intuitive in nature, allowing an individual to move more freely beyond the craft to the more important consideration, the final visual statement. In this regard, this book is not meant to replace any other texts on the subject, but to complement them by providing a more realistic basis from which to grow and develop. The shroud of myth that has surrounded printmaking processes, even in the face of a renaissance of interest and activity, can be at last broken by any interested individual who feels a true sense of need and, correspondingly, a true commitment to learn by doing.

Being primarily addressed to the beginning student of printmaking, this handbook is relatedly addressed to instructors interested in a procedural approach to beginning levels, who should very definitely find this text complementary to their printmaking teaching. The advanced printmaker should find this text to be excellent review, and for those not familiar with every medium covered, it is a good starting point for the in-

troduction to a new process. And, of course, a general public not particularly interested in production but wanting a basic knowledge of fine art printmaking methods should find this text invaluable.

The scope of the text is basically technical in nature, providing an initial insight into the historical evolution of the various methods covered. It carries the reader through the procedural steps without distraction, by including alternative approaches developed and followed by various printmakers of the past and present. Although the text is primarily devoted to "black and white" printing, with the exception of the collagraph, each medium part is concluded with suggestions for advanced approaches that include color. It concludes with exhibition information and a discussion on the need and process by which one develops a personal printmaking aesthetic.

Through a fundamental approach to writing, this handbook presents a thorough illustrative expose. Unlike most contemporary printmaking texts, exposure to process and image is accomplished through the utilization of students and student work, most of whom are no more than two or three semesters into the learning of various printmaking processes, to decrease the inhibitions posed when displaying work by professionals only. It is hoped that through these verbal and visual presentations, and the choice not to present work by experts, that the interested novice will feel more enthusiastic toward making the commitment to develop as a fine art artist/printmaker.

Acknowledgments

I wish first to thank Teachers College, Columbia University for their continued support and commitment to me and to the operations of a professional printmaking workshop dedicated to furthering the educational standards of fine art printmaking. In particular, I wish to express my sincere gratefulness to the Chairman of the Department of Art and Education, Dr. William Mahoney, for his personal encouragement and continued enthusiasm for the printmaking program at Teachers College. Further, my thanks should go to the recent commitments made by the College of New Rochelle in the formation of a printmaking workshop in their institution based on the principles and standards I have formalized at Columbia University.

My sincerest and deepest thanks should go to my students, past and present, whose patience and assistance throughout the organization and writing of this text were invaluable. A special thank you to Virginia Smit, Caryl Spinka, and Sheldon Strober, who assisted with and appear in particular sections of the text.

I gratefully acknowledge the support given to this project from the beginning by my photographer, Dr. Howard A. Unger. And to Lynne Lumsden, editor of Spectrum Books, Prentice-Hall, Inc., a very appreciative thank you for encouraging the project in the first place.

xxiii

And, finally, the most important thanks of all to Ginny, Margaret, and Mitchell, who have continuously made their support known for all of my work as an artist/educator with the most important life element—love.

Printmaking

I

PRODUCING AN INTAGLIO PRINT

The word *intaglio* is derived form the Italian *intagliare* meaning to cut or ingrave, this being derived from the late Latin *taliare* of the Latin *talea* (a cutting). Today, it has a twofold meaning. It refers to the actual cutting or incising of lines, tones, and textures into any receiving surface by means of hand carving tools or chemical etching. And it also refers to the process by which ink is pushed into those incised areas to be transferred onto a piece of paper, which usually results in an embossed or raised surface. The *intagliate* is that incised surface of a particular plate. It is usually made using the processes of hard ground line etching, aquatint etching, soft ground etching, sugar-lift etching, drypoint, burin engraving, and mezzotint.

Although intaglio plate making can find some relationship to painting and drawing, unlike lithography the relationship is not very direct. The medium owns the ability to evolve an image out of its own intrinsic nature.[1] The perceptive artist/printmaker establishes a dialog with the intaglio plate, listening to the dictates of the materials as well as personal process thoughts. This dual process nature of the medium opens many new paths of imaginative expression for the artist.

Yet, the realization of this is a fairly new phenomenon. Intaglio prints for hundreds of years served only the function of recording the outside world

[1]Stanley William Hayter, *About Prints* (London: Oxford University Press, 1962), p. 124.

2 for duplication purposes. For many varied reasons, the concept of a fine art intaglio print produced strictly for its aesthetic value was not totally apparent until the twentieth century.

This evolution of a concept, of course, has a long history. Albrecht Dürer, a master of engraving who also experimented with etching, is perhaps considered a prime originator of the concept in the fifteenth and sixteenth centuries in northern Europe. And the fifteenth-century artist/engraver Andrea Mantegna exemplifies the concept in Italy.[2]

Later, during the seventeenth century, the slow development of fine art intaglio printing was carried by the Frenchman Jacques Callot, known for his experiments with multiple acid dipping of etched plates and the combining of etching and engraving on the same plate.[3] And, of course, the master Dutch etcher, Rembrandt, considered by many as the greatest intaglio artist ever, carried the growth of the concept much further with his explorations into combining etching, engraving, and drypoint simultaneously.[4]

The eighteenth and early nineteenth centuries are exemplified by the work of the English artist William Blake, who developed further growth steps with his experiments in multiple color intaglio prints, utilizing intaglio and relief printing on the same plate.[5] And although the beginning of the twentieth century is marked by some intaglio work by Braque, Picasso, Gris, Leger, Villon, and Matisse, it was not until the 1920s that an experimental intaglio workshop was established, by Stanley William Hayter, an American working in Paris. The shop, Atelier 17, moved to New York in 1939, returning to Paris in 1955. Its avowed purposes were to advance technically intaglio processes and to establish firmly the medium as a fine art.[6]

One of Hayter's students, the now famous Mauricio Lasansky, insists that the intaglio process is an "independent medium . . . not a transfer drawing, nor is it painting or sculpture; yet it has the qualities of all three."[7] The recognition of this fact by the contemporary artist has firmly established the processes of intaglio as a fine art medium in its own right.

[2]Carl Zigrosser, *The Book of Fine Prints,* rev. ed. (New York: Crown Publishers Inc., 1956), p. 61.

[3]Arthur M. Hind, *A History of Engraving and Etching from the 15th Century to the Year 1914* (London: Constable and Company, Ltd., 1927), p. 105.

[4]Zigrosser, *The Book of Fine Prints.*

[5]Jules Heller, *Printmaking Today* (New York: Holt, Rinehart and Winston, Inc., 1972), pp. 195-196.

[6]Donald Jay Saff, "Contemporary Masters and Methods of Intaglio" (Unpublished Ed.D. dissertation, Teachers College, Columbia University, 1964), p. 12.

[7]Mauricio Lasansky, *A New Direction in Intaglio,* exhibition catalogue, Minneapolis, Walker Art Center (1949), p. 2.

1

Etching

INTRODUCTION

The craft and art of etching dates to the early part of the fifteenth century.[1] However, the process was confined at this time to the metalsmith, armorer, and gunmaker. The first record of an etched-made print is in 1513, the year that Urs Graf produced *Girl Bathing Her Feet.*[2] And it is quite well known by now that Dürer was working with etched plates around 1515. From this period, etching has become a major art form, practiced by artists of every realm. Art history is truly rich with the multitudes of etchings by painters, sculptors, and printmakers of the past.

To produce an etching, a metal plate is covered with an acid-resist coating, which remains thin and soft enough to scrape through it with various tools and methods, exposing metal areas in the form of lines and textures. These exposed areas are then brought in contact with acid bath solutions called *mordants*. The mordants eat or bite out the exposed metal until the plate is

[1] Arthur M. Hind. *A History of Engraving and Etching from the 15th Century to the Year 1914* (London: Constable and Company, Ltd., 1927), p. 105.

3 [2] Ibid., p. 106.

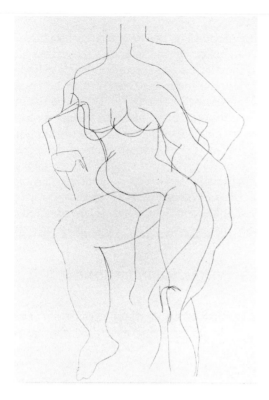

Fig. 1-1 Hard ground line etching. *Untitled,* 12″ × 18″, Colette Delacrois, 1974. (Drawing was created utilizing the model in a series of gestural poses.)

Fig. 1-2 Hard ground line etching. *Blades,* 9″ × 11½″, Lynn Rubino, 1975.

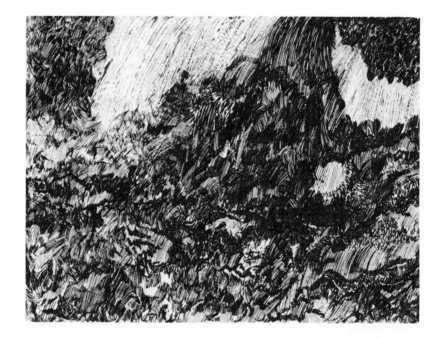

5

Etching

removed from contact with the acid solution. The ground is then removed, revealing the now incised lines and textures in the plate. These lines and textures are filled with ink and the plate is run through a double cylinder press with paper on top, causing the incised inked areas to be transferred. The etched print reveals a distinct embossed effect where the paper was pushed into the incised lines, textures, and outer edge of plate.

Although etching appears, either by a full verbal or written description, to be a very complex process, it is basically very simple to understand as long as one researches the art by patient *doing.* As an abstraction, it will always remain complex, and, accordingly, it will seem to some, uninviting. Through a step-by-step approach, which can be accomplished in a very short period of time with a minimal amount of supplies and equipment, the production of fine art prints by means of etched plates can be achieved by most anyone.

WORKSHOP, EQUIPMENT, AND SUPPLIES: INITIAL PREPARATIONS

A large working space is not essential. The author has seen complete printshops equipped for etching in areas no larger than 9 by 12 feet. This fact is especially important to those persons wishing to take up the art of etching in their own homes or small classrooms. Art teachers interested in presenting etching to their students can designate a small area of a normal classroom as a "printshop" and, by following the supplies and equipment

Fig. 1-3 Charles Brand Machinery Inc. etching and relief printing press.

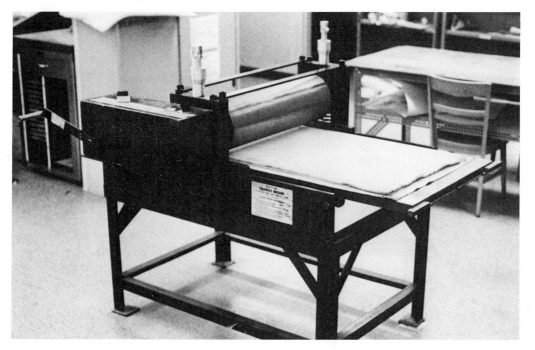

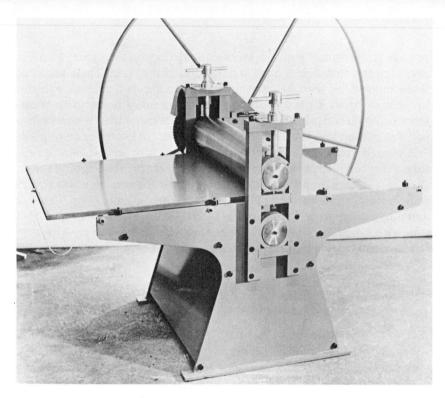

Fig. 1-3A American French Tool Company etching press.

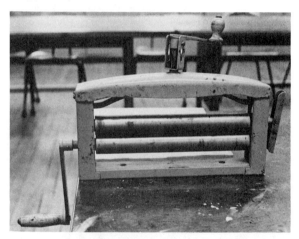

Fig. 1-4 Wringer-type portable press.

instructions presented here, can add a very dynamic and intrinsically interesting medium to their art curriculum.

The largest expense, and that one item that will usually occupy a considerable amount of designated space, is the etching press. Chapter V begins with an introduction into press possibilities. Here, it is pointed out that one can begin with a very simplified adaptation of a double cylinder etching press that will not occupy much space and will produce prints, if not of the highest quality, still worthwhile. Additionally, there are on the market

small table model presses which are relatively inexpensive, do not require a large area, and produce very high quality prints. (See Figures 1-3, 1-3a, and 1-4).

An essential item in any workshop area organized for etching is an accessible cabinet that can be locked. The cabinet should be conveniently arranged and kept neat at all times. If solvents are to be stored in the cabinet, it should be fireproof.

The following list of supplies will be stored in the workshop cabinet.

Universal Etching Ground, hard, 1 pint
Universal Etching Ground, soft, 1 pint
Universal Etching Ground, paste-type, extrasoft, 1 jar
Stop-out varnish, 1 pint
Zinc plates, 16 or 18 gauge, amount as needed
Etching needle
Burnisher
Scraper
Metal files, six-inch, smooth and rough
Scotch hone
Snake slip stick (pumice stick)
Steel wool, #0000
Emery polishing cloth, 4/0
Draw tool (plate cutting tool), (optional)
Sharpening stone
Metal straight edge (ruler)
Burnt plate oil, 1 pint
Household oil, small can
Oil of clove, 1/4 ounce
Acid brush or sea gull feather
Masking tape, 1-inch roll
Measuring cup, pyrex
Putty knife
Rubber brayer, 6-inch, semisoft
Whiting or French chalk, 2 pounds
Ammonia, 1 quart
Stencil brush, 1/2-inch diameter
Watercolor or Japanese brushes, wide selection as needed
Push pins, aluminum #5
Rubber gloves (used with solvents and acids)
Plastic funnel
Tweezers
Rolling pin, for pie making
Tarlatan, as needed
Granulated sugar, 1/2 pound

India ink, small bottle

Contact-type paper, 2 yards

Newsprint pad, 24" x 36"

Cosmos blotting paper, amount as needed (see Chapter 5)

Proofing/Printing Paper, amount as needed (see Chapter 5)

Soft toothbrush

Krylon paint spray, 1 pint can, red

Wax paper

Aluminum foil

One or two-ply cardboard, 3 sheets, 18" x 24"

Inks (see Chapter V for types)

Small notebook

Sketchbook (drawing paper)

Drawing pencils, amount as needed

Jars, with tight-fitting lids

Newspaper

Paper towels

Old rags

Glass, 12" square piece or larger

Paint thinner, 1 gallon

Denatured alcohol, 1 gallon

Lacquer thinner, 1 pint

Work apron

For supplies for any of these items, refer to Appendix A.

You may also wish to store your supply of nitric and acetic acid in the same cabinet (1 gallon of nitric acid, 1 pint of acetic acid). This is perfectly okay as long as the cabinet is in a cool area and it is kept *very tightly* capped. If at all possible, however, it is recommended that a separate chemical cabinet be installed, which should also be locked when not in use. Acids are highly corrosive and have a tendency to destroy metals from slow-leaking fumes alone. Accordingly, your etching tools may be damaged when kept in the same vicinity as the acid.

Another piece of equipment you will occasionally need is a hot plate. Figure 1-5 shows a hot plate specifically designed for printshops; it is an expensive and large item not essential for the small shop. A flat tray-type hot plate or a burner-type that includes a quarter-inch steel plate on top will work adequately.

A sturdy working table located under adequate light should be available. The table need not be large; a working space of approximately three feet square is more than adequate.

Designate a separate space for using solvents, storing extra newspapers, and for general cleanup. Again, this can be a small table, which you should keep covered with many layers of newspaper. Discard solvent soaked newspaper as necessary in a safe receptacle, preferably metal with a

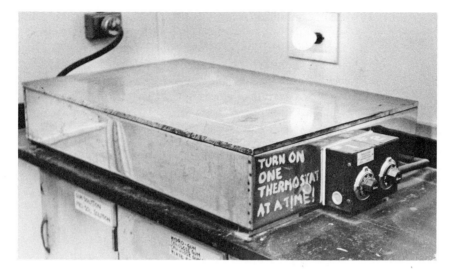

Fig. 1-5 Professional hot plate by Charles Brand Machinery Inc.

metal cover. Some printshops use a box with sawdust in it for the absorption of solvent runoff. Keep solvents, if possible, in small safety cans so that they are easy to pour and are not wasted.

If possible, printing and proofing paper should be stored in a clean, flat, well-ventilated area. It should not be exposed to sunlight or moisture. If a separate cabinet is not available for this purpose, such as a blueprint or map cabinet, small quantities can be placed in a separate portfolio and stored in your supply locker or in an adjacent area that is safe.

A clock should be available. It is not good to wear an expensive watch while working in a printshop and you will need some form of timing device. Some printmakers use a cooking timer, which will work fine if it is precise.

Because you are working with highly combustible materials, it is important that you have on hand the proper fire extinguisher for the materials in use. It should be quickly accessible and very easy to use.

Finally, an essential item is a sink with running water. Although it is not extremely important that this be located in the immediate area of printing and plate production, it should be fairly close by. The acid baths should be located near the sink and running water. Of course, ventilation should be available in this area. A fan, with exhaust capabilities, and an open window should be adequate.

It should be noted that this list of supplies and workshop space described is primarily for the individual or small group and must be modified and expanded for larger situations.

The main objective when organizing your workshop, equipment, and supplies is to provide the most efficient and safe system possible. As you follow the procedures of making an etched plate and printing from it, modifications to your beginning plans should be made to provide a space **9** ideally suited for the process at hand and your particular working habits.

Poorly organized shops that require excessive walking, talking, searching, stumbling, and so on cause early fatigue, unsafe conditions, and disorientation. This situation, of course, will defeat one very quickly in the process of making a fine art print. Learn the organizational habits best suited for you, modify them immediately upon noticing that they are bad habits, and finalize a system of working that is so automatic that you do not have to think about it. There are too many other things, both technical and aesthetic, to concentrate on.

One last word on your working space. Once the shop is organized along the lines described, it is possible to incorporate most other printmaking processes into the operation. As these other processes are discussed in the following chapters, the modifications necessary for your shop will be individually covered.

HARD GROUND LINE ETCHING

PLATE PREPARATION

In general, there are two metals to choose from: copper or zinc. For etching, both are purchased in 16- or 18-gauge micrometal plates. Although zinc retains certain limitations, it is ultimately the best choice for the beginning printmaker bcause it is relatively inexpensive. As one advances in technique, it may become beneficial to switch to copper. The change requires only minor modifications in terms of chemicals and methods. It should be noted, however, that many professional etchers never use copper and actually prefer the qualities of zinc, which implants an aesthetically pleasing tone to the final print, reacts quickly to the acid baths, allows for greater variability in line and texture, and increases the range of certain possibilities within color printing.

Zinc plates can be purchased commercially prepared for fine art etching from any well-stocked art dealer (see Appendix A). They usually can be purchased in any size, already cut or cut-to-order. It is less expensive to purchase larger plates and cut them to size yourself. A plate cutter is sometimes available in well-equipped printshops, which makes the plate cutting very simple. However, this piece of heavy duty equipment is quite expensive and occupies considerable space. Accordingly, plate cutting in the small or beginner's shop will utilize a hand tool, that, although somewhat slower and more tedious, works quite adequately (Figure 1-6).

The plate *face* is sometimes purchased with a protective covering of contact-type paper. The back of the plate is usually covered with a coating of acid-resist material carrying the brand name of the plate on it. If the face is not protected, you should immediately cover it with an inexpensive contact-type paper. If, for some reason, the back of the plate is devoid of the acid-resist material, paint the back with stop-out varnish, let it dry thoroughly, clean your brush in alcohol, and store both in a safe area of your locker until ready to use.

11

When you are ready to cut your plate to size, place the following items at your work station: plate cutting tool, metal straight edge/ruler, sharpening stone, household oil, sharpened pencil, and the plate. Make sure that your work station is free of any debris that may scratch through the protective covering and coating, and place the plate face side down on your table. Measure out the plate size with a pencil and rule and mark it with a penciled line. (It is suggested that you begin with a plate size of approximately 9 ″ by 12 ″ .)

Fig. 1-6 Draw tool for hand cutting of metal and plastic plates.

Fig. 1-7 Sharpening of draw tool cutting face.

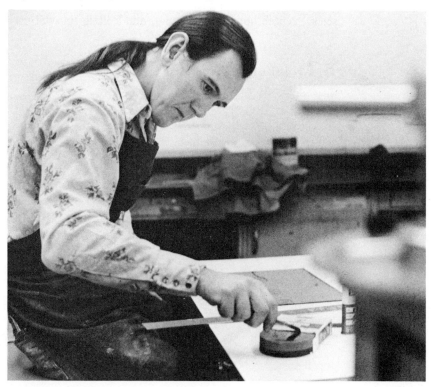

Before proceeding to cut, make certain that your cutting tool is sharp. You must keep the tool perfectly sharp throughout the cutting procedure. To sharpen the cutting tool, place a little houshold oil on your sharpening stone and rotate the cutting edge gently in a clockwise manner, being careful not to create a new or false edge (see Figure 1-7). Do this a few times, and your tool should be ready for cutting.

Now place the metal straight edge along the penciled line, which you have placed on the back of the plate. Holding the straight edge firmly in place, gently pull the cutting tool down the line creating a minor incision. Repeat this a few more times, allowing the incision to go deeper with every pull. Avoid using excessive arm pressure, allowing the tool itself to do most of the cutting. Add a few drops of oil to the incision and continue cutting. After you have created a fairly deep incision into the metal, you can eliminate the straight edge. Check the sharpness of the cutting tool and continue the procedure, pulling the tool through the incised line allowing for it to go deeper and deeper (Figure 1-8).

After you have cut into the plate two-thirds or more, it is ready to be snapped in two. Place the plate on the edge of your working table so that the incision aligns with the edge. Beginning with gentle pressure, push down the section of the plate hanging over the table edge, firmly holding down the other section (Figure 1-9). The plate should snap into two pieces; if not, your incision is not deep enough. Cut off any excess contact-type paper and repeat procedures until you have cut the plate to your chosen size.

When the plate is finally cut to size, it is ready to be beveled. For this procedure you will need a rough and smooth metal file, a snake slip (pumice stick), scotch hone (stone hone), and a little tap water.

Fig. 1-8 Using the draw tool to cut the plate.

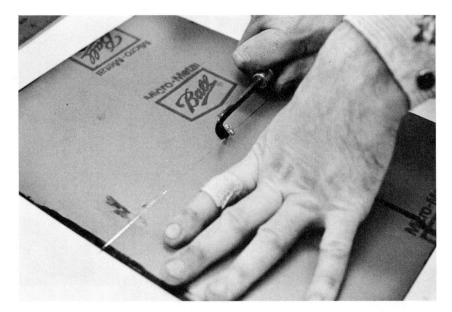

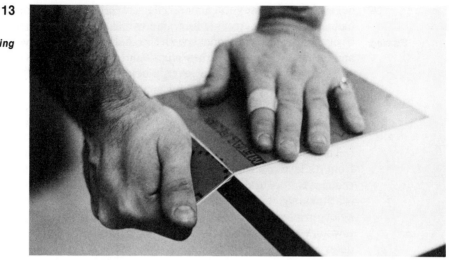

Fig. 1-9 Snapping the plate along the draw tool incision.

Place the cut plate, face side up, on the edge of the working table. Hold the plate with one hand and begin rounding the edges of the plate with the rough file. Corners also should be rounded. When filing, do not stay in one place for a lengthy period of time, but carry the file over the entire edge in a continuous, even fashion. You must avoid any "valleys" along the plate edges. Continue filing with the rough file until all edges are evenly beveled. Repeat the procedure with the smooth file until edges are smooth to the touch.

Now take your scotch hone, dip it into a little water, and rub it along each

Fig. 1-10 Filing the plate bevel.

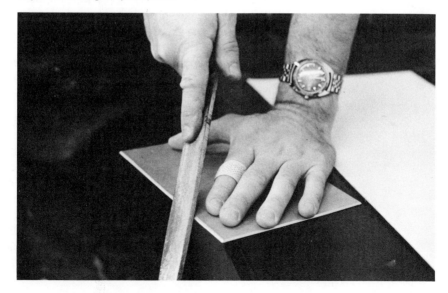

edge of the plate several times. The scotch hone will remove any excess metal burr caused by the filing, and will smooth out the edge more effectively. Repeat this procedure with the snake slip, dipping it into the water and rubbing it several times along the edge. When finished, the edge should be perfectly smooth, evenly beveled, and perfectly straight (Figure 1-10). The scotch hone and snake slip procedure may have to be repeated continuously throughout the etching prior to proofing or printing of the plate, if the edges begin to show signs of pitting from false acid biting (see Appendix B).

The plate is now ready to be cleaned. Plate cleaning removes any grease from its face caused by the contact-type paper or human handling, and reduces the natural oxidation of the zinc. This procedure will be repeated continuously, before placing ground on plate, after removing ground, before printing, after printing, and so on. The procedure requires soft paper towels, whiting, French chalk, or powdered pumice (or any mild household detergent), household ammonia, and water.

Remove the contact-type paper from the plate and place the plate face side up in the sink. Put a very small amount of whiting in the center of the plate, create a "doughnut" hole in the center of the whiting, pour a small amount of ammonia in the hole, and *gently* carry the mixture across the plate. Do not use excesive pressure when rubbing, or an excessive quantity of whiting, for the abrasive nature of these items may cause unwanted scratches on the plate. Wash the mixture off with clean water, and dry the plate with paper towels. (Figures 1-11 to 1-13 show the cleaning process.)

If the plate has not been protected during storage or handling, it may be overly tarnished. To remove this, use a mild metal polish or wash it with a mixture of 25 percent acetic acid to 75 percent tap water several times. When the tarnish is removed, wash it again with the whiting and ammonia.

The plate is properly cleaned when the water from the faucet rolls evenly across the plate as it is raised slightly. If the water appears to separate or form into globules, the grease has not been properly removed. It is very important to insure that the grease is completely removed, or it will cause unnecessary problems with future procedures.

The plate is now prepared properly for the placing of the ground, drawing, and etching. Do not touch the face of the plate at any time after cleaning.

PLACING GROUND ON PLATE

There are many different grounds on the market. Additionally, many professional etchers have formulated their own grounds and have made these formulas available to the public. It is unnecessary for the beginning printmaker to pay attention to the multitude of hard and soft grounds available. Perhaps, as one progresses, certain grounds other than the ones recommended here will become necessary for certain effects. The hard ground to begin with is a naptha-based (mineral spirits) liquid ground made by Graphic Chemical Company called "Universal Liquid Ground" (see Appendix A).

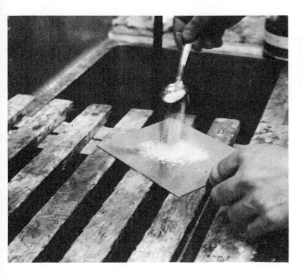

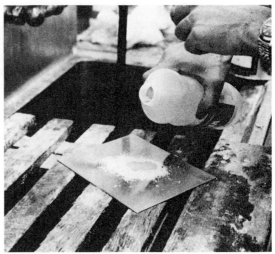

Fig. 1-11 Applying whiting to the plate.

Fig. 1-12 Pouring household ammonia into center of whiting.

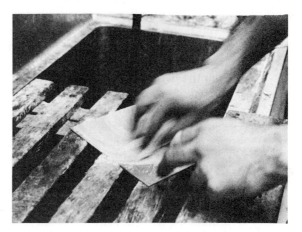

Fig. 1-13 Gently carrying the whiting/ammonia mixture across the plate surface to remove oil, grease, and minor oxidation.

Besides the Universal Liquid Ground, you will need newspapers, a soft hair (oxhair or imitation sable) brush, a small jar with a tight-fitting cover, and your cleaned plate.

Place newspaper on the table top and prop your plate up against a firm surface so that the plate forms a slight angle. Shake the can of Universal Liquid Ground well, open it, and pour a small amount into your separate jar. Notice the viscosity of the liquid ground when first opened. It should always be used at this viscosity. If it ever appears to get too thick, because of evaporation of its solvent base, add a little paint thinner to it, bringing it back to its original viscosity.

Now saturate your brush by mixing it into the separate container of liquid ground. Keeping the brush generously supplied with liquid ground, make quick horizontal strokes across the plate as evenly as possible, letting the

15

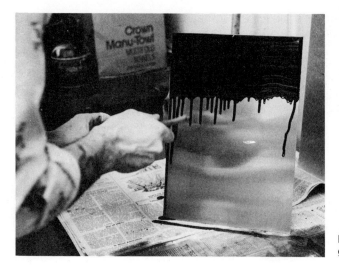

Fig. 1-14 Applying liquid hard ground.

excess ground flow to the newspaper below. Continue the horizontal strokes across and down the entire plate, until it is covered with ground. Work quickly and evenly without going over any spots that you may have missed at this point. If you try to go over the spots, you will only pick up ground or streak it, allowing for open areas that will be false-etched by the acid baths. The ground dries fairly rapidly. After a few minutes of drying, lift the plate from the back, holding it flat at face level. Take your brush with a small amount of ground on it, and touch up any minor exposed areas such as the edges. If you were overly inconsistent when first applying the liquid ground, and the plate shows large areas of open metal or streaking, remove the ground with paint thinner, clean it again with whiting and ammonia, and repeat the application procedures (Figure 1-14).

Upon successfully applying the liquid hard ground to the plate and allowing for about 5 to 10 minutes of thorough drying, the plate is ready for drawing. Place the plate at a clean, well-lighted area, face side up. Before proceeding with the drawing, clean your brush with paint thinner, and wash it well with a mild hand soap until all traces of pigment are removed. Reshape the brush and let it dry naturally. Tightly cover all containers of hard ground.

CREATING THE LINE DRAWING THROUGH HARD GROUND

The purpose here is not to present a lesson in drawing. However, there are a few things unique to etching, and printmaking in general, that you should be cognizant of when preparing to draw on a plate. The first rule is to remember that everything you draw will print in the reverse. That is, if you draw the word "love" through hard ground on a plate so that you can read it properly as drawn, it will print backward as in a mirror image. Another thing to remember is the fact that darks and lights are created by the amount of time exposed areas are allowed to etch in the mordants.

Accordingly, you do not have to press lighter for light lines, or harder for dark lines. The lines, when drawn through the ground with an etching needle, will appear fairly equal. This may give one a problem at first, especially if you are used to drawing in pencil or charcoal. The beginning etcher should get used to drawing directly through a ground and not rely on traced drawings. Traced drawings usually result in labored lines and destroys the spontaneity of the initial conception. Finally, you must get used to the handling of an etching needle, whether it is one that has been commercially purchased or one of your own devising. The needle is very different from a pencil, usually having much more weight, is thinner, and requires very little drawing pressure.

Before beginning to draw directly onto the plate, practice some drawing in a sketchbook with a hard pencil (H or 4H) until you feel comfortable with a drawing or two. It can be beneficial, if you have no idea of what you would like to draw through hard ground, to make arrangements to attend a figure drawing session. With a pad of newsprint and a hard pencil, also carry a prepared grounded plate and your etching needle. Make several drawings from the model on your newsprint pad, keeping to the scale of your plate size. After gaining confidence with the drawings, take out your plate and needle, retain the same attitude, and create a line drawing through the ground using the model as your motif (Figure 1-15). Of, if you prefer, take a plate outdoors and use the same procedure with the landscape as motif.

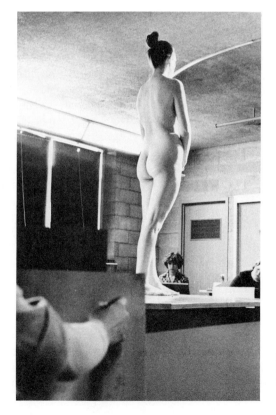

Fig. 1-15 Creating a hard ground line drawing of the female model directly.

When you are ready to draw through your hard ground plate, you will need one other item besides the plate, the etching needle. There are many different types of etching needles on the market, all of which work quite adequately. In addition, you can make your own by grinding down to a point old dental tools or large nails. You can also use push pins, hat pins, dissecting needles, manicuring tools, and other items. The main thing is to find an etching needle that you personally feel comfortable with and that gives you the line results you want. When doing the drawing, you should immediately

Fig. 1-16 Beginning the hard ground line drawing directly unto plate with various etching needles.

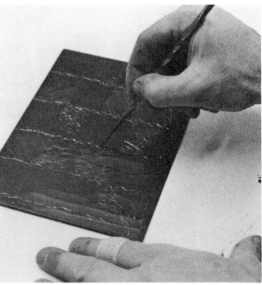

Fig. 1-17 How the hard ground line drawing appears in progress.

notice that the tool glides very freely through the ground, exposing the metal as you proceed. If the needle grabs or sticks, you are pressing much too hard, scoring the metal, and creating burrs. All you have to do is expose metal, not incise it. Straight edges, French curves, compasses, and others can be used with little difficulty. The ground is fairly tough and will not lift if you are careful (see Figure 1-16 and 1-17).

When you have completed the drawing, there is one more step before placing the plate into the acid bath. You will need, at this point, a small Japanese or watercolor brush, stop-out varnish, another small jar with a tight-fitting cover, and, of course, your drawn plate.

Stop-out varnish is made by dissolving rosin in denatured alcohol. It is sometimes pigmented and sometimes left natural, which is a transparent beige color. The Graphic Chemical Stop-Out Varnish is an excellent, premixed, pigmented all-purpose product. Take note, again, of the viscosity of the stop-out varnish when first opened after shaking well; if it gets too thick, add a little denatured alcohol.

Take a small amount of any type stop-out varnish in a separate container, and with your small brush, paint out any areas you do not want to have etched, that is, exposed edges, unnecessary lines, cracked ground. Be careful not to get any stop-out into lines you definitely want to print (see Figures 1-18 and 1-19).

Check the back of the plate, and stop-out any scratches that were inadvertently made through the protective coating. Allow the stop-out varnish to dry thoroughly. Clean your brush well with denatured alcohol and soap and water. Cap all containers tightly.

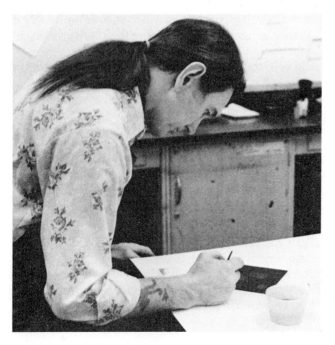

Fig. 1-18 Applying stop-out varnish to completed hard ground line drawing before beginning the etching procedures.

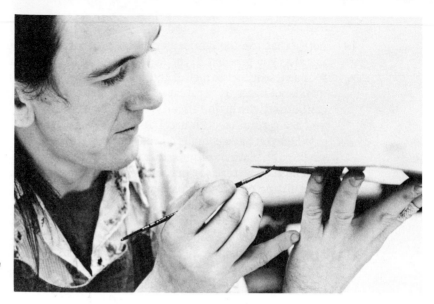

Fig. 1-19 Applying stop-out varnish to plate edges before beginning the etching procedures.

ETCHING THE DRAWN LINE
AND PREPARATION OF THE ACID BATH

While the stop-out varnish is drying on the plate, you should prepare your acid bath. Again, there are many different formulas used by professional etchers regarding acid baths. As you become more proficient, and retain a better understanding of the medium, these varied formulas will become more important. It is enough at this point to say that, in general, the stronger the acid bath or mordant is, meaning it has a greater mixture of acid or other corrosive material to water, the more radical will be the etched bite. The more radical the etch is, the less control you will have over the quality of line and area. As a beginner, an average etch mixture for a hard ground line drawing on zinc is eight parts of water to one part of nitric acid.

Accordingly, you will need the following to prepare your mordant: nitric acid, two plastic photographic trays or Pyrex baking dishes larger than your plate, an empty glass container with a tight-fitting plastic cap, a measuring cup, a plastic funnel, tap water, and a container of ammonia or baking soda (acid neutralizers). Additionally, it is recommended that you wear plastic or rubber gloves when working with acid.

With gloves on, begin by placing eight parts of cold water into one tray, using your measuring cup. Next, carefully pour out one part of nitric acid into your measuring cup and gently add it to your water. Remember, as a general safety rule, *always add acid to water, never water to acid.* Safety always comes first when working with acid. If you add water to acid instead of the proper way, it can spatter up onto your skin and possibly into your eyes. Pure acid can cause serious problems. If contact is made, flush the area with water and a weak ammonia or baking soda solution. Always insure that the area where acids are exposed to the air is well ventilated, and never stand directly over acid trays when following the progress of your plate.

20

Besides insuring that your acid tray is in a well-ventilated space, there should also be sufficient light to watch the progress of your plate effectively. Alongside your acid tray, place another tray of clean water. Also have on hand a soft feather (sea gull feathers are excellent) or a commercially produced acid brush.

To realize the variety of line one can achieve by allowing exposed areas to etch at different lengths of time, it is recommended that you consider your first plate as a test plate. Make a quick drawing to scale that generally simulates the drawing on the plate. Now slowly place your plate into the mordant (being certain that the stop-out varnish has dried on all exposed areas you do not want etched), insuring that the plate is fully submerged. Keep the plate in the acid bath, thereby letting the lines etch, for five minutes. Watch the plate carefully, and as bubbles begin to form in the lines, take the feather or brush and very quickly and gently remove them; otherwise, the bubbles are indicative of air pockets being formed in the lines, which do not allow for consistent etching.

After five minutes, tip the edge of the tray, remove the plate from the acid, and place it immediately into the water tray. Let it sit in the water a few seconds, remove it, and gently pat the plate dry with soft paper towels or clean blotters. Now take your stop-out varnish and small brush; select a number of lines that you wish to have appear light and thin in the final print and stop-out those lines. Make a note on your simulated drawing of the lines that you have stopped-out and mark them as five-minute lines. Again, place the plate completely into the mordant after the stop-out is dry, keep the bubbles out of the lines, and let it bite for 10 minutes, removing it from the acid, placing it into the water, drying it, stopping-out some more lines, marking your drawing accordingly, and placing the plate back into the mordant. Remember you are dealing with accumulated time, so that your drawing should indicate those lines that have etched for 5 minutes and those lines that have etched for 15 (five plus ten) minutes.

Insure that the stop-out varnish is completely dry before placing the plate into the mordant or you will etch where you do not want it etched, and continue to bite the lines following the same procedures, marking your drawing accordingly. The final period of time is up to you; just be sure you keep accurate notes. By comparing your notes to a final print, you will be able to make fairly close predictions with later plates. When the etching process is complete, pour the mordant into a separate glass container by using your measuring cup and plastic funnel. Mark the bottle with "8:1," date it, cap it tightly, and store in a cool, safe place. The mordant can be used over and over again; it begins to neutralize with time and should be remixed when air bubbles no longer form in the exposed metal areas. When this is apparent, flush the mordant down the drain, using plenty of tap water, and prepare a new acid bath.

It should be pointed out that acid baths, unless controlled under ideal conditions, fluctuate as to strength. Accordingly, room temperature, mordant temperature, humidity, age of bath, and hardness or softness of metal are all variables over which you have little control, and this fact must

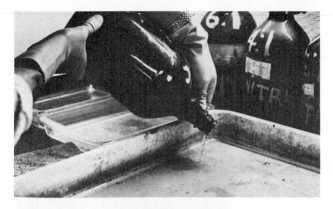

Fig. 1-20 Gently pouring out the prepared 8:1 mordant; note use of rubber gloves.

Fig. 1-21 Gently submerging plate in 8:1 mordant.

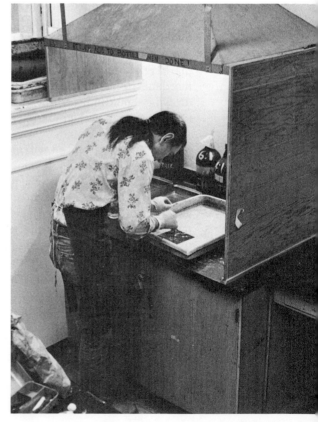

Fig. 1-22 Checking progress of plate; note proper air ventilation hood over acid bath installed in a large school workshop.

Fig. 1-23 Removing the air bubbles from the etching lines with a rubber set acid brush (or sea gull feather).

be taken into account when working on future etchings. To avoid too much fluctuation, warm mordants to 80°F before each use.

Figures 1-20 to 1-23 show the above described procedure for creating an etched test plate. Upon completing the etching process to your satisfaction, you can lay aside your record of proceedings in a safe place, and begin to prepare the plate for proofing, correcting, adding, and final printing.

CLEANING THE PLATE; PREPARATION FOR PROOFING

Take your plate to the designated cleaning station and lay out several layers of newspaper. Place the plate face side up on the newspapers and pour a small amount of denatured alcohol over the entire surface. Take some paper towels or old rags and clean the stop-out varnish from the plate. Now pour a small amount of paint thinner over the entire plate, and with some paper towels or old rags, clean off all hard ground. Remember that denatured alcohol cleans stop-out varnish, and paint thinner cleans ground. Alternate as necessary between the two solvents. If you have some difficulty removing the varnish or ground from the lines, take a very soft toothbrush and gently clean out the etched incisions. Do not use a very stiff brush or you may unwantingly put minor scratches into the plate (Figure 1-24). Clean the back of the plate as well with both solvents as necessary.

After you finish using solvents, throw away the soaked newpaper in a safe container, cap all solvent cans tightly, and wipe up any runoff that may have fallen to the table or floor.

Fig. 1-24 Smoothing out plate bevel with scotch hone and snake slip to clean up any minor false biting along edges.

Take your plate to the sink and clean it with the same whiting and ammonia solution you used when you first took the contact-type paper off. Wash it well with water and make sure that no lines are holding particles of whiting or detergent. Cover the plate with a few layers of paper toweling or clean newsprint and place it in a safe place with nothing on top of it that may cause scratches. The plate is now ready for proofing (see Chapter 5 on one color intaglio printing.)

If the plate is to be stored for a week or more, cover the surface with a thin coat of petroleum jelly, which can be cleaned off with paint thinner before printing. This reduces any possible corrosion due to oxidation.

AQUATINT ETCHING

Aquatint etching is a method of producing values from black to white, dark to light (see Figures 1-25 to 1-29). You are dealing now with mass rather than line; although line may determine where you will put a particular value, the value will be defined by mass or volume and not by the line itself. Figure 1-30

Fig 1-25 Aquatint and line etching. *Alphabet,* 7¾″ × 10″, Robin Sweet, 1974.

Fig. 1-26 Aquatint and line etching. *Epreuve d' Artiste,*
10″ × 14″, Suzanne Sydler, 1973.

Fig. 1-27 Aquatint and soft ground
collage etching. *Strata,* 14¼″ × 18″,
Mary Studeny, 1975.

Fig. 1-28 Aquatint etching. *Untitled,* 9″ × 13″, Dorothy McGahee, 1975.

Fig. 1-29 Aquatint and line etching. *Speedball,* 7½″ × 11″, Bernard Bradshaw, 1975.

indicates a series of eight possible values acquired through aquatint etching. Through careful control, one can conceivably acquire many more values.

PLATE PREPARATION AND STOPPING-OUT

Here again, the plate choice will be zinc. It is suggested that you purchase or cut one that is approximately 9″ by 12″. As with the plate for line etching through hard ground, you should treat this plate as a test. Eventually you will choose to mix the several etching methods described to produce the wanted results as determined by the particular imagery you are working with, and these test plates will be of great value.

As was done for the line etching, bevel the edges of the plate and make sure they are smooth, remove the contact-type paper, clean the plate with whiting and ammonia solution, dry it, and place it on your working table without touching the plate face.

There are, basically, two methods of applying a powderlike, acid-resist substance to a plate to produce an aquatint etching. The first, which is the more traditional method, uses powdered rosin. This method is quite effective, producing very satisfactory aquatint results. However, it is also quite cumbersome, usually requiring ideal conditions, extensive equipment, and considerable practice. A new method of creating aquatint values has been in practice for a few years and, although frowned upon by some of the more "traditional" printmakers, is in use quite extensively by most professional etchers. It produces very nearly the same satisfactory results, is much simpler to apply, and requires no extensive equipment. It is especially preferable in the small or home printshop.

This more modern method uses spray paint. When sprayed on a properly cleaned plate, the paint dries quickly, adheres extremely well, and is acid resist. Krylon Brand spray enamel produced by Bordon Company (see Appendix A) gives the best results.

Accordingly, you will need the following items for your aquatint etching: one pint can of red (or similarly bright, easily seen, color) Krylon Spray Enamel, stop-out varnish and brushes, two large sheets of cardboard, contact-type paper, and a roll of masking tape.

Your first step is to decide what spatial areas you want to have printed clean, or white. These areas will hold no aquatint tones or values and, therefore, will not need to be sprayed.

You can stop-out these particular areas in three ways. First, you can use the stop-out varnish as you did in the line etching through hard ground; this method is most suitable for painterly effects, very small areas of space, calligraphic or spattered effects. Simply paint the stop-out varnish onto a clean plate utilizing the brush that will give you the wanted effects— Japanese brushes for calligraphic effects, watercolor brushes for large, small, and dry brush areas, flat brushes for painterly effects, and a toothbrush for spattering the stop-out varnish onto the plate.

A second method of stopping-out when dealing with spatial relationships is through the use of contact-type paper. This adhesive paper is acid resist

and will not lift from the plate when submerged in the mordant as long as the acid mixture is not overly radical and the plate is not left in the bath for very long periods of time. Shapes can be cut from the paper, its backing removed, and the shapes put in place on the plate. Make sure that the paper adheres tightly to the plate, especially along the edges. After the paper is laid down, clean the plate gently with the whiting and ammonia solution (using a minimal amount of moisture) to remove any grease caused by handling of the plate.

Third, you can use masking tape of different widths as a stop-out. Masking tape is also acid resist and is ideal for creating straight line separation of values. Figure 1-30 was created by using masking tape. Again, be sure the tape is secured tightly to the plate, clean the plate with whiting and ammonia after handling, and proceed to the next step.

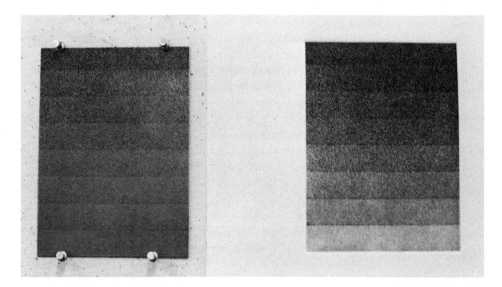

Fig. 1-30 Aquatint plate (left) and aquatint print (right) showing eight value possibilities.

SPRAYING ON THE ACID-RESIST PAINT

Place a piece of cardboard against a wall and a piece on the working table. Without touching the face of your clean plate, place it at a slight angle against the cardboard that is resting on the wall. Open the can of Krylon spray paint, shake it well, and begin by cleaning the valve of the can so that you get an even spray. Spray a little paint off to one side, until you are sure that the spray is coming out consistently with no heavy droplets or speckles. Holding the can about 10" to 14" from the plate, begin to spray, keeping the can moving rapidly and consistently in a horizontal back-and-forth motion. Continue to spray, never stopping while the can is pointed at the

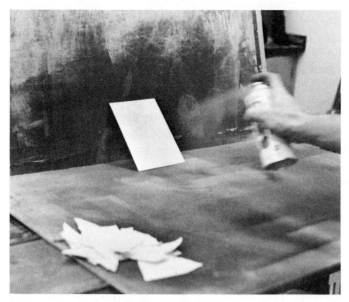

Fig. 1-31 Spraying the acid-resist Krylon enamel paint onto the cleaned metal plate.

Fig. 1-32 Detail showing under application of Krylon enamel.

Fig. 1-33 Detail showing over and uneven application of Krylon enamel.

Fig. 1-34 Detail showing proper application of Krylon covering approximately 50 per cent of the plate surface evenly.

plate. Stop only after you have completed a full horizontal motion and the can is pointed at the cardboard (see Figure 1-31). Cover approximately 50 percent of the plate surface so that it appears to have an entire surface coverage as in Figure 1-34. (Figures 1-32 and 1-33 show incorrect applications of spray paint.) Let the plate sit for about five minutes to insure that the paint is thoroughly dry. Turn the spray can upside down, and spray until it no longer releases paint; this will keep the valve clean. After you have used approximately three-fourths of the pint can, throw it away or use it for another purpose, as it will begin to splatter. If the valve clogs, clean it by removing it from the can and soaking it in denatured alcohol.

ETCHING THE AQUATINT AND FURTHER STOPPING-OUT

It will be necessary to prepare a new acid bath mixture for aquatint etching. An 8:1 mixture is usually too strong for aquatints. Following the safety rules discussed earlier, prepare a mixture of 14 parts of water to 1 part of nitric acid. (See the section on preparation of the acid bath under *Hard Ground Line Etching*.)

Make another quick sketch that simulates the spatial arrangement you have put on your plate, first marking the clean or white areas. Using one or a combination of previously discussed stop-out methods, stop-out any additional areas you have designated as "white" areas, those you do not want etched, including edges, scratches on the back of the plate, and such.

Now place your plate into the 14:1 mordant, and let it etch for five seconds. Do not feather or brush the plate to remove the air pockets, but slightly tip the edge of the tray up and down so that the motion of the mordant itself removes any bubbles. As soon as the plate has etched for five seconds, tip the tray so that you can easily remove the plate, place the plate into the water tray for a few seconds, remove it, and *very* gently blot it dry with paper towels or blotters.

Stop-out some additional spatial areas using one or all of the three stop-out methods. It is also possible to use the spray paint itself as a partial stop-out. This method is very effective when you are trying to create value separations that do not leave clear indications of line or contour breakups.

To accomplish this, as shown in Figure 1-35, simply cut out paper stencils (or stencils of your own devising) from any drawing paper, place your plate on the cardboard, and put a spray over a previously sprayed area, holding the paper stencil in place so that the new spray does not take effect in certain areas. As the spray builds up, it will continuously reduce the aquatint etching effect, creating a partial stop-out and changing the values from area to area. The plate used to illustrate the printing procedures in Figure 5-24, Chapter 5 was produced in this way. Simply remember that the more spray paint you put in an area, the less that area will etch, and, accordingly, the lighter it will be in the final print.

After stopping-out additional spatial areas, mark your simulated sketch showing the areas with the five-second aquatint etch.

Place the plate into the 14:1 acid bath again, timing it and tipping the tray

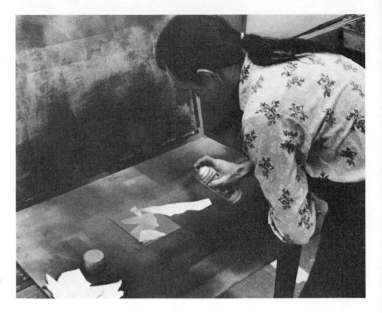

Fig. 1·35 Applying stencils and spray paint to create various aquatint values; the process continues until value changing motif is completed to satisfaction. Plate is then submerged in a 14:1 mordant for one etching time period.

occasionally for 10 more seconds. Take it out of the mordant, immerse it in the water bath for a few seconds, blot it dry and prepare to stop-out more areas. You now have three distinct spatial/value areas; a clean or "white" area, a 15 second "grey" value, and a five second "grey" value. Remember, accumulated time. You can continue this procedure until you have as many different values as you want. Just be sure to keep accurate notes so that you can refer to them in the future, making appropriate changes as you see fit.

Upon completion of the etching process, clean up your acid and mark the bottle accordingly, "14:1." Cap the bottle tightly, date it, and store in a cool, safe area.

CLEANING THE PLATE; PREPARATION FOR PROOFING

Bring your aquatint etching plate to the cleaning station, lay out plenty of newspaper, and place your plate on the newspaper face side up. By the time you have finished the entire process, it is usually very difficult to remove the spray paint from the plate with normal solvents. If the Krylon paint has not been on the plate too long, it usually can be removed with denatured alcohol, which will also remove the stop-out varnish. Other brands of paint require different solvents to remove the spray; when necessary, lacquer thinner should be used.

Cover the entire plate with a small amount of selected solvents, being careful not to breathe in the fumes directly, especially in the case of lacquer thinner. Carry the solvent across the surface of the plate with an old rag or paper towel and you will immediately note the loosening of paint and stop-out. Clean the plate well, making sure all paint is removed. Clean all brushes with the respective solvents and place drenched newspaper, **31** toweling, and rags in a safe container.

Take your plate to the sink and wash it thoroughly using the whiting and ammonia solution. Put your simulated drawing with its record of timings in a safe place. Cover the plate with a few layers of paper toweling, clean newsprint or blotters, and place it also in a safe place with nothing on top of it. The plate is now ready for proofing (covered in Chapter 5). Petroleum jelly can be used to cover the plate as an added protection if the plate is going to be stored for over a week.

It should be noted that as an extra safety factor it may be advisable to use a fume and dust respirator approved by the Bureau of Mines or the National Institute of Occupational Safety and Health (see Appendix A) when working with aerosol sprays, toxic solvents, and chemicals.

Fig. 1-36 Soft ground collage etching. *Untitled,* 9″ × 11¾″, Linda Martin, 1973. (Collage was created with natural weeds; note change of scale, that is, small weeds become a thick forest.)

Fig. 1-37 Soft ground collage etching with open biting. *Les Freves,* 8½″ × 11½″, Lynn Rubino, 1975. (This print was made from two separated plates; the upper plate was detached from the lower plate through use of a strong 4:1 mordant.)

Figure 1-38 Soft ground collage and line etching. *Untitled,* 7¾″ × 14″, Virginia Evans Smit, 1975.

SOFT GROUND COLLAGE AND LINE DRAWING

Unlike hard ground, soft ground never hardens. Accordingly, when composing a motif through soft ground it is possible to obtain extensive variation in line and texture. By placing different types of textural papers on a plate that has been properly prepared with soft ground, and drawing through these papers with a variety of items from a soft pencil to a plastic hone, one can achieve effects that very closely simulate an actual paper drawing. And, by combining an unlimited "palette" of available textures, soft ground etching can create a very painterly looking print. When mixed with the many other etching methods to be described, one's repertoire of possibilities becomes increasingly more abundant.

PLATE PREPARATION/CHOOSING COLLAGE MATERIALS

The choice of zinc versus copper here is important. As pointed out before, zinc is a softer metal. In most cases, this is a drawback, but in soft ground work it is an asset. The softness of the metal actually extends textural and soft line qualities. Again, it is suggested that you begin with a 9" by 12" plate. To discover the many possibilities in working with soft ground, treat the first plate in a very exploratory and experimental way.

As before, you must first bevel the edges of the plate, insuring that they are smooth and well rounded. After the beveling is complete, remove the contact-type paper and clean the plate well by using the ammonia and whiting solution. Dry the plate and place it face side up at your working table without touching the front.

Before proceeding any further, you should assemble a variety of textural items. Cloth is ideal for this purpose and, of course, comes in many different types of textural patterns. Burlap, lace, cheesecloth, tapestry, corduroy, terry cloth, and canvas are quite effective. Other possibilities include a variety of strings and rope, textured tin foils, electronic templates, corking, salt, grass, weeds, flowers, leaves, human skin texture, vinyls, leather, sawdust, different papers, and similar items. Use your imagination here; almost any kind of texture can be imprinted through soft ground.

PLACING GROUND ON PLATE

There are on the market a variety of prepared soft grounds. It is possible to mix petroleum jelly to hard ground to produce a workable soft ground. However, this is sometimes cumbersome and time-consuming. Accordingly, it is recommended that you purchase a separate container of premixed soft ground. Like hard ground, it comes in two basic mixtures. The paste-type soft ground is ideal for most line and collage work. However, for some procedures, it may be beneficial also to have on hand a container of liquid soft ground (see Appendix A). The difference between the two will be explained as we proceed.

Therefore, you should have on hand a jar of paste soft ground and a container of liquid soft ground, a separate container with a tight-fitting lid, a container of stop-out varnish, a flat soft bristlebrush and a smaller brush, a semisoft six-inch rubber brayer, any type of flat hot plate with medium heat, a roll of aluminum foil, textured drawing paper (charcoal paper), your accumulation of textural materials, a variety of drawing instruments (soft pencils, popsicle sticks, cotton swabs), and a double cylinder press (optional).

There are many ways to work with the soft ground, and, accordingly, it should be emphasized that you should explore as many variations as you can. Begin by working with the paste soft ground. Place your plate on the hot plate, which is set at a medium temperature. Let the plate get evenly warm to the touch. Open your container of paste soft ground and dab a little onto the center of the plate, creating a horizontal strip a little larger than your six-inch brayer. Now roll the paste out until you have covered the entire plate evenly, allowing for no open or exposed areas, and have a sufficiently dark, slightly thick layer of soft ground adhered to the plate surface. If the plate gets too hot, the soft ground will not adhere and will simply turn into liquid. If this is apparent, take the plate from the heat, let it cool some, and roll the soft ground out "cold."

After you have sufficiently covered the plate with soft ground, be very careful not to touch the face of the plate. The soft ground is very fragile and will lift from the plate easily. It is also important while working on the soft ground not to press anything into it, including fingers, unless you want this impression.

Remove all soft ground from brayer and hot plate with paint thinner, and turn the hot plate off.

When you are ready to explore the possibilities of the liquid soft ground, you should apply it in the same manner used to put the hard ground on the plate (see Hard Ground Line Etching).

IMPRINTING COLLAGE MATERIALS INTO SOFT GROUND

Take the plate and your cleaned brayer (or a rolling pin for baking) to your working table and place it face side up. Assemble your textural items and begin, in a collage manner, to place them on the plate. It is recommended that you work with one textural item at a time; different size layers of items will not allow for all of them to be imprinted through the soft ground in one procedure. As seen in Figures 1-39 and 1-40, place your first item on the plate, put a sheet of smooth aluminum foil over the top of the textural item and plate, and while holding the foil in place by pressing down on one edge that is not making contact with the plate, run your brayer or rolling pin down the entire plate from top to bottom, using moderate pressure when you feel the brayer ride over the textural item. Remove the foil, and very carefully lift the textural item from the plate. A pair of tweezers or a push pin can aid in lifting the item without getting your fingers in the way. When you lift the textural item from the plate, you should note that the soft ground has attached itself to the textured surface,

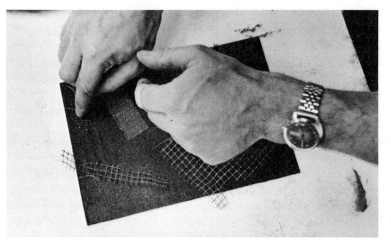

Fig. 1-39 Placing textural items carefully onto a plate with paste soft ground applied.

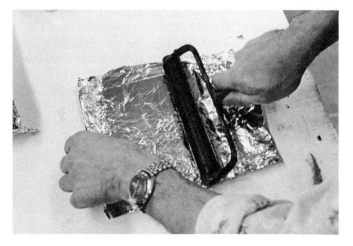

Fig. 1-40 After placing a sheet of aluminum foil over textures and plate, brayer is used with medium pressure. Ground transfers to textures, thus exposing metal for etching.

has imprinted its pattern into the ground, and, accordingly, has exposed a pattern on the metal for etching.

When this pattern is etched and finally printed, you will note that the result will be much softer in appearance than the stiffness associated with the lines made through hard ground. It is, however, possible to get a stiffer feeling with soft ground if you so desire. Here is where the liquid soft ground becomes important. After it has been applied, you will note that it does seem to dry on the plate slightly and not form a sticky, thick layer as was apparent with the paste ground. Yet, with increasingly more pressure than was applied with the paste ground, it will result in patterned imprints. The final printing, however, will reveal a somewhat cleaner, stiffer area.

36 By this time you should be familiar with the double cylinder etching

press. You have used it to proof print the line etching through hard ground and the aquatint etching. If you are not familiar with the press, see Chapter V before proceeding, and review the sections that deal with the press, pressure, and blankets.

After you have applied the liquid soft ground to a properly cleaned and prepared plate, which can (or not) be the same plate used for the paste soft ground, carry it to the press area. Place a clean sheet of newsprint on the press bed and put your plate face side up in the center of the newsprint. Assemble your textural items near you and begin, one item at a time, to place them on the plate in a collage manner. Here it is possible to put more than one textural item on the plate, allowing for the extra pressure of the press to compensate for the different layers. However, the difference in layers should not be too radical, and if you desire a clear visual separation between textures, working with one pattern at a time is still desirable.

When you are satisfied in terms of design, place a piece of smooth tin foil (or wax paper, waxed side down) over the textural items you have placed on the plate, which is, of course, on the press bed. Make sure that the foil is at least 2″ larger than the plate all the way around. This protects the blankets from ground runoff and keeps the textures from shifting. Cover the foil with a sheet of clean newsprint. Now set the pressure of the press somewhat lighter than for printing purposes, place the blankets over the foil/newsprint-covered plate and squarely on the press bed, and run everything through the press once. The amount of exact pressure necessary to imprint the textures varies considerably, and, accordingly, a little experimentation is necessary.

Fig. 1-41 Applying cheesecloth (for texture) over a plate with liquid soft ground painted onto its surface.

Fig. 1-42 Aluminum foil is placed over plate and cheesecloth, newsprint next, and blankets of press over this.

Fig. 1-44 Setting pressure on Brand's micrometer dials.

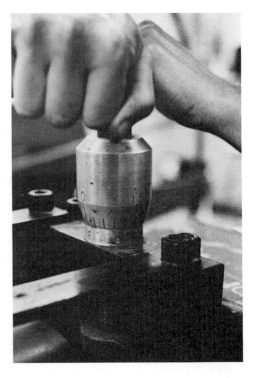

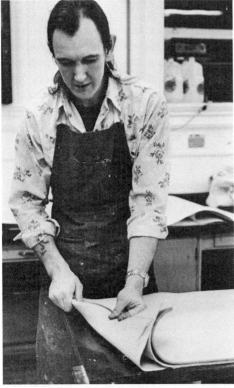

Fig. 1-43 Three blankets in proper order: sizing catcher (bottom), pusher (middle), cushion (top).

38

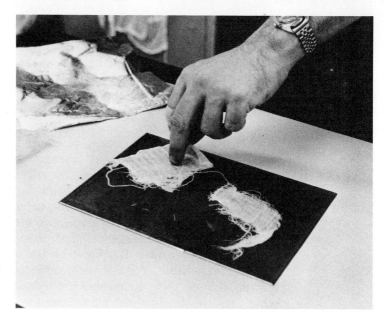

Fig. 1-45 After soft ground plate is pulled through press, textural items are carefully removed. Plate is then etched.

After you are sure that the textures selected have imprinted properly, remove the blankets, foil, and textural items, check the plate for unwanted exposed metal areas, stop-out accordingly, as well as the edges, and prepare to etch the plate in a mordant.

Figures 1-41 to 1-45 show each of the above described methods. Remember that to get the best textural finesse, each textural item should be separately imprinted and separately etched. Accordingly, you should imprint, etch, clean the plate with paint thinner and the ammonia/whiting solution, reapply the soft ground, imprint, etch, and continue in this fashion until your design is complete.

LINE DRAWING THROUGH SOFT GROUND

The printed results of a line drawing through soft ground are very different from the results of a line drawing through hard ground. The soft ground line, when properly drawn, produces a gentle grained line that resembles a crayon or grease pencil mark. As you have probably noticed by now, the hard ground line is crisp and without too much intrinsic variety. However, the "changing" single line is quite possible when working with a soft ground, various types of drawing instruments, and textured lightweight drawing paper such as charcoal paper.

Although it is possible to draw directly through a layer of soft ground with various etching needles and tools, the best results are achieved by drawing through paper. Additionally, drawing items other than a hard pencil or pen should be used. Grease pencils, plastic hones, popsicle sticks, hard felt tip pens, ball point pens, ends of paint brushes, and pencil-like typewriter erasers, when used singularly or in combination with each other, provide a host of possibilities in terms of line quality.

39

To begin your drawing, you will need a zinc plate that has had an even coat of paste-type soft ground applied, the textured drawing paper, the drawing instruments, and a roll of masking tape. Of course, you can use a plate that has already been through another process. Ultimately, you will want to combine all the etching methods described to produce the best possible image.

When you are ready to begin, place the plate face side up on your working table. Gently, without pressure, place a sheet of textured drawing paper over the plate so that it covers the entire plate surface, letting it hang off at the top. Tape down the paper on this top margin to the table top. Pick up your drawing instrument(s) and with the proper pressure (as dictated by the instrument in use), begin your drawing. As you work, you may lift the sheet of paper to see if you are using the proper amount of pressure when drawing to lift the soft ground completely from the plate to the paper. You will also be able to check the progress of your drawing (Figure 1-46). Remember not to touch the plate with anything other than the drawing instrument, for the soft ground will surely be transferred where you do not want it to be. You may find it necessary to build a simple wooden bridge on which to rest your arm while drawing.

As you have probably noted by now, transferring already completed line drawings from drawing paper becomes quite simple when using soft ground. Simply make a tracing of the drawing on a good quality thin tracing paper, tape it down over the textured drawing paper, which has been taped over the soft ground plate, and, using a little more pressure,

Fig. 1-46 Drawing through paper unto a soft ground plate; ground adheres to drawn line exposing metal for etching. Very soft, varying lines are the result.

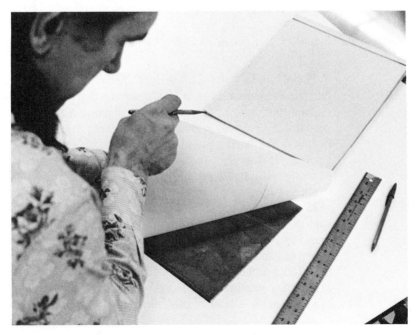

trace the entire drawing, transferring it to the plate. (Remember your drawing will print as a mirror image; therefore, you must allow for this when making your transfer.)

When the drawing is complete, remove all covering papers, stop-out any mistakes and unwanted exposed areas as well as the edges, and the plate is ready for etching.

ETCHING A SOFT GROUND COMPOSITION: LINE AND/OR COLLAGE

Experience has shown that it is best to etch a soft ground plate in a somewhat weak mordant. This requires longer etching times, but it insures the retention of delicate lines and textures.

Carefully prepare a 12:1 acid bath, and slowly lower the plate into the tray, making certain that the mordant is fully covering the plate surface. Because soft ground remains quite soft, to remove the air pockets simply tilt the acid tray back and forth every so often, allowing the motion of the mordant to eliminate bubbles.

There is no recommended time periods for etching soft ground plates. From your experience with the hard ground line etching and the aquatint etching, you should be able to make your own judgments. Remember that you are biting slowly in a weaker solution, and, therefore, you must leave the plate in the acid for longer periods of time. Begin with at least a 15-minute first etch before removing the plate for further stopping-out. If you do not intend to stop-out lines or patterns as you proceed, etch the entire plate for at least 45 minutes. It should be noted that textural patterns or lines that are very busy or very close together will etch in a way that will cause very dark areas when printed out, especially if etched for a long period of time.

CLEANING THE PLATE; PREPARATION FOR PROOFING

Bring the soft ground etching plate to your cleaning station, place plenty of newspaper under it, and clean it well, first with denatured alcohol to remove the stop-out varnish, and then with paint thinner to remove the soft ground. Insure that all ground and stop-out has been removed from the lines and textures, or you will produce frail prints.

Clean all brushes with the respective solvents and soap and water. Cap all solvents tightly. Cover ground and stop-out bottles. Throw away solvent-drenched newspaper, toweling, and rags. Place mordant into properly marked bottle, date it, and cap tightly, storing in a cool, safe area.

Wash your plate well with the whiting and ammonia solution. Cover it with a few layers of paper toweling or clean newsprint (petroleum jelly, if needed) and store it in a safe area until you are ready to proof print it (see Chapter 5).

Previously described methods of etching require an indirect way of producing the initial drawing. By utilizing sugar-lift methods, you can produce a drawing very directly. The lines that you place down with a pigmented sugar-lift on a clean, ungrounded plate are going to print exactly as you put them down. This allows for the maximum amount of spontaneity in the drawing stage. You can draw with a multitude of available pen points, as well as creating very painterly imagery with various brushes and brush techniques.

Fig. 1-47 Sugar-lift, open-biting, and aquatint etching. *Untitled*, 8″ × 10″, Susan Chin, 1973. (Spacial and transparent effects created by multiapplications and etchings of sugar-lift lines; some left open and some closed with aquatint values.)

Etching Start with a suggested 9″ by 12″ zinc plate. Bevel all edges of the plate until they are smooth (see Hard Ground Line Etching). Remove the contact-type paper, clean the plate well using the whiting and ammonia solution, dry it, and place it on your working table without touching the plate's face.

You should now prepare your sugar-lift mixture. There are, like everything else in printmaking, several formulas that have come down through the years. The two main purposes of the mixture are: 1) to obtain a solution that flows freely from pen and brush, and 2) to obtain a solution that adheres to plate well but lifts easily when put in contact with water. Accordingly, the solution should have a consistency of slightly thickened milk and ingredients that are highly water soluble. Generally, the following is an excellent mixture:

> 5 tablespoons of granulate sugar.
>
> 5 ounces of boiling water.
>
> 1 ounce of black ink (India or Sumi).
>
> 1 ounce of gum arabic solution.
>
> 1 ounce of liquid detergent (optional); double amount of detergent if gum arabic is not available.

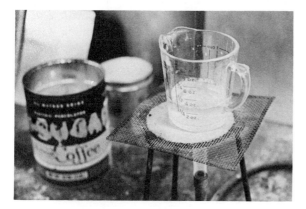

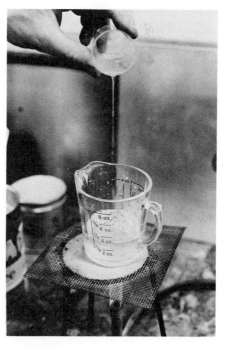

Fig. 1-48 Adding sugar to boiling water for sugar-lift mixture.

Fig. 1-49 Adding gum arabic solution to the sugar-lift mixture.

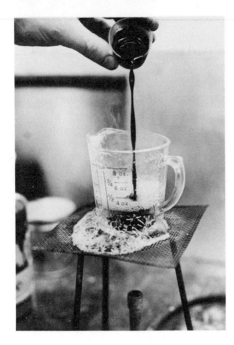

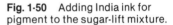

Fig. 1-50 Adding India ink for pigment to the sugar-lift mixture.

As shown in Figures 1-48 to 1-50, heat the water in a Pyrex measuring cup until it boils. Add the granulated sugar and reduce the heat, mixing slowly. Now add the gum arabic and/or liquid detergent, and, finally, the black ink. Mix thoroughly and turn off the heat. Let the mixture cool before using. The sugar-lift solution can be stored in a container with a very tight-fitting cap. If it begins to get too thick, add a little boiling water.

DRAWING WITH SUGAR-LIFT; BRUSH AND PEN

When you are prepared to complete a sugar-lift drawing, have ready the following items: the sugar-lift mixture; several brushes of various types (watercolor, Japanese, stencil, hard bristle, toothbrushes); a pen point holder and several different pen points for drawing; a properly cleaned zinc plate (it is imperative that the plate be free of all grease); stop-out varnish slightly thinned with denatured alcohol or hard ground also slightly thinned with paint thinner; a flat soft bristlebrush; and a pint can of brightly pigmented Krylon spray enamel.

It is recommended that you practice drawing with the sugar-lift mixture several times on your plate with the assortment of brushes and pen points before you decide on a final drawing. You can clean the plate at any time with clean water first, then with the ammonia and whiting. Again, make sure no grease is apparent on the plate before drawing. Practice as much as you wish, for it will not affect the plate in any way.

Each brush will give you different effects. Watercolor brushes will produce smooth broad strokes as well as dry brush effects. Japanese brushes are usually used for calligraphic line work, but should also be

44 explored further. Stencil brushes provide very interesting textures as well

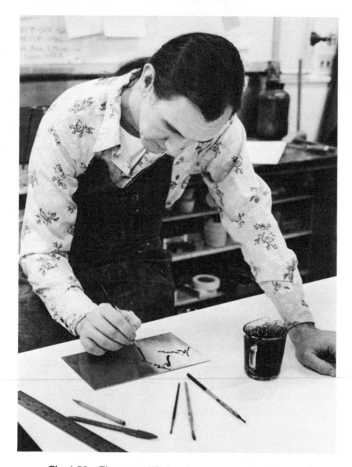

Fig. 1-51 Beginning a direct drawing onto a clean plate with sugar-lift.

Fig. 1-52 The sugar-lift drawing progresses with use of various brushes.

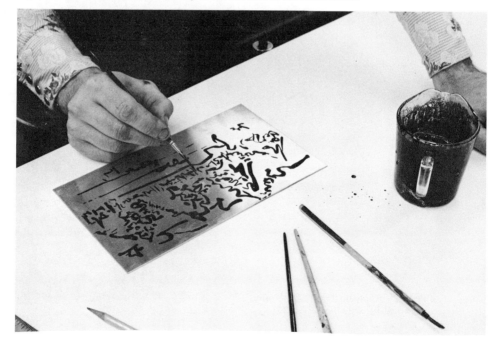

as hard bristle oil or acrylic paint brushes. And toothbrushes are excellent for stipple and splatter effects. Pen points of various sizes will work just as they do when lettering or creating an ink drawing, although this will take some practice; for this purpose, a thinner sugar-lift solution may be necessary. You may also wish to experiment further by dropping textural items such as cheesecloth that has been soaked in the sugar-lift mixture onto the plate. This "monoprinting" technique can give unique effects.

After deciding on a final drawing, make sure the plate is clean and proceed as you did in your experiments. Figures 1-51 and 1-52 indicate the development of a sugar-lift drawing. After applying the sugar-lift to your satisfaction, allow it to dry thoroughly. It may take as much as one hour for the solution to dry thoroughly on the plate surface.

STOPPING OR GROUNDING OUT THE PLATE/THE LIFT

It is sometimes recommended by many printmakers to use a thin coat of ground for the next procedure. Although this will work quite well, this printmaker has found that a more transparent stop-out varnish is more effective. It can be thinned without destroying its excellent coverage and adherence qualities; it will not lift when put in contact with warm, or even, hot water; and because of its extended transparent base, the sugar-lift drawing can be seen easily, allowing for more effective lifting. Figure 1-53 shows the application of ground over a sugar-lift drawing; stop-out would be applied in exactly the same way.

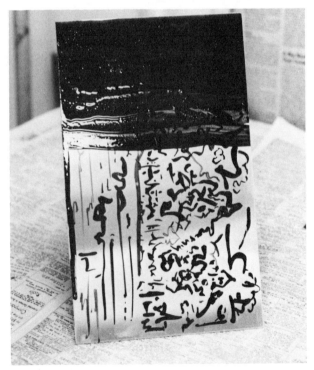

Fig. 1-53 Applying liquid hard ground over sugar-lift drawing.

After the sugar-lift solution has thoroughly dried on the plate, carry it to your cleaning station, and place several layers of old newspaper under the plate, propping it up on an angle as you did when applying liquid grounds. Pour approximately two ounces of stop-out varnish into a separate container. Add to this one-half ounce of denatured alcohol, and mix well. The mixture should flow easily, result in a very thin layer, and cover the entire plate thoroughly. With a saturated brush, flow the stop-out varnish onto the plate in the same way you have applied liquid grounds (see Hard Ground Line Etching), working quickly and consistently and not allowing for any exposed metal areas.

Allow the stop-out varnish to dry until it is tacky to the touch. Immediately place it into a tray of warm water. You will note that the sugar-lift mixture is starting to dissolve and lift from the plate, exposing the metal. If some areas do not lift immediately, they may have to soak longer. You can encourage lifting in several ways. Try, first, to hold the plate under a strong faucet or hose of warm water. The action of the water will sometimes be enough to lift any problem areas. If this does not work, add a little acetic acid to the water tray, and soak longer. And, finally, if some areas still do not lift, very gently rub them with your finger under warm water, prompting the water to leak under the stop-out and dissolve the sugar-lift (Figures 1-54 and 1-55).

Fig. 1-54 Soaking a sugar-lift drawing that has transparent stop-out varnish applied; the drawing is encouraged to lift by use of warm water, light finger rubbing, and water pressure.

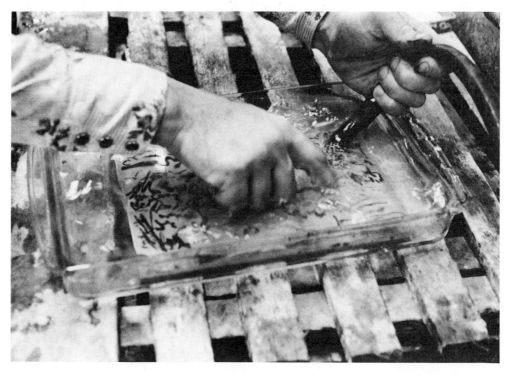

After all the sugar-lift has dissolved and lifted from the plate, wash it gently several times with a weak solution of acetic acid and warm water. Household vinegar will work as well for cleaning in this case. The cleaning will remove any grease from the exposed areas and allow for proper aquatint etching.

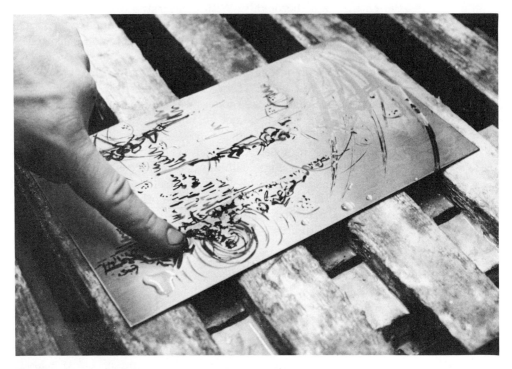

Fig. 1-55 Close-up indicates sugar-lift mixture has partially lifted, taking the stop-out varnish with it and exposing the metal in these areas for etching.

OPEN BITING AND/OR AQUATINT AREAS

Open biting simply means to allow the acid bath to etch an open or exposed area of the plate. If these areas have not been aquatinted, they will print out quite differently than you may be used to. If they are open lines that are quite thin, they could resemble the line made with soft-ground without the well-defined edges. However, if they are thick lines, as would be made with a wide pen point or Japanese brush, they will etch so that the final print reveals slightly "greyed" areas with black edges. Very large open bite areas will also show a distinct grey tone. And depending on how long you allow these open bit areas to etch, they will appear on your printed paper as very distinctly embossed surfaces. To see how open biting affects a drawing, it is recommended that you try leaving some areas open as well as some areas closed with aquatint.

Fig. 1-56 Spray paint being applied to exposed areas for normal aquatint etching.

Aquatint line or painterly areas will have the same changes in value that were evident in the aquatint etching. It is simply a matter of etching these areas at different time periods to get your variation (Figure 1-56).

ETCHING A SUGAR-LIFT DRAWING

You will have to mix another acid bath solution for the open biting procedure. Open biting can take quite a long time in weak solutions, and it is really unnecessary to waste this time. If the stop-out varnish has been applied correctly, a stronger acid will not negatively affect the plate.

Paying attention to all safety precautions when mixing acid, produce a solution of one part nitric acid to four parts of water. As mentioned, to keep this more radical mordant biting at its optimum, you can warm the acid to about 80°F before using.

Prior to lowering the plate into the mordant, check to see that anything you do not want etched is properly stopped-out with varnish. This is especially important with this more radical acid solution. When ready, slowly lower the plate into the mordant, insuring that it is covered with the solution, and feathering or brushing it occasionally to remove the air bubbles. Let the plate bite for at least 10 minutes, remove it, wash it lightly in clean water, and check to see how deep it has etched. This will be quite apparent when you gently rub your finger across the plate surface. If you are satisfied with the degree of bite, stop the open biting at this point. However, you may wish to create different surface depths. If so, stop-out some areas, and allow the plate to etch for another length of time. Remember, those areas that you are stopping-out at this point will print as open bites. Continue the procedure until you are satisfied with the number of different depths created, saving a few areas for aquatinting.

49

Place the 4:1 mordant in a tightly capped bottle properly marked, and slowly pour out the 14:1 mixture into your tray. As you did when aquatinting spatial areas of the plate (see Aquatint Etching), spray the entire plate with an even coat of paint, covering about 50 per cent of the plate surface. Now place the plate into the 14:1 mordant and etch at different time sequences, using your aquatint notes as references for determining changes in value. Stop-out accordingly, and complete the etching process. Properly secure the mordant when finished.

CLEANING THE PLATE; PREPARATION FOR PROOFING

As you did on the aquatint etching plate, clean everything off with appropriate solvents. Insure that everything is removed from lines, textures, and open-bite areas.

Clean all brushes with appropriate solvents and soap and water. Clean pens and brushes used for applying the sugar-lift with hot water and hand soap, removing all pigment. Cap all solvents, stop-out varnish containers, and sugar-lift solution containers tightly, and throw away solvent-soaked newspaper, toweling, and rags.

Wash your plate well with ammonia and whiting. Cover the plate and store it safely until ready to proof print it (covered in Chapter 5).

2

Drypoint

INTRODUCTION

It is difficult to determine the historical placement of the drypoint method of creating intaglio plates for fine art printing. Although it had to be associated with the development of engraving, its chronological progression as a fine art medium is more closely associated with etching. There is evidence to indicate that Dürer used drypoint in isolation as well as in association with his engravings and etchings during the sixteenth century.[1] However, after Dürer there are few traces of evidence to indicate that the medium was being explored, and it was not until the seventeenth century that we see drypoint becoming an essential part of the artist/printmaker's repertoire. All evidence indicates that the revival or true recognition of the medium came about through the middle and later period prints of Rembrandt, between 1640 and 1655.[2] Although on occasion Rembrandt used drypoint as an isolated medium, his prints indicate that he saw its real potential when combined with etching.

[1] Arthur M. Hind, *A History of Engraving and Etching from the 15th Century to the Year 1914* (London: Constable and Company, Ltd., 1927), pp. 79-80.

[2] Ibid., pp. 172-180.

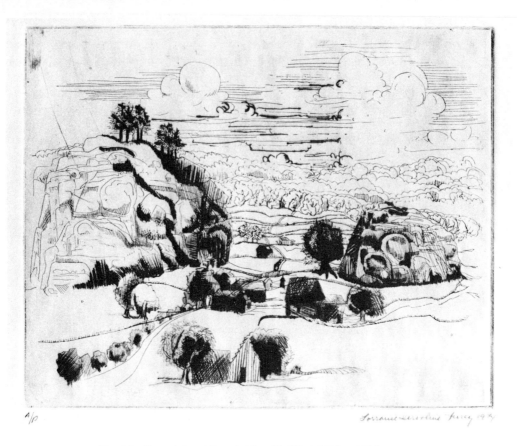

A/P Lorraine Furey 1974

Fig. 2-1 Drypoint and line etching. *Untitled*, 6¼″ × 7¾″,
Lorraine Furey, 1974.

Images totally produced by drypoint are not apparent until the nine-
teenth century. At this time, the English revival of printmaking in general
led many artists to explore the possibilities of drypoint as evidenced by the
work of Laura Knight,[3] W. Russel Flint,[4] Edmund Blampied,[5] Francis
Dodd,[6] and James McNeill Whistler.[7] The apparent exploitation of the
medium was probably due to the discovery of steel facing by commercial
engravers of the nineteenth century; when a drypoint is steel faced, it can
withstand the pressure of the press for a much longer period of time,
allowing for extensive multiple impressions. Many artists working in the
German Expressionistic manner made drypoint an essential part of the
graphic visual image, and the twentieth century gives us many examples of
the medium used in isolation, as exemplified in the prints of Lovis

[3]*Modern Masters of Etching*, Vol. 29 (New York: William Edwin Rudge, 1932).
[4]*Modern Masters of Etching*, Vol. 27, 1931.
[5]*Modern Masters of Etching*, Vol. 10, 1926.
[6]Hind, *History of Engraving*, p. 322.
[7]Ibid., p. 325.

Corinth.[8] Picasso also produced many drypoints during his long career.[9] However, it seems that most contemporary printmakers look to the tradition of Rembrandt when working with drypoint, using it in combination with etching.

For the beginning printmaker, drypoint is to be considered the simplest method of producing the intagliate. It requires no special chemicals such as mordants; no special dexterity except the ability to hold a drawing instrument of a specific type in the hand and manipulate it as you would a pencil; no application of grounds or stop-outs; and it can be accomplished on inexpensive plastic plates if desired.

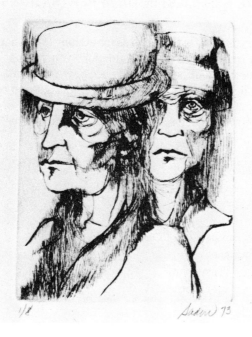

Fig. 2-2 Drypoint. *Untitled*, 4″ × 5″, Harriet Sadow, 1973.

The method simply entails the direct scratching, hammering, and/or incising of a plate. It is, primarily, a linear medium that acquires tonal effects through the tightness of line patterns. When used in combination with other printmaking media, the printed image takes on a unique visual appearance. As pointed out in Chapter 1, the etched line is very clean and stiff without too much intrinsic variety. The drypoint line, however, shows every move and change the artist makes, revealing as distinctly as possible the personal "hand writing" of an individual. The line is created by the rising metal burr produced as the needle cuts through the metal; it is, when

[8] Jo Miller, "The Dry Points of Lovis Corinth," *Artist's Proof* VIII (Greenwich, Conn.: New York Graphic Society, 1966), pp. 35-37.

[9] Hind, *History of Engraving*, p. 339.

printed properly, a very soft line with "fuzzy" edges that impart a rich deep visual. On close inspection of the paper, the drypoint would tend to create convex printed lines, whereas engraving and etching tend to create concave printed lines. This is more true when the drypoint is done on metal versus plastic.

Its limitations lie in the fragile quality of the intagliate, especially when the metal plate is not steel faced. Additionally, it is primarily a drawing medium, and, therefore, when isolated its visual effectiveness depends solely on the mastering of line draftsmanship.

WORKSHOP, EQUIPMENT, AND SUPPLIES: INITIAL PREPARATIONS

The workshop space is exactly the same as for etching (see Chapter 1), with one exception. As indicated in the introduction, you will not need acids. Accordingly, extensive ventilation is not necessary. Solvents will still be used, however, and some ventilation in the area designated as a cleaning station is important.

Besides the equipment necessary for intaglio printing (see Chapter 5), you will need the following:

Plates (either copper or plastic)
Drypoint needle (steel, carbide, or diamond tip)
Metal punches (a variety, as necessary)
Hammer
Sharpening oil/Arkansas stone (if using a steel point)
Household oil (for stone)
Felt tip pen (black, sharp point)
Vibro-type power inciser (optional)
Scraper
Burnisher
Ink or dry pigment (black)
Petroleum jelly
Whiting, French chalk, or powdered pumice
Household ammonia

(See Figure 2-3 for an accumulation of the essential drypoint supplies.)

The choice of plates is discussed in the following section under Plate Preparation.

There are several different types of drypoint needles on the market. You can also improvise your own by grinding down heavy steel nails, old dentist tools, or the like, until the needle holds a very fine and firm point. The improvised tool will give you interesting results, but usually will not produce the traditionally beautiful drypoint line. When the finest results are wanted, you should purchase a diamond point drypoint needle from your art equipment supplier (see Appendix A). Another tool that gives

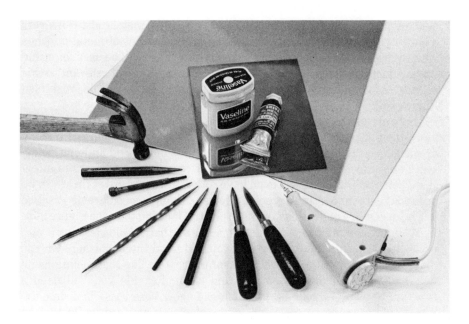

Fig. 2-3 Accumulated drypoint tools.

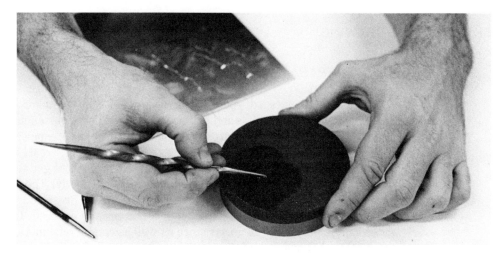

Fig. 2-4 Sharpening steel drypoint needle.

satisfactory, if not perfect, results is a carbide tip engineer's scriber, which can be purchased at a well-stocked hardware store. Also available is a tempered steel drypoint needle, which is very similar to an etching needle. Many art suppliers interchange the two; just make sure it is tempered, high quality steel. (See Figure 2-3 for types of drypoint needles on the market.) When using the steel drypoint or improvised needle, you will have to keep it sharp constantly by rotating it consistently and evenly on **55** an oiled oilstone and Arkansas stone (Figure 2-4).

Metal punches can be improvised from a variety of metal rods. However, a hardware store will usually stock a large assortment of metal punches with square, round, lozenge, and shaped tips. These will be used for criblé work, which is not strictly part of the drypoint medium but relevant to this section. A metal hammer, not too heavy, is perfect for criblé work (see Figure 2-3).

There are on the market electric engraving instruments, usually called vibro-tools. Some are simply for marking personal possessions with name or social security number. These usually have one speed and one point. More expensive models will have variable speeds and some have interchangeable points; some will even have rotating wheels. All of these can be used to create innovative drypoint effects, although considerable practice will be necessary before mastering an electric incising tool (see Figure 2-3).

At times, you may wish to burnish a line so that it holds less burr and, accordingly, prints lighter; for this you will need the burnisher. Or you may wish to remove the burr altogether to create a line that maintains its delicate nature but prints smooth and clean; for this you will need a scraper. Figures 4-2 and 4-3 in Chapter 4 show both these instruments. These tools are most applicable to metal plates and are ineffectual on plastic.

DRYPOINT LINE DRAWING

PLATE PREPARATION

It is possible to place a drypoint intaglio image into any metal or plastic plate. However, some metals and plastic have proven more beneficial than others. Using metal, copper plates are best. Zinc can be used, especially for practice purposes, but it is too soft for extensive printing, creates more irregular lines because of its brittle nature, and is difficult to get as much variety because of its coarseness when incised into directly. The copper should be purchased in 16 or 18 gauge and immediately protected with a covering such as contact-type paper, if it is not already covered. Copper plates can be purchased in an art store as well as commercial metal plate outlets (see Appendix A).

The plastic plate is a fairly new innovation. Plastic sheet can be purchased in most art stores and certainly in commercial plastic outlets (see Appendix A). Most art suppliers sell a prepared clear plastic, which is usually .050 to .060 inches thick (which makes it flexible) and comes in a variety of rectangular, circular, and square shapes. It is manufactured for drypoint work and produces excellent prints. Additionally, any piece of Plexiglass or Lucite plastic approximately 1/8″ thick will work. Plastic plates have many intrinsic qualities: they are usually clear, allowing for easy tracing of already prepared drawings; easy to cut in any shape; as you ink, by holding the plate to the light you can easily judge how the ink is being applied and controlled; plates can be incised with almost every tool

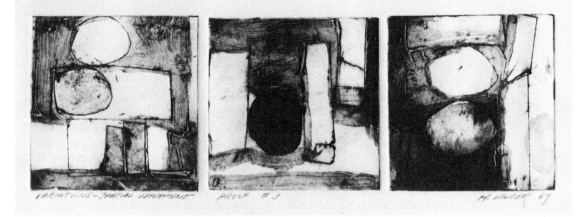

Fig. 2-5 Plastic drypoint with acetone and polymer. *Variations-Spatial Experiment,* 5¾" × 17¾", Howard Unger, 1969.

including heated tools; and textures can be easily created directly on the plate by melting or breaking down the plastic with solvents. Of course, it will not give you the same soft drypoint line that is unique to copper; it is, at times, more difficult to get good inkings for printing; and it is difficult, if not impossible, to correct mistakes on plastic.

The thick plastic or metal plate is cut with a draw tool if not bought to size (see Chapter 1). Additionally, the plastic plate easily can be cut into various shapes: to accomplish this, the thick plastic will require a hand coping or powered jigsaw; the .050" or .060" plastic plate can be cut with a heavy pair of shears. The cutting can be done before or after drawing on the plate.

The copper plate will require the same sort of beveling as described in Chapter I under Plate Preparation. The 1/8" plastic plate also should be beveled with a smooth file and fine sandpaper only. Be careful not to breathe in the plastic filings or dust, as they are very toxic. Bevel all edges so that they are well rounded without any sharp points or corners. When beveling, be sure to keep the face of either the metal or plastic plate covered to protect it from being scratched.

After beveling, remove the protective covering and clean the face of the plate. The copper is cleaned with a small amount of whiting, French chalk, or powdered pumice and ammonia in the same manner described for cleaning a plate in Chapter I. When you use powdered pumice for the cleaning, the plate will become very dull allowing you to complete the incising without excess glare on your eyes. However, this step is not absolutely necessary depending on your personal preferences. The plastic plate needs only to be cleaned if you notice some of the adhesive from the protective contact-type paper covering adhering to the face. To clean the plastic, simply wipe it off with denatured alcohol and a soft, clean cloth. Your plate
57 is now ready to receive the incised drawing.

Drypoint There are, of course, several ways to create a drawing for drypoint printing. The preference is usually to work directly onto the plate with only a beginning concept, letting the drawing develop naturally, spontaneously, and intuitively. However, the beginning printmaker may prefer to work from an already prepared pencil or ink drawing.

If you are planning to proceed in this way, use a pencil or pen point that will show a lot of intrinsic line value. A 4B pencil or a thick, flat-tipped pen point is ideal. Prepare the drawing on heavy, transparent tracing paper.

When ready to transfer the drawing to the metal plate, decide how you want it to appear. If you want it to appear exactly as drawn, cover the front of the drawing with black conte or graphite. If you want it to appear backward (as in a mirror image), cover the back of the drawing with conte or graphite. Tape one edge of the drawing to your table and slip your clean copper or zinc plate under it. With firm pressure and a hard pencil, trace the main parts of the drawing onto the plate. Remove the plate from under the tracing paper and begin to work the drypoint line into the main areas. After completing this, mix a little ink or black dry pigment with some petroleum jelly and rub the mixture into the drypoint line, wiping away the excess so that you can see the incised line more clearly (see Figures 2-6 and 2-7). The pigment is mixed with the petroleum jelly so that it will not dry out in the lines. Now, based on your pencil or ink drawing, work up the plate accordingly, constantly checking the drypoint work by rubbing in the ink and petroleum jelly and wiping away the excess.

If you are working on clear plastic, a previously prepared drawing is very easy to transfer. Tape the drawing, whether on tracing paper or not, onto your work table. Place the clear plastic plate over the drawing and

Fig. 2-6 Creating drawing with diamond drypoint needle.

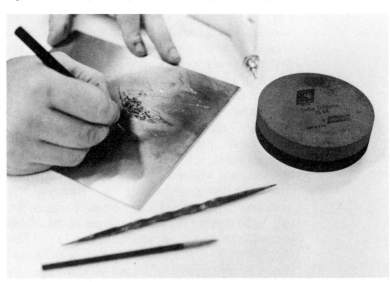

also tape it down. You will be able to see your drawing quite easily and transfer it into a drypoint plate with little difficulty. You can also watch the progress of the drawing by wiping the pigment and petroleum jelly into your incised lines if preferred.

The line that you do incise into either metal or plastic takes on very distinct qualities depending on how you hold the drypoint needle. If you hold the needle perpendicular to the plate, the line will print very fine because the remaining burr on the plate will be even and minimal. Holding the needle at various angles will change the line considerably: the more radical the holding angle of the needle when drawing, the more burr you will cause and the darker the line will be when printed. And, of course, the amount of arm pressure you use will affect the darkness and lightness of the line. The thing to remember while drawing is that every change you make with regard to holding and drawing with the drypoint needle will show in the print; this should not be a point of worry but simply a fact to be aware of—the intrinsic nuances in the line, as pointed out before, are exactly what you are looking for in drypoint work.

Any time you wish to create a cleaner or stiffer line, especially on the metal plate, either burnish it down using light circular strokes or cut the burr away with the scraper. (See Chapter 4 regarding the use of the burnisher and scraper.)

DRAWING FROM LIFE OR STILL LIFE

Drypoint work is ideal for drawing directly onto a plate. You can take a prepared plate with you anywhere, allowing for extensive landscape drawing. And, in the same way, working from a model is an excellent

Fig. 2-7 Wiping into drypoint lines ink and petroleum jelly mixture to expose progress of drawing.

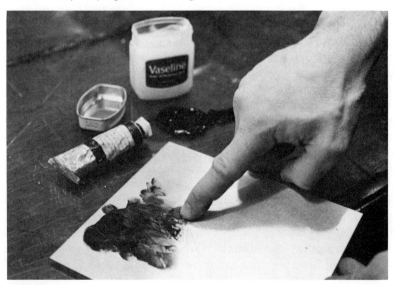

approach (see Figure 1-15, Chapter 1). Additionally, a still life composition can be set up using any number of materials and objects and drawn directly onto the plate—the still life approach has the added versatility of allowing you to leave the setup throughout the "proofing" stage so that you can make necessary additions to the plate as you see fit before pulling the edition.

When working directly in this manner, have available a sketching pad and pencil, your clean plate protected against scratches, a drypoint needle, a small container of ink and petroleum jelly mixture, and a clean cotton rag to keep the plate clean.

In all three situations, begin by making several quick drawings in your sketch pad. Continue until you have found an approach and angle you like best and have acquired a true spontaneity and confidence in the drawing. Now take the plate and drypoint needle, and without changing attitude, proceed to draw directly on the plate. As the drawing develops, check it with the ink and petroleum jelly mixture, and continue as necessary.

When your drawing is complete, protect the plate with a covering until you are ready to print the plate. You may wish to clean the lines out with some paint thinner before storing the plate, but this is not absolutely necessary. (See Chapter 5 for proofing and printing procedures.)

CRIBLÉ DRAWING OR IMPRINTING

Criblé drawing may be considered closer to engraving than to drypoint by some printmakers, but this is a minor point. It is a method of producing an image with small punch holes rather than lines, and can be used individually to create a total composition or in combination with any other printmaking medium. It is, in actuality, unique to itself, and is included here because this author sees its approach and result most closely associated with the direct and soft print qualities of drypoint. Imprinting, as referred to here, is a method of producing "drypoint" type textures by hammering textural items directly into the plate surface.

Like a pointillist drawing, such as those of by postimpressionist French artists Seurat and Signac, criblé areas are created on a plate by imprinting with punches. By placing the punched dots closer together, you create dark areas. By placing the dots farther apart, you create lighter areas. Accordingly, value changes from dark to light can be very effectively created with this method. It is tedious at times, but its effect is quite beautiful when properly controlled (Figure 2-8).

Imprinting direct textural patterns into metal also can be very visually effective. You will have to explore those items that work best; they must, of course, be very strong to withstand the heavy pounding. Such items as heavy, medium, or fine grained carbon paper, screws or nails, staples, metal scrapings, bottle caps with sharp edges, grit or fine stone, and similar materials can be placed on the plate, held in place with a piece of tin or aluminum foil covering, and hammered on using variable amounts of

strength. Imprinting is usually most effective in combination with drypoint lines.

Drypoint

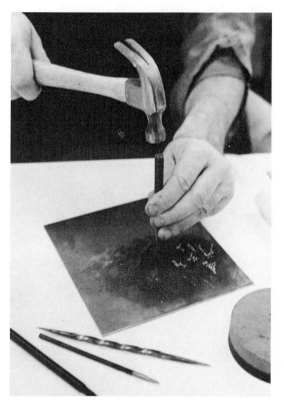

Fig. 2-8 Creating tone and texture with various punches.

ADDITIONAL DRAWING ON PLASTIC

As pointed out, plastic has a few additive qualities not found when using metal. Besides all of the above, such as the power inciser (Figure 2-9), drawings on plastic can be made in several other ways.

By using heat directly on the plastic plate, very unusual results appear. To experiment along these lines, you will need a clear plastic plate that has been prepared and cleaned with denatured alcohol. Additionally, you will need an instrument that can easily be heated or generates its own heat electrically and can be held and worked with like any other drawing instrument. Three items have been found ideal for this purpose: electric wood-burning tools (carried in most craft or hobby stores), electric soldering pencils with interchangeable points (in most hardware stores), and the X-acto electric cutting tool (in most art stores). (Figure 2-10 shows an electric soldering pencil.) Let the item heat up to its maximum level, and begin drawing. Work slowly, allowing the heat to penetrate and melt the

Fig. 2-9 Drawing into plastic with power engraver.

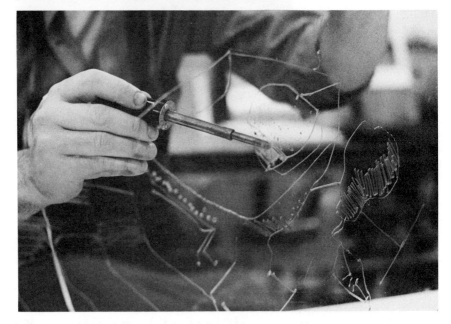

Fig. 2-10 Drawing into plastic with soldering pen (electric heat).

plastic. The "burr" created in this case will be soft and smooth; it will not hold as much ink as a result. Explore the many possibilities in line that can result from holding the tool for longer or shorter periods of time in one place, or using finer or thicker points.

62 Additionally, you can create tonal and textural areas by burning out

large sections of plastic plate with heat or a plastic solvent (ketones) such as acetone. When doing this, work in an effectively ventilated area, or work with a vapor mask. The fumes generated by melting plastic or using acetone are extremely toxic.

Controlling the melting process is somewhat difficult when using heat. To accomplish this, a butane torch set at a very low flame works best. More control can be acquired with the acetone or similar plastic solvent. You can brush it on in one area, allowing it to "eat" away the plastic, stopping the process when you feel you have reached the desired effects (Figure 2-11). When working with drypoint and related methods on plastic plates, remember it is almost impossible to correct a mistake.

After completing the intagliate drawing on the plastic, clean it again with a light application of denatured alcohol, and print it as you would any intaglio plate. (See Chapter 5.)

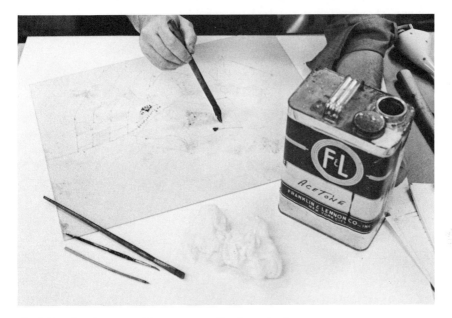

Fig. 2-11 Creating tone with acetone; applications of polymer and plastic glues also can be used to create painterly tone and texture.

STEEL FACING THE METAL PLATE

Because the drypoint line and related methods, including the engraving methods in Chapter 3, are not as firmly set in the metal as in etching, the intagliate image will break down fairly quickly from the pressure of the double cylinder press in printing. Accordingly, proofing should be kept at a minimum when using these intaglio processes, utilizing instead the pigment and petroleum jelly method for analyzing the development of image.

After the image is completed to the point where you must proof it to see what it ultimately looks like, do so using minimum press pressure (see Chapter 5). After you have pulled a proof, determine whether you need to add more drypoint lines, textures, and so on; this, of course, is easily accomplished. If you need to subtract line or texture, see Chapter 4. After you have finalized your image, and before you pull an edition of prints, it is time to decide if the plate should be steel faced.

You will be able to pull an edition of approximately 10 to 15 prints without losing the subtlety of a drypoint (or engraved) image on copper. Zinc will break down after about 5 prints. Accordingly, if you wish to pull more than the above, the plates must be steel faced by electrolysis before printing. This is usually done by commercial process engravers (see Appendix A) for a nominal fee. The copper plate is placed into an electrolytic bath, and a very thin coat of steel, nickel, or chrome is layered onto the plate electrochemically. A zinc plate first must be coated with copper, then coated with steel (at considerably more cost and loss of subtlety). Once the plate is steel faced, it is printed as usual and will last for at least 50 to 75 prints without breaking down.

3

Metal Engraving

INTRODUCTION

Engraving, defined as a method of directly impressing deeply or incising into a substance so that the inscribed form holds a relative permanency, has been a part of human evolution almost from the beginning. Cave dwellers left an extensive record of incised markings on bones, animal horns and hoofs, stone, and shell. As part of Western culture, the engraved impression has a long history, confined, however, to the decorative and functional aspects of art until the middle of the fifteenth century. The goldsmith, metal-chaser, and armorer were the prime engravers prior to and, to a large extent, after the Renaissance. Not until about 1440 does history record an engraved image transferred from metal to paper by printing. At this time, printed engravings appear as illustrations by unknown artist-craftsmen, as in the *Flagellation of A Passion* series, which was evidently part of a manuscript. Carried a step further, playing cards were illustrated with engravings by an unknown artist simply referred to as the "Master of the Playing Cards." And apparently a few

65

nonmanuscript illustrations appear by an artist-craftsman known as the "Master of the Year 1446." [1]

Metal Engraving

Although the year 1446 records the beginnings of extensive paper-engraved impressions, it was not until the turn of the century that we discover an engraving from an artist's hand made primarily for its own aesthetic value. Martin Schöngauer produced some very fine imaginative, expressionistic engraved images of a northern European mannerism during the early sixteenth century. And, of course, the master artist/printmaker of the period, Albrecht Dürer, perfected the art of engraving to an extremely sophisticated point. The methods and approach taken by Dürer have changed little since. [2]

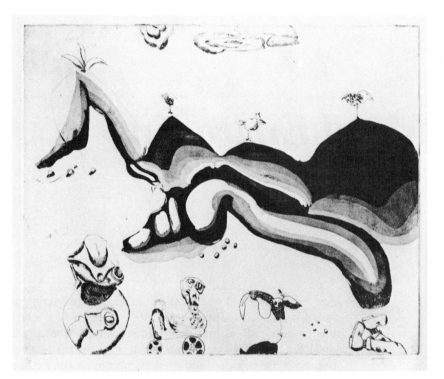

Fig. 3-1 Copper engraving with aquatint etching. *Untitled,* 13¾″ × 16¾″, Michael Socoloff, 1973.

Engraving is not an easy method of producing an intagliate image on a plate. It requires extensive practice and patience; the contemporary artist's temperament usually finds the method overly tedious, boring, and anachronistic. However, there is no other way to produce or simulate the

[1] Arthur M. Hind, *A History of Engraving and Etching from the 15th Century to the Year 1914* (London: Constable and Company, Ltd., 1927), pp. 20-22.
[2] Ibid., p. 24.

Fig. 3-2 Copper engraving and drypoint. *Untitled*, 3¾″ × 4½″,
Lorraine Furey, 1974.

engraved line. Etching, the method of incising through the use of grounds
and acids, was originally perfected to replace engraving because of its
relative speed and ease. However, etching never truly replaced the
engraved line, it simply became complementary to it. And drypoint,
although closer in method to engraving, produces a line very different from
both etching and engraving. These facts, although avoided by the con-
temporary artist for the sake of expediency and convenience, should not be
overlooked.

Stanley William Hayter, one of the most prominent contemporary print-
makers, has clearly indicated in his writing and teaching the importance
and effectiveness of the engraved image, used singularly or in conjunction
with the many other intaglio processes.[3] His stress on the method has
caused many artist/printmakers of today to reevaluate the importance of
engraving, the result of which has been an ever-incresaing reinterest in
and investigation of the medium evidenced by the recent availability of
contemporary prints utilizing engraved methods.

[3]Stanley William Hayter, *New Ways of Gravure*, 2nd ed. (London: Oxford University
Press, 1966), pp. 18-22.

For this reason, the engraving process should not be overlooked by the beginning printmaker. Although it may take many years to perfect its use, the beginner should explore its possibilities and uniqueness to build properly a personal printmaking "vocabulary" that can be easily called upon when needed.

WORKSHOP, EQUIPMENT, AND SUPPLIES: INITIAL PREPARATIONS

As in drypoint, the workshop space is the same as for etching (see Chapter 1) with the same exception—no acid is used, reducing the extensive ventilation requirements, except when using solvents in the printing stage.

Your additional equipment list is as follows (see Figure 3-3):

Plates (copper preferred; zinc can be used; 1/8 plastic can also can be used, recognizing the difference in results)

Engraving burins (a variety, as necessary)

Engraving liner (as applicable)

Engraving scorper (as applicable)

Roulettes (as applicable)

Stippling graver (as applicable)

Rotating device (such as modeling stand or sandbag)

Oil/Arkansas stone

Household oil

Scraper

Burnisher

Flair pen, soft pencil, or grease pencil (for drawing on plate)

Engraver's magnifying glass

Whiting, French chalk, or powdered pumice

Household ammonia

The choice of plate is discussed later under Plate Preparation.

The primary tool in engraving is the burin, sometimes referred to as a graver. It is a relatively small, lightweight tool, expertly hand manufactured. It is usually 4″ to 5″ long, made of tempered steel square rod about 1/8″ thick, which is bent near the handle end at an angle of 30° to 40°. A wooden handle that is rounded on one side to fit nicely into the palm of the hand, and flat on the other side so that it does not get in the way when engraving, is attached in a way that allows it to be removed quite easily at any time to be replaced, changed to make it more comfortable, or used on another burin. The cutting tip or face of the square rod is slanted at an angle of 15° to 45°, depending on its designed use (Figure 3-4). There are also lozenge-shaped rods producing lozenge-shaped cutting faces, which are primarily used for wood engraving but can be effective in metal engraving when a finer line is desirable.

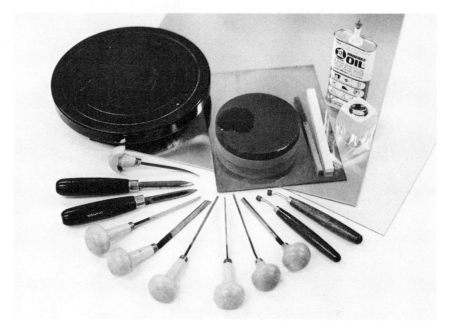

Fig. 3-3 Metal engraving tools and equipment.

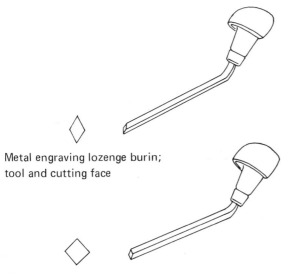

Metal engraving lozenge burin;
tool and cutting face

Metal engraving square burin;
tool and cutting face

Fig. 3-4 Metal engraving burins.

An engraving liner or lining tool consists of a cutting edge with several parallel points used to engrave several parallel lines simultaneously. This multiple-line tool is purchased on the basis of the amount of lines per square inch, which can range from 20 to 200 lines. A typical liner will have about three to six line points on its cutting face (Figure 3-5).

An engraving scorper will usually be of two basic types, round and

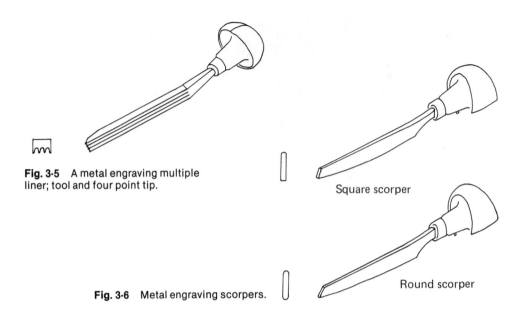

Fig. 3-5 A metal engraving multiple liner; tool and four point tip.

Square scorper

Fig. 3-6 Metal engraving scorpers.

Round scorper

square. They are sometimes turned up slightly at the cutting tip and are used to gouge out metal rather than engrave a line. Characteristically, they produce a textured or tonal line pattern. Figure 3-6 shows round and square scorpers. The scorper and liner are not essential tools, but the beginner should be aware of their existence for future use.

Another engraving-type tool that is not essential is the roulette. Many engravers consider the roulette as part of the mezzotint process, a method of producing an intagliate plate working from dark to light—the reverse of etching, engraving, or drypoint. The plate is darkened completely by working a mezzotint rocker (Figure 3-7) and roulette over the surface of the plate until a uniform "black" emerges. The image is then worked up by removing or softening the incised texture with a scraper and burnisher. It is a very difficult procedure that requires a high degree of proficiency. Although it produces uniquely velvet blacks, the intrinsic skill demanded and its highly anachronistic value does not lend the medium to be included as part of the beginning printmaker's repertoire.

However, the roulette itself can become a very effective drawing (engraving) instrument where tonal areas are required. The roulette consists of a metal rod with a rotating drum, which is uniquely textured on one end. A wooden handle is attached to the other end of the rod. There are several different drums available, each creating a different textured tone. The most common are the line pattern drum (Figure 3-8), the regular patterned drum (Figure 3-9), and the irregular patterned drum (Figure 3-10).

A stippling graver is similar to the burin or scorper, but is used to create dots rather than lines. Although the burin can be used to produce dots as

Fig. 3-7 Mezzotint rocker.

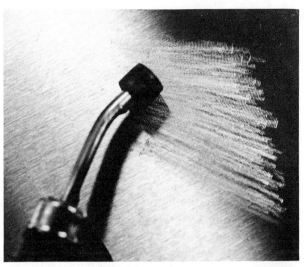

Fig. 3-8 Line pattern roulette with engraved pattern on copper.

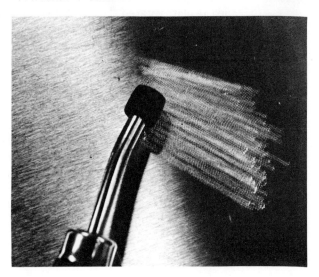

Fig. 3-9 Regular pattern roulette with engraved pattern on copper.

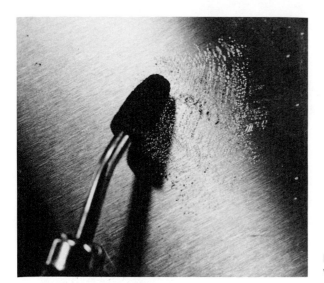

Fig. 3-10 Irregular pattern roulette with engraved pattern on copper.

Fig. 3-11 A metal engraving stippling graver; tool and cutting face.

well, the dots of a stippling graver are much more consistent and the tool is much easier to control. As Figure 3-11 shows, it is bent in the opposite direction when compared to the burin, and has a very fine, sharp point on its face.

To engrave curves or circles into a plate, the burin must be held steady and the plate rotated. To facilitate this action, some type of rotating device is necessary, such as a modeling stand or leather sandbag (see Figure 9-10, Chapter 9). Traditionally, a sandbag has been used for this purpose. If the working table surface is slick enough, the plate usually can be turned or rotated without these items.

Some type of magnifying glass should be available to check the progress of your work in close detail. The engraver's glass shown in Figure 3-3 is excellent and quite inexpensive.

As in drypoint work, the scraper and burnisher are also necessary. The scraper is used to cut off end spikes of metal or excessive burrs. The burnisher is used, as in drypoint, to soften lines. Of course, both are used as correcting tools (see Chapter 4). All of these items can be purchased from a well-stocked art store, directly from the manufacturer, or from a printmaking supplier (see Appendix A).

CREATING AN ENGRAVED DRAWING

PLATE PREPARATION

The engraved intagliate image can be incised into any printable metal or plastic plate. Copper is the ideal metal for engraving. It is a hard metal without being brittle or overly coarse like zinc. It is not as difficult to handle as steel, and yet holds the engraved image quite well, especially if it is steel faced (see the section in Chapter 2 on steel facing the metal plate).

The plastic plate, preferably 1/8" thick, no more and no less, can be used for engraving as well as for drypoint. All the tools except the scraper and burnisher are applicable. The plastic plate will create a unique image, but will not have the same quality as copper. If you choose to work with plastic, refer back to Chapter 2 for an explanation of its properties and possibilities.

Initially, the copper plate of 16 or 18 gauge should be properly beveled. Remember to cover the plate face with a piece of contact-type paper before filing the edges. After you have properly beveled the plate, remove the protective covering, and clean the plate face with some whiting, French chalk, powdered pumice (or a nonabrasive detergent), and ammonia as outlined in Chapter 1. Leave a thin layer of any of the above powders to dry naturally on the plate. This will dull the plate face, allowing you to work on it without eye strain and producing a surface different than the engraved areas so that you can determine the progress of your drawing.

THE INITIAL DRAWING

It is, of course, an individual choice as to whether or not you should begin with an already prepared drawing. As a beginner, especially in this very difficult medium, it would perhaps be best to work directly onto the plate without a preconceived drawing. When you have analyzed the printed results after several attempts at producing an engraved plate, you may then wish to work from previously created pencil or ink drawings. If you wish to transfer an already prepared drawing to a plate, see Chapter 2 on drawing from a drawing.

You can begin the direct drawing onto the plate surface by using a soft pencil, felt tip pen, or grease pencil. Quickly sketch out the main parts of your concept without attention to too much detail. As you incise with the various engraving tools, the drawing will probably take a different shape than was originally thought, and detail will be determined by the drawing's development. The main concern at this point is to build up an expertise and understanding of the engraving tools and methods. Therefore, consider this plate more experimental and exploratory, creating a drawing from an intuitive, reactive base.

Of primary importance before the burin touches the plate surface is to be sure that the tool is extremely sharp. Usually, when the tool is first purchased, it is at its best. However, it does not take long before it requires resharpening. To sharpen the square burin, lozenge burin, and scorper, you must go through three steps. On your oilstone, which has a few drops of oil applied to it, lay the tool flat upon one of the bottom edges, and, with a back and forth motion, grind lightly the whole length of the metal rod by placing your fingers along the rod's opposite edges, and gently, with even pressure, push and pull the instrument to and fro approximately 10 to 15 times (Figure 3-12). Now apply a few more drops of oil to the stone, turn the rod around to its other bottom edge, and repeat the process. Again, repeat the same procedures on each of the bottom edges of the rod on the more finer Arkansas stone, applying a little oil to it also. Now turn the tool to allow the cutting face to lay flat against the Arkansas stone, and, with even, gentle pressure, rotate the instrument clockwise, making sure that it remains flat against the stone (Figure 3-13). Continue to rotate the cutting face until it appears evenly sharp along the two bottom edges when holding it up to a light source; the tip should show no reflective light on an additional facet created by poor grinding (not keeping the edges and face flat against the stone).

The stippling graver needs little sharpening as you use it, but when you feel that it is dull, grind on both stones the two flat sides of the tool, keeping it flat against the stone and sliding back and forth with gentle pressure.

Fig. 3-12 Sharpening bottom sides of burin.

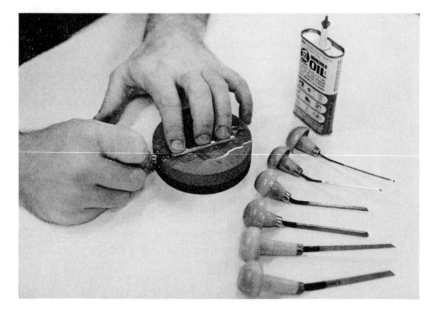

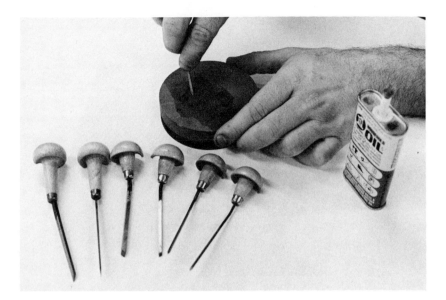

Fig. 3-13 Sharpening cutting face of burin.

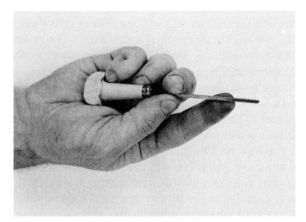

Fig. 3-14 Holding a metal engraving burin, scorper, or liner.

The engraving liner will only require very gently, clockwise grinding on the cutting face using the Arkansas stone. (See Chapter 4 for procedures to sharpen the scraper.) You must continue to sharpen the tools throughout the engraving process, but never attempt to sharpen the roulettes.

As Figure 3-14 indicates, there is a specific way to hold the burin, scorper, or liner. Turn your palm up and place the tool into it so that the handle lays on the rear, middle part of the hand and the rod extends out along the index finger. The flat part of the handle should be facing up, the thumb grasping the outer edge of the rod and the three other fingers gently wrapped around the upper part of the rod. Turn your hand over, facing the plate surface, and align the rod parallel to the plate. Place your **75** pinky finger on the plate surface, using it as a guide and rear support.

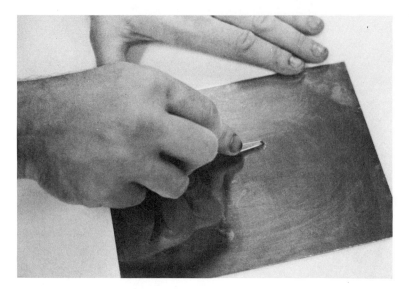

Fig. 3-15 Beginning a burin line in copper.

Keeping the tool as parallel to the plate surface as possible, begin your cut. Do not push the tip down into the surface of the plate, but gently glide it through the metal using very little strength (Figure 3-15). The metal should cut without heavy pressure; if it overly resists, the point is not sharp. Continue the line to its end, deciding how you want to complete it. If you stop suddenly, you will leave a spike at the end of the line, which you must carefully cut off with the scraper; this will print out as a very dark end. If you prefer a light end to the line, continue cutting but lift the tool slightly allowing the line to taper out; this will take some practice. Never force or push down on the tool or the instrument will slip, producing unwanted scratches and irregular spots. If the initial line is not as deep as you wish (remembering that the deeper it is, the darker it will print), repeat the cut of the line in exactly the same way, using the incised valley as your guide. You can repeat the cutting of a single line as many times as you want; never try to cut a deep line with the first incision.

Cutting curves presents a particular problem. It is almost impossible to guide the tool itself along a proposed curve or circle. The tool must be held still with one hand and the plate turned with the other to create the curve. Have the plate resting on a device that will allow it to be rotated or turned easily. A sandbag is often used for this purpose. However, any rotating device is good, such as a modeling stand for sculpting. Also, you are encouraged to produce such a device on your own. When you are ready to cut the curve, place the plate on the rotating device, hold the tool steady and parallel to the plate, use little pressure, and, with the other hand, begin to turn the device in a way that will produce the desired curve. This procedure is one of the most difficult steps in engraving and will take considerable practice (Figure 3-16).

76

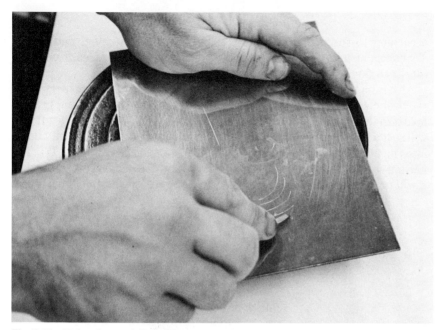

Fig. 3-16 Using the modeling stand to turn plate while burin remains still; for engraving curves and circles.

Fig. 3-17 Using a stippling graver.

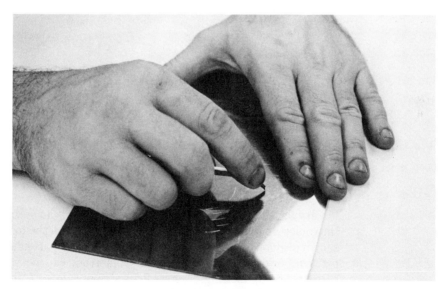

Tonal areas can be created, without using the roulette, in three ways. With the various burins and scorpers, you can place lines very close together for dark areas, further apart for lighter areas, and with variations can create visual gradations from light to dark. Another method is through the use of the engraving liners, which will mass different amounts of lines according to the tool (the amount of lines it creates in one incision) and

77

according to the placement (close together, cross-hatching, and so on). Tones can also be created with dots, placing them in masses from many (dark) to few (light).

Although tones can be created with any of the burins or scorpers, they are best controlled with the stippling graver. To use the stippling graver, hold it in the palm of your hand as you held the other tools. The index finger will rest on top of the rod, and the cutting point will be pushed gently down into the plate rather than slid against the plate surface (Figure 3-17). The harder you push, the deeper the dot will be, and the deeper it is the darker it will print. Space the dots in such a way as to create variable tonal areas.

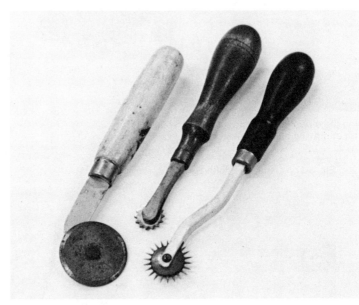

Fig. 3-18 Various innovative roulettes.

ROULETTE DRAWING

Very dark tones, or areas that hold a lot of ink, can be created only with the roulette. There are several types of roulettes on the market. The three shown previously create a line pattern, a regular pattern, or an irregular pattern. Additionally, improvised "roulettes" can be used for various pattern or dot incising. Figure 3-18 shows a few of these improvised roulettes, adapted from leather crafting tools.

The roulette is a simple tool to use and quite effective in the creation of tonal areas. Simply decide where you wish to place the tones and begin by holding the tool so that the rotating wheel is flat against the plate surface. With medium pressure, drive the rotating wheel across the desired area. This first incision will produce a light "grey" tone; to darken all of it, or part of it, drive the wheel across the same area again in the same direction. To

darken it even more, repeat the procedure. For very "black" areas, drive the wheel across the area in different directions; the more you vary the directions, and the more you repeat the procedure, the darker the area will get. Also, a roulette with a simple pattern on its wheel will create lighter tones than a more complicated pattern. Through the proper buildups of continuous patterns, much variance in tone can be created that will simulate crayon or charcoal modeled drawings.

It is important not to overwork the engraving, either with lines or dots, and especially with roulette tones. As you proceed, you should pull one or two proofs (see Chapter 5), drawing on the proofs to determine each addition or change to the drawing. You also may wish to work into the incisions a little ink and petroleum jelly (see Chapter 2 on drypoint line drawing) to expose the cut lines and patterns as you engrave.

If you wish to lighten a line or tone already incised into the metal (plastic will not accept this type of correction), you will have to burnish it down. If you wish to remove a line or tone completely, you must do so with the scraper. (Chapter 4 will explain the use of the burnisher and scraper.)

STEEL FACING AN ENGRAVED PLATE

The lines and patterns engraved into a copper plate are not as delicate as drypoint work. Therefore, the plate should hold quite well for 20 to 30 prints. This, of course, depends on how deep you made the lines and roulette patterns. If you consider the incisions too delicate for extensive printing, or if you plan to pull a very large edition of prints from an engraved plate, it will be necessary to steel face the plate.

If you engraved into zinc, the intagliate will break down much faster; the zinc plate also can be steel faced by first applying a thin coat of copper, an expensive process. If you decide to steel face the plate, refer back to Chapter 2 under the section Steel Facing the Metal Plate. If you decide not to steel face your engraved image, you are ready for the printing stage, which will be described in Chapter 5.

Corrections
On Metal Plates

All metal plates that hold an intaglio image can be corrected, altered, or changed. Softer metals, such as zinc, will take corrections much easier than hard metals, such as copper or steel. Although some correcting can be done on plastic plates, the kinds of complete unidentifiable changes made on metal are not possible on plastic. Accordingly, plastic plates will require trial and error explorations when it comes to making surface changes.

For corrections on metal, you will need the following:

Plate (to be corrected)
Scraper (three sided)
Burnisher (bent or straight blade)
#0000 steel wool
#4/0 emery polishing paper
Oil/Arkansas stone
Household oil
Scotch hone
Snake slip
Charcoal polishing block
80 Jeweler's rouge

All of these items are not necessary for all types of corrections or changes. Each item is used for a particular reason, and its purchase should depend on how important the changes or corrections are, what kind they are, and the desired perfection.

The scraper and burnisher, the scotch hone, and the snake slip are necessary for most every intagliate work on metal. Also, you should already have a sharpening stone and a can of household oil. The steel wool, polishing paper, optional charcoal block, and the rouge can be purchased at most art stores, hardware stores, or a jeweler's supplier.

You must first be sure that the scraper is sharp on all three edges, which must be kept sharp at all times. To do so, place a little oil on the oil stone and keep one edge of the scraper flat against the stone. Push and pull the blade across the stone 5 to 10 times. Repeat this on all three edges. The tip of the blade is tapered inward and must be sharpened by rotating one flat side of the blade against the stone, rocking it gently so that the entire edge of the tip is sharpened. Again, this must be repeated on all three edges. This entire procedure should be repeated on the finer Arkansas stone (Figure 4-1).

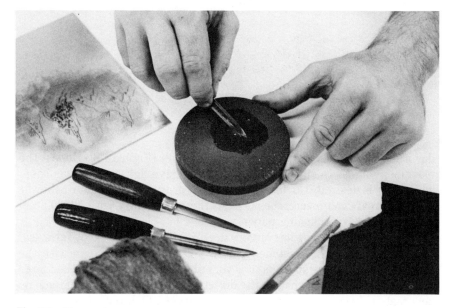

Fig. 4-1 Sharpening a scraper.

After sharpening the scraper, cover the back of the blade with some electrical tape, exposing about 1″ of blade. You will be handling this rear area of the blade; the tape will keep you from cutting your fingers.

To keep your scraper and burnisher perfectly smooth and free from corrosion, coat it with a thick layer of petroleum jelly, removing it only when using the tool.

CORRECTING A LINE OR SCRATCH

A simple scratch on a metal plate is relatively easy to remove. If it is not too deep, sometimes it will not print out at all; determine this in the proofing stage. When you have pulled a proof or two before the final printing of the edition, mark (on the proof) all the areas you wish to correct, change, or alter.

If the scratch does print, but shows up very lightly, it probably is possible to remove it by gentle burnishing and light polishing. To soften a dark line, the procedure is exactly the same. Run the burnisher along the length of the line by holding the handle in your palm and pushing gently

Fig. 4-2 Using a burnisher to soften line, aquatint, or soft ground and roulette texture.

down on the smooth blade with your index finger (Figure 4-2). Repeat the movement across the line until it appears to have lightened or vanished, whichever is desired. Do not use excessive pressure on the burnisher or you will create more scratches. Polish the area lightly with #0000 steel wool and/or #4/0 polishing paper.

To remove a very deep line or very deep dot (usually caused by false acid biting if dealing with an etched plate), you will have to begin with the scraper. After making sure that it is very sharp, begin to scrape the line or dot completely out, alternating the direction of your cutting so that you do not create ridges or cut marks. Do not try to cut a little out, concentrating only on the line or dot itself; take out a wide area of metal so that you create a valley that will not hold ink (Figure 4-3). After the line or dot is completely gone, burnish the area with medium pressure, pushing down any loosened metal, polishing the surface of the plate. Now take your scotch hone, dip it into a little water, and with very little pressure guide it across the same area until it appears smooth (Figure 4-4). Repeat this procedure with the snake slip and a little water. Lightly polish the area with the steel wool and polishing paper (Figure 4-5).

82

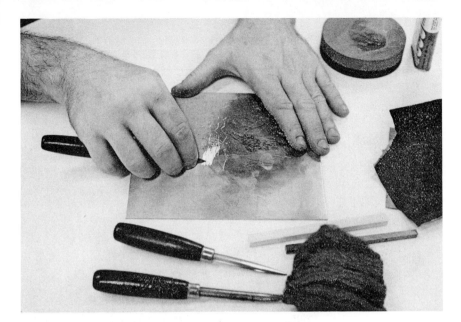

Fig. 4-3 Using the scraper to remove a drypoint line.

Fig. 4-4 Smoothing out corrected area with scotch hone and snake slip.

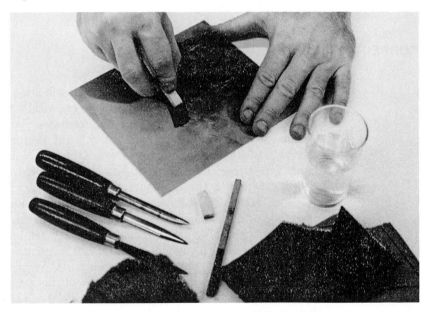

When you print the plate, the area should show no difference in tone and no additional scratches. If a dark tone appears, the plate needs more polishing. If a light tone appears, the plate is too polished in one spot; correct this by polishing the entire plate with steel wool and polishing paper. If additional scratches appear, you must start from the beginning.

83

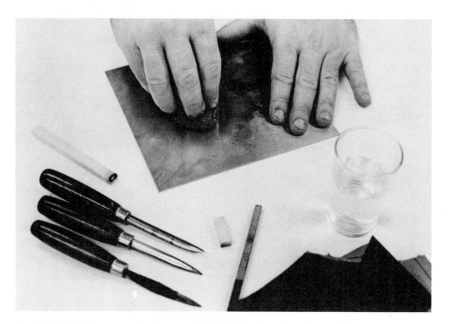

Fig. 4-5 Polishing corrected area with #0000 steel wool and #4/0 emery polishing paper.

CORRECTING AN AQUATINT OR ROULETTE TONE

To lighten a toned area, or to extend the possibilities of an aquatint or roulette pattern by creating tonal changes within the area without showing distinct identifying gradation changes, you will need the burnisher, steel wool, and polishing paper. First, designate the area to be lightened and stencil out adjoining areas of the plate with masking tape or contact-type paper. Depending on how light you want the area, begin to polish it down with the burnisher. If you wish very slight changes or lightening, start with steel wool. After you have taken down a desired amount of the tone and have, therefore, lightened an area, polish it slightly with the #4/0 polishing paper. You cannot really tell how much you have lightened an area until you pull a proof. Print it and make further determinations based on what you see. A little practice through trial and error will be necessary to build a proper knowledge of this procedure. However, when mastered it can provide extremely effective results, allowing for much more modeled-type intagliate drawings. Volumes, lights and darks, and abstract tonal changes are made much more possible with this method.

To darken an aquatint area, simply respray it, stop-out adjoining areas, and re-etch in the 14:1 nitric mordant. To darken a lightened roulette tone, work the tool over the area once again. Working in combination with the above procedures from dark to light and from light to dark, you can greatly **84** expand the possibilities.

It is somewhat more difficult to remove large areas of an intagliate plate. But it can be done effectively. Here again, the scraper, being continuously resharpened, is used. Scrape small areas at a time, altering your strokes so that no ridges are created. Do not try to dig deeply with one stroke, but shave one thin layer after another, insuring that the final layer is fairly even. Be careful not to scratch the plate in other areas with the metal particles produced by scraping.

The burnisher is of little use here. Instead, you must smooth out and harden this area by working it well with a little water and scotch hone. This will take some time, but it must appear firm and very smooth before going on. When completed, work over the entire area well with snake slip, using a little water with it to make the procedure easier. Wipe the plate surface often with a damp cloth to determine the apparent smoothness of the metal. If printed in this state, the plate would retain a light tone. You may prefer to polish it with some additional items.

First, polish the area where you scraped out metal with the #0000 steel wool and #4/0 polishing paper. Then wet the entire plate and rub it all over with the charcoal polishing block. Concentrate on the area that has been scraped, but use the charcoal block over the entire plate so that you will get uniformity in the printing. When the plate appears highly polished, retaining the same reflective value on its entire surface, it can be printed. If after printing you are not satisfied with the "cleanliness" of the plate (that is, it is still retaining too much of a tone), it can be polished further with jeweler's rouge.

Using a very soft rag or your finger tip and a little water, rub the rouge across the entire plate, using light pressure. Do this evenly and make sure you are covering the total surface of the plate; repeat two or three times. Now wash the plate thoroughly with ammonia, a very small amount of whiting, and water. The plate should print out with no false or unwanted tones.

You can now add to the plate by going through any one, or combination of, intaglio processes already discussed. The area that was scraped out will take these processes in exactly the same way as a new plate would.

One Color
Intaglio Printing

INTRODUCTION

The *intaglio* image, the body of lines, textures, aquatints, and spatial areas that have been incised into the plate through the methods discussed in Chapters 1 through 4, is now ready to receive ink and be transferred to paper. Intaglio printing is, of course, as old as engraving itself, and the process has changed little since early times. This process is a fairly uncomplicated procedure that can be mastered with consistent practice in a very short period of time. The primary prerequisite to achieving well-printed images is organization. Your personal organized system of printing will vary, but there must be a specific system to begin with, and it must be followed precisely each time you print. Following is a beginning system which you can adapt to your style. This system, developed through the printing experiences of the author, is one of the most simple of intaglio printing methods.

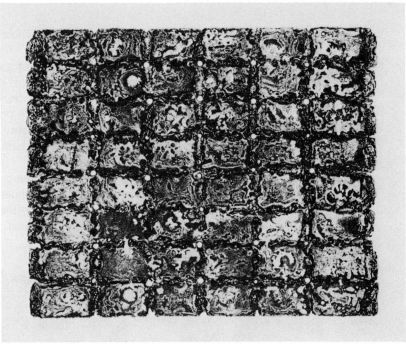

Fig. 5-1 Blue/black multiprocess etching. *Process in Depth,*
20½" × 26", William C. Maxwell, 1975. (The washlike texture
was created by floating acid-resist lithographic water tusche
on an etching plate; other areas are radically open-bit; aquatint
creates the various values.)

THE PRESS OR NONPRESS OPTIONS

Because oil-based ink is pushed into incised, below-the-surface lines and
significant pressure must be applied to the paper to transfer the ink from
these lines, it is impossible to produce "pure" intaglio prints without some
sort of mechanical press. There are numerous etching presses on the
market. They are commonly of one type, consisting of a bed that passes
through two cylinders in wringer-type fashion. It is not necessary to
describe every available press, outlining minor differences. They differ
only in terms of being geared or nongeared (direct drive), motorized or not,
pressure set by springs or the weight of the upper roller, large or small,
metal and/or wood, and, of course, manufacturer.

Used for the accompanying illustrations are two presses, one larger than
the other, and both considered by experts to be outstanding etching
presses. The first, manufactured by American French Tool Company of
Warwick, Rhode Island, has a 40" by 70" steel bed, a 4:1 gear ratio, is all
metal, has its pressure set by the weight of the upper cylinder, and is not
motorized (Figure 1-3A, Chapter 1). The second press is manufactured by
87 Charles Brand of New York City. It has a 20" by 40" steel bed, a 6:1 gear

ratio, is all metal, pressure set by springs with micrometer gauges, and is manually operated (Figure 1-3, Chapter 1).

Also included in the illustrations is an adaption of a double cylinder etching press based on the simple wringer-type rollers of old-time washing machines (Figure 1-4, Chapter 1). In fact, rollers from such washing machines, if in good condition and allowing for variable pressure settings, are an excellent beginning if a commercially manufactured etching press is not available. The wringer-type press illustrated is manufactured for the home or classroom workshop (see Appendix A).

As shown in Figure 5-2, by using one piece of 1/4″ tempered Masonite as a bed and a piece of close-pored polyurethane foam rubber as a blanket, it is possible to produce adequate intaglio prints. Most often, the prints will be of "proof" quality and will only suffice until you can get to an actual etching press.

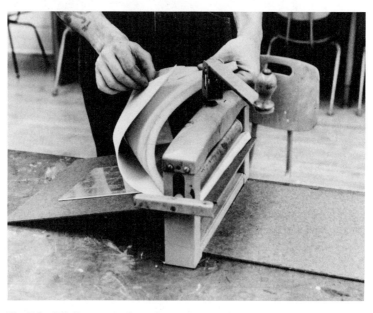

Fig. 5-2 Printing on a wringer-type press.

THE PAPER AND ITS PREPARATION

SELECTING PAPER

You will eventually discover a multitude of printing papers available on the market. Rather than attempting to describe each paper individually, we will choose a few that are universally acceptable and easy to work with. Later, as your intaglio work progresses, you may wish to experiment with various papers.

The initial printing will consist of producing artist working proofs. In the beginning stages, it is best to stick with the proofing papers for they are relatively inexpensive and, therefore, allow for considerable trial and

error. The transition to better papers is extremely simple, requiring little if any adaptations. The intaglio procedures you use with proofing papers are the same for final printing.

Recommended as proofing papers are Basingwerk Medium or Heavy and Domestic Etching. Basingwerk is a machine-made paper that is 45 per cent esparto pulp, has a smooth surface, and prints cleanly without taking too much pressure. Domestic Etching, another universally good proofing paper that can be used for some final editions, has a 50 per cent rag content, is also machine made with a light texture, and prints out in a fairly consistent manner as long as there are not too many deeply bitten areas that require extreme pressure. Both papers are normally available in any well-stocked art supply store at a nominal price (see Appendix A). They come in 26″ by 40″ sheets and should be stored, preferably flat, in a protected area where dirt and moisture will not affect them.

When you are ready to produce final editions of your intaglio images, it is better to purchase a high rag content, mold-made, imported printing paper. Two are recommended: Arches Cover and Rives BFK. Both are readily available (see Appendix A), are treated for printing in exactly the same way, and are universally ideal for intaglio work. Arches Cover comes in buff and off white, is 90 per cent rag content, mold-made, has a light felt texture, and intrinsically natural coloring and finish. Rives BFK is a very opaque white paper of 100 per cent rag with a smooth texture and slightly lighter weight. Both papers come in 22″ by 30″ and 29 1/4″ by 41 1/4″ sheets and are approximately the same price. Rives BFK also comes in large rolls. Extra care should be taken to keep these papers in excellent condition; they are relatively expensive and, because they are used for your final prints, must be kept clean and neat.

If possible, paper should be kept in a map or blue print-type cabinet. Such a cabinet is also the place to store finished prints. It should be kept in a conveniently accessible area, away from water, and well organized.

TEARING PAPER TO SIZE

At this time, your hands should be very clean and you should have a large work table that is also very clean. It is advisable to cover the table with sheets of clean newsprint when working with the printing paper.

If using an imported, high quality printing paper, such as those suggested, each sheet will usually have a watermark in one corner as shown in Figure 5-3. Hold the paper up to the light and determine where the watermark is (it normally spells out the paper's manufactured name).

Fig. 5-3 Identifying the watermark of Rives BFK printing paper.

Turn the paper so that you are facing the watermark in a way that allows you to read it normally, from left to right. This side of the paper is called the felt side, and is the side normally used for printing. Place the felt side of the paper face down on your working table. Measure the size of the plate you are ready to print. Allowing for a minimum of an extra three to four inches on each edge, which will act as a margin, put small push-pin holes or light pencil marks to indicate where the paper will be torn. Using a good metal straight edge that is also clean, tear the paper according to your markings on the back of the sheet.

Tearing the paper properly will take some practice. Here again, the proof paper or some heavy newsprint can be used for practice tearing. Proofing paper is prepared in exactly the same way, except that you may not find a watermark on it and it can be printed on either side.

When ready to tear, the paper must be perfectly flat and totally on the surface of the table. The metal straight edge is put into place, your hand holding it firmly. Pick up one edge of the paper and tear straight up to you, making sure you are standing perpendicular to the straight edge (Figure 5-4). If you tear away from you, the paper edge will look inconsistent and sloppy. If you tear toward you, the edge will be practically without a deckle and will show a high "lip" on one side. The idea is to tear so that you simulate the natural deckle of a mold-made paper. Contemporary prints are commonly not matted when placed in frames, making the deckle and margin very evident to the viewer; therefore, they should be kept as neat and aesthetically pleasing as possible.

If you are preparing good paper, after tearing your sheet to size, place a light pencil mark on the back to indicate that the other side is the printing or felt side of the paper. Remember, you will be tearing most of the sheets so that they no longer show the watermark, and, accordingly, you will not be able to depend on this mark after the paper is torn.

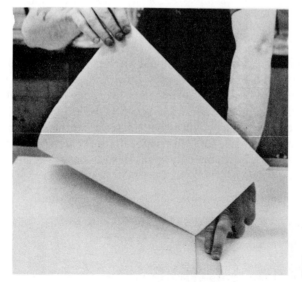

Fig. 5-4 Tearing paper to printing size.

It should be noted that extra large margins may be desirable, especially in the beginning stages of learning to print. It may take a little practice to learn to drop your paper evenly on an inked plate, which once dropped cannot be moved. If the paper is dropped unevenly, extra large margins allow you to tear the print down again, "squaring off" the image. And, because this author's recommended way to dry prints is to attach them to a bulletin-type board with push pins, extra large margins allow for tearing away the pin holes.

DAMPENING THE PAPER

The proofing and printing papers, recommended here should be soaked in water for 30 minutes or more. Soaking makes the paper flexible, allowing for the pressure of the press to force it into the incised intagliate area of the plate.

Prepare a dampening tray for the soaking process. Any tray approximately 3″ deep and large enough to hold the premeasured and torn sheets will be adequate. Clean the tray thoroughly with a little ammonia and water, rinse well, and fill with about 2″ of water. With clean hands, wet the sheets by drawing them from edge to edge under the water. Turn the sheet over and repeat. Now place the sheet, felt side down, on the water surface, and gently force the water over the paper so that it covers evenly. Continue until all the paper you are going to use during this printing process is submerged (Figures 5-5 and 5-6).

Do not simply drop the paper into the water. That would probably cause

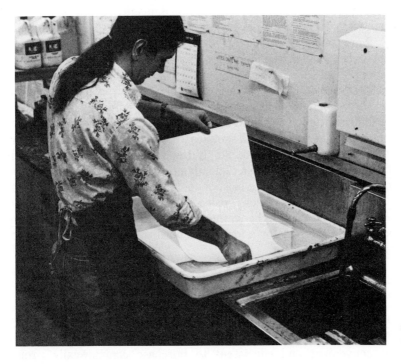

Fig. 5-5 Properly submerging printing paper.

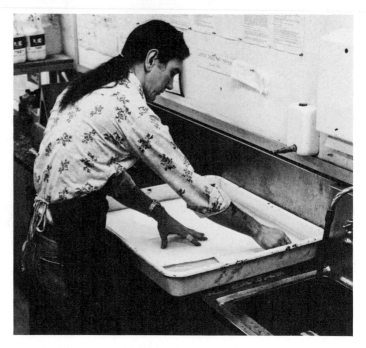

Fig. 5-6 After paper has been properly submerged, push it under water and allow to soak for 30 or more minutes. Cover the tray.

an air pocket or the water will not get on top of the sheet, resulting in uneven wetting. Cover the tray with a piece of cardboard to keep the paper and the water clean.

After the paper has been soaking about 30 minutes, it is ready for printing. However, do not remove it from the water until you are ready to place it on the plate. Extra soaking will not damage the papers, but it is not good practice to leave the paper soaking for excessive periods. If you tear down more paper than you can use for that printing session, place the dampened sheets between blotters, letting them dry naturally. They can be resoaked later.

It should be noted that papers other than those recommended require different dampening procedures. Some require no dampening at all, but are usually not good for intaglio work. When working with papers not recommended here, test small samples to determine how much dampening is necessary to make it flexible. If the paper does not require much wetting, you can simply run a clean, damp sponge over the surface before printing, or prepare stacks of sponge-dampened paper that are placed between blotters and kept in a sealed plastic garbage bag until use. Some papers will need such light wetness that they should be placed only in predampened blotters for a few hours until they absorb just the proper amount of water.

THE INK AND ITS PREPARATION

Although inks for intaglio printing can be made from "scratch" by thoroughly mixing powdered pigment and burnt linseed oil (plate oil), it is more convenient and consistent to purchase commercially prepared

etching inks. Most black and earth-colored inks on the market for intaglio work are quite adequate. Variance of the product depends on amount of pigment to oil, method of mixing, types of pigments used, and so on. An inexpensive good quality intaglio ink is manufactured by Cronite Company of New Jersey (see Appendix A). A finer product with a wider range of colors can be purchased from Graphic Chemical Company of Illinois. Also very good, and a bit more expensive, are the French inks, Charbonnel and Lefranc. Many art suppliers have their "own" brand of intaglio inks; in any case, each ink must be individually explored.

The ink usually comes in one-pound cans and tubes, although it is possible to purchase intaglio inks in smaller tubes of about seven ounces each. The cans are less expensive and, if maintained properly, are just as easy to work with as the tubes. Most canned intaglio inks are sealed with a piece of vinyl tape. The tape can be pulled slightly, stretching it tight around the can to seal it properly from the air. If kept clean, the tape can be used over and over.

Besides the ink itself, you will need a putty knife with a flexible blade, burnt linseed oil (plate oil), magnesium carbonate powder, oil of clove, and a large enough piece of glass for the mixing surface. Putty knives can be purchased in any hardware store. Plate oil, made by the same manufacturers of the intaglio inks, can be purchased in any well-stocked art supply store. It also can be made by boiling raw linseed oil (available in any paint store) until it thickens and becomes difficult to pour. Magnesium carbonate powder can be purchased at any chemical supply house. However, it is not normally necessary to have on hand magnesium carbonate for intaglio work since it is used only to stiffen ink that is too oily (long); the inks made for intaglio work are usually manufactured stiff (short) and need to be made longer. Oil of clove can be purchased in small quantities at any drugstore.

When ready to prepare your ink, take the tape from the can, saving if for future use. You will note that the can of ink, when first opened, has a piece of paper on it to protect it from the air. It is important that this paper be saved if the ink is not used often, or another seal be made later from wax paper, so that when you store the ink, the air does not have as great a chance of drying the top layers. Any dried-out ink must be totally removed before use. A light application of spray vegetable shortening between the ink and the paper seal or a thin coat of water on top of the ink will reduce the drying out. There are commercial ink sealers in spray form as well.

After opening the can and removing the seal, take out a small amount of ink by pulling the putty knife blade gently around the surface of the ink as shown in Figure 5-7. Repeat until you have removed the desired amount. Do not remove ink by putting large "hills and valleys" into its surface; that makes the ink dry out much quicker. The amount of ink needed, of course, varies greatly, and, therefore, it is difficult to set up specific rules. Nevertheless, as a beginning step, for a 9" by 12" plate, about a 2" diameter of ink approximately 1/8" high will be sufficient (see Figure 5-8). After gaining experience, you will know exactly how much ink to dispense for the particular plate being printed.

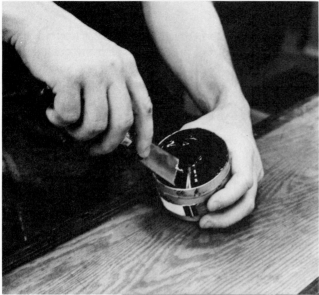

Fig. 5-7 Removing ink from one-pound can; take from surface only.

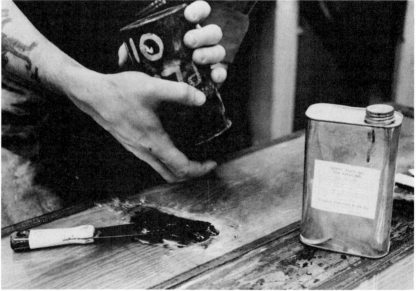

Fig. 5-8 Adding burnt plate oil to make ink long.

Move the ink around the glass slab with your putty knife until it appears consistently mixed. If the ink seems to be too short, add a few drops of plate oil until it reaches the consistency of toothpaste. If it is too long, which is usually never the case, add magnesium carbonate powder a little at a time, mixing it well into the ink until it completely disappears. Now add one or two drops of oil of clove; this will keep the ink consistently moist much longer, allowing you to work slowly at first and more coherently later on. Mix the oil of clove into the ink well. The ink is now ready for the intaglio application to the plate (Figures 5-8 to 5-10).

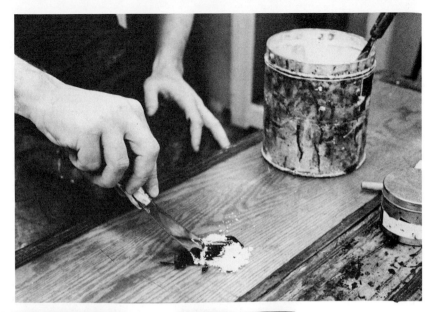

Fig. 5-9 Adding magnesium carbonate to make ink short.

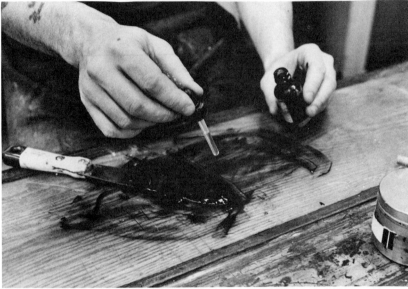

Fig. 5-10 Adding a few drops of oil of clove to keep ink moist.

PLATE PREPARATION FOR PRINTING: INKING THE INTAGLIATE

Clean your hands of any excess ink and remove the plate from its storage area. Remove the protective covering, take it to the sink, and clean the plate well with whiting and ammonia. Make sure that no whiting is caught in the intagliate areas. Rinse the plate well and dry it without touching its printing surface. Plates print best when cleaned by using the ammonia and whiting procedure between every print. It is best to get into this habit immediately, which will mean that the printing will be most consistent.

95

After cleaning the plate well, bring it to your inking station. There are several ways of applying the ink to the plate. Two basic methods are recommended, which you can modify. If your plate consists mainly of line and aquatint, the cardboard method of application will work best. If your plate consists of numerous areas of texture, especially if they are very deeply bitten or are open-bite areas, the stencil brush application is best.

The cardboard method is quite simple. Prepare a stack of 2″ square pieces of one-or two-ply illustration board, mat board, or noncorrugated cardboard. Cut them evenly and clean with either a very sharp paper cutter or mat knife. As shown in Figure 5-11, take one piece at a time, apply a little ink to one edge of the cardboard, and, with some pressure, scrape the ink across the plate surface, holding the plate from underneath or resting it on the table. Cover the plate with an even, thin coat of ink, making sure that all incised areas are collecting ink as well. Do not use an excess amount of ink. When you have covered the plate entirely, take another clean piece of illustration board, mat board, or cardboard and pull off all excess ink from the plate surface. As you pull this excess off, the intagliate areas of the plate will catch ink without overfilling. Continue changing cardboard pieces as necessary.

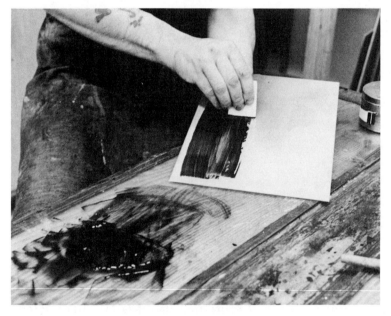

Fig. 5-11 Applying ink with cardboard pieces.

If you are using the second method, you will need a medium-sized (1/2″ diameter) stencil brush. It can be purchased in any art supply store and is inexpensive, which allows you to keep several on hand as they wear out quickly. As shown in Figure 5-12, hold the stencil brush straight up and

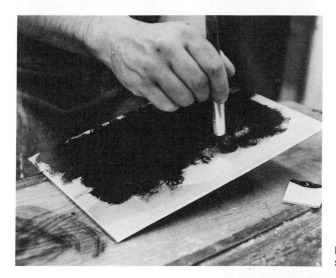

Fig. 5-12 Applying ink with a soft stencil brush.

Fig. 5-13 Gently removing excess ink with cardboard pieces.

down, apply a little ink to the tip, and, using circular strokes, force ink into all deeply incised areas without allowing them to fill. Cover the entire plate with ink, but be sure that the intagliate areas have not accumulated excessive amounts; only the incised *surface* levels should be inked. After covering the entire plate using this method, take a few pieces of cardboard and scrape the ink from the surface, leaving only a very thin layer (Figure 5-13).

It is sometimes recommended to warm a plate lightly before applying ink. This can be an asset when using a very stiff ink, and, in certain cases, such as dry point or engraved plates, this may be desirable but not absolutely necessary. Working in a cold space may also require slight warming of the plate. However, if the ink is prepared as described, especially if oil of clove is used, it should be adequate for most inking jobs. Under no circumstances should a plate be *hot* when applying ink or printing.

97

Either method of ink application requires the next two steps; tarlatan wiping and hand wiping. Tarlatan is a heavily sized cheesecloth-type material. It can be purchased from most art suppliers, or directly from manufacturers such as those listed in Appendix A. Some printmakers prefer to wash most of the sizing out by soaking pieces of tarlatan in cold water for about 20 minutes and letting it dry naturally by stretching it over a rope or similar device. However, this is not absolutely necessary. Tarlatan can be softened to the point where it is most effective simply by taking 12″ square pieces and rolling/rubbing them between your hands (away from the plate and ink). Doing this, you will immediately notice the sizing coming out of the cloth in a fine powder; continue until the cloth is quite flexible. You defeat the quality and purpose of the tarlatan if you take too much sizing out, making it overly absorbent.

As illustrated, fold the 12″ pieces of tarlatan into a soft ball, using two or three pieces at first. Pull the tarlatan across the plate, or use circular motions, overlapping your strokes as the ink is removed from the plate surface. Keep changing the tarlatan ball so that you expose a cleaner area, and continue removing ink until the plate shows a somewhat thin even haze of ink. Do not remove too much ink, especially from the intagliate areas. You may have to add clean, softened pieces of tarlatan to the original ball as you proceed. Do not throw the tarlatan pieces away until they are thoroughly covered with ink; these pieces provide an excellent cushion for the center of the ball. When that thin haze is apparent, the plate is ready for hand wiping (Figures 5-14 and 5-15).

Fig. 5-14 Softening tarlatan before wiping plate.

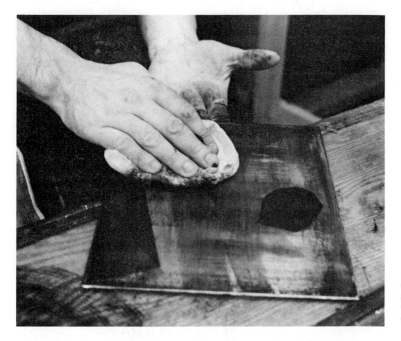

Fig. 5-15 Wiping excess ink from plate and forcing remaining ink well into the intagliate with tarlatan.

Hand wiping is the last and, usually, the most crucial step in preparing the plate for printing. However, it is not difficult and can be successfully mastered with some patient practice. Place a *little* whiting into an open saucer or on the table surface. Sprinkle some whiting onto your hands to absorb wasted inks. Holding the plate in one hand from underneath, pick up a *little* whiting on one hand and wipe it well onto the side of your apron so that the palm is covered. A common error here is to use too much whiting; you need only enough to absorb excess oils from the ink or your hand as you wipe. *Whiting particles should never be apparent on the plate*. Using the heel or the side of your palm, and *little* pressure, make one complete stroke across the plate using an edge as your guide. Now stroke the side of your apron where the whiting has been applied, allowing it to absorb excess oils. Now another stroke across the plate, slightly over-lapping the first stroke. The strokes should be *very gentle*; if you push or pull too hard, the ink will grab in areas and you will create excessive buildups of dry ink. With every stroke across the plate, make another stroke across the whiting on your apron. Continue until you have over-lapped your strokes across the entire plate surface (Figure 5-16). Now change the plate position and repeat the wiping procedure. You should only have to repeat this wiping of the entire plate surface, changing the plate position each time, three to four times. If it takes longer than this, you left too much ink on during the tarlatan wiping. The hand wiping is not meant to take excess ink off as much as to clean the plate of blurred, smeared, or streaked areas. It also increases the visual effectiveness of tonal areas, especially aquatints, and the crispness of lines.

99 After hand wiping the plate until it shows an even distribution of ink in

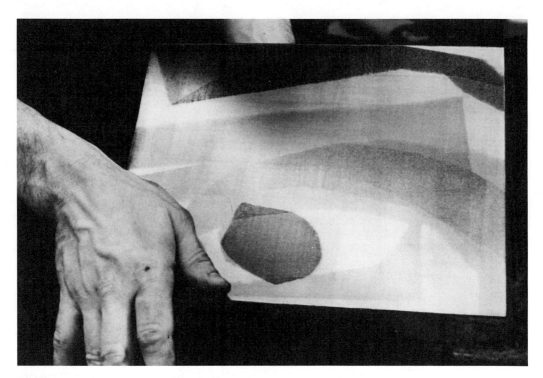

Fig. 5-16 Hand wiping the inked plate to remove tarlatan marks and as a final cleaning removing smudges and blurred areas.

areas where ink should be, and the rest of the plate appears "clean" with no unnecessary smears or blotches, hand wipe the edges until they are clean. If the edges have been damaged through false biting or other errors, they will hold ink. If it appears that the edges are holding ink, they should be cleaned before printing the edition. The proofing stage, where you should be at this point, will reveal the cleanliness of the edges. As you get more proficient with the medium and your particular image, it may be desirable to include foul edges into the basic motif. You should feel quite free to do this, but do not make this choice simply out of laziness.

The plate is now ready to be printed. Do not worry about the underside. Lay the plate aside and quickly clean your hands with a strong hand soap or waterless hand cleaner.

PROOFING AND PRINTING THE PLATE

In the learning stage, or between different changes that take place on the plate, you will be at the proofing stage of printing. Simply, this means that you are producing prints on inexpensive paper either to acquire printing experience or using the proofs to make further aesthetic choices with regard to changing, adding to, or subtracting from your initial image.

The proofs tell you how well you are doing as a printer; if you are overwiping (taking off and out too much ink), lines or texture will show open or "white" spots and the print will be frail in appearance. If you are underwiping, ink will ooze from lines and textures, and the print will show an all-over dullness or "greyness." From this feedback information, modify your printing accordingly, and continue until you have achieved desired results. Be patient.

You will also use the proofs in terms of making further changes or corrections on the plate. If subtraction corrections are necessary, refer to Chapter 4. If additive changes are desirable, make them first on the proofs with pencil or a drawing item that simulates the change as close as possible. This allows you to experiment with as many additive changes as you want without making an irreversible change on the plate itself. Subtracting from metal intagliate plates is much more difficult than adding. Of course, adding to a plate requires that you follow the directions again for creating the intagliate.

After proofing the plate to the point that you are sure about your printing, and sure about the image, you can proceed to the pulling of the edition. The number of prints in the edition is up to you (refer to Appendix B for an explanation of "edition"). It should be noted here that the steps for proofing a plate are exactly the same as printing, except for the difference of paper, for example, Basingwerk versus Rives BFK.

These proofing and printing steps require some initial preparations. After cleaning your hands, you will need to set the pressure on the press and insure that the blankets are properly in order and squarely on the press bed. The press bed should have on it three woven or pressed surgical-type felt blankets cut slightly smaller on all sides (one to two inches) than the press bed itself. As shown in Figure 1-43, Chapter 1, they should be on the press bed in the following order : thinnest (1/16"), called the sizing-catcher on the bottom (which will make contact with the printing or proofing paper); medium thickness (1/8"), called the pusher blanket (on top of the sizing-catcher); and the thickest (1/4"), called the cushion on top (making contact with the upper cylinder of the press). (See Appendix A for felt outlets.) Make sure they are completely on the press bed and not hanging over on any side, front, or back.

If you are using a spring-type press, such as a Brand press previously discussed, you will set your pressure with micrometer dials. When the press is not in operation, the dials are usually kept high, at least above the number six on the vertical shaft of each micrometer dial, keeping the upper cylinder from resting on the bed. When in such a position, you can place the blankets squarely underneath the cylinder and completely on the bed. After doing this, bring the press bed completely to one side, and turn down the dials clockwise to a setting of "0 over 2" to "0 over 3" (see Figure 5-17). If you are working with 16-gauge plates, and have on the bed in their proper order the above blankets, a setting between "0 over 2" and "0 over 3" will be your average. Adjustments should be made, depending on your particular plate, so that optimum but not excessive pressure is achieved.

When working with the press that has no springs to raise or lower the

Fig. 5-17 Setting printing pressure of "0 over 2" on the Brand micrometer dials.

Fig. 5-18 Setting printing pressure on the American French Tool press (5-21A) by opening enough space to allow upper cylinder to rise when plate, paper, and blankets are pulled through.

upper cylinder, such as the American French Tool press, the pressure is set by opening the set screws, allowing for enough space between the cylinder and the bed for the blankets, paper, and plate to be pulled through with little difficulty and so that you get clear, well-printed images. To set the pressure here, make sure nothing, even the blankets, is under the cylinder. Bring the set screws down all the way (clockwise). Then nothing can pass under the cylinder except the thinnest of paper (the cylinder, by its own construction, never rests on the bed). Now turn the set screws one and one-half revolutions counterclockwise (*average* setting). Square off the blankets, pull the press bed all the way to one side, and slip the blankets slightly under the cylinder. Stand to the side of the press that has the cranking wheel on it, crank the wheel toward you, and push the press bed slightly with one hand until it begins to move on its own accord by cranking the wheel only. Once two inches of the blankets have gone under the cylinder, stop. The press is now ready for printing (Figure 5-18).

With either press, the recommended settings will have to be modified if you are working with thicker or thinner blankets or plates. Adjustments also should be made depending on your particular intaglio image. You should try to reduce the pressure so that you are producing good prints with the minimum amount of pressure; this is especially relevant when

102

working with aquatint, dry point, or engraved intaglio plates. If you use too much pressure with these plates, the image will be "squeezed" out very quickly, no matter whether you are using zinc or copper. The recommended settings are only averages and are shown simply as beginning points to create a proper "dialogue" with the press.

And, of course, if you are working with presses other than those described, you will have to learn individually how to set the pressure. Using the wringer-type press with a piece of close-pored polyurethane foam, you will have to experiment until you find a proper pressure setting. This may cost you some proofs, but finding the optimum pressure for a particular plate and press is essential. Before you make any judgments as to the quality of your wiping of the plate as discussed below, first be sure that you have found this optimum pressure setting.

Now that you have placed your blankets in order and have set the press pressure, flip all blankets over the cylinder and out of the way of the press bed. If they are under the cylinder by a few inches, they will hold in place and will be easy to flip back. Place a piece of clean newsprint in the center of the press bed that is larger than the piece of proofing or printing paper you are about to use. As shown in Figure 5-19, carefully drop the plate into the

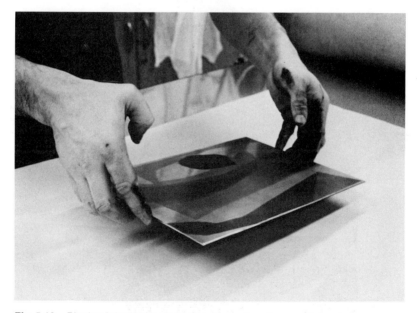

Fig. 5-19 Placing inked and wiped plate in center of newsprint on press bed.

center of the newsprint. Do not move the plate once it is dropped into place, for the underside is dirty and will leave unwanted ink marks on the newsprint to be printed onto your clean printing or proofing paper.

Now you are ready to take the proofing or printing paper from the

water. Make two 3" cardboard tabs by folding them in half without getting the inside of the tab dirty. Use these tabs to handle the paper from now on. Additionally, prepare a stack of four to six large, clean, white, untextured blotters. Cosmos Brand blotting paper, which can be purchased in most art stores (Appendix A), is excellent for this purpose. Place the stack of blotters on a flat, clean table preferably near the soaking tray. Lift the cover from the soaking tray, take one sheet of paper out of the water with the tabs, tip it to one side, and let the excess water drip off. Place it in the middle of your stack of blotters and squeeze out the extra water with the back of your arm or a rolling pin. Check the paper, making sure that there are no slick spots where you have left too much water. The paper should be totally and evenly blotted.

Now lift the paper from the blotters with the tabs on alternate corners (diagonal corners). Letting the center of the paper hang lower than the corners, carry it to the press bed, center it over the plate, keeping it about three inches from the plate surface (Figure 5-20). Now drop the paper gently to the plate, releasing the tabs simultaneously as the paper lowers.

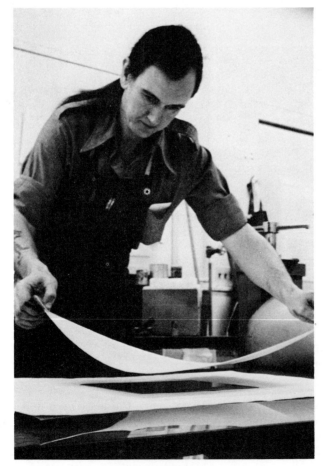

Fig. 5-20 Dropping dampened printing paper onto inked plate by using cardboard tabs to protect paper from dirty fingers.

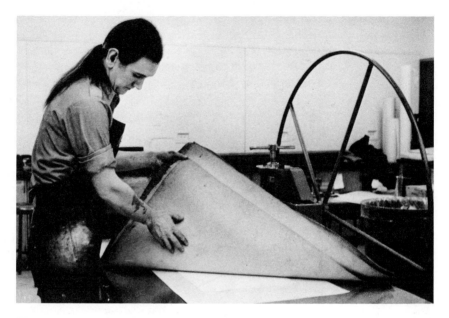

Figure 5-21 Carefully dropping the three blankets over the paper and plate.

Once the paper has made contact with the plate, do not move it, for this movement will show on the print as a smudge or double line. (Remember, when using good printing paper, place it felt side down as indicated by your pencil mark.)

Bring the blankets over the paper, which is on top of the plate, which is on top of the newsprint, which is on top of the press bed (Figure 5-21). Place the blankets over the paper evenly, without any overlaps or folds. Also check again to see that the blankets are not hanging over any sides of the press bed. If they are, they may get caught between the bed and the mechanism under the bed, which will cause them to tear; this mistake can be very costly.

Once you are ready to pass the bed, newsprint, plate, paper, and blankets through the cylinders, be prepared to do so in one continuous motion. As shown in Figure 5-22, crank slowly but consistently, and never stop on the plate itself. This will cause a line to print out across the paper. Crank until the press bed is completely on the opposite side from where it started. With your tabs, lift the blankets and flip them to one side. Again with your tabs, slowly lift the paper from the plate (Figure 5-23). This point, probably the most exciting one in the process, where you finally see the results of your labors transferred to a sheet of paper, will (or should) make it all worthwhile. Of course, until you fully master the printing procedures, it may take some time to get perfect results. But "mastering" is achievable by most anyone with determination, and will come more quickly than you might think. Again, patience is extremely important.

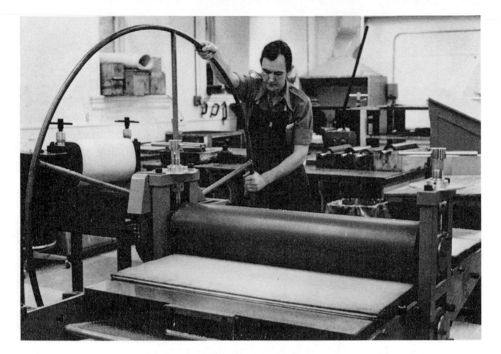

Fig. 5-22 Grinding the plate, paper, and blankets completely through with one continuous turn of the wheel.

Fig. 5-23 Pulling the printing paper from the plate; the intaglio print is revealed.

It is recommended that you immediately attach a freshly pulled print to a bulletin-type wall board, such as Homasote, available at any lumber store. You will also need aluminum push pins, number five. Take the wet print to the board using the cardboard tabs, and attach it with a push pin in one corner, approximately 1/4" (no less) from the edge. Keeping the print perfectly flat, put a pin in each corner, keeping to the 1/4" margin. Follow through with the pins all along the edges, placing them about 2" apart (Figure 5-24). Make sure you push the pins in as far as they will go so that the paper, as it shrinks, will not pull from them.

Fig. 5-24 Pinning the wet print to Homasote board for drying. (This aquatint print was created by Mary Juhasz using the paper stencil aquatint method described in Chapter I.)

The water from the wet paper will evaporate in approximately one hour, depending on the humidity of the drying area. However, the ink will stay wet for about 24 to 36 hours. If you cannot leave the print on the wall *after* the paper is thoroughly dry, remove it and put it between clean sheets of newsprints, storing it on a flat surface with nothing on top. Store it in this way until the ink has dried completely.

When the ink has dried, remove the newsprint from between the prints, tear off (from the back of the print in the same manner you originally tore down the paper) the edges that show the push pin holes. Do not try to tear too close to the edge. At the same time, you can "square off" your image within the paper as long as you allowed for large margins.

If you were careless about attaching the print to the wall, or allowed it to dry too much before attaching it, the print will appear warped. It can be redampened with a sponge from the back of the print, put between clean,

dry blotters, placing the entire package underneath a flat board on top of a flat table. Place a heavy weight on top of the board (perhaps a pile of books). Check the prints daily to see that they are not mildewing; you may have to change the blotters occasionally during this process to avoid mildew. Where you could not attach prints to the wall as recommended, you will have to dry them in this same way, between blotters. Usually this process will take from two to four days until they are completely dry.

After tearing the push pin holes away and squaring off the image, store the prints between sheets of ordinary white tissue or glassine paper. As with new paper, it is best to store these prints in a map or blueprint-type cabinet. (Part V will discuss matting, framing, and exhibiting of prints.)

CLEANING THE PLATE; REINKING

The plate should be thoroughly cleaned, front and back, with paint thinner. Use a *soft* toothbrush to take out ink from the intagliate. Dry the plate and clean it with ammonia and whiting.

You can now reink the plate for further proofing and/or printing, change it or correct it, or store it safely in newsprint. If you store the plate for a long or indefinite period, cover it with a coat of petroleum jelly before wrapping it in clean newsprint. When ready to print it again, clean it well with paint thinner and the ammonia and whiting procedure.

6

Advanced Explorations In Intaglio

COLOR

The mastering of intaglio skills will naturally lead you into color explorations. It is a simple matter to print an incised image in one color other than black or earth pigments. Obtain a good quality color etching ink, such as Perfection Palette Inks by Graphic Chemical and Ink Company, mix your desired color, using white and black as appropriate mixing agents, bring it to the normal etching ink viscosity by adding burnt plate oil, and ink the plate normally. However, it should be noted that certain colors, such as the cadmiums, will react with the metal of the plate, especially in the case of zinc. Accordingly, pure color is sometimes difficult to obtain in an etching.

Two colors, one through intaglio methods and one through relief methods, can be simultaneously applied and printed, following the procedures outlined in Chapter 5. Three colors can be applied simultaneously on the same intaglio plate in certain cases. The plate must be deeply etched, creating three distinctly separated textured layers. Three different colors are mixed: the first for normal intaglio work, the second very stiff and rolled-on with a hard roller, the third very long and rolled-on with a soft roller. The rollers must be of a wide diameter and cleaned between each

print, eliminating any offsetting problems. You must roll with one complete pass or unwanted offsetting and mixture of inks will occur. You can alternate the process as much as you desire for different results, for example, the second color very long and applied with a soft roller and the third color very stiff and applied with a hard roller. This is called "viscosity printing," and you should refer to more advanced literature for further information on the process.

Multicolors can be applied to a single plate by a stencil method. The stencils are cut accurately by first printing the plate in one color intaglio on several sheets of a good quality vellum tracing paper (kept dry), reducing the pressure of the press considerably so that the line will print very lightly and the paper will not tear. The ink is allowed to dry on the tracing paper, and then areas are cut out with an X-acto knife following the printed line. The paper, with the cut-out areas, is placed over the same plate that has been inked in intaglio, and, with small brayers, colored ink is rolled onto the plate through the stencil. By keeping the stencil cuttings far enough apart, several colors can be applied simultaneously over the intaglio plate, and a multicolor print can be accomplished with little difficulty.

Another simultaneous inking method is called *à la poupée*. One color is applied by the intaglio method to one specific area, tarlatan and hand wiped, and then another color applied by the intaglio method to a separated area, and so on. Each color will slightly mix with another color where the two meet; this should be expected and exploited. This method, however, is not a very consistent process, but for certain plates with uncomplicated and separated imagery, it can produce very beautiful results. It should not be rejected simply because of its inconsistent nature.

MULTIPLATES AND JIGSAW PLATES

To print several plates superimposed on each other, a simple registration procedure using acetate and a traced template should be made on the press bed (see Chapter 11 on registration). Each plate should be exactly the same size, inked in intaglio and/or relief, and placed near the printing press. The printing paper is taken from the soaking tray, blotted, and taped down to the acetate on the top edge with water-paper tape. The paper is then flipped over the blankets, the first plate put in the premarked area, paper flipped back onto the plate, and printed normally. When the press bed comes fully to the other side, flip the blankets over the cylinder, lift the paper gently from the free edge, removing the first plate, and place the second plate in the premarked area. The paper is again placed over the plate and printed normally. This is continued until all preinked plates have been superimposed onto the print. This process lets the wet ink mix together, which used correctly can produce very exciting results; used incorrectly, the result will be a very flat, muddy color.

Jigsaw-type plates can be precut on a sabre or jigsaw equipped with fine metal cutting blades. They then can be individually etched as desired,

inked using any of the covered processes, and assembled on the press bed and printed normally in one procedure. The acetate/tracing template also will aid here in placing the plates in the same position each time.

Jigsaw cutting also can occur after an entire plate has been previously etched. This allows you the possibility of retaining areas of certain plates that did not work as a total image, reworking the image by cutting and etching additive plates, and assembling them in "collage" fashion to produce very dynamic results. You should never, therefore, totally discard a "failed" plate, but save it for future use utilizing the above suggestions. (See Chapter 17 for additional possibilities, such as *chiné colle* and other combined methods.)

II

PRODUCING A RELIEF PRINT

The production of a relief print refers to the process by which a raised surface is produced and inked, the result being a transfer on paper. It is, technically speaking, the opposite of intaglio. Yet many of the incising methods used to produce an intagliate are associated with the process of relief plate production. This can include relief etching, woodcut, linocut, wood engraving, and more experimental relief methods.

Block relief printing is considered a Chinese invention during the reign of Ming Huang (712-756 A.D.). These early forms of relief printing were meant for strictly religious purposes. [1] Yet, if one considers the process of a stone rubbing as part of relief reproduction printing, the Chinese Han dynasty of the second century should be considered the proper inventor, for they produced an "authenticated" version of the Confucian classics on stone in relief from which rubbings were taken for distribution to the masses. [2] The use of relief blocks for authentication purposes lasted throughout the years, with its introduction into Europe for the use of creating impressed letters and characters on paper during the early fourteenth century or slightly before. [3]

[1] Thomas Carter, revised edition by L.C. Goodrich, *The Invention of Printing in China* (New York: The Ronald Press Co., 1955), p. 41.

[2] Ibid., p. 20.

[3] W.A. Chatto, *A Treatise on Wood Engraving* (London: Charles Knight and Co., 1839), p. 67.

114

Relief printing was eventually used for commemoration purposes, as seen by the rolled Sanskrit book of *The Diamond Sutra* of 868 A.D.[4] This tradition was carried to Europe and is exemplified by the printed series of the Triumphal Arch, the Triumphal Car, and the Triumphal Procession glorifying the feats of Emperor Maximilian I.[5] With the introduction of the printing press during the early Renaissance years (fifteenth century), an invention considered to be perhaps the most important in history, the relief printed word and illustration became the lasting conveyance of information.[6]

The fine art relief print is still perhaps an "infinitesimal and indefinable portion of the total number of printed pictures," but this is changing rapidly.[7] Because of modern technology, the relief print process is more confined to contemporary aesthetic endeavors practiced for its own creative potential in producing a fine art image.

[4] Herbert Furst, *The Modern Woodcut* (London: John Lane, The Bodley Head Limited, 1924), p. 11.

[5] Chatto, *Wood Engraving*, p. 309.

[6] William M. Ivins, Jr., *Prints and Visual Communication* (New York: De Capo Press, 1969), p. 142.

[7] William M. Ivins, Jr., *How Prints Look* (Boston: Beacon Hill Press, 1958), p. 142.

Woodcut

The woodcut and wood engraving together are referred to as the art of *xylography*. The history of xylography is, to a great extent, the history of relief printmaking.

A wood engraving is done on hardwood, such as boxwood or maple, cut endgrain (across the grain), processed into 1″ to 2″ small blocks, 7/8″ thick, which are laminated together to create a larger block. A woodcut is done on soft wood—sycamore, beech, pine, apple, poplar, pear, cherry—which is cut parallel to the grain of wood into one total plank block usually about 7/8″ thick. The printed woodcut will show the grain of the wood, whereas the wood engraving will show no grain. (Figure 9-1, Chapter 9 shows the two types of wood blocks.)

The earliest woodcut prints are Chinese and were used as book illustrations. The earliest known woodcut print is the title page to the Chinese text of a Sanskrit book, *The Diamond Sutra*, dated the ninth year of Hsien-t'ung (or 868 A.D.). [1]

[1]Herbert Furst, *The Modern Woodcut* (London: John Lane, The Bodley Head Limited, 1924), p. 11.

Early European specimens of woodcut prints come from the very early fifteenth century and were done by artisans or craftsmen of unknown identity for decorative purposes in books, on lids of offertory boxes, as calendars, and similar uses. Albrecht Dürer is credited with first introducing the "fine art" woodcut print, which did not accompany text. His series of "Apocalypse" prints marks the beginning of his style and approach; consisting of 15 prints in its first edition of 1498, it was added to by one print and republished in 1511. [2] As all or most of Dürer's woodcuts, these prints were made from blocks cut by Jerome Kösch of Nuremberg. [3] The first European to print in color from a woodcut was Albrecht Altdorffer, in his *Beautiful Virgin of Ratisbon,* dating around 1505. [4] Dürer's approach and the basic design of the block were simplified in the work of Hans Holbein, his blocks being cut by Hans Lützelburger from around 1525 on. [5]

These German artists truly represent the "masters" of the traditional Western woodcut. Although there were some highlights after this period in the work of Niccolo Boldrini, who cut blocks from Titian's pen drawings, and the cutting of Christopher Jegher for Rubens, the art of Western woodcutting diminished in value up until the beginning of the nineteenth century, when the English revised it through the work and teaching of Thomas Bewick. [6]

Although multiblock color printing was explored by the Italian craftsman Ugo da Capri in his interpretations of the drawings of Renaissance artists such as Raphael to achieve chiaroscuro effects,[7] the Japanese perfected this approach in what is known as the *Ukiyo-e* woodcuts, which were initially introduced by Moronobu (1638-1714).[8] The approach was modified and perfected by Masanobu, Harunobu, Utamaro, Hokusai and others, the process losing its greatness around the middle of the nineteenth century.[9]

The introduction of the Ukiyo-e print into Europe greatly altered Western art approaches in general, and significantly changed the concepts of woodcutting in particular. Much of this is shown in the woodcuts of Paul Gauguin and Edvard Munch.[10] All this was eventually filtered into the United States, especially through the works of Kandinsky, Fenninger, and Emil Nolde. [11]

The approach to woodcuts today takes in all of the past, and, as with all contemporary printmaking media, are marked with much exploration and experimentation. It is an exciting medium, with few technical problems associated with it, and, accordingly, it is easy to achieve significant results without excess frustrations and interruptions.

[2]Ibid., p. 17.
[3]Samuel Greenburg, A.M., *Making Linoleum Cuts* (New York: Stephen Daye Press, 1947), p. 96.
[4]Furst, *Modern Woodcut,* p. 18.
[5]Ibid., p. 20.
[6]Ibid., pp. 22-24.
[7]Ibid., p. 24.
[8]Ibid., p. 90.
[9]Ibid., pp. 92-93.
[10]Ibid., pp. 104-106.
[11]Ibid., p. 106.

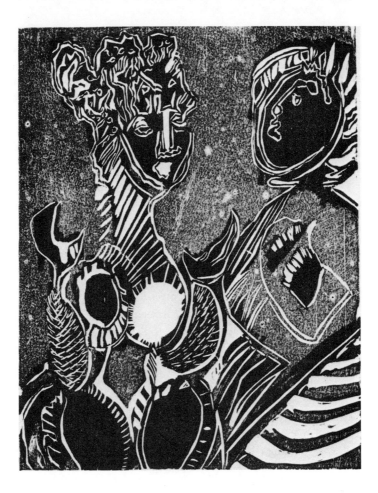

Fig. 7-1 Black and white woodcut. *The Duo*, 20° × 30″, Lisa Weinberg, 1973. (The black areas of this print were accomplished by hand printing with a Japanese rice spoon utilizing heavy pressure; other areas were hand printed with a Japanese baren.)

WORKSHOP, EQUIPMENT, AND SUPPLIES: INITIAL PREPARATION

The medium of woodcut printmaking requires very little in terms of space and supplies. The space need only consist of a worktable (kitchen table is quite adequate), a small storage locker for minimal supplies, a cleaning area (which could be the same table) partially covered with old newspapers, and an open window in the immediate area for the venting of solvent fumes.

Essentially, the only supplies you need to begin are a very sharp penknife, a block of plank pine, a small, flat wood chisel, a tube of printing ink, a semisoft rubber brayer, an ordinary wooden kitchen spoon, some printing paper, and a can of cleaning solvent (paint thinner). All lines and

117

dots can be cut with the penknife, which should be covered with any sort of tape exposing only 1/2″ of tip, and all large areas can be cut away with the chisel. Proofing and printing can be kept very simple with the application of one color by brayer and hand printing on any type of paper with the back of the wooden spoon.

Once you get the feel of it, however, you will probably want to get somewhat more "professional" with the process. Then you will have to purchase additional materials:

Wood blocks (as needed)
V-vieners or scrives
U-vieners or scrives
Knives (several types and sizes)
Chisels (flat and round, several sizes)
Gouges (large and small, several sizes)
Wood engraving tools (as needed)
Innovative tools (punches, stamps, and such, as needed)
Power tools (routers, grinders, sanders, drills, and such, as needed)
Hammer
Wooden mallet
Rasps and files (as needed)
Wire brush
Sandpaper (rough and smooth)
Raw linseed oil (1 pint)
India ink (as needed)
White poster paint (as needed)
Household oil
Oil/Arkansas stone
Slip stone (or heavy grade emery cloth)
Masking tape (1″ roll)
Plastic wood (small tube)
Bench hook (easily made)
Drawing paper (white and black sheets, as needed)
Tracing paper (as needed)
Carbon paper (office type, as needed)
Pencils (4B/4H and white pencil)

The materials necessary for printing the woodcut will be covered in Chapter 10. (Figure 7-2 shows the various cutting and sharpening supplies available.)

The traditional woodcut was created from planks of poplar, beech, sycamore, pear, apple, and cherry. These woods range from semisoft to hard, never being as hard as the endgrain wood engraving block. They can be purchased at most well-stocked art stores, or from dealers that specifically manufacture woodcutting materials (see Appendix A). The

Figure 7-2 Various woodcutting tools.

price of the blocks ranges from 10 to 30 cents per inch, depending on the type of wood. A less expensive wood that produces excellent results, as long as one is not concerned with very close detail, is plank pine. There are usually three types of pine available: white, which has a wide grain and tends to be soft; yellow, which has a close grain and tends to be medium soft; and parana, which has the closest grain and is slightly harder than any other pine. If you purchase this wood from a lumberyard, it is sometimes difficult to find a particular pine. You will usually ask for clear pine (versus two less expensive but inadequate grades) with no warps and cut from 10" to 24" wide planks, which are about 3/4" to 15/16" thick. If you do not want knots, you must state this; however, knots sometimes can be used quite effectively in the design, even though they cannot take a cut directly. Large blocks can be cut from pine plywood, although it chips and splinters very easily. And for some work, weathered wood of all kinds can be quite effective.

To insure that your piece of pine does not warp before, during, or after your cutting, rub a small amount of raw linseed oil into the wood with a soft cloth and let it dry at room temperature (about 4 to 5 days). This step is not absolutely necessary, but a flat block is easier to print, especially if you decide to work with a press (see Chapter 10).

The tools for woodcutting are usually made from tempered steel, are sharpened to a razor edge, and are attached to comfortable handles. The vieners, "V" for thin lines and "U" for thick lines, are exactly the same as linocut vieners, except they are usually much sturdier (Figure 7-2). Vieners are sometimes called scrives, but this term is more appropriate for wood sculpture tools. Knives come in various sizes for woodcutting, are usually cut at 45° at the end, and are short bladed with long handles. An

ordinary penknife, opened and covered with some tape exposing 1/2" of

Fig. 7-3 Three types of knives used for woodcutting.

Fig. 7-4 Three different types of bench hooks; note their construction.

blade, works quite well. (Figure 7-3 shows three types of knives.) There are chisels specifically made for woodcutting; however, any type of flat and round chisels can be used. Gouges are similar to chisels, but are smaller and are meant to take out small areas of wood versus the chisel's job of taking out large areas. If available, wood engraving tools can be used for fine work in a woodcut. However, they are expensive and should not be purchased unless you also are going to produce wood engravings.

A variety of other tools should be on hand as required. Power tools, such as routers and drills, can, of course, do things to the surface of wood that can be quite unique. Files and rasps also can be used in unusual ways to raise the grain and for texturing. Punches, stamps, nails, staples, gears, and such can all be stamped into the surface of wood with a hammer to create interesting patterns. And a wooden mallet is sometimes necessary when working with the chisels.

120 All tools should be kept extremely sharp. Large chisels can be sharpened

on an electrical grinder/sharpener. However, never use power sharpeners on your vieners, gouges, and knives. They should be sharpened using the oil/Arkansas stone and slip stone as described in Chapter 8 in the section on workshop, equipment, and supplies.

A bench hook, or similar holding device, should be made for cutting the block to protect yourself from pushing the tools into your hands (Figure 7-4). Again, refer to Chapter 8 for the procedures on making a holding device.

A WOODCUT DRAWING

THE DRAWING

It is a good idea to take a look at woodcut prints that have been produced over the years to ascertain their unique qualities. This research can be both enjoyable and rewarding. It will certainly give you an idea of the woodcut look, how it has been approached, and how you best can "attack" the block to produce a unique image personal to you.

You will probably note in woodcut prints an obviously "black and white" separation, except for the Japanese approach. As mentioned in the introduction, the Japanese were the masters of the multiblock, multicolored woodcut print. There were complete divisions of labor where the process was divided into design, cutting, and printing, each procedure requiring its individual personnel. The process, therefore, is certainly of an advanced level and should not be attempted by the beginner until there is a complete understanding of the medium.

Fig. 7-5 Drawing materials for woodcuts, linocuts, and wood engravings.

The black/white approach, therefore, should be your basis for beginning. You should practice this method by creating drawings that simulate the process with the drawing materials illustrated (Figure 7-5). First, do several with brush, pen, and India ink on white paper. Then do several on black paper with white poster paint, brush, and white pencil. The first approach will simulate a basically black line/white blackground print, whereas the second approach will simulate a white line/black background print. Of course, these two qualities can be intermixed on the same block, but as a beginner, try the two approaches separately to understand the visual effects fully.

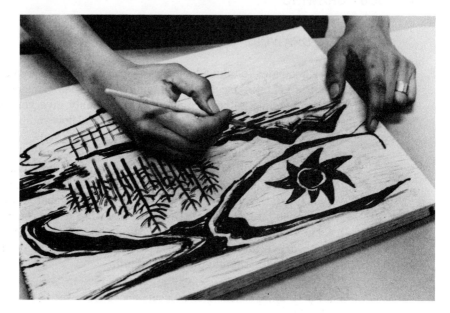

Fig. 7-6 Direct drawing on plank pine with India ink and white poster paint for black line cutting.

Although the transferring of a previously produced drawing from paper to a wood block is possible as described in Chapter 8, it is recommended that you work directly into the wood, using your previous drawings only as beginning guides. Tape a body of drawings, either white on black or black on white, in front of you, and begin drawing with India ink and/or white poster paint directly onto the previously conditioned wood (rubbed with raw linseed oil and allowed to dry completely). If you intend to start with the basic black on white approach, begin your drawing on the wood, just as you did on the white paper, with India ink (Figure 7-6). Corrections can be made with the white poster paint and redrawn, if necessary, with India ink. If you intend to begin with the basic white on black approach, rub a thin coat of India ink (which can be thinned out with a little water) into the wood surface with a soft rag or brush, let dry, and begin to work up the drawing with white poster paint (Figure 7-7).

Fig. 7-7 Direct drawing on plank pine darkened with India ink for white line cutting.

Corrections can be made here with the India ink and redrawn with the white poster paint. When your drawing is complete, it is ready for cutting. Again, if you prefer to transfer a drawing previously done on paper to the wood block, follow the directions in Chapter 8 on drawing into linoleum.

DRAWING WITH THE KNIFE

A good way to start the cutting is first to outline all drawn areas with your knife (Figure 7-8). Choose a knife that has a small, very sharp point. Hold it so that the edge cuts a nearly perpendicular slice, angling it sightly

Fig. 7-8 Beginning the woodcutting by outlining with a knife.

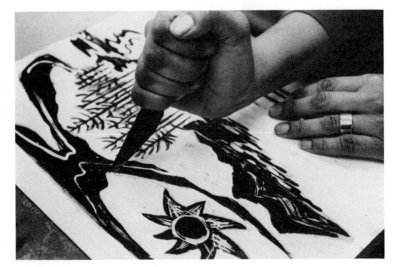

outward so that you do not undercut or create extreme verticals, which will weaken the remaining surface area, allowing the edge of the wood eventually to crack and split away. This initial cut need not be very deep; about 1/32″ will be more than sufficient as a beginning outline. Some woodcutters never outline, but proceed immediately to cutting line with knives and vieners.

If you are working with the basic white on black approach, every line can be cut with the knife. Hold the knife firmly in the hand as if you were going to stab the wood. Decide on the line to be cut, tilt the knife 45° to the left edge of the line, and draw the knife toward you with gentle pressure, holding the block with your other hand (Figure 7-9). You will discover that the wood will cut easily when cutting with the grain. Curves and circles are difficult but not impossible; take your time and cut down slowly, making several cuts instead of two or three that would be required for a line. The harder the wood the more consecutive cuts you will have to make; never try to cut very deeply in one cut. Now swing the knife to the right of the line at an angle of 45° and again draw the blade toward you the length of the previous cut. The piece of wood will begin to lift with this second cut (Figure 7-10), although you may have to start it with a small perpendicular cut at the beginning of the line. Every line can be cut in this way, although the variety will be somewhat limited.

Fig. 7-9 Beginning a knife line cut by angling the tool to the right.

Fig. 7-10 Finishing the knife line cut by angling the tool to the left; wood sliver begins to lift.

Fig. 7-11 Using the V-viener.

Fig. 7-12 Using the
U-viener.

DRAWING WITH THE VIENERS AND GOUGES

The V-viener will create a line similar to the knife cut line, depending on the width of the V. However, you must push rather than pull this tool. You should first place the block into your bench hook or similar holding device so that you do not have to hold the block with your hand in front of the cutting tool, which can cause very nasty accidents.

To cut the V line, place the tool at the beginning of the line, holding it at an angle of approximately 30° to the surface of the wood, and push gently, lifting the strip as you proceed (Figure 7-11). Either taper the end of the

line upward or stop short at the end and cut it off with the knife. You should experiment with the different V-vieners to determine the most effective size of line for your motif and to realize how much intrinsic line quality is possible.

The U-viener is for wide, very open lines, and should be used in the same way as the V-viener (Figure 7-12). However, the more wood you remove, the more resistance the wood will give you. Have patience and cut with gentle pressure. You can assist the cutting with a slight rocking motion from left to right, allowing the tool to glide more effectively through the line. However, this should not be overdone, as it will produce waving ridges along the length of the line when the rocking is too severe. And never force the tool through the line, with rocking motions or otherwise; if it is necessary to force the tool, it is probably not sharp. Always resharpen tools as often as necessary for clean easy cutting.

The gouges are used to remove total areas of the surface. They are particularly necessary to create the black on white approach. Here, the width of a black line should be decided on and the knife first used to outline it on both sides, angling the cut at 45° outward. You can then open this initial cut on both sides of the line a little more with a V-viener. Remove the surrounding area with a small or large gouge, holding it as you would the viener, as is appropriate for the amount to be removed, leaving the raised or relief line to pick up ink.

As you understand the two basic approaches to the block more fully, you can effectively incorporate them in the same block, but this does take some careful planning beforehand.

Fig. 7-13 Detail showing how large areas of wood are removed with a half-round chisel.

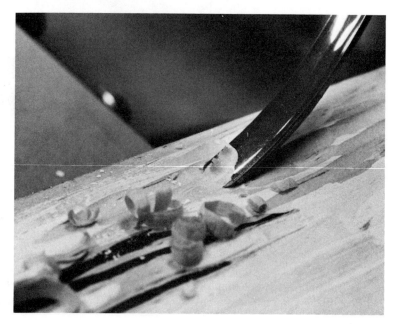

Woodcut Large areas that you want removed completely, where no evident ridges are left in relief on the surface, should be cut out with a very sharp flat chisel. The size of the chisel, of course, depends on the amount to be removed. Large areas for removal where ridges are wanted (these ridges can be quite effective in the printing, revealing the cutting procedure) will require curved or half-round chisels (Figure 7-13).

For some, it is more convenient to push the chisel lightly through the wood with a mallet. This is especially true with harder wood blocks. You must be careful not to hammer very hard to avoid unwanted slips. Light taps with the mallet is all that is necessary.

The chisels, whether pushed by hand or tapped with the mallet, should be held at about a 30° angle to the surface of the wood. Never hold any tool so that it digs deeply into the wood surface, stopping the cut or causing unnecessary holes. The cut need be only about 1/16″ deep, for you are printing just the surface, the relief areas, and lines of the block.

TEXTURING A WOOD BLOCK; IMPRINTING OR IMPASTO

It is a simple matter to hammer different types of punches, nails, and similar items into the wood surface. Again, deep hammering is not necessary. Any surface indentation will appear as long as the ink is applied stiff and with a semihard roller so that the relief areas only pick up ink. This more experimental approach can, at times, be overdone, so keep that in mind when creating the image.

Fig. 7-14 Placing staples on block for imprint texture.

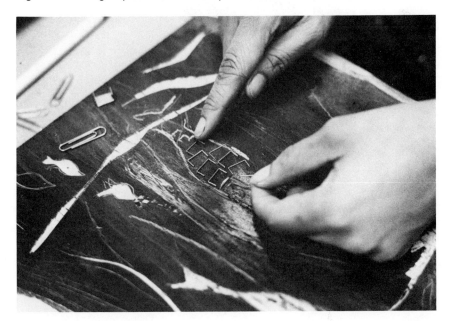

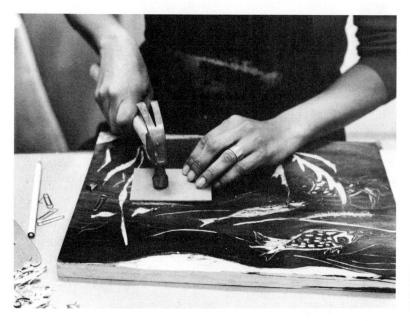

Fig. 7-15 Piece of cardboard placed over staples and hammered with firm pressure.

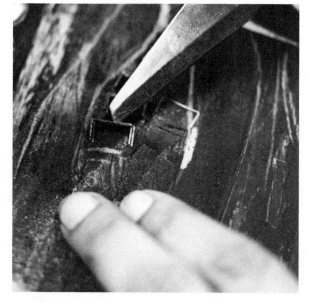

Fig. 7-16 Imprinted staples removed from wood surface.

Items such as staples, paper clips, tacks, hairpins, grit, pebbles, small gears, and the like also can be imprinted into the wood surface for textural effects. Place the textural item in the designated area (Figure 7-14) and cover it with a piece of two-ply cardboard or another small piece of wood, hammering it with medium pressure (Figure 7-15). The item will imbed itself into the wood, which is removed after the hammering, leaving the outline of the item in the wood surface (Figure 7-16).

Impasto areas of texture can be created on the wood surface as well. You can brush on, or use a palette knife to apply, plastic wood, polymer acrylic modeling paste, white glue, or polymer acrylic gel medium directly to the raised portion of the block (Figure 7-17). You should not apply this very thickly; a very thin textured coating is all that is necessary for printing. Let it dry thoroughly, after which it can be lightly sanded as required.

One of the most significant aspects of a woodcut, as pointed out in the introduction, is the printed grain of the plank. The grain can be visually heightened by several effective methods. A rough sandpaper will remove the softer wood from the grain and texture the harder wood. A fine sandpaper will accomplish similar effects, with the harder wood producing soft grain edges (Figure 7-18). A wire brush, used manually or on a power tool (drill or buffer), will remove deeper areas of soft wood, leaving strong

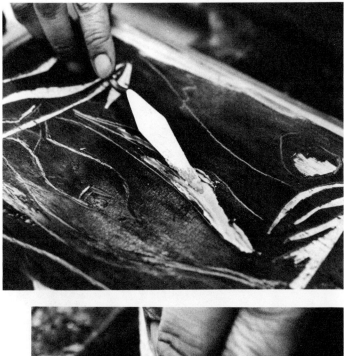

Fig. 7-17 Texturing wood surface with modeling paste.

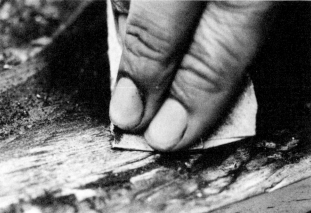

Fig. 7-18 Raising the natural grain with sandpaper.

linear textures on the harder grains, which can be left as is or sanded smooth. A rasp or file also can be used to produce similar effects (Figure 7-19). Innovative items, such as leather crafts tools, can be effectively used for interesting grain textures (Figure 7-20). A very effective method of accentuating the grain is by burning the surface of the wood with a propane torch or gas burner; the soft wood burns out, leaving the harder grains in relief with smooth surfaces and edges (Figures 7-21 and 7-22). (Very effective and unique images can be created on the surface of wood using only torch flame and/or wood burning craft tools available at most hobby stores.)

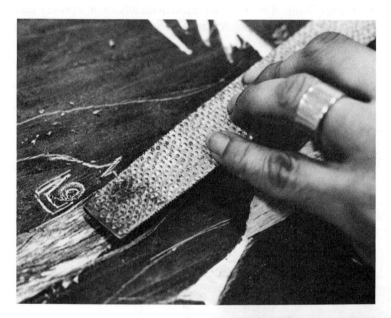

Fig. 7-19 Texturing and raising grain with a rasp.

Fig. 7-20 Using a leather craft roulette for a cloth pattern.

Fig. 7-21 Raising the grain by burning out the softer wood.

Fig. 7-22 Detail showing raised texture accomplished by burning, with small V lines incising into the wood surface.

131

Woodcut Corrections are possible but usually cumbersome and difficult to hide. For simple line and scratch mistakes, plastic wood is your best bet. Overfill the mistake with plastic wood, and, after leaving it dry thoroughly, sand it down to the surface of the block.

Large corrections are difficult. They require plugging with pieces of pine block or dowel. Cut out deeply the area to be plugged, about 1/4" deeper than the already lowered areas, to the shape of the plug. Or drill out the area with the appropriate size bit for inserting a piece of 1/8" to 1" dowel. Cut the dowel or shaped plug about 1/2" longer than needed. Apply a little plastic wood to the bottom and sides of the plug and force it into the cut or drilled area by hammering it. After insuring that it is tightly plugged, cut the surface excess away with a flat, fine tooth, saw blade and sand the surface of the plug smooth. You may have to fill tiny separations with plastic wood.

Large area corrections are really difficult. You can use the plugging type method by cutting out the large area and inserting the new piece of wood into the opened space, glueing it down with white glue, and filling any open area with plastic wood. A power router can be useful to remove clean large areas. Or you can cut away parts of the block and replace them with new blocks, which can be glued in place with white glue and clamped tightly until dry.

This obviously brings up the point that you can cut blocks into several pieces that somehow fit together jigsaw puzzle fashion. They do not have to be glued together, allowing you to ink each separately (different colors) and assembling them before printing (see Chapter 10). These variable shapes can be cut quite easily from the wood planks with a jigsaw or sabresaw.

DEVELOPING THE DRAWING THROUGH PROOFS

It is sometimes necessary to proof the block or blocks through each stage of cutting, especially if you wish to be very precise with the development of the drawing. However, the black/white and white/black drawings you previously made should give you a pretty good idea of the way the final print will look. As the process gets more and more complicated, as you so choose, it will then be necessary continuously to proof-print the block (see Chapter 10).

It is suggested that you proof-print with water-based black ink on white paper of any kind. This allows you continuously to draw back into the block with the water-based India ink and poster paint. Remember to proof-print as much as is necessary for proper development of your image. You cannot overproof a woodcut, and this process can be very helpful, especially for the beginner. When the cutting is completed, you are ready to print the block (see Chapter 10).

8

Linocut

INTRODUCTION

The linocut (linoleum cut) has long been considered the simplest of print-making processes—therefore, ignored by the so-called serious contemporary printmaker. And the teaching of the method often has been confined to the production of propaganda, greeting cards, stationery, and the like.

Looked at another way, the basic simplicity of the medium is its true advantage, allowing the artist to use the characteristic appearance of a linocut print without the somewhat detailed learning that is required for more technical printmaking processes, such as lithography or etching. It is relatively inexpensive to produce linocuts, and the materials are readily available. It does have many limitations, but imaginative use of the medium individually or in combination with other fine art media, such as drawing or painting as well as other printmaking processes, can produce unique and satisfying visual images. The linocut is certainly one of the most expedient ways of understanding the basic concepts behind the production of multiple images from relief surfaces.

133 In 1862, Frederick Walton discovered linoleum in England while trying

to produce an imitation leather for bookbinding.¹ It took another 50 years before linoleum was used to produce prints. An art school for children in Vienna, run by a Professor Cisek, introduced the medium to the art world, and during the early twentieth century it found its way into the United States in the works and teachings of Arthur Wesley Dow and Ernest W. Watson. ²

The medium's predecessor, the woodcut, certainly provided the basis for linocut technicalities. Much of the cutting is equivalent to the woodcut process, using much the same type of tools and methods. The printing of the linocut when in type-high form (linoleum attached to a wood base) follows the same rules as for woodcuts. And the final print is similar, in many respects, to the woodcut print. There are, of course, unique possibilities to each medium. Linoleum differs from wood, obviously, in many ways. The texture of wood will not appear in a linocut print; it will not retain the same linear qualities of wood; and linoleum is not absorbent at all, which reduces the "watercolor" appearance often seen in the woodcut print.

Fig. 8-1 Linocut hand printed on dry rice paper. *El Arca de Noe*, 18″ × 26″, Consuelo Claudio, 1974.

¹Samuel Greenburg, A.M., *Making Linoleum Cuts* (New York: Stephen Daye Press, 1947), p. 111.
²Ibid., p. 112.

But linoleum, unlike the type-high woodcut, need not be mounted, allowing the print to be pulled through a double-cylinder etching press and creating unique embossed effects. It is not restricted by size like the woodcut, allowing the contemporary artist a wide range of scale possibilities. And because it need not be mounted, it can be cut quite easily into any shape or shapes (see Figures 8-1 to 8-4).

The method employs the work-up of a basic drawing, the cutting of line and pattern by pulling, pushing, and stamping simple tools, and the quick roll-up of ink on its relief surface for printing, which produces a "white" or exposed line on a colored background. It is a method that is simple to explain, easy to understand, and quick to master.

Fig. 8-2 Unmounted linocut print on Rives BFK printed on an etching press. Untitled, 9″ × 12″, Linda Hanauer, 1975.

Fig. 8-3 Unmounted linocut print on rice paper printed on an
etching press. *Gynina Semertosa,* 14″ × 24″, Joann Messina-
Shefflin, 1975.

Fig. 8-4 Mounted linocut print on rice paper printed on an
etching press. *Zebras,* 14″ × 17″, Mary Juhasz, 1974.

The setup of a workshop for linocut print production is exactly the same as for woodcut printing. However, if you intend to print linocuts unmounted through an etching press, you will have to add this piece of equipment to your list (see Chapter 1 for a description of double-cylinder presses).

Following is a list of supplies for thorough linocut print production. The list is meant to be comprehensive; a linocut print also can be made with a simple set of Speedball of X-acto linocut tools, a piece of linoleum, an inexpensive brayer, easily cleanable water-base inks, inexpensive drawing paper, and a tablespoon for transferring the inked image to the paper. But for thorough linocut work, you need:

Linoleum (mounted or unmounted, amount as needed)
V-viener
U-viener
Gouge (small area)
Gouge (large area)
Knife (boyscout type or specially made linocut knife)
Oil/Arkansas stone, slip stone (or heavy grade emery cloth)
Household oil
Felt tip pen (or India ink, pen, and small brush)
Pencils (4B/4H and white pencil)
White poster paint (as needed)
Fine sandpaper (as needed)
1" masking tape (1 roll)
Spray fixative (1 pint can, Krylon Crystal Clear recommended)
Bench hook (easily homemade)
Talcum powder (small container)
Household ammonia (small container)
#7 watercolor brush
Drawing paper (white and black sheets, as needed)
Tracing paper (as needed)
Hammer and punches (optional)
Plastic wood (small tube)

The materials necessary for printing the linocut will be covered in Chapter 10.

The type of linoleum (Figure 8-5) used here is called battleship linoleum and usually comes in a light grey or dark brown and is 1/8", 3/16", or 1/4" thick. It is backed with burlap and can be purchased mounted on plywood or pressed wood (approximately 15/16" or exactly .918"), or unmounted. The mounted blocks come in a variety of surface sizes and can be purchased at any art store. Most art supply stores will also stock unmounted

linoleum, which can be sometimes purchased from linoleum dealers. The

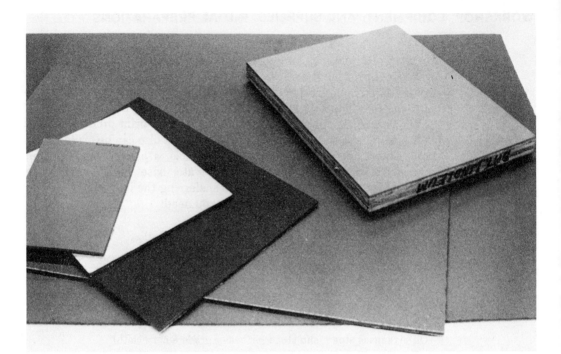

Fig. 8.5 Several types of linoleum, mounted and unmounted.

light grey battleship linoleum has proven to be the best. Previously available from Armstrong, it is now imported from Europe and can be purchased from Graphic Chemical and Ink Company (see Appendix A). It is less expensive to buy the linoleum unmounted; it can be mounted later by gluing it with a "white" glue, such as Elmer's, to a piece of 15/16″ thick plywood. If you do not have a press available, or do not intend to print the linocut on a press, the linoleum should be mounted (which can be done before or after the cutting of the drawing) for easier printing. Linoleum should be stored face-to-face at room temperature; when cold, it will crack. Bringing linoleum to approximately 75° F will make it much easier to cut.

The three primary tools used in linocutting are the viener, gouge, and knife. Woodcut tools, if already owned, can be used. Additionally, innovative exploration of various tools can give very exciting results. Speedball and X-acto produce a very inexpensive set of linocut blades that attach to a single hand and are interchangeable. X-acto, Sheffield, Craftool, and many others make a more expensive, more extensive set of linocut tools that do not have interchangeable blades.

Essentially, each set consists of a knife, a V-viener and a U-viener to produce thin and thick lines, and one or two gouges to remove large and small areas of space. In addition, you should explore the possibilities of imprinting by hammering punches, nails, staples, leather craft tools, and so **138** on into the linoleum.

The cutting of linoleum with these tools can be very deceptive in that the tool will flow easily through the material with little pressure, but the cutting edge will wear down very quickly, much faster than using woodcut tools in most woods. Accordingly, you must sharpen the tools quite often. Lay the angle of the cutting edge flat against the oil stone (which has a few drops of household oil applied), and rotate it gently a few times on both sides of the tool (Figure 8-6). Repeat this on the Arkansas stone. The

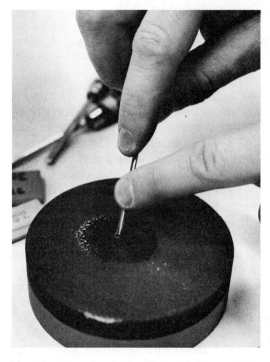

Fig. 8-6 Sharpening a linocut viener on the oil/Arkansas stone.

Fig. 8-7 Removing the burr from the sharpened U-viener with a slip stone.

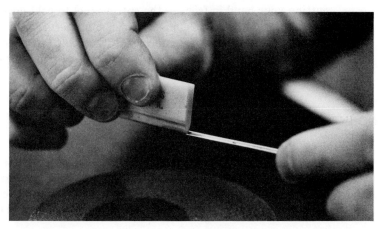

Fig. 8-8 Removing the burr with a piece of emery cloth.

U-viener and gouges must be carefully "rocked" on the stone as you rotate it. There is available, at some expense, a concave sharpening stone for these rounded tools, but it is not necessary to have one. With a little practice, you will be able to rock the rounded tools with ease. The inside of the cutting edge will produce a slight burr from the sharpening procedure; this can be removed by a slip stone (small rounded stone) (Figure 8-7) or a piece of heavy grade emery cloth (Figure 8-8). Remember to sharpen your tools often or you will be fighting with the cutting procedure rather than enjoying its relative ease.

A bench hook, or what is sometimes called a holding jig, is simply made from two pieces of 1″ by 2″ common pine and a piece of masonite or plywood (see Figure 7-4, Chapter 7). The size of the bench hook is determined by the piece of linoleum to be cut. Measure the piece of linoleum and cut a piece of plywood or masonite 2″ larger on all sides. Now cut two pieces of 1″ by 2″ common pine the size of the upper and lower edges of the masonite or plywood. Nail or glue one of these cut pieces to the top, upper edge of the masonite or plywood, and one to the bottom, lower edge. The bench hook will then grab onto one edge of the table, while holding the linoleum against the upper edge so that push-cutting is easily achieved without putting your hand in front of the cutting tool to hold down the linoleum. Larger unmounted linoleum pieces can be secured to the table with small wood stops directly attached to the table top with glue, nails, or they can be directly nailed to a wood table, the resulting holes cut away before printing or incorporated into the basic design.

DRAWING INTO LINOLEUM

It is, as always, your own personal approach that will determine whether or not an initial drawing on paper will be made to use for transferring to the linoleum, or to draw directly onto the linoleum and begin cutting, adding, subtracting, or otherwise modifying as the cut areas are produced. In

140

either case, it is recommended that you begin with a few sketches that simulate the type of print that eventually will be created.

To accomplish these trial and error sketches, have ready your drawing items (see Figure 7-5, Chapter 7), begin a few on white drawing paper with black felt tip pen, and/or India ink and pen and brush, and 4B pencil. If you choose to transfer one of these drawings done on white paper with black drawing items, you will have to cut away, on the linoleum, all the areas that are left white. This will produce a print with mostly "white" or open areas with "black" lines. Also try a few sketches with white poster paint and white pencil on black paper. If you choose to transfer one of these drawings to the linoleum, the resultant print will produce mostly "black" or closed areas with "white" lines. Keep this in mind when doing your sketches, and you will have a better idea of how to proceed and how the end product will look.

After choosing one of your drawings, and you decide to transfer it and not work directly into the linoleum using the drawing only as a guide, blacken a piece of tracing paper with a number 4B pencil or stick of graphite (or use a piece of carbon paper). Before transferring your drawing to the linoleum, lightly sand its surface with a fine sandpaper (Figure 8-9); do not overdo it, simply roughen the surface slightly. When finished, wipe the surface with a soft rag and some household ammonia. These two steps will make the linoleum more receptive to the transfer drawing, or direct drawing with India ink, felt tip pen, and/or white poster paint.

If you are working with a dark brown linoleum, it should be lightened in order to see what you are doing. Dilute some white poster paint (about 75 per cent paint to 25 per cent water) and wipe it over the entire brown linoleum surface and let it dry (Figure 8-10).

Fig. 8-9 Lightly sanding the surface of linoleum, which is then wiped with ammonia.

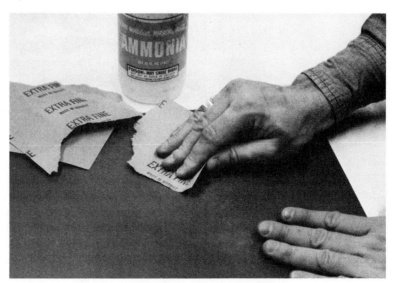

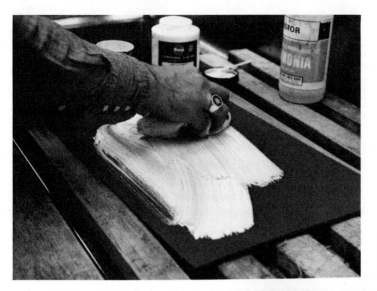

Fig. 8-10 Wiping on a thin layer of white poster paint to the surface of brown linoleum.

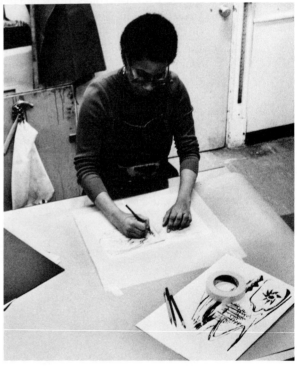

Fig. 8-11 Transferring a drawing to a relief surface; some procedures used for any relief surface (woodcut, wood engraving, and linocut).

Now place your piece of tracing paper (or carbon paper) blackened side down on the linoleum. Place your drawing over this and tape it in place. With your 4H pencil and medium pressure, trace the drawing onto the linoleum (Figure 8-11). You can lift the drawing and tracing paper, as long as they are taped down to the table or side of the linoleum, to check if the drawing is properly transferring (Figure 8-12). As with most printing, the

142

Fig. 8-12 Checking the progress of the drawing transfer.

image will reverse itself when printed (mirror image); you must compensate for this if you do not wish it to reverse, especially with numerals or letters. This can be accomplished by first transferring the drawing to the back of your sheet of drawing paper. Place a piece of blackened tracing paper (or carbon paper) blackened side up on your table, placing the drawing face up over it, and tracing in with light pressure and 4H pencil. This will transfer it to the back of the drawing and reverse it. (The original drawing can be saved by interleafing it with thin tracing paper if you prefer.) This reverse drawing is then placed over another blackened sheet of tracing paper (or carbon paper) face up, which has been placed on the linoleum, and taped down. The reverse drawing is then traced onto the linoleum with a 4H pencil and medium pressure.

If you choose to work up a drawing directly onto the linoleum, simply use brush and pen with India ink and/or black felt tip pen (see Figure 7-6, Chapter 7). Corrections on this direct drawing can be made with white poster paint.

When the drawing on the linoleum is complete, you are ready for cutting. To protect the drawing throughout the cutting stage, spray the linoleum with a couple of thin coats of Krylon Crystal Clear.

USING LINOCUT TOOLS

Place the linoleum either into the bench hook or against the tabs secured to the table top. Make sure your tools are perfectly sharp (they should be when first bought) and begin by outlining all areas and lines with the knife. Do not press hard or struggle with the linoleum. It is not necessary to cut very deep with the knife (about 1/32" deep). Holding the knife blade up and

143

down, pull it toward you gently. You may recut the outlines if you do not think they are deep enough, but do not try to cut very deep lines in one cut. If you notice throughout the cutting that the instrument is resisting or the linoleum seems to crack open rather than cut, the cutting tool is not sharp or the linoleum is too cold.

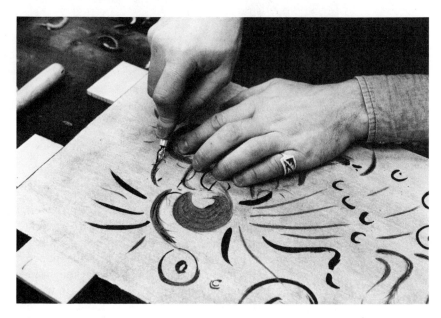

Fig. 8-13 Using a Speedball V-viener on unmounted, whitened linoleum.

After the outlining is complete, you must next decide what lines you want to print black and what lines you want to print white. Check your drawing, and after deciding begin to cut your white lines with the V-viener, following your outline (Figure 8-13). Hold the vieners and gouges at an angle of approximately 30°, gently grasping the tool with your palm, placing your index finger on the rod or back part of the blade, and using it to guide the tool across the linoleum. Use medium to light pressure and never force the tool. You can either taper out your line endings or have them stop abruptly by halting with the tool at the end of the line end and either snapping off the piece of linoleum or cutting it clean with the knife. Lines that you wish to print out black will require two cuts; following the outline, cut away both outside edges of the line with the V-viener and then clean away surrounding area with your gouges, leaving a raised line of linoleum.

Never undercut or create perfectly vertical sides. Always cut so that tapered sides remain; this will insure a firm surface for printing with either the press or by hand. Straight cuts can be made easier by guiding your tool along a straight edge (Figure 8-14).

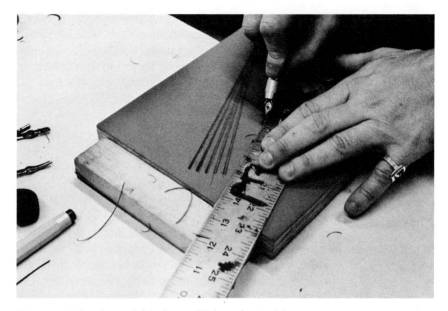

Fig. 8-14 Using the straight edge and V-viener for straight or angular lines and shapes.

Large areas of space, of course, are removed with the gouges. Using the appropriate sized gouge for the space to be opened, begin at the center of the space and push the tool toward the surrounding outline or line. When you get to the outline or line, stop and snap off the piece of cut linoleum. If you try to gouge-cut right to the line edge, you will most likely cut into the line, a sometimes costly error. If you want thinner lines than any of your tools can create, you can make thin V cuts with the knife alone, one on one side and another on the other side.

Do not try to remove the ridges created by the vieners and gouges in open areas. They will not print out, except for slightly raised ones, and these usually add to the aesthetic value of the print. If the linocut is printed in the press, the ridges will appear as sightly embossed areas, which again adds to the final print.

Never cut overly deep. You are only printing in relief (the surface *only* is being inked), and there is no need to weaken the linoleum with deep cuts.

Corrections may be difficult but not impossible. When done properly, they will never show. Small mistakes can be corrected by filling them with plastic wood or polymer modeling paste, letting them dry, and lightly sanding to produce an even, clean surface. Large areas that need correcting can be removed completely and replaced with another piece of linoleum, which can then be recut. First, outline the area to be cut out, and, with a very sharp knife, begin an outline cut without going too deep at first. Cut deeper and deeper very slowly, and when you finally cut through the burlap backing, remove the cut piece. Cut a piece of linoleum to size from a separate source, and force it into the cut-away area, filling the cut edge with plastic wood, and, after letting it dry, sanding it smooth. This is a

145

little difficult to accomplish when the linoleum is already mounted, but with a little patience, it can be done.

To create dark tones, place lines close together or create cross-hatched areas (lines crossing each other). Or group dots or hash marks together in one area. To change tones from dark to light, place your lines or dots close together for dark areas, and slowly open the spaces between them as you work out from the darkest area.

EXPERIMENTAL LINOLEUM CUTTING

Some very exciting textures can be cut into linoleum. You should explore the different patterns that can be created with leather craft tools, if they are available. They come in all different type patterns and can be hammered into the linoleum or, if on a wheel, can be rolled over areas.

Metal punches of all types can be used in linoleum (Figure 8-15). You can also place items such as staples, nails, and screws on the linoleum, put a small piece of wood over them, and hammer their patterns into the surface (see Chapter 7).

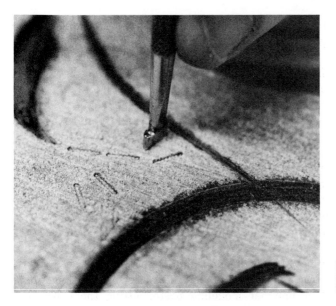

Fig. 8-15 Creating a textural pattern by hammering leather punches into the linoleum surface.

If the linoleum is not mounted and there is an etching press available, it is possible to emboss or imprint low relief items into the linoleum surface. Place the linoleum on the press, drop such items as thin gears, metal washers, metal screening, or paper clips into place on the linoleum surface. Cover this with a full piece of one-ply cardboard, and drop a sheet of 1/2″ close-pore foam rubber over everything, running it through the press with light pressure, increasing the pressure only so that the items cleanly cut

the linoleum (use no blankets in this case). The linoleum can be slightly warmed before doing this to increase the imprinting effect.

Because linoleum is sensitive to heat, heated tools like those used in plastic intaglio work (see Chapter 2) can be used on linoleum. They will create very different line and dot effects.

DEVELOPING THE CUTTING THROUGH PROOFS

It is not absolutely necessary to proof-print your linocut as you proceed, if you have a pretty good idea of what you want in terms of drawing from the beginning. By utilizing the black and white drawing procedures effectively with India ink and white poster paint, you should have an excellent concept of the final product.

However, for those working more intuitively, or exploring with some of the above experimental suggestions, proofing is necessary. In this case, you cannot overproof. (See Chapter 10 for proofing details). You may wish to pull the proofs in a black water-based ink so that you can determine further cutting rapidly by working into the proof with white poster paint to decide what to take out next. Inking a plate with water-based inks is exactly the same as with oil-based inks. Cleaning, of course, is accomplished with water in this case. Proofs pulled with oil-based inks take much longer to dry and are not receptive to the water-based poster paint. It is still recommended, however, to do your final printing with oil-based inks if you want the clearest of prints.

BEFORE PRINTING YOUR LINOCUT

Prior to proofing or printing the linocut, the poster paint and/or India ink must be completely removed with some warm water and very little powdered detergent or whiting. Do not soak the linoleum or submerge it in the water. It should clean quite easily without getting it overly wet.

After drying it completely, wipe the surface with a soft rag slightly soaked in ammonia, and again dry it. Then lightly talc the face of the linocut, brushing off the excess powder with a soft brush. The linocut is now ready for printing (see Chapter 10).

Wood Engraving

INTRODUCTION

Although wood engraving is traditionally considered part of the medium of xylography, which includes the woodcut because the basic problem is very much the same—the production of a multiple image from a relief block of wood, it probably owes its history more to metal engraving than to wood-cutting. The tools used are very similar, the tediousness associated with engraved cutting is very noted in both, the tradition of burin engraving is as much part of wood as it is of metal, and most of the historical exemplars of wood engraving began as engravers of metal.

Although there probably exist examples of wood engraved blocks and prints prior to the late eighteenth century, much of the credit for making the medium a viable art and craft must go to Englishman Thomas Bewick, who was born in 1753. As an apprentice silver engraver at the age of 14, he began to fill requests for wood blocks.[1] Although he initially began his work with knife and plank grain wood (which is woodcutting), he eventually made the association of metal engraving burins to the hard

[1] *1800 Woodcuts by Thomas Bewick and His School*, introduction by Robert Hutchinson (New York: Dover Publications, Inc., 1962), p.v.

endgrain wood block. Whether or not he did this by accident or not is questionable, especially when there is evidence that others were working along these lines before or at the same time, such as the French engraver J. M. Papillon, who experimented with copper plate engraving on wood and wrote a treatise on the subject in 1766.[2]

Bewick's genius was in his utmost perfection of the medium and through examples of his own work and his proficient teaching of the craft, making it a significant part of the printmaker's repertoire. He is personally noted for his excellent examples of genre illustrations of his everyday world, which he called "talepieces."[3] Bewick trained many artisans in his Newcastle shop, who, along with Bewick, answered the need of a commercial market increasingly receptive to engraved illustrations that could be locked into the press with type and could take many thousands of printings before wearing down. The engraved block was ideally suited for long printing runs because of the intrinsic strength and durability of the endgrain wood. The wood engraving lasted as the primary means of producing book and periodical illustration until it was replaced by photoengraving.[4] Photoengraving was discovered by another English engraver, named Bolton, who first put a negative image onto a wood block with a light-sensitive emulsion around 1875; by 1880, commercial photoengraving completely replaced hand work.[5]

Although wood engraving became primarily an artistic venture, most artists, even today, find it too tedious and limiting a medium. This somewhat prejudicial association is unfortunate, for wood engraving provides a very unique image and method that has, in the finished print, a revelation of personal intimacy and intrinsic simplicity not usually found in other printmaking media.

Americans especially seem to dislike the process, for there are few outstanding American artists we can point to who are working proficiently and creatively as wood engravers. Historically, Alexander Anderson is considered the father of American wood engraving, working in Bewick's white line tradition around 1780.[6] The black line engraving, where most of the block is removed revealing only the relief line, comes from Germany following the methods of Adolph Menzel, who began his work around the end of the eighteenth century.[7] The American artist Thomas Cole, working in an "impressionistic" manner, seems to have incorporated both white and black line methods of working.[8] This dual method is still the approach taken by most American artists who choose to explore the process. Outstanding names include Leonard Baskin, Misch Kohn, and Fritz Eichenberg.

[2]Herbert Furst, *The Modern Woodcut* (London: John Land, The Bodley Head Limited, 1924), p. 46.

[3]*1800 Woodcuts*, p. vi.

[4]Ibid., p. vi.

[5]Michael Rothenstein, *Relief Printmaking* (New York: Watson-Guptill Publications, 1970), p. 19.

[6]*1800 Woodcuts*, p. viii.

[7]Furst, *Modern Woodcut*, p. 50.

[8]Ibid., p. 56.

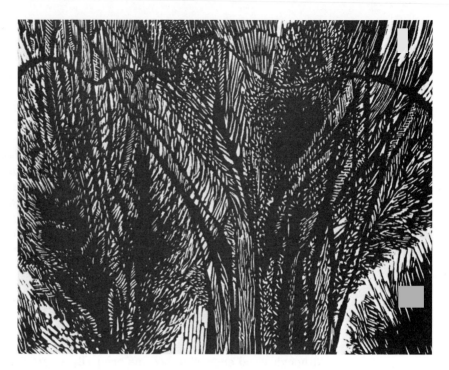

Fig. 9-1a Wood engraving. *Dream of the Forest*, 4″ × 5″, Mariette Bevington, 1973.

Fig. 9-1b Wood engraving. *Vision*, 4″ × 5″, Mariette Bevington, 1973.

WORKSHOP, EQUIPMENT, AND SUPPLIES:
INITIAL PREPARATIONS

A large working area is not necessary for wood engraving. Workshop stipulations pertaining to woodcutting and linocutting also pertain to wood engraving, with some printing differences.

Because wood engraving has become an outmoded craft to many artists, the materials and supplies necessary to learn the medium are sometimes difficult to obtain, and usually expensive. It is possible to create a wood engraving on a relatively low budget by purchasing a small maple endgrain block, using one or two burins, and printing on readily available machine-made papers with a small rubber or gelatin brayer and one tube of black oil-based ink. However, if one truly wishes to explore the possibilities of the medium, it will be necessary to include many more supplies, such as:

Endgrain wood blocks, boxwood and/or maple (as needed)
Square burin (different sizes, as needed)
Lozenge burin (different sizes, as needed)
Spitstickers (different widths, as needed)
Angle tint tool (different widths, as needed)
Elliptic tint tool (different widths, as needed)
Multiple liners (different sizes, as needed)
Round scorper (different widths, as needed)
Square scorper (different widths, as needed)
Chisels (different sizes, as needed)
Knife (engraving)
Power engraver (optional)
Engraver's sandbag
Fine sand paper
Plastic wood
White poster paint
India ink
Pen holder and points (variety of point sizes)
Artist's brushes (as needed)
Felt tip pen (black with fine tip)
Oil/Arkansas stone
Household oil

Materials necessary for printing the woodcut will be covered in Chapter 10.

Endgrain boxwood now usually comes from South America, and although it is inferior to the traditional Turkish boxwood, it is, by far, much more available and less expensive. Boxwood costs from 30 to 40 cents per square inch; the softer and less durable maple blocks cost about 20 cents per square inch, and come in larger sizes. (Figure 9-1 shows endgrain blocks as compared to plank grain blocks.)

Fig. 9-c Engrain wood blocks (left) compared to plank grain wood blocks (right).

As pointed out, a wood engraving can be made with one or two burins. However, the beauty of the wood engraving is the intricate line and pattern work that is possible as long as one has a wide selection of engraving tools. Accordingly, once you begin any serious work in this medium, frustration will be the result if you do not have this wide tool selection on hand.

The engraver's knife (Figure 9-2) is used for very thin lines and dot patterns. The burins, as in metal engraving, are used primarily to create thin and thick straight lines (Figure 9-3). The spitstickers are used for single lines that can vary in width and are excellent for curves (Figure 9-4). The angle tint tool is for nonvarying single lines that can be straight or curved, but differ in quality as compared to the burin or spitsticker (Figure 9-5). The elliptic tint tool will have curved sides as compared to the angle tint tool and will produce much wider lines that will intrinsically vary from beginning to end (Figure 9-5). The multiple liners, measured by how many lines would occur per square inch, produce even, consistent, nonvarying parallel lines that are very close together (Figure 9-6). The round scorper removes areas of wood close to the image (Figure 9-7) and the square scroper removes even larger areas of wood not directly next to the image (Figure 9-8); used innovatively, these tools can produce unique engraved areas of their own. The chisel (Figure 9-9), similar to the square scroper, but larger is for even larger open areas of wood. All these tools come in various sizes and widths. The power engraver, or electric vibrating tool,

152

Fig. 9-2 Wood engraver's knife; tool and cutting face.

Square burin (cutting face)

Lozenge burin (cutting face)

Fig. 9-3 Square and lozenge wood engraving burin cutting faces.

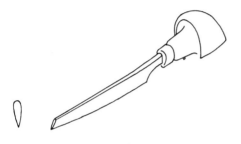

Fig. 9-4 Wood engraving spitsticker; tool and cutting face.

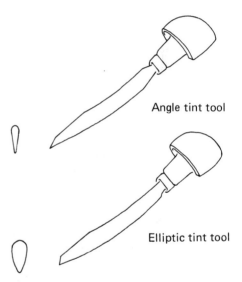

Angle tint tool

Elliptic tint tool

Fig. 9-5 Wood engraving tint tools.

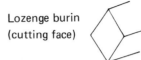

Fig. 9-6 A seven-point multiple liner for wood engraving showing parallel line pattern possible with seven points.

Fig. 9-7 A round wood engraving scorper.

Fig. 9-8 A square wood engraving scorper.

Fig. 9-9 A wood engraving chisel; tool and cutting face.

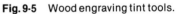

such as described in Chapter 2, will produce unique engraved areas with very little difficulty once control of the tool is maintained.

You will need an engraver's sandbag to turn the block (while holding the tool still) to make curves (Figure 9-10). Many engravers have produced innovative turning devices or have used other items that serve the purpose, such as clay modeling stands as used in Chapter 3 on metal engraving.

Fig. 9-10 Leather-covered engraver's sandbag.

Your tools always should be kept razor sharp. The method of sharpening in Chapter 3 is the same for wood engraving tools. It may be beneficial to purchase a sharpening jig to aid your beginning attempts to sharpen engraving tools (Figure 9-11).

The cutting tools are expensive, ranging from about $1.50 to $10 each. However, if kept clean and sharp, they will last indefinetely. Engraving tools have been passed down for generations; it seems that the older they get, the better they operate. In any case, keep the tools in a safe container, such as a cloth bag. Store them in a dry area, and never allow them to be exposed to acid or acid fumes, for they will rust and deteriorate almost instantly. When they are to be put away for long periods, wipe the tempered steel rods and tips with a coating of petroleum jelly or heavy oil. This easily can be cleaned off with some solvent when ready to use. When working with these tools, keep rods stuck into a piece of styrofoam, or a roll of corrugated cardboard, to avoid dropping them on the floor and causing chipping of the points (Figure 9-12).

Many engravers prefer to have available a magnifying glass that is

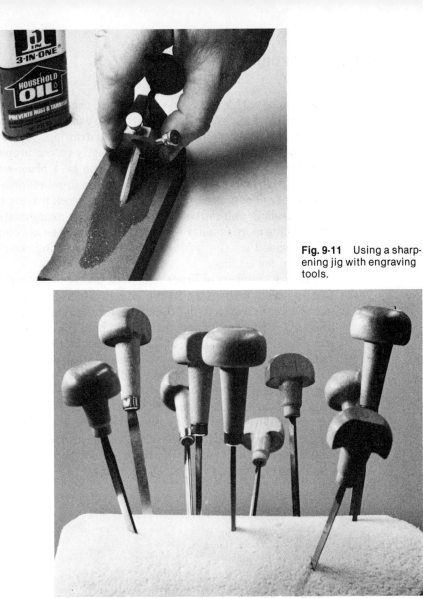

Fig. 9-11 Using a sharpening jig with engraving tools.

Fig. 9-12 Wood engraving tools stuck into a block of styrofoam while being used to cut.

attached to a swinging rod and can be shifted away at any time. This is not essential as long as you have good eyesight, but a small engraver's glass (as was used for Metal Engraving, Chapter 3) is helpful to check very intricate textural work. Of course, in this respect good lighting is essential.

If the working table you have is not sufficiently high enough so that you do not have to lean constantly over the block to see what you are doing, raise the block with a pile of large books, or build a wooden stand. The sandbag easily can be used on top of the pile of books or stand.

155

Once you have chosen the block, measure the size and prepare some preliminary black and white drawings to scale using India ink, pen, brush, and felt tip pen. When you have decided on a drawing, you can transfer it as described under linocuts, or copy it directly onto a prepared block. The drawing, as described under woodcut, can be a black-working drawing (will engrave away wood leaving the image in relief) or a white-working drawing (will engrave the image out of the block leaving the background wood in relief), or it can be, with some practice, a combination of both. You will become more familiar with the two approaches as you work. Once you have decided on the basic approach and drawing, the block must be prepared for cutting.

Prepare a mixture of 75 per cent white poster paint to 25 per cent water. Take a look at the surface of your endgrain block; if it has any raised wood particles or debris on it, lightly sand with some fine sandpaper and brush it clean. If it has any minor dents in it, hold the block over some steam, allowing it to expand back to its normal surface (this can be done at any time during the cutting also). Now place a small puddle of the poster paint mixture in the center of the block, and spread it across the wood with a soft brush or wipe it with a soft rag until the paint is evenly spread onto the wood and the surface begins to get shiny. You may repeat this step until you get an even white shiny coating on the surface (Figure 9-13). If the paint seems to grab and dry too soon, you do not have enough water in it, or you are spreading it too slowly. Brush off any particles with a dry rag, and the block is ready to receive the drawing.

Fig. 9-13 Creating a white surface on an endgrain block.

If you are not going to transfer the drawing through the conte or carbon paper method, but work directly from a prepared drawing onto the block (which is the recommended method to retain freshness and spontaneity in the drawing), place the drawing in front of you, and first work up the outline in a fine, felt tip, black pen. Do not try to simulate the engraved tonal and pattern areas; the attempt can only lead to boredom and, ultimately, a static image. Next, take India ink and brush and complete the initial drawing by filling in the outline where necessary (Figure 9-14). The drawing is now ready to receive the engraving.

Fig. 9-14 Creating a drawing on surface of a whitened endgrain block utilizing preliminary drawings as a guide.

ENGRAVING THE BLOCK

The beginner will find it difficult to decide on line quality at this point, since as previously mentioned, each tool chosen has its own unique cutting quality and must be explored by the individual engraver to determine how it can be used in relation to the selected imagery. Generally, following the tool descriptions above will allow for beginning choices that later can be

modified as the need occurs. The main instruction here is the holding of the tool and how it is used. As shown in Figure 9-15, the tool should be grasped so that the flat of the handle is facing down (toward the block), and the round part of the handle is firmly held in the cup of the heel with all four long fingers tightened on one side of the rod and the thumb finger pushing against the other side of the rod with the tip of the rod exposed from the thumb by about 1/2″. Now place the block in front of you, and pick out the first line to be cut (it is best to work from top to bottom on the block, so try to pick out a line that is at the top of the block). The lines are cut across horizontally, never vertically, from left to right (left handed) or right to left (right handed). Now place the tool so that it is nearly parallel to the surface of the block with the tip at the beginning of the line. Place the index finger of your other hand against the tip of the thumb of the hand holding the tool, and relax both hands. Now push the tool forward with firm but light pressure from the heel of your hand so that the thumb holding the tool pushes against the index finger of the other hand, and gently pushes it away, allowing the tip of the tool to sink slightly into the wood and push a line through it no more than 1/8″ long (Figure 9-15). Never try to make one continuous line, but add to your line a little at a time until it is complete. This will seem tedious and cumbersome at first, but it is the only way to achieve maximum control over tool and wood.

Do not try to make thick lines by digging deeply into the wood; this will not work. Change tools; pick out one that has a wider point. Fine lines require the thinnest of tools, such as the engraver's knife. Continue to engrave your lines and outlines as is appropriate, working in exactly the same way, from top to bottom 1/8″ horizontal cut at a time. When you want to add a line above another line, turn the block upside down. If you want to

Fig. 9-16 Using the wood engraving chisel for removal of large areas after outlining.

Fig. 9-17 Using the angle tint tool and sandbag to create curves and circles.

make a diagonal line, turn the block diagonally. But always cut horizontally, working from top to bottom. Areas should be removed with the scorpers or chisels (Figure 9-16) cutting horizontally as before.

Curves at first will give you some problems, but stick with it. Place the block on the sandbag (or alternate turning device), place the tool into the beginning of the curve, and turn the block slightly with the free hand while holding the slipsticker or angle tool firm, allowing the point gently to sink into the wood and follow the turning of the block 1/8″ at a time. At first, you will constantly want to push the tool, rather than let the wood be pushed into the tool, but you must keep that tool perfectly still while the block rotates or you will never get good curves (Figure 9-17).

159

Fig. 9-18 Using the power engraver on the endgrain block to create a unique texture.

Fig. 9-19 Detail of partially cut wood engraving block.

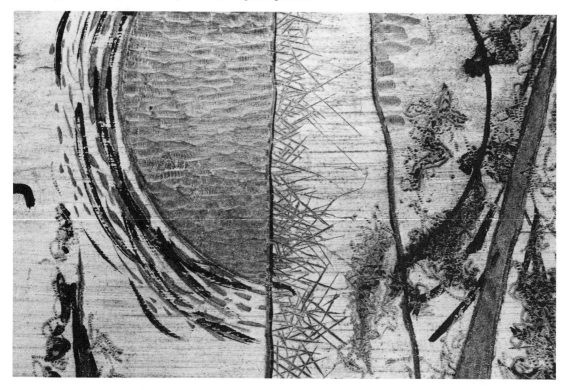

For areas of tone and texture, use such tools as the elliptic tint tool or round scorper, holding them at approximately 45° to the block surface, and push the tool down and out. Each textured area will have to be explored with each different tool. Tones also can be made by placing lines closer and farther apart, or by cross-hatching. Also explore the electric vibrating engraver (Figure 9-18), being careful not to overuse it or let it get out of control (practice with it on another surface, such as steel or even a piece of hard plank grain wood like oak). Figure 9-19 shows a wood engraving block partially cut in detail.

PROOFING, DEVELOPING THE DRAWING, CORRECTING

When you have completely outlined your drawing, and have worked it up to the point that you no longer need to see the black ink drawing on the white surface, you should pull a proof, using very stiff black ink and machine-made smooth paper and following the printing directions in Chapter 10. Before pulling the proof, wipe off the poster paint and India ink with a dampened cloth or sponge, and lightly talc the block surface. Brush off excess talc, and hand rub the block for a few minutes to make it receptive to the oil-based stiff ink.

After pulling a proof, many engravers prefer to keep the ink on the block to see how additional cutting changes the engraving. To do this, pat the remaining ink (after pulling the proof) with some old newspaper, sprinkle the block with a little whiting or talcum powder, and rub it into the ink with the palm of your hand, creating a thin semiblack shiny surface on the relief sections of the block. Now continue to cut and proof as necessary, wiping the remaining ink with powder each time. (Clean the block of old ink and powder with kerosene before each reinking.)

An endgrain block, as you will immediately notice after pulling your first proof, does not show any grain or intrinsic texture. Accordingly, you do not have to worry about filling the wood with ink. However, you should not let oily (long) ink fill any lines or textures; use a stiff toothbrush and a little solvent (kerosene) to remove this ink.

When you have completed the engraving, wipe the block with a thin coat of kerosene and soft rag, let it dry, and it is ready for edition printing. A wood engraving prints best in some form of press as described in Chapter 10, and in the case of a block print (or an adaptation of a press built to produce vertical pressure), you can utilize maximum pressure without worry about damaging the block. As pointed out, an endgrain block will withstand heavy pressure and a lot of printing. Wood engravings can be hand printed, but with considerable patience and energy.

Correcting mistakes on a wood engraving is extremely difficult. Try to incorporate any minor mistakes into the image when they occur. However, if the correction is unavoidable and considered worth the time and trouble, it is possible. If it is simply a line or texture that you want out, and do not intend to recut in that area, plastic wood will work. Clean the area out

well, removing all excess grease with a little benzine or gasoline, and rub it with some talc, brushing away any excess powder. Overfill the line or texture with plastic wood (such as Weldwood brand), let it dry thoroughly, and sand it down very smooth with some fine sandpaper.

Larger areas, or areas that you do intend to recut, must be plugged. Boxwood plugs can be purchased from a few suppliers (Appendix A), or they can be made from scrap pieces of boxwood or maple with a lot of care and patience. The area to be plugged is drilled out, or opened with a power router so that it is a little smaller than the plug top (a plug is usually tapered, thin at the bottom and thick at the top). The plug is forced into the opening with a mallet. It is then cut off at the surface with a hacksaw blade removed from the saw itself, and filled and sanded to the block surface.

Some wood engravers prefer softer lines; this can be accomplished either by lightly sanding the line edge or pushing it down tight with a burnisher used in metal work (see Chapter 1). The burnisher also can be used to emboss the paper lightly or aid in picking up small areas of an inked block that are not being reached by the press or hand rubbing tool.

10

One Color Relief Printing

PRESS AND NONPRESS OPTIONS

This chapter deals specifically with relief printing as it pertains to the woodcut, linocut, and wood engraving. However, it should be noted that any plate that can be printed utilizing the intaglio method, such as line etching or collagraph, can be relief printed as well. This, of course, means that a plate printed in intaglio can be printed in relief simultaneously or through a process of registration; this fact was pointed out in Chapter 6 and should be remembered for further multicolor development after achieving sufficient expertise with the various processes using one color printing.

There are a variety of presses available for relief printing. However, many are adaptations from old, anachronistic commercial printing presses and, because they are not manufactured anymore, are not available to the general public. Some school printing shops do have these presses on hand, such as the older Vandercook (used by typographers to proof the setting of type; still being manufactured in more sophisticated models) or the Washington-type letterpress (Figures 10-1 and 10-2), and instructions for the operation of these presses should be checked out from older pertinent

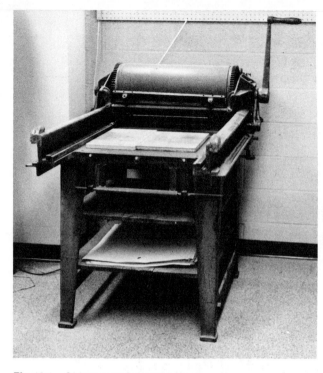

Fig. 10-1 Old model Vandercook press.

Fig. 10-2 Washington-type letter-press manufactured by F. Wesel Mfg. Co. (not being made anymore).

literature or from the instructor in charge. The presses to be dealt with here are the most available and are relatively easy to operate, that is, the double cylinder etching press with spring-set pressure, the block print press adapted from the bookbinding press, and the hand proofing press, similar to the Vandercook but smaller and simpler.

The etching press described in Chapter 5 equipped with pressure setting springs (also see Figure 1-3, Chapter 1) so that the upper cylinder can be raised higher than the block to be printed, is the type necessary for printing type-high blocks. This press is also the best for printing unmounted linoleum. It may have micrometer dials to determine correct and even pressure settings, but these dials are not essential. When not available, simply raise the cylinder above the bed surface by turning the pressure screws counterclockwise until the cylinder is evenly 1 1/4" to 1 1/2" high. With the micrometer dials, start with the pressure set at approximately "0 over 12" so that the upper cylinder is at least 1 1/4" high (Figure 10-3). A wringer-type press, also described in Chapter 5, can be used as long as the cylinder will part by about 1 1/2". Under no circumstances should you attempt to use a double cylinder etching press that is not equipped with pressure setting springs, such as the American French Tool Company press (Chapter 5) for type-high blocks.

164

Fig. 10-3 Type-high wood block placed under cylinder of Charles Brand etching press.

The block print press was designed after or adapted from the bookbinding press of the past. If an old bookbinding press is available it also can be used in the same way as the commercially available wooden block printing press, such as the one manufactured by Weber (see Figure 10-4 for both). As can be seen, these presses are simple, made up of a turn-screw, which is attached to a moveable platen that lowers onto the block, which is resting on the base.

The proofing press comes in a variety of styles, ranging in size, sophistication, complexity, and expense. A small, uncomplicated proofing press will cost about $250. Typically used by the small printshop or audio visual department of a high school or college for instruction in typesetting or for sign making, this press is excellent for type-high block printing. The press shown (Figure 10-5) consists of a base equipped for locking letters into place, a paper holding device, and a pressure roller that can be raised and lowered quite easily.

Fig. 10-4 Weber block printing press (left) and old bookbinding press (right).

Fig. 10-5 A Showcard Machine Co. proofing press.

You would choose to use a press, when available, if you intend to pull large editions or want strong flat areas of color. A press has the tendency to eliminate much of the subtle grain of a woodcut unless it can be set for consistently light pressure, as in the case of the etching press with spring-set pressure. Because linoleum allows for little intrinsic texture and typically prints flat, any press is ideal. This is especially true in the case of unmounted linoleum where you can use water-soaked heavy paper and print it as you would an intaglio plate. This will cause unique "white" embossed areas on the paper where the linoleum has been cut out and is not receiving the relief ink. Although the press eliminates much of the tedium associated with hand printing, the nonpress methods produce prints that are unique and, therefore, should be explored and utilized when the image and material dictates.

There are many nonpress options; those described here will surely lead to your own individual methods. The first method utilizes the back of a large spoon, such as a metal soup spoon, a wooden mixing or salad spoon, or, ideally, a Japanese rice spoon (Figure 10-6). Another method uses the baren, which in traditional Japanese style is made up of a piece of heavy circular paper on top, a coil of thin bamboo cord next, and a piece of bamboo sheath covering it and holding the baren together (Figure 10-7). Also available is the U.S. version of the baren available from Speedball, as shown in Figure 10-8). Another method utilizes two large doorknobs that have been glued together (Figure 10-9) and sanded smooth. Prints also can be pulled in relief by utilizing a brayer, heavy finger and hand pressure, or placing the block upside down on the paper, which is on the floor, and walking or stomping on the block with your feet; no hand printing methods will give perfect, consistent pressure, but, as you will see, this can be used to your advantage.

166

Fig. 10-6 Three types of hand printing spoons: wooden mixing spoon, Japanese rice spoon, and metal salad spoon.

Fig. 10-7 A Japanese baren (front and back views).

Fig. 10-8 A Speedball baren.

Fig. 10-9 Two doorknobs glued together for hand relief printing.

THE PAPER AND ITS PREPARATION

Theoretically, any paper can be used for relief printing; it does not require soaking nor excessive pressure. However, all papers are not necessarily aesthetically pleasing; there are times when you may wish to soak for certain effects, and the life-deterioration aspects of certain papers must be considered.

167 For woodcuts and type-high linoleum cuts, handmade Japanese papers

are the best. Recommended are Hosho, Okawara, Torinoko, and Mulberry; the first three are semiopaque, strong, very absorbent, and can be used with press or hand printing; the last, Mulberry, is thin and transparent, and although not very strong (it cannot be used for press printing), it produces very nice woodcut prints. Japanese papers are sometimes quite difficult to tear following the procedures described in Chapter 5: but, if possible, you should tear the paper rather than cut it. Paper that will not take tearing will have to be cut on a very sharp paper cutter or with a mat knife (scissor cutting usually produces very uneven sheets). These papers do not have to be moistened before using unless you prefer, after experimenting, a more flexible paper or are using water-based inks that do require some dampness. To moisten, wipe each precut or pretorn sheet with a lightly dampened sponge and pile one sheet on top of another; make sure you are working with clean water, a clean sponge, and a clean surface. Place the sheets between two dampened white untextured blotters (Cosmos blotting paper is best), put the pile inside a plastic garbage bag, and seal it, allowing a little air to escape, placing the pile flatly on a table with a large heavy board over it, and letting it sit this way for 2 to 3 hours before using. When using damp paper, you should place a sheet of dry newsprint between the paper and the rubbing tool or press, to keep it from lifting or tearing.

You can also use Rives Lightweight, Arches Text, or Strathmore Bond for woodcuts and linocuts when a stronger more opaque paper is desired. This paper should definitely be torn, not cut, and used dry for best results.

A wood engraved block requires a paper that is very smooth, with a fine, almost nonexistent texture. As such, machine-made papers usually prove most satisfactory for the wood engraving; Basingwerk Lightweight, Strathmore Bond, and Kromekote paper are excellent. The only handmade papers useful here are Troya and Goyu Japanese papers and Rives Lightweight. It is not necessary to moisten paper for wood engraved blocks, for they are always printed with oil-based inks. These papers can be cut.

Proofs should be pulled on smooth newsprint. Newsprint should be kept on hand not only for proofing but for protecting the back of your printing papers or the blankets of a press where applicable.

When working with unmounted linoleum, any paper applicable to intaglio printing (see Chapter 5) can be used, in exactly the same way, when a distinct embossment is desired.

THE INK AND ITS PREPARATION

OIL-BASED INKS

These inks print dense and strong, drying to a satin sheen that adds a nice touch to the finished print. They are typically made from a base of linseed oil and ground pigment, coming in a large variety of colors in

one-pound cans, or tubes (recommended for longer life use) ranging from three ounces to one pound each. It is also possible to use varnish base letterpress, offset, or hand lithographic inks. And many relief printmakers use a good quality oil paint that is known for its abundance of pigment to base. The Perfection block printing oil-based inks manufactured by Graphic Chemical have proven to be excellent; the same manufacturer's Perfection Palette inks are outstanding.

Block printing inks tend to be relatively very stiff (short); accordingly, most other inks or oil paints used for printing in relief must be made correspondingly short. To test for shortness of ink, place a small ball of ink that is approximately 1/2" in diameter by 1/2" high on a glass slab. Take your ink knife (spatula) and push down on the ink about midway, then quickly raise the knife, using your wrist, to see where the ink breaks. It should break at about 2 1/2" to 3" above the ball of ink. It should be noted at this point, however, that relief blocks with a lot of details, fine lines, and fine textures (especially in the case of wood engravings) require this stiff ink, while blocks with large areas and more open cutting will take a looser (longer) ink, which would break at 4" to 6" above the ball. The ink must never be so long that it oozes into your lines and cut areas. The above test is not foolproof and will require a little practice to get used to. (See Chapter 11, The Roll-up, for illustrations on ink preparation.)

If your ink gets too long, add small amounts of powdered magnesium until it reaches the desired viscosity. If your ink gets too short, or starts out too short, add a drop or two or raw linseed oil (or burnt plate oil) or light (#00) varnish, depending on the respective base of your product until it reaches the desired viscosity.

All inks and oil paints come in a wide range of colors. This chapter deals with one color relief printing only, but the color is your choice, and if your block has areas that are completely separated from each other, such as a sun totally divorced from surrounding mountains, two colors can be applied easily with two rollers keeping the colors away from each other. The following chapter will deal briefly with further expansions of color possibilities.

WATER-BASED INKS

As the name implies, these inks are composed of pigment and extender or body in a water miscible base. They also come in the same variety of sizes with some limitations as to colors. The Perfection block printing, water-based inks are of the highest quality, in body, and pigment intensity, and permanence. Although they are somewhat easier to clean up than oil-base inks, they dry out faster on the roller and slab, do not print with the same strength or density, and result in a more transparent look—and so, are used when such effects are desired.

Water-based inks, printed on dampened paper, produce a unique softness and sensuous appearance in contrast to oil-based inks. When the paper is very damp, the edges will bleed slightly, giving the print a definite

watercolor look. And because they dry faster, numerous colors can be overprinted quickly; the overprinting is further extended by the intrinsic transparent quality of the waterbased inks. The Japanese Ukiyo-e prints mentioned in the Introduction to Chapter 7 were printed with water-based inks.

It is possible, under certain conditions, to use a very good quality transparent watercolor paint, gouache, or tempera, but they tend to be too long for roller work and must be painted on quickly with brush, a precarious process for the beginner.

Finally, water-based block printing inks should be used as they are, directly from the tube or can, for roller purposes. If they ever dry out slightly, add a few drops of water to make the ink longer, but be careful not to make it run. Do not try to use the same test of viscosity for water-based inks as you did for oil-based inks.

Cap all ink tubes tightly after use. Cover cans with a circular piece of wax paper, and in the case of oil-based inks add about an inch of water to the top of the ink to decrease the drying-out process. Any dried-out pigment should be completely removed before rolling out the ink.

PROOFING AND PRINTING THE PLATE

SUPPLIES AND EQUIPMENT

Based on the preceding information, you will have to choose the supplies and equipment for your printing needs. Generally you will want to add the following to your cutting supplies, equipment, and workshop area:

Tube or can of ink (as appropriate)
Raw linseed oil, burnt plate oil, or #00 varnish (as appropriate)
Ink knife (putty knife)
Inking slab (piece of glass, marble, masonite, or such)
Brayer(s) (see below)
Rubbing tools (as appropriate)
Press (as appropriate)
Solvent (paint thinner and kerosene for oil-based inks; water for water-based inks)
Rubber gloves (to be used with all solvents)
Precut or pretorn paper (as appropriate)
Blotters (if dampening paper) and plastic garbage bags with ties
Newsprint (smooth)
Old newspapers, rags, paper towels, and toothbrush (for cleanup)
1-ply and 2-ply cardboard (for certain presses, see below)
Registration frame (optional, see below)
Masking tape or push pins (as appropriate, see below)

You should have on hand at least two different types of brayers; a hard brayer to be used with short ink on fine cut blocks and a semisoft brayer to be used on open cut blocks with large inking areas, which will be used with longer ink. Although brayers are made in a variety of different materials from gelatin to leather, rubber is most universal. Do not buy cheaply made brayers; you will find that they have warps or flat areas and are, therefore, useless. Check them carefully before purchase and be sure that you can return them if they are not correct. Brayers come in a variety of sizes and if you eventually get deeper into relief printing you will want a variety, but the two with which you begin should be at least 4″ to 6″ long and 1 1/4″ in diameter. When using the brayer, never leave it rest on the rubber; most brayers are equipped with stands to keep the rubber off the slab so that a flat side is not created. If not equipped with a stand, make a hooking arrangement on the handle so that it can swing freely from the side of the table. Keep your brayers clean with kerosene (or water as appropriate), and never let ink build up and dry out on the rubber surface.

When you are ready to print, first insure that the printing area is clear of any debris and lay out your printing materials for easy access. Wipe off the inking slab with a little paint thinner and a damp sponge. Clean your block with a stiff toothbrush, removing any loose particles that could mix with the ink or tear the paper. After choosing your method of printing, press or nonpress, place your readied paper near the printing area along with two 2″ square cardboard tabs for handling the paper with dirty hands. Also place enough precut newsprint near the paper for proofing or protecting the backs of the good paper. You may wish to tape or pin your paper in place; accordingly, have readily available masking tape or push pins.

PRINTING BY HAND

Although the paper can be placed directly on the block with little difficulty, it is somewhat cumbersome to get uniform and neat margins without a registration frame (Figure 10-10). This frame is essential when and if you move into multicolored, multiblock printing. This optional piece of equipment can easily be made. Take a large sheet of 1/8″ plywood or masonite, at least 18″ by 24″. Cut two pieces of 1″ by 2″ unwarped pine the length and width of the large sheet; glue or nail these pieces squarely along the top and right side of the large sheet. Now cut two pieces of 1 1/2″ lattice stripping (1/4″ wide pine stripping) the same size as the two 1″ by 2″ pine pieces, and glue or nail them to the outer edges of the pine so that they protrude 1/8″ above the pine surface, which will be your paper placement guide. Now cut two more pieces of 1″ by 2″ unwarped pine at least 12″ long; glue or nail these so that they are up against the square of the first two pieces of 1″ by 2″ pine (this will allow for a minimum of 4″ margins; 2″ margins will not require these extra pieces; if larger than 4″ margins are desired, place these pieces farther in from the square, making sure that they are parallel to that square; do not print with smaller than 2″ margins).

Fig. 10-10 Registration frame for hand printing type-high blocks.

For unmounted linoleum cuts that you wish to hand print with consistent neat margins, you should devise a tab system similar to the tabs used to hold the unmounted linoleum for cutting.

You should now be ready for rolling out the ink. With your ink mixture of

Fig. 10-11 Rolling out ink with a semisoft brayer.

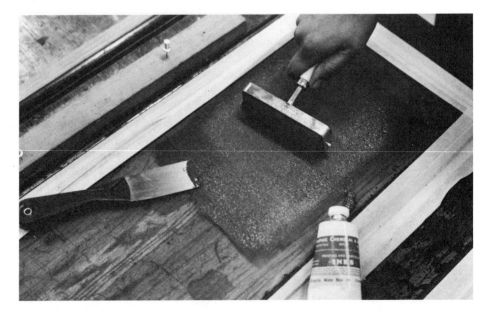

the correct viscosity, and holding the appropriate brayer so that it is about 30° to the ink slab surface, roll out a thin layer of ink the length of the brayer and begin to spread in vertical and horizontal directions, changing the roller position each time to allow for an even distribution of a thin layer of ink on the slab and roller (Figure 10-11). Repeat this step with another thin layer of ink; usually two applications are enough to start with. You can add more ink to roller and slab (recharging) in the same manner as the initial roll-up, as you need it. Do not allow for an excessive buildup of ink on roller or slab; this can only cause difficulties.

With your block next to you, roll out the ink using vertical and horizontal strokes, just as you used it to roll out the ink on the slab (Figure 10-12).

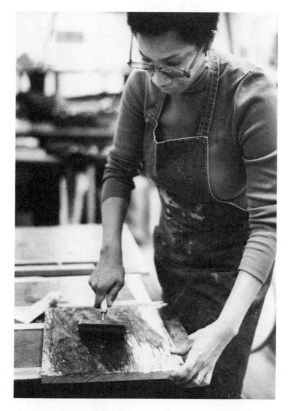

Fig. 10-12 Rolling up wood block with even layer of ink.

Recharge the brayer and slab as needed. Continue, repeating the steps until your entire block is evenly coated with a thin layer of ink (Figure 10-13). Do not overink; careful, controlled inking is extremely important for quality prints. Practice will tell you the correct inking applications for your particular block, so be prepared to pull several proofs on newsprint until you have reach optimum results.

If you are using a registration frame, place your paper (using the cardboard tabs) squarely against the paper guides and either tape or pin it in place (Figure 10-14). Flip the paper over the top of the frame, slip the inked

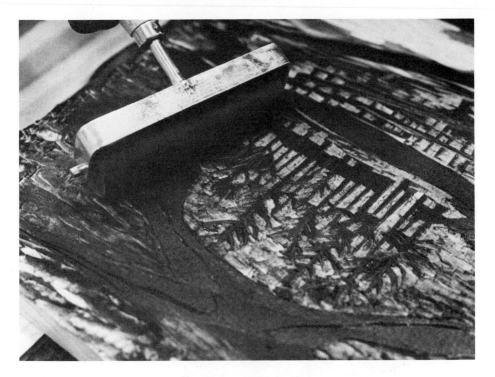

Fig. 10-13 Detail showing application of consistent layer of ink.

Fig. 10-14 Pinning rice paper to registration frame for hand printing.

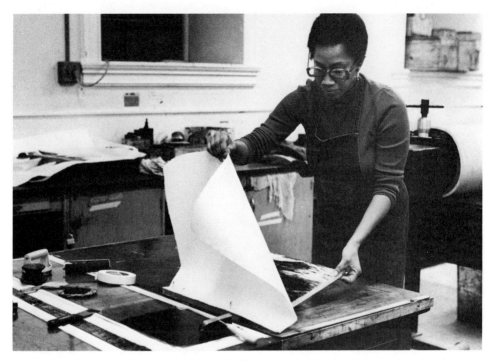

Fig. 10-15 Placing inked block in right angle of frame; paper is
then carefully dropped unto block.

block into the corner of the square (Figure 10-15), and flip the paper back
onto the block.

If you are not using a registration frame, drop the paper evenly over the
block by holding the alternate corners of the paper with the cardboard tabs
and letting it sag in the middle; you can then tape it to the table. With one of
the rubbing tools, use light, very sensitive and circular, short strokes over
the entire block relief areas adhering the paper to the inked block. Now
continue to rub using a little more pressure; be sure you are rubbing the
entire surface consistently. (Figures 10-16 and 10-17 show this procedure
with two rubbing tools.) Repeat the procedure a third time, and, after
completing, lift the bottom of the sheet carefully but not totally from the
block to see how it is printing and whether or not you need more pressure
in the rubbing, more rubbing itself, or whether or not you applied too little
or too much ink (Figure 10-18). If you applied too much ink, take the proof
off and clean the block with some paint thinner, and try again. If you inked
too little, you can either try reinking after the paper is flipped back or start
anew.

Continue pulling proofs until you have found the appropriate rubbing
tool, correct ink application, and most sensitive pressure. At this time, you
may also explore creating tonal changes by not rubbing as much in certain
areas for light tones, or rubbing with extra pressure for dark areas.

175 Remember, when you decide how these tonal changes will be for the final

Fig. 10-16 Hand printing with rice spoon; variable pressure will create changing ink values.

Fig. 10-17 Hand printing with double doorknobs; this item will give very dense and sharp hand prints.

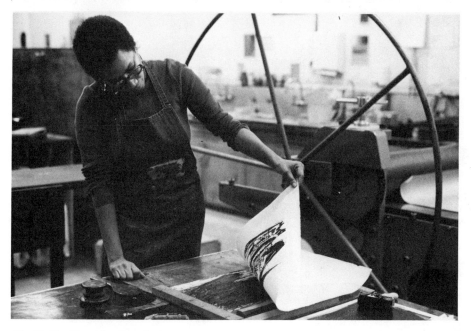

Fig. 10-18 Checking the printing progress.

edition, keep the selected proof in front of you when rubbing so that you can pull a consistent edition.

You may wish to hand emboss certain areas; this easily can be accomplished by pressing the paper down into those areas with your fingers or with a burnisher (see Chapter 1 for a description of this tool). Do not try to get deep embossments with this procedure, or you will tear the paper (Figure 10-19).

Fig. 10-19 Using a burnisher to hand emboss the paper.

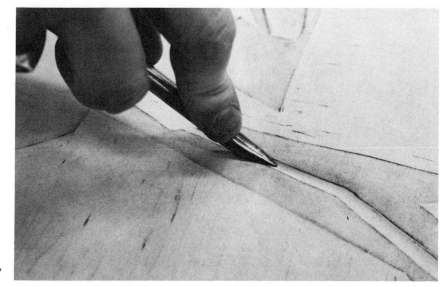

Fig. 10-20 The completed hand printed woodcut proof in black by Virginia Evans Smit.

Pull your edition in exactly the same way as you did your proofs (Figure 10-20). If your good paper is very frail, or you wish to keep the back perfectly clean, place a piece of smooth newsprint over the paper before you begin rubbing, and increase the hand pressure slightly, or make a few more entire rubbings.

As you pull the prints, place them between pieces of newsprint for drying. If the print has large inked areas, it may be necessary to pin or tape them by a corner to a wall or other appropriate drying surface. Oil-based prints will dry overnight; water-based prints will dry thoroughly in about 30 to 60 minutes, depending on ink application and dampness of paper. You do not have to clean the block between each printing as long as you do not allow for excessive ink buildup or begin to lose the grain of a woodcut because of ink filling the wood.

If your prints are wrinkled after drying, they can be straightened by placing them between sheets of newsprint, creating a stack that is placed between two dampened blotters, put on a flat surface with a heavy board on top, and left for approximately 24 hours.

Again, insure that you are using a double cylinder press that is equipped with pressure-setting screws, such as the Charles Brand press described in Chapter 5, which allows the upper cylinder to be raised by at least 1 1/2". Usually, these presses will have three blankets on them; you will only need the top, thickest one, called the cushion blanket. Flip this blanket aside (over the upper cylinder) and place your uninked block in the center of the press bed. Place a piece of newsprint over the block and the blanket over the newsprint. Push the bed forward with one hand until the block reaches the upper cylinder and begin to grind the bed forward with the other hand. If the press resists in any way, *stop*, and release more pressure by turning the pressure screws or micrometer dials counterclockwise until the block rides easily through with light pressure. If the block does not because the cylinder is too high, meaning there is no pressure on the block at all, turn the screws or dials clockwise a little at a time until you can grind the block through and feel light pressure. When you can feel this pressure, mark the setting down (if equipped with micrometer dials) or take note as to how high the upper cylinder has been raised from the bed. Under *no* circumstances should you try forcing a type-high block through the press.

Now place the press bed all the way to one side of the cylinder, flip the blankets aside, remove the newsprint and discard, take the block off the bed and bring it to your inking station. Roll out the ink and ink the block in exactly the same way as described earlier under Printing by Hand. Place the inked block in the center of the press bed, place a sheet of good paper over the block by using the cardboard tabs on alternate corners, dropping it on the block so that you have even margins (Figure 10-21). Place a piece of newsprint over this good paper, and then carefully place the blanket over the newsprint without shifting either sheet of paper. Move the press bed so that the block is next to the upper cylinder, and begin to grind the block forward with consistent turns until the block is completely through (Figure 10-22). Pull the bed completely to the other side, lift the blankets carefully from the block and flip them aside. Carefully remove the newsprint and discard. Lift one corner of the good paper holding another corner down lightly with a finger of your other hand and check to see if you got a dark enough print. If not, there probably is not enough pressure; this being the case, drop the corner back onto the block, place the newsprint and blanket over the block, turn the pressure down (clockwise) slightly (one-quarter turn), and run the block through the press again. Recheck, and continue to do this until you get a full inking (Figure 10-23). Modify your pressure notes accordingly. Now continue to pull your edition, stacking the prints in exactly the same way as in Printing by Hand. You do not have to clean the block between each printing. However, woodcuts tend to lose their grain when filled with ink; accordingly, you may wish to clean the woodcut block with kerosene every third or fourth printing.

If your block happens to have a warp in it, as sometimes happens after extensive cutting and proofing, place the block so that the warp is parallel

Fig. 10-21 Printing the woodcut on the Brand press; inked block in place, damp paper is placed over the block utilizing cardboard tabs. Paper is then covered with a piece of newsprint and the cushion blanket.

Fig. 10-22 Press bed is brought forward so that block is against upper cylinder; it is then pulled completely through.

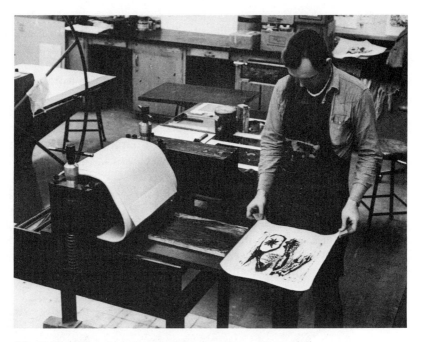

Fig. 10-23 Blankets and newsprint removed, proof is carefully pulled from block and checked for accurate printing.

Fig. 10-24 To register paper on a Brand press for even margins or multiblock printing, a cardboard tab registration system is created on the press bed.

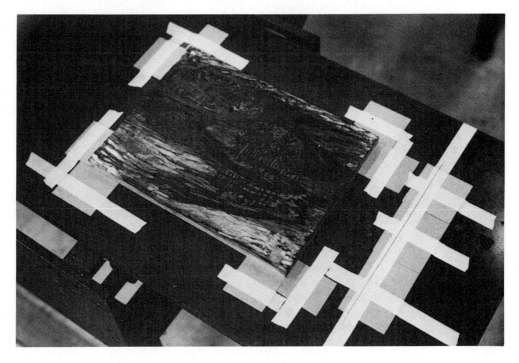

to the cylinder (in the case of woodcuts the grain will be parallel to the cylinder). This will allow for the block to easily ride under the cylinder. Do not attempt to straighten the block out by using the press, or you will split it and/or damage the press.

If you wish to keep your margins even when working on the press, place your uninked block onto the press, and at all four corners, tape two pieces of 2-ply 1″ square cardboard to form the square of the corner. Now tape a 2″ by 12″ piece of 2-ply cardboard approximately 1″ from the block (this will give you approximately 2 1/4″ margins); draw a felt-tip pen line across the 12″ strip, 1/4″ from the edge closest to the block (this line will be your paper placement guide) (Figure 10-24). Now when you start, remove the block, tape your paper down to the 12″ strip of 2-ply cardboard with two small pieces of masking tape and flip the paper over the blanket (which is resting on the upper cylinder). Ink your block, place it within the corner tabs, and flip the paper down onto the block (Figure 10-25), and run it through the press. Remove the tape, and continue with this procedure throughout the edition.

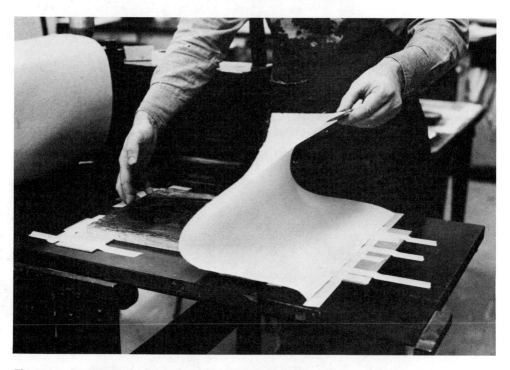

Fig. 10-25 Block is removed from tabs; paper is taped to guide; block is inked and placed within tabs and the print is pulled.

To print an unmounted piece of linoleum so that it reveals maximum embossment from the cut-out areas, you must use a heavier paper, such as Arches Cover or Rives BFK, which is used in intaglio work. Refer to Chapter 5 and begin by determining the approximate pressure to be used:

place the uninked linoleum on the press bed, put a sheet of newsprint over it, and center all three blankets on top of the newsprint, with the thinnest blanket on bottom and thickest on top. Raise the upper cylinder about 5/8″ (or about "0 over 4" on the micrometer dials), and run it through the press. Check the newsprint to see if it began to tear along the cut-out areas; if not, repeat turning the presssure down until the newsprint does tear evenly. Make note of your pressure setting. Pretear your paper allowing for extra large margins that can be torn down after the print has dried, and soak it in a water tray for at least 30 minutes.

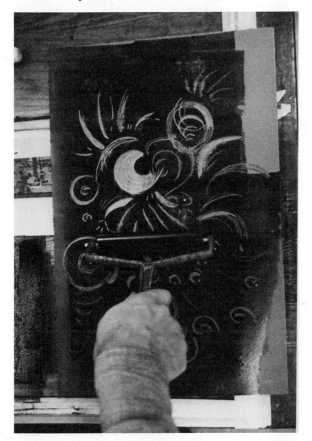

Fig. 10-26 Unmounted linoleum inked for printing on a Brand press.

While waiting, ink the slab, roller, and your linoleum (Figure 10-26), and place it in the center of the press bed. Remove the paper from the water with the tabs, blot it well between two clean white blotters, and by holding it on alternate corners and letting the center sag, place it over the unmounted, inked linoleum. Place the blankets over the paper and run it through the press. Lift the paper carefully from the linoleum (Figure 10-27), and pin it to a bulletin-type wall, placing push pins 1/4″ in from the edge and 2″ apart all the way around the print. Pull your edition in the same way, and let these prints dry thoroughly (24-36 hours) before removing from the wall and tearing down to square off the image. You do not have to clean the linoleum between each inking.

183

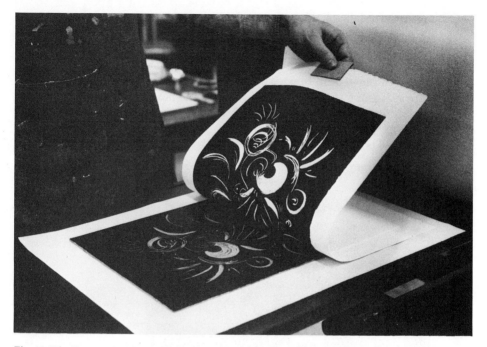

Fig. 10-27 Unmounted linoleum printed on damp Arches Cover Buff paper with heavy intaglio pressure.

PRINTING ON A BLOCK PRINT PRESS

To get an accurate printing using this method, begin by turning the platen screw all the way up. Now place a 1/4" layer of old newspaper on the bed of the press and over that place a sheet of 2-ply smooth cardboard. Now place a sheet of clean smooth newsprint over the cardboard. Ink your block in exactly the same way as you would for hand printing. Using the cardboard tabs, place a sheet of good paper over the *newsprint*. Now lift your block, turn it upside down, and drop it carefully down onto the good paper. Place another 1/4" layer of newspaper over the block, and turn the platen screw down very tightly (this press requires a lot of pressure, Figure 10-28). Release the pressure, turning the platen screw all the way up. Remove the top old newspaper layer, carefully lift the block (the print will usually adhere to it), turn the block over, and carefully remove the print. Replace the newsprint (it will usually be dirty), and continue to pull your edition.

Some relief printmakers utilizing this press prefer to assemble the package (newspaper, cardboard, newsprint, paper, inked block, newspaper) off the press bed and then carefully place the entire package under the open platen. This method is especially helpful when working with a very small block print press.

Unmounted linoleum must be mounted before using it on this press when **184** you want optimum results.

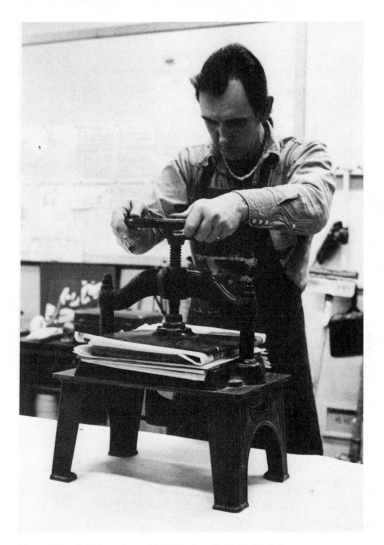

Fig. 10-28 Printing a type-high block on the block print press.

PRINTING ON A PROOFING PRESS

This press, if available, will be the easiest and quickest to use after a little practice. You must first check to see if the roller, when drawn across the block, makes contact with the relief surfaces. If it does not, raise the block by placing one-ply pieces of cardboard underneath it. Some proofing presses will have a mechanism to lower the roller for better contact, which eliminates the need for this procedure.

Ink the block in the same way described under Printing by Hand with the block on or off the press bed (Figure 10-29). Most proofing presses have a paper-holding device; slip the paper into this device, which is usually on the left side, and flip the paper away from the bed of the press. Place your block over the cardboard (center of the press bed) face up (if not already there), flip the paper onto the block (Figure 10-30), and draw the roller

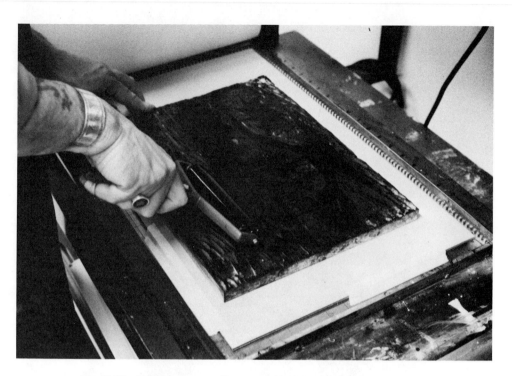

Fig. 10-29 Printing on a proofing press; block is centered and inked on press bed.

Fig. 10-30 Paper is placed into holding device and dropped onto inked block.

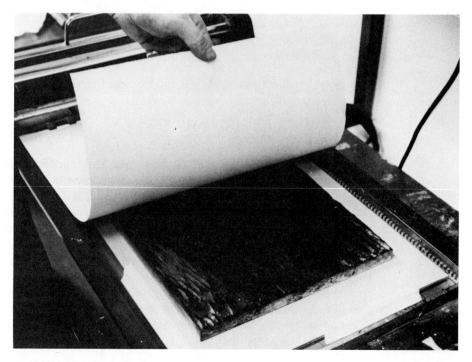

Fig. 10-31 Pressure roller is pushed down and across paper; pressure released, roller is brough back to starting position, and print is taken from block and holding device.

across the block holding the handle down for pressure (Figure 10-31). Stop at the other side (right side), lift the pressure handle, and draw the roller back to the left side with pressure released. Release the paper-holding device and check your print for accuracy. It may be necessary to decrease or increase the pressure. Now, without cleaning the block between printings, reink and pull your entire edition, stacking them as described under hand printing.

Unmounted linoleum must be either mounted or raised with cardboard to print with this press.

Most proofing presses come with "lockup furniture," which is used to hold firmly the type-high letters and numerals into place on the press bed. This lockup furniture is not necessary for the type-high block unless desired. Each proofing press has its own type of lockup furniture, and, accordingly, you must check the accompanying instructions with someone in charge to determine how this particular lockup furniture works. When the block is locked up, you can easily reink it right on the press; otherwise, this procedure may become cumbersome. The lockup furniture also allows you to incorporate lettering into your motif if the type-high letters and numerals are available.

If the pressure roller begins to get dirty, or the paper being used is quite fragile, you can insert your good paper with a clean piece of newsprint over it into the holding device. The newsprint will not detract from the printing.

The roller can be kept clean with a small amount of paint thinner on a clean rag.

STORAGE OF PRINTS AND CLEANUP

Your prints should be stored with sheets of glassine paper or tissue between them, and kept flat in a map or blueprint-type cabinet as described in Part I. Before storing them, be sure that the ink is perfectly dry and the paper is not wrinkled (check Printing by Hand for correcting wrinkled relief prints).

When you have completed your printing for the day, scrape up all ink with the ink knife. Clean remaining ink away with paint thinner. Also, clean your brayers with kerosene, placing a thin film of household oil on the cylinder rubber for protection; the brayer should be recleaned before using again.

Clean your plate with a little paint thinner and a stiff toothbrush, and wipe the excess away with a clean rag or paper toweling. Woodcut and wood engraving blocks should be wiped with a thin coat of oil or petroleum jelly if they are to be stored for a long period of time and are meant for reuse. All blocks should be wrapped in old newspaper and stored flat in a cool, dry area if to be reused.

Clean off all presses with paint thinner. Discard all flammable materials in a safe container for quick removal from the printing area.

Advanced Explorations In Relief Printmaking

COLOR

Once you have a thorough understanding of the various relief media, and have perfected the process of relief printing in one color, it is inevitable that you will want to explore multicolor possibilities. Relief printing intrinsically provides for an easy transition from one to multicolor printing.

The first consideration is the type of color ink to be used. Initially, it will be simpler to make the transition by using regular oil painting colors. These colors can be made semitransparent with raw linseed oil or an offset transparent white ink. The addition of either of these items also will make the ink long. It can be made short with the addition of magnesium carbonate, as discussed in Chapter 10.

As your multicolor explorations become more proficient, you should obtain regular colored inks for relief printing, such as Perfection Block Print ink by Graphic Chemical (oil based) or any commercially available, offset colored ink (varnish based). These inks will usually have available a transparentizing agent and extender. They can be made longer with the addition of linseed oil or varnish (as appropriate) and made shorter with the addition of magnesium carbonate.

189

The oil colors or inks are prepared exactly the same as for one color printing, rolled out on individual rollers or brayers of the appropriate size (determined by the size and complexity of the relief image), and experimented with until optimum satisfying color combinations are reached in the proofing stage. Once the color combination has been established, the consistency of color application should be made throughout the printing of the edition. If the edition cannot be printed in one session, accurate color notes should be maintained, with samples of particular colors kept for future printing.

MULTIBLOCK AND MIXED BLOCK PRINTING

To explore color possibilities properly, more than one block per print will have to be cut. There are many ways to attack the problem. The easiest deals with a reduction method, whereby a block is cut, an edition printed in one color, the prints let to dry, and the same block recut, taking out more areas and altering the original image as desired. The reduced block is then inked in another color, placed back on the press or registration frame, and the dried edition registered over the block and printed again. This process of reduction and addition of another color can go on until there is no more relief surface to remove from the block.

Another simple method is to cut the first block, ink it up in one color (preferably black, long ink) transfer the image to a piece of machine-made smooth paper through normal relief printing methods, place the newly inked and wet paper, image side down, squarely on top of another block, which should be exactly the same size as the first block, and hand transfer the image onto the new block with a baren or other appropriate rubbing tool. Talc the transferred image lightly, let it dry some, and you can begin to cut into this new block, using the original transferred image as a guide to where you should add new imagery. This process calls for a different block for each color (it is possible to use both sides of a wood block), the amount of desired colors and additions of imagery determining the number of blocks to be cut. When ready to print, it is possible to print in the same way you would a reduction block (print the entire edition in one color first, register the next block, and print the next color) or you can print every color and block consecutively on the first piece of paper. In this case, the ink layers will not have a chance to dry between printings, and, therefore, there will be some mixing of color during the printing of the edition. Figures 11-1 and 11-2 show the printing of a two-color, two-block linoleum cut on a proofing press. Figures 11-3 and 11-4 show the printing of a four-color, four-block woodcut on a registration frame by hand. (Figures 11-5 to 11-9 show the four separations and the final print.)

Still another approach to multicolor printing is the use of jigsaw-type blocks. One block may be cut into several separate pieces that are individually carved in relief. The blocks are then separately inked in different colors that properly relate, assembled on a press (or put into appropriate position one at a time on a registration frame for hand printing), and printed together in one pull.

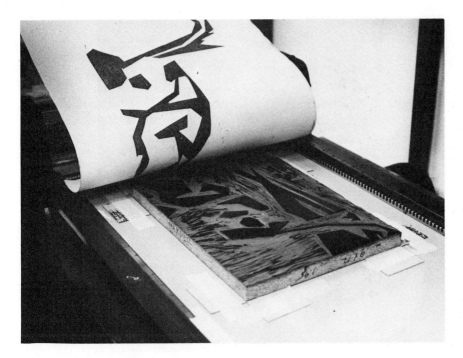

Fig. 11-1 Registration tabs placed on proofing press bed;
block placed into tabs and inked in first color; paper inserted
into holding device and printed; paper is then lifted and the first
color block is removed.

Fig. 11-2 Second block placed into tabs and inked; print
dropped unto second block and printed in second color.

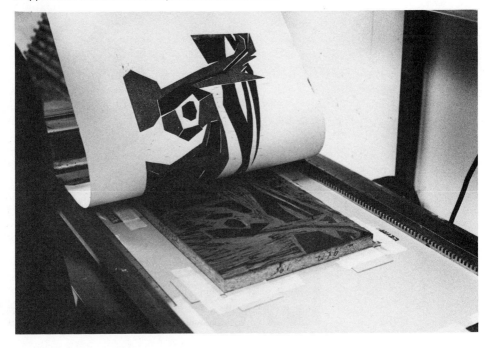

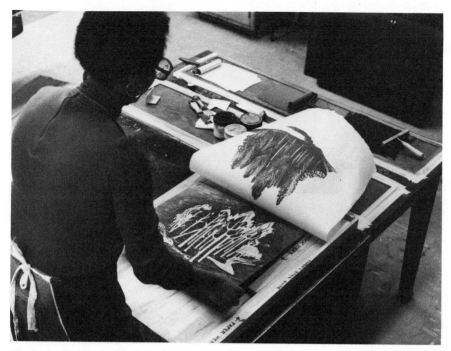

Fig. 11-3 Multicolor hand printing; print containing first three colors flipped back and fourth color block positioned into right angle of registration frame.

Fig. 11-4 Fourth and final color block printed; paper removed from frame.

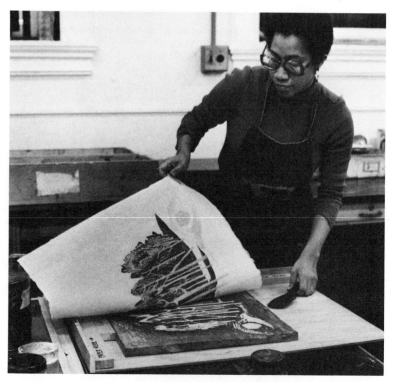

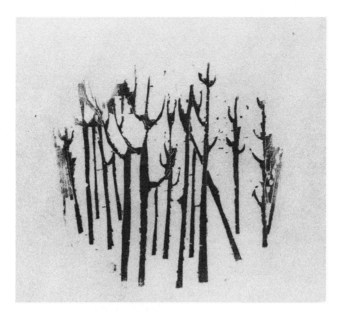

Fig. 11-5 First color/block of four color woodcut.

Fig. 11-6 Second color/block of four color woodcut.

Fig. 11-7 Third color/block of four color woodcut.

Fig. 11-8 Fourth color/block of four color woodcut.

Fig. 11-9 Final woodcut print by Virginia Evans Smit showing the four colors.

REGISTRATION

All of the above suggestions require a method of proper registration to allow for consistency and appropriate placement of imagery. The registration frame has already been explained in one color relief printing. By using the frame paper guide on uniformly torn paper, and careful placement of individual blocks into the right angle of the frame, registration in hand printing is quite simple.

When printing on a press, some form of registration template is required on the press bed. A simple method of cardboard tabs was discussed in Chapter 10 when using the double cylinder press. A similar method can be utilized on the proofing press.

In the case of jigsaw-type blocks, you can use the cardboard tab method where applicable. However, this method is sometimes not feasible, especially in the case of unmounted pieces of linoleum or irregular-shaped blocks. As shown (Figures 11-10 to 11-13), the alternative method utilizes a

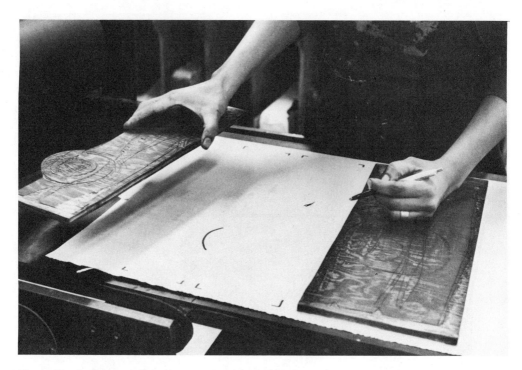

Fig. 11-10 Creating a template registration system for a jigsaw plywood woodcut to be printed in three colors.

Fig. 11-11 The traced template being covered with acetate.

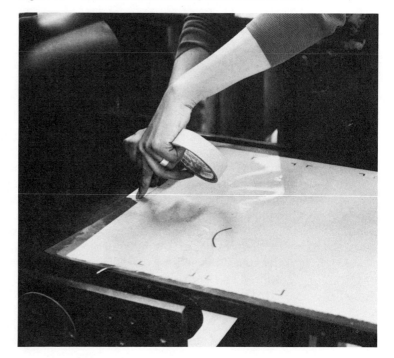

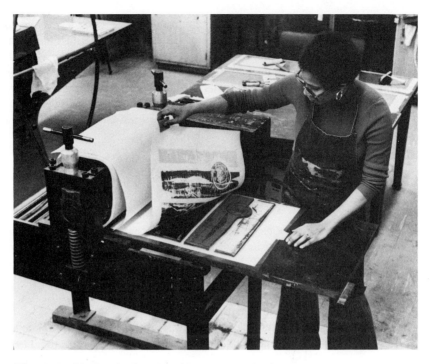

Fig. 11-12 Placing the three inked jigsaw blocks in place according to template.

Fig. 11-13 Pulling the print, utilizing the Brand press and template, from the jigsaw plywood woodcut.

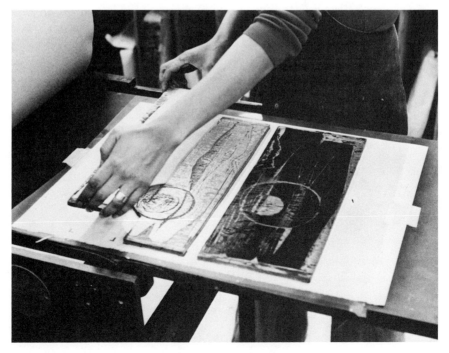

traced drawing of the various block outlines to be assembled on the printing surface, which is taped in place. A piece of clear, thin acetate or mylar is placed over the tracing (which can be cleaned easily between printings with a rag dampened with a little paint thinner) and taped into place. The numerous blocks are then individually inked, assembled as appropriate on the printing surface, covered with a piece of paper, and printed. This method of registration is also utilized for collagraph plates and color printing with etching plates.

RELIEF PRINTING FROM INTAGLIO PLATES

As previously mentioned, any intaglio plate can be printed in relief. When a white line against a colored background is desired, the relief ink (which can be any of the relief inks suggested, or etching ink made very stiff) is rolled onto the plate with a hard roller or brayer, being careful not to fill the intagliate area by using too much pressure, and printed normally in a double cylinder press.

When a colored line against a colored background is desired, the plate is inked normally using the intaglio printing method. The intaglio ink is not allowed to build up excessively or fill the intagliate, but is kept to the "walls and floor" of the incised areas. A hard roller or brayer is rolled up with a very stiff ink of another appropriate color, and applied with little pressure to the surface of the intaglio plate. In this case, the rolling on of the ink should be done with a large diameter roller or brayer and applied in one firm roll, to reduce any offsetting of the intaglio image, and the roller or brayer cleaned between each printing. The plate is placed on a double cylinder press and printed normally.

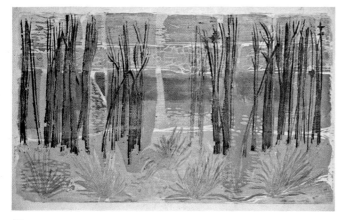

16

Color woodcut (16″ × 27½″),
Virginia Smit, untitled, 1972.
Handprinted in 4 colors from 4 registered blocks.

Etching/collage (18″ × 25″),
Ed Buonagurio, untitled, 1974.
A combined media print
utilizing intaglio, hand coloring,
and collage processes.

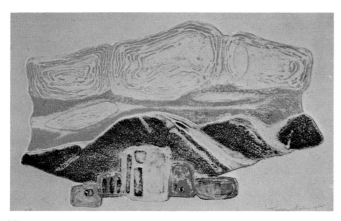

22

Color collagraph (18″ × 12″),
Sheldon Strober, *Adobe Dawn,* 1976.
Printed in 6 colors using a combined
relief and intaglio process.
(This plate was used for
demonstrations in Chapter 16.)

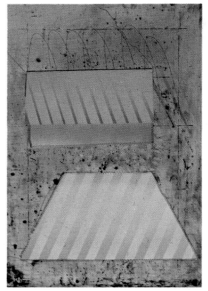

47

Color lithograph (21″ × 27″),
W.C. Maxwell, *Process 12, State IV,* 1974/1975.
An 8 color lithograph utilizing
planographic and relief stone processes.

3

Color lithograph (18½ " × 12"),
Janet Hughes, *Banana One,* 1973.
Overprinted from 3 metal plates in the
3 primary colors to achieve a spectrum
by utilizing extremely transparent inks.

9

Color collagraph (11½ " × 14"),
Victor Huggins, untitled, 1974.
A 2 plate collagraph utilizing
a combined relief and intaglio process.

33

Color viscosity etching (15" × 18"),
Judith R. Rymer, *Mountains of the Sun*, 1974.
Utilizing both relief and intaglio processes,
3 colors with varying ink viscosities
are applied simultaneously.

23

Color woodcut (22" × 35"),
Virginia Smit, *Big Sun,* 1974.
Hand printed in 4 colors
from 4 registered blocks.

5

Color etching (12″ × 12″),
Stan Damast, *Moon Glow*, 1975.
Printed in intaglio and relief
utilizing 3 etched plates.

50a and 50b

Five-color collagraph (22″ × 30″),
Janet Hughes, *Mr. Haynes*
(top and bottom view), 1975.
Color was applied to these cardboard
plates utilizing an *á la poupée* process.

6

Color collagraph (9½″ × 14¼″),
Caryl Spinka, untitled, 1975.
Inked first in intaglio, the plate is then
relief inked utilizing a "rainbow" method
of rolling out several colors simultaneously.

24

Color lithograph/color collagraph (11″ × 18″),
Sheldon Strober, *Insular Reminiscence*, 1975.
Combined stone lithograph and a viscosity
printed cardboard plate.

2

Color lithograph (15″ × 21″),
Richard Siegal, *Sunrise Maine,* 1975.
Overprinted in 7 colors from
a stone and metal plates.

34

Color viscosity etching (6″ × 8″),
Carol Reilly, untitled, 1973.
This plate shows areas that were
etched completely through, revealing
highly embossed areas on the print.

15

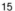

Color linotype (12″ × 12″),
Denise Martin, untitled, 1974.
A press printed unmounted linocut
revealing heavy embossement
and "rainbow" relief colors.

17

Color collagraph (21″ × 32″),
Sheldon Strober, *Amaranthine,* 1975.
Combined process utilizing
6 cardboard plates inked
in both intaglio and relief.

12

Color photo lithograph (9″ × 7″),
Lorraine Hoffman, *Time,* 1975.
A solarized negative was used
on a photographically presensitized
aluminum plate to produce this image.

10

Color soft ground etching (6″ × 8″),
Linda Hanauer, *Third State,* 1975.
Inked in intaglio first;
"rainbow" relief colors applied next.

31

Color collograph (17″ × 9″),
Janice Rogers, *Red House,* 1974.
The entire plate was made from cardboard
and intaglio printed in one color.

Color collagraph (15″ × 16″),
Janet Hughes, *Jessica 6,* 1973.
Cardboard plate *á la poupee* printed.

38

Color lithograph (17½″ × 26″),
Lisa Weinberg, untitled, 1974.
Multi-metal plate and stone lithograph
printed with very transparent inks
and off registration.

26

Color lithograph (11″ × 14¾″),
Janet Hughes, *Plastic America,* 1973.
Stone and metal plate overprinting
utilizing very accurate pinpoint registration.

8

Color collagraph (8″ × 15″),
Linda Hanauer, untitled, 1975.
Cardboard plate printed in relief
and intaglio simultaneously.

37

Color lithograph (17″ × 22½″),
Lisa Weinberg, untitled, 1973.
Registration is slightly altered during the over
printing to create an extreme illusion of depth.

4

Photo lithograph/collagraph/collage/hand colored
(22″ × 28″), Janet Hughes, *Metaphysical Graffiti or
In One Ear and Out the Other,* 1973. Combined media
print that relies on a thorough knowledge of all
processes for an effective image.

32

Color viscosity etching (15″ × 17″),
Ed Buonangurio, untitled, 1974.
Printed in relief, intaglio,
and viscosity utilizing
etched plates.

29

Hand colored etching (8″ × 12″),
Susan Gelier, *Picture I,* 1974.
A very simply hand colored
intaglio etching.

30

Color collagraph (15″ × 18″),
Victor Huggins, untitled, 1974.
2 cardboard plates printed in relief
and intaglio simultaneously.

36

Color lithograph (15″ × 18½″),
Richard Siegal, *Forest Cross-Section*, 1975.
An effective use of 3 stones to produce
the spectrum with the 3 primary colors.

13

Color lithograph (13¼″ × 21½″),
Sheldon Strober, *The Higher Palisade*, 1974.
4 zinc plates utilized to produce
this bleeded image lithograph.

44

Color etching (26″ × 38″), W. C. Maxwell,
Process: One to One to III, 1975/1976.
A multi-process etched plate printed in
1 intaglio color, and hand colored with
an airbrush and stencil.

III

PRODUCING
A PLANOGRAPHIC
PRINT

A planographic impression is, simply, one that is printed from a flat surface. Unlike any of the other media covered in this book, this method does not rely on pulling a print from either a relief (raised) surface or from an incised (recessed) surface. Planography can include the transferring of an image from a lithographic stone, a lithographic metal plate, or a paper plate, by means of hand lithography, photolithography, offset printing, and photo-offset. All of these processes are based on the principle that water and grease do not mix, and, therefore, the parts of a surface drawn upon with grease-containing items repel water, while the undrawn parts of the surface absorb water. This principle is enhanced through chemical controls by either the printer or the press, or both.

This section is concerned primarily with the process of hand lithography on stone and metal plate, either directly drawn or through a process of transfer. It does not cover photographic methods nor the commercial processes, which is beyond the scope of the beginner or beyond the scope of fine art printing, or both.

The history of lithography is especially interesting because no other printmaking medium has such a sure and accurate historical accounting. We know exactly when and how the process was discovered, and its exact evolution from the date of discovery. Much research has authenticated the fact that Aloys Senefelder, who was born in Prague in 1771 or 1772, invented the medium and developed it to a point where future lithographers could add

little but to perfect his methods, excepting the addition of photographic processes in later years.[1] The discovery and methods are well documented in Senefelder's book, *A Complete Course of Lithography: Containing Clear and Explicit Instructions in all the Different Branches and Manners of the Art: Accompanied by Illustrative Specimens of Drawing to which is Prefixed a History of Lithography from its Origin to the Present Time*, published in German in 1818, and translated into French and English soon after.[2]

Although Senefelder began a vocation as a lawyer, and then as an actor, the need to print and publish his own authored plays in a quick, easy, and inexpensive way led him to much experimentation with various printing processes, including stereotyping and copper engraving.[3] Using a Kelheim polished stone (normally as an inking surface, the ink being made from wax, soap, and lampblack, and, accordingly, greasy and acid resisting), he was forced to copy a washerwoman's bill onto the stone with the ink for lack of paper and pen in his shop. It occurred to him after studying this writing on the stone that it was possible to etch away the surrounding areas with a nitric acid solution and, thereby, hold the writing in relief so that the stone could then be printed as a wood block. Although this was not, as he later called it, pure "chemical lithography," the process of "relief engraving on stone" was patented in 1796.[4]

Although he produced printed matter utilizing the relief method, such as the musical composition "Conflagration of New Oetting" for Herr Lentner in 1797, which is particularly notable because it contains the first drawing by an artist that is printed by Senefelder, he had great difficulty finding or producing a press to print these engraved stones without splitting them. Further, he was looking for a method of transferring writing and drawings from paper to stone so that he could avoid the insurmountable labor of writing backward (impressions always print in reverse) and to avoid the need to bring artists into his shop to work directly on the stone. These facts led him, after "several thousand experiments," to the production of gummed paper that when drawn upon with grease would allow, after soaking with water, the transfer of image to the stone. It further occurred to him after this discovery that this gum process would be adaptable to direct drawing on the stone creating a chemical stabilization whereby the grease-drawn areas would only attract greasy ink, and the gummed nondrawn areas would only attract water and repel the ink.[5]

And so, by 1798, Senefelder had discovered lithography as a true planographic chemical process. The discovery caused as much personal hardship for him as it eventually caused financial success. The documentation of this personal history is, in itself, of increasing interest but beyond the scope of this text. For our purposes, it is only important to note that his discovery caused a revolution in the printing industry of the time, and by the middle of the nineteenth century, lithographic shops existed in every European country and the first American shop had been opened by Barnett and Doolittle in New York.[6]

[1] Joseph and Elizabeth Robbins Pennell, *Lithography and Lithographers: Some Chapters in the History of the Art* (New York: The Century Co., 1898), p. 6.

[2] Ibid., pp. 21-22.

[3] Ibid., p. 6.

[4] Ibid., pp. 7-8.

[5] Ibid., pp. 11-34.

[6] Ibid., p. 23.

The commercial lithographer was quite successful, but the process as a fine art medium did not share in this huge success. There was little fine art lithography in Germany during the nineteenth century, and although it proliferated more successfully in England at the time, France was the prime mover in terms of treating it as an artistic venture. This was a result of the direction given to it by Godefroi Englemann, who viewed the medium primarily as a method of multiplying original drawings. His work in France, even though Senefelder had already produced color prints, led him to the perfection of "chromo-lithography" for which he was highly honored by the French government for producing the "first" fine art lithograph in color.[7] His direction caused almost every nineteenth-century French artist to produce work in the medium, from Delaroche, to Fragonard, to Ingres, to Gericault, to Delacroix, to Honoré Daumier.

However, by 1860 or 1861, lithography as a fine art fell into disrepute. Many forces were at work to cause this, but primarily it occurred first out of a loss of enthusiasm and commitment by artists to the medium; second, out of the increasing interest and enthusiasm for photography; and third, out of a lack of interest by the general public, who, under the new industrial and capitalistic consciousness, were more interested in mass production. By 1875, purely artistic printers and publishers no longer existed in England or France.[8]

Although history traces examples of lithographic prints being produced throughout Europe during the last quarter of the nineteenth century, and valiant attempts to create new fine art interests in the process, lithography was primarily confined to commercial industry. Even the English lithographer, Thomas Way, who tried desperately to talk artists into working in the medium, found few sympathetic ears of any prominence, except for the American James McNeill Whistler (working in England at the time), who, seeing the medium full of intrinsic possibilities, produced almost 200 editions of prints. But as late as 1887 these very prints could be purchased for approximately one penny each.[9]

Yet, the turn of the century did see many excellent lithographs produced, and a new found interest in the process. Initially, this excitement was fermented by the exploration of the work of Goya, Latour, Manet, and Redon, who all worked in the medium. And with the interest shown by the Impressionists, namely, Pissarro, Degas, Renoir, and Lautrec, lithography did experience a minor "renaissance." However, this excitement was nothing like that which followed Senefelder'a initial discovery.

Lithography in America was primarily confined to commercial work until 1960, although there are scattered examples before this time. The first lithograph published in America appeared in the *Analectic Magazine* for 1819 and was drawn on American stone by Benjamin Otis of Philadelphia. Notably, Rembrandt Peale won the first silver medal given by the Franklin Institute for a lithograph of President Washington in 1827. And there are examples of pure artistic lithographs by Thomas Cole, a famous early American painter.[10]

Further, the interests displayed by the Impressionists had spurred some

[7] Ibid., pp. 42-50.
[8] Ibid., p. 161.
[9] Ibid., pp. 165-167.
[10] Ibid., pp. 246-248.

American artists, such as George Bellows and Joseph Pennell, to produce lithographs at the turn of the century. And with the infusion of European artists, such as Max Beckman, George Grosz, Wassily Kandinsky, and Henri Matisse, who all worked in the medium, the United States was treated to a sincere consideration of lithography as a serious fine art process. And by the author's own claim, Bolton Brown was the first American to attempt to produce "the first published offer in this country to teach artistic lithography" in 1919, which was later revised in 1930.[11]

However, not until the resurgence of interest promoted by Tatyana Grosman of Universal Limited Art Editions and June Wayne of Tamarind in the '60s do we see a major popularity in the United States regarding the multiple lithographic fine art print. Today, almost every major American artist works or has worked in the medium, including Jasper Johns, Robert Rauschenberg, Willem de Kooning, and Frank Stella, to name but a few.[12] We are experiencing today, without a doubt, a major "renaissance" in fine art lithography.

[11]Bolton Brown, *Lithography for Artists* (Chicago: University of Chicago, 1930), p. viii.

[12]Thomas B. Hess, "Prints: Where History, Style and Money Meet," *Art News*, 70, no. 9 (January 1972), 29, 66.

Stone Lithography

The Kelheim stone, mentioned earlier as the type of stone first used by Senefelder, is available in limited quantities at a very high price and is still the best of all planographic surfaces from which to work. This limestone quarried from Solnhofen of Bavaria is an extremely stable stone with very close pores that are exceptionally even and consistent. When properly ground, the stone reveals a very uniform surface, as well as color and imperfections. The colors range from yellow to grey, the latter being the hardest, with closer pores, and best suited for all types of drawing and printing. Yellow stones can be used, but they are somewhat more difficult to print precisely and to hold intricate detail when pulling large editions. Some stones will be both yellow and grey, providing obvious difficulties based on the above data. Other imperfections, some serious and some not, range from iron marks to crystal formations to tiny cracks. Stones come in various lengths and widths, and are usually 4″ to 6″ thick when new.

To produce a multiple image from a stone, even though the basic principle may sound simple, is far from an easy task. It requires close

Fig. 12-1 Stone lithograph (crayon and autographic ink). *Untitled*, 16¾″ × 22¾″, Karen Washington, 1974.

attention to detail, extreme patience, and mental as well as physical stamina. No other printmaking medium requires as much from you as does lithography, but no other printmaking medium will give you such a versatile, direct, and aesthetically sophisticated impression. There is a certain "magic" in this process that, once experienced, will force you to develop yourself as a fine art lithographer of the highest proficiency. However, for those without that stamina, patience, and extreme concentration, the magic will be lost and the process will only frustrate. To choose to work in lithography is to choose to develop these personal qualities to the extreme. Yet, it is this development of discipline that will ultimately lead you to an ever increasing enjoyment and enthusiasm for, and freedom within, the medium.

This medium is more directly related to drawing and painting than any other printmaking process. Additionally, it intrinsically holds a multitude of possibilities that are not possible in any other art media. For these reasons, there are few contemporary artists who have not produced or wished to produce lithographic prints, in collaboration with a lithographer or singlehandedly, from conception of image to the pulling of the edition.

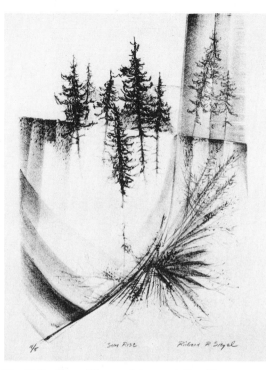

Fig. 12-2 Stone lithograph (crayon). *Sun Rise,* 18″ × 24″, Richard R. Siegel, 1975.

Fig. 12-3 Stone lithograph (crayon, tusche, and autographic ink). *Untitled,* 16″ × 20″, Dorothy McGahee, 1975.

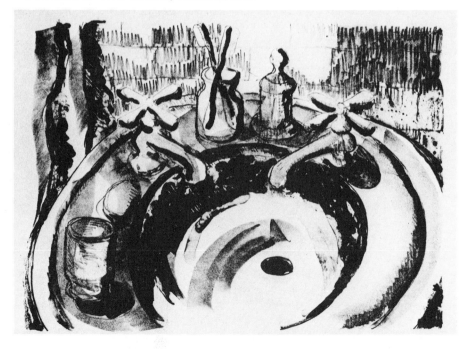

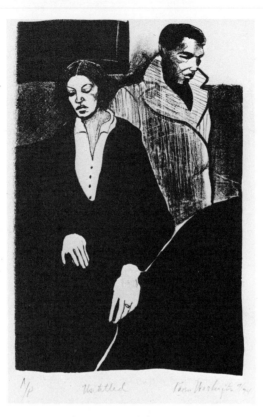

Fig. 12-4 Stone lithograph (crayon, tusche, and autographic ink). *Untitled,* 11¼″ × 14¾″, Karen Washington, 1974.

Fig. 12-5 Stone lithograph (autographic ink and tusche). *Untitled,* 14″ × 20″, Linda Hanauer, 1974.

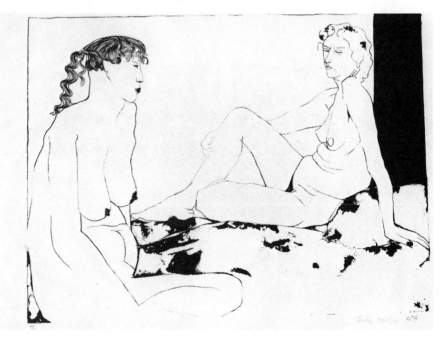

The attempt here is not to give you a comprehensive study of the art and craft of lithography, but to consolidate and condense the process to make it as simple as possible for the beginner. The attention you give to "not miss one step" will almost always result in a satisfying lithographic print edition. Once a basic understanding and competency are reached, the student of lithography wishing to go further with the process should consult advanced instruction and/or literature, such as *The Tamarind Book of Lithography: Art and Techniques*.[1]

WORKSHOP, EQUIPMENT, AND SUPPLIES: INITIAL PREPARATIONS

Of course, the size of your shop and the amount of supplies and equipment necessary are dependent on how many will utilize the facilities. With this in mind, the preliminary design here is meant for one person, unless otherwise stated.

As such, a large space is not needed. Most of your time will be spent physically on the press itself, and, therefore, this somewhat large piece of equipment should be the core of your shop. Approximately 250 square feet of space should house everything and provide you with adequate flow space.

There is absolutely no way to produce a correct lithograph without a lithographic press (Figures 12-6 and 12-7). These presses are available from several manufacturers and are relatively expensive (Appendix A). They usually consist of the frame, a wooden or steel bed that can be moved freely by hand or turned by a crank when the clutch is set; an arch that has attached the scraper box, which is adjustable for pressure; the scraper bar inside the scraper box; and a pressure arm that raises or lowers the scraper box onto the stone (or plate), which is resting on a perfectly level bed. The scraper bar is usually made of a hardwood such as maple or a compressed hardwood such as Benelex; it is tapered on one side to which a 1" to 1 1/4" piece of leather is attached to act as a cushion against the stone. The scraper bar is attached to the press by opening a set screw on the scraper box and firmly slipping the bar all the way into the box, leaving the leather side extend out and down, and tightening the screw. The scraper bar should be wide enough so that it covers the *image area* of the stone or plate, but not quite as wide as the stone or plate (if appropriate, several sizes should be on hand). Also necessary is a tympan, which like the scraper bar is not an integral part of the press and must be purchased separately. It is usually made of red pressboard, or thin plastic cut smaller by 1" or 2" than the press bed (it is convenient to have the tympan cut a few inches larger all the way around than the stone or plate, and, if appropriate, to have several sizes handy).

An overall safe storage cabinet should be in the area, large enough to hold all necessary supplies, as listed below. It is not recommended that this

[1]Garo Antreasian and Clinton Adams, *The Tamarind Book of Lithography: Art and Techniques* (New York: Harry N. Abrams, Inc., 1971).

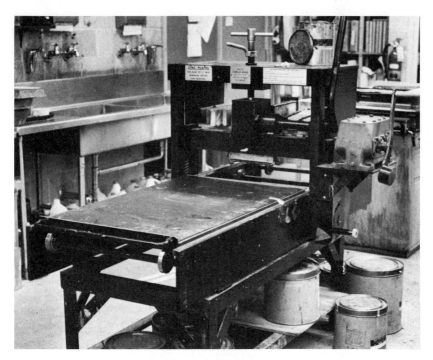

Fig. 12-6 Charles Brand lithographic press.

Fig. 12-6A American French Tool lithographic press.

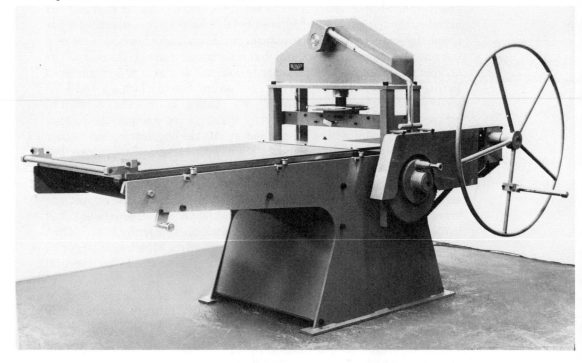

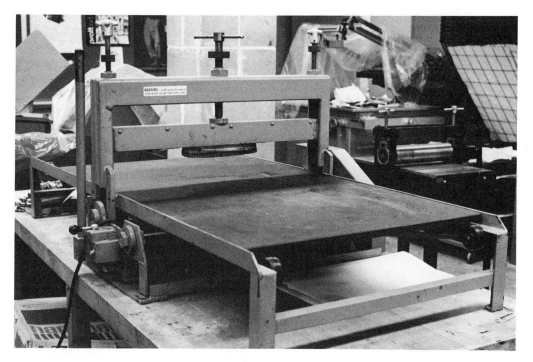

Fig. 12-7 Dickerson combination lithographic, intaglio and relief press. (Available through Grapic Chemical and Ink Co.)

Fig. 12-8 Stone storage racks.

209

cabinet also be used for paper and print storage. A separate paper and print storage cabinet should be available, as described in Chapter 1.

If you are working with one or two stones and a few plates, storage of these materials is not a problem. They can be stored in your cabinet, if convenient, or a storage rack of some type can be built under the drawing or printing table. If you have on hand several stones, an adequate storage rack for them is a must (Figure 12-8).

Large stones are heavy and difficult to move. Accordingly, some type of rolling table should be purchased or built to allow for easy stone mobility from sink to drawing table to press.

One large rubber roller, made for lithography, will be adequate for the beginner. Later, you may wish to have on hand several rollers of different lengths and diameters. The softness or hardness of lithograph rubber rollers is measured by durometers; the roller used should normally be 35 durometers (hard to medium hard). They should be cleaned thoroughly with turpentine and soft rags, and powdered with talc when stored.

Rollers should never be left to rest on the rubber face; this will quickly destroy an expensive roller by creating a flat side or by letting it roll off a table, causing the handles to break off or severely denting the rubber. Accordingly, a roller box should be built (see Figure 16-31, Chapter 16) and the roller always placed in this box when not in your hands.

A solvent cleaning station should be set up. All solvents should be kept in safety cans, and a metal waste can with a top should be available for discarding solvent-soaked rags, paper towels, and old newspaper. Near the solvent cleaning station should be an adequate fire extinguisher. A very small shop can use the inking table as a cleaning station when the printing is complete.

There are on the market presses that can be converted from intaglio work to lithographic work (see Figure 12-7); this type of press is advisable for those individual or small classroom shops to allow for both processes to be explored (see Appendix A). Although electric power-driven presses are available, they are not recommended for the beginner or small shop.

You will need an inking station, which is usually placed on the side of the press that has the pressure arm attached, approximately 3 to 4 feet from the press. This can be made from a very stable table or cabinet to a height that is comfortable (about 48"). It should have a formica surface, or an inking slab should be placed on its top. This slab can be made from an old, nonusable stone (less than 2" thick) or plate glass that can be lightly sandblasted for better ink adherence. The table should be large enough for sufficient space to the left of the slab to store roller/roller box and other minor materials.

A press table can easily be built to be placed over the press, the height of the press arch. It should have two shelves built into it; the top shelf to hold tympan, blotter and miscellaneous working materials; and the bottom shelf to hold the scraper bar, tympan grease, and various other small items. It is placed to the rear of the press with the top shelf level with the arch; the press bed can then ride easily underneath the table bottom shelf.

A drawing and processing table is next. This need not be large; adequate enough to hold your stone (or plate) and your small amount of drawing/processing materials, a height convenient for drawing, with a stool or chair placed underneath.

A sink is a must. It should be within your immediate work area. A drain board should be built for the top of the sink well to allow the stone to drain easily when grinding it down for drawing. A short hose should be attached to the spigot. Your grinding stone or levigator should be near by (Figure 12-9).

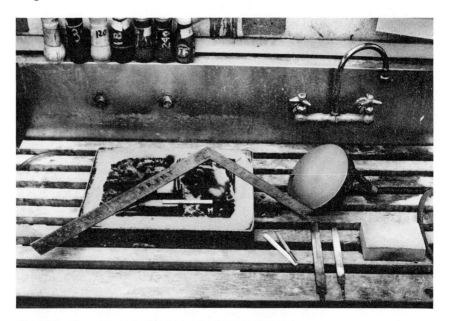

Fig. 12-9 Supplies, including levigator, for grinding and beveling lithographic stones.

About 4 feet from the press, and directly in front of the press bed, you should locate another small table (or cabinet) that is at least as high as the press itself. This table will be used to set out your proof, printing, and newsprint paper when ready to print.

Build a simple fan (see Figure 12-63) or have on hand a power hair dryer that blows cold air (never blow hot air onto the stone).

Finally, you will need the following supplies for stone lithography:

Silicon carbide (carborundum), #80, #120, #180, #220, 5 lbs. each

Tympan grease (mutton tallow or similar grease), 5 lbs.

Turpentine (or lithotine), 5 gallons

Paint thinner, 5 gallons

Gasoline, 1 gallon

Levigator (or an additional stone for grinding), 12 "

Nitric acid, 70% USP, 1 gallon
Phosphoric acid, 85% syrupy, 1 pint
Glacial acetic acid, 1 pint
Gum arabic solution 14° baumé, 1 gallon
Rosin, powdered, 3 lbs.
Talcum powder, 5 lbs., asbestos free
Lithograph varnish, #00, 1 pint
Magnesium carbonate, 5 lbs.
Powdered potassium alum, 1 lb.
Distilled water, 1 gallon
Korns liquid tusche, 4 oz.
Korns autographic ink, 2 oz.
Korns tusche stick, 1
Korns rubbing ink sticks, soft, medium, hard, 1 each
Korns litho pencils, #1, #3, #5, 2 each
Korns litho crayons, #00, #2, #5, 1 box each
Korns litho crayon slabs, #1, #5, 1 box each
Snake slips (pumice stick), 2
Scotch hones, 2
Close-Pore Photo Sponge, 2
Open-Pore Regular Sponge, 1
Sanguine conte crayons, 2
Measuring cup, graduated scale (1-8 ounces)
Ink knife (putty knife), 1 or 2
Water buckets, 1 gallon, 2
Water bowl, 1 pint, 1
Dropper bottle, plastic, 2
Cotton, small package
Pen holder and points (various sizes, including crow-quill point)
Newsprint, smooth, 1 ream
Cosmos blotting paper, 50 sheets
Masking tape, 1", 1 roll
Push pins, #5 aluminum, 1 package
Watercolor and/or Japanese brushes, various sizes (as needed)
1" to 1-1/2" flat, soft hair, watercolor brush, 1
Cheesecloth, 1 large package
Straight edge, metal, 36", 1
Metal files, smooth and rough, 6", 1 each
Razor blades, single edge, 2 or 3
Plastic funnel, small, 1
Roll-up black lithographic ink, Siebold, Hanco, or Graphic Chemical Brand, 2 lbs.
Bubble level tool
Waterless hand cleaner (Boraxo or similar brand)
Hand soap (Lava or similar brand)

Paper towels

Old soft, clean rags (cotton recommended), 10 lbs.

Old newspapers

Old jars (with lids)

Note and sketchbook

Drawing and tracing paper (as needed)

4B and 4H drawing pencils (as needed)

Work apron, cloth

Rubber apron, for grinding stone

Rubber gloves (should be used with all solvents, acids, and chemicals)

Again, this workshop, equipment, and supply list is meant basically for one person. Of course, much of the major equipment and supplies can be shared by more than one. Many school workshops will supply many of the items listed, as well as most of the major equipment. This would usually include the fully laid out workshop with appropriate storage areas, sinks, drawing and processing stations, cleaning stations, and so on, as well as rollers and roller boxes, press and accompanying press equipment, fire extinguisher, fireproof waste containers, funnels, solvents and safety cans, inking slabs, silicon carbide, tympan grease, levigator, all chemicals, rosin and talc, roll-up ink, varnish and magnesium, hand cleaners, and paper towels. Additionally, the school shop will usually supply the stones. Those purchasing their own stones should refer to the introduction to this chapter. Because new, grey stones are very expensive, the buyer should be very particular as to quality, size, delivery, and such. A few suppliers have used stones for purchase, but they tend to be relatively expensive as well. A stone is only obsolete for printing when it gets thinner than 2″, is broken (although the pieces, if large enough, can be used for printing), or an unexpected negative imperfection occurs after several grinds (which usually can be worked around). As pointed out before, old stones make excellent ink slabs when ground and lightly polished with pumice powder.

STONE GRINDING

Place at your grinding station (sink with appropriate drain board and hose) the four different silicon carbide grits (#80, #120, #180, #220) in four jars or appropriate containers that allow for sprinkling; the rough and smooth file; one snake slip and scotch hone; the straight edge; your stone to be ground; and the levigator or another stone nearly the same size as the stone to be ground (Figure 12-9). Run the cold water lightly. Place your stone near the hose, allowing for plenty of room to grind. Depending on the size of the stone, decide on a grinding pattern that will cover the entire stone evenly, such as a X pattern or linear horizontal pattern.

When ready to grind with the levigator, you will lift it by the handle and place the edge on the stone with the base resting on the drain board. Place

your other hand around the outer edge of the levigator, lift and start it spinning in a circular motion. The hand on the handle will take over, and keep the levigator spinning until the pattern is completed three or four times. You will finish where you started on the edge of the stone and let the weight of the levigator drop/tilt the instrument so that it is again resting on the stone's edge with the base on the drain board. When turning the levigator, *do not break your wrist*; let your whole lower arm turn the levigator in a circular pattern. Never pull the levigator off the stone, or scratches will occur. (*No* scratches, no matter how small, should be present, for they will print as white lines.) Let the centrifugal force of the turning levigator aid in keeping the levigator's base spinning.

When grinding with another stone (if both stones have previous images on them, place the stone with the darkest image face down on top of the face of the other stone) of the same size as the lower stone, place the upper stone in the center of the lower stone, square them both off, and consistently turn the upper stone in a circular pattern with both hands. On every third or fourth pass, switch the positions (upper/lower) of the stones. If the upper stone is smaller than the lower one (which should be avoided, if possible), grind by moving the upper stone up and down, slowly pushing it from left to right and back again for one complete pass. When the pass is complete, carefully, without dragging one stone across the other, lift the upper stone from the lower and place it on its edge alongside the lower stone. If the two stones refuse to separate, force some water between them allowing air to dislodge the suction action; never slam them apart. Although grinding with two stones is more difficult than levigator grinding, both stones will be ready to accept an image when you are finished grinding.

When stones are brand new, or have been used successfully with a prior image, they will usually be level. If there is any doubt, however, the level of the stone surface should be checked before grinding. Find a level area in your workshop by placing a bubble level flatly on a surface large enough to accept the stone, checking to see that the bubble lies evenly between the two indicated lines on the level. After locating such an area, place your stone (after insuring that there is nothing attached to the underside) face up on that surface and again place the bubble level on the stone, moving it up and down the length of the stone (top to bottom), making sure that it is level (Figure 12-10). If the bubble indicates that one side is higher than the other, remember to make extra passes with the first coarse #80 grit on the higher side (top or bottom). Most modern lithograph hand presses will correct for unlevel right and left sides, so you do not have to check for this.

When you begin, you will sprinkle each grade of silicon carbide, in sequence, evenly across the stone's *wet* surface; the amount of water to amount of grit will be ascertained with practice—as a rule, you will know when you have reached optimum amounts when no scratches occur in the grinding. And before changing from one grade of grit to another, or before sprinkling another new layer of the same grit on the stone, thoroughly hose off the drain board, stone(s), levigator, and hands. *Never* mix the grits; scratches will certainly result.

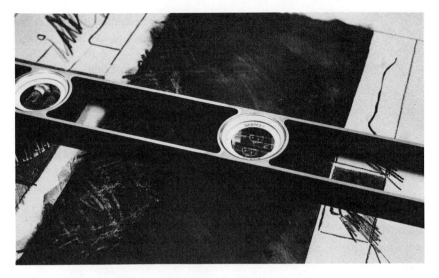

Fig. 12-10 Determining the levelness of the stone with a Sentry bubble level tool before grinding.

Begin, after making sure that the stone is level, by hosing down the entire area, stone(s), and levigator, also being sure that there is no dirt or old grit to foul you up. Wet the stone(s) and levigator thoroughly with cold water and sprinkle the first #80 grit (the lower the number, the coarser the grit) evenly onto the stone, pick up the levigator (or other stone) as described, and start the grinding procedure, continuing as follows:

1. Continue to grind with #80 until the old image disappears. (This will usually occur after 5 to 10 complete passes, depending on how many times you totally cover the stone with the grinding on each pass and the strength of the old image. A *pass* is complete when the grit mixes with the ground stone to form a "milky" grey sludge that creates difficulty in turning the levigator or other stone.)

2. Hose down area, stone(s), levigator, and hands. (At this time, check to see if you created any hills and/or valleys on the surface of the stone. Place the straight edge so that the flat side of one edge is against the face of the stone, and the ruler is held diagonally across the stone from corner to corner. Pushing firmly down on the edge of the ruler, try moving its center by bending it back and forth; or place your eyes level to the stone surface to see if any light is evident through a separation between the edge of the ruler and the surface of the stone; or place a thin sheet of tracing paper under the edge of the ruler, and while pushing the edge down with one hand, try to pull the paper through with the other hand. Do this all over the stone, holding the ruler on its edge diagonally, horizontally, and vertically. If none of these things occur anywhere on the stone, there are no hills and valleys. If they do occur, remember where the valley or hill is and continue with #80 grit, making extra passes where the hills are until the stone is flat. It is *absolutely* necessary to insure that the stone is perfectly flat before continuing. Each time you change grit numbers, check the stone for flatness.)

3. Change to #120 and make 3 to 4 passes, wetting and reapplying new grit between each pass.

4. Hose down area, stone(s), levigator, and hands.

5. Change to #180 and make 3 to 4 passes, wetting and reapplying new grit between each pass.

6. Hose down area, stone(s), levigator, and hands.

7. Change to #220 and make 2 to 3 passes, wetting and reapplying new grit between each pass.

8. While the stone is wet, file the edges so that they have rounded bevels where ink cannot be captured during the roll-up processes: first, with rough file; second, with smooth file; third, with scotch hone; and, last, smooth out with snake slip. Keep stone wet while working on edges, hosing it down well after completion, so that no stone or grit particles remain on the surface.

9. Blot stone with clean newsprint and fan dry.

10. Cover stone with a clean sheet of newsprint and place at your drawing/processing station. *Do not touch surface.* (Figures 12-11 to 12-22 show the grinding process.)

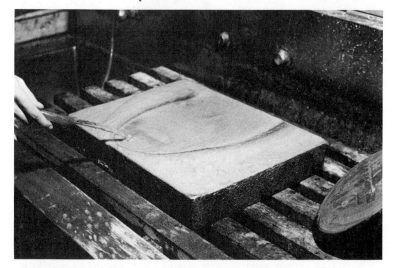

Fig. 12-11 To begin grinding, wash down stone and levigator well.

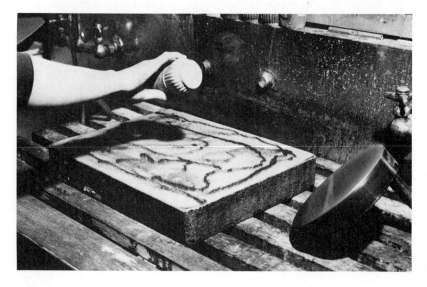

Fig. 12-12 Sprinkling the carborundum evenly across the stone surface.

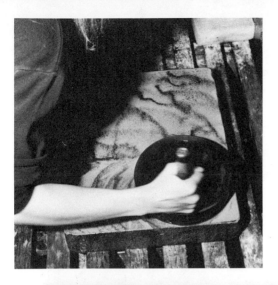

Fig. 12-13 Beginning a square pattern grind from bottom right corner of stone.

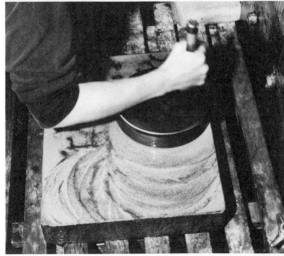

Fig. 12-14 Continuing the square grind from top right corner of stone.

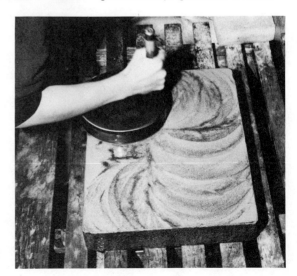

Fig. 12-15 Continuing the square pattern grind from top left corner of stone.

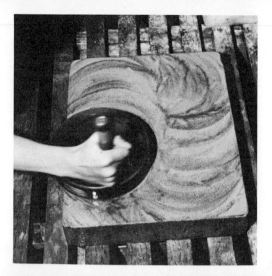

Fig. 12-16 Completing the square pattern grind at bottom right corner.

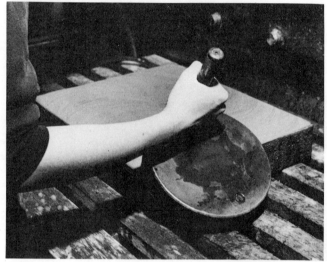

Fig. 12-17 Levigator's weight makes it easy to tilt off stone on final corner.

Fig. 12-18 Levigator is then tilted back to rest position using both hands. (The process here and in Figure 12-17 is reversed to start the grind again after thoroughly washing stone and levigator and adding new carborundum to stone's surface.)

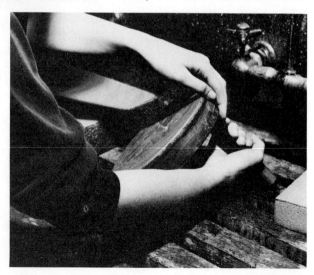

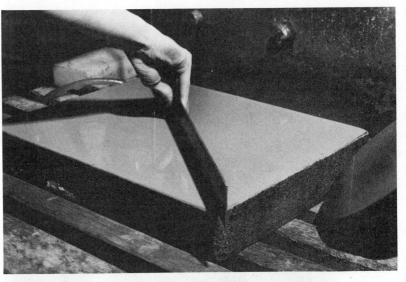

Fig. 12-19 The possibility for "hills and valleys" is checked out using a heavy, steel straight edge.

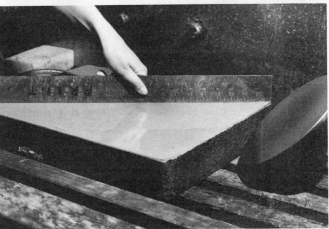

Fig. 12-20 The straight edge is placed in several positions, corner to corner and edge to edge, making sure no hills and valleys are present.

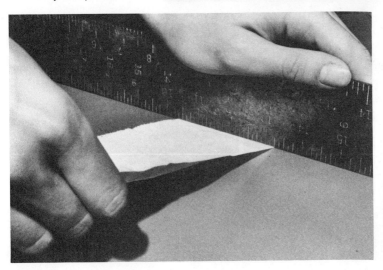

Fig. 12-21 Small pieces of paper layed under the straight edge and pulled gently to determine where the hills and valleys exist.

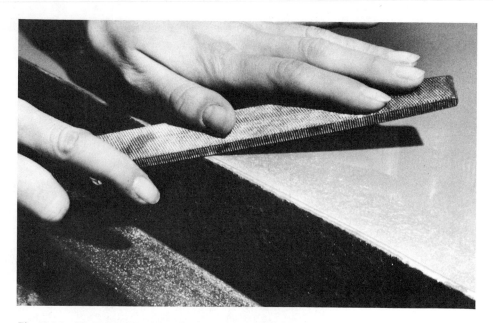

Fig. 12-22 The stone edges are beveled with coarse and
fine files, scotch hone, and snake slip until perfectly smooth.

If any scratches, no matter how small, occurred during the grinding pro-
cedure, they must be removed or your prints will have very obvious white
scratch marks through them. Watch the stone carefully each time you hose
it down, and take note of any scratches. They can be seen more clearly if
you wipe away the excess water from the stone surface with a very clean,
nearly dry sponge (Figure 12-23). If a scratch is evident, go back one grit
number (from #180 back to #120), and the scratch will usually come out
within a few passes. When the stone is completely dry at the end of

Fig. 12-23 The stone is
continuously checked
with a slightly damp
sponge to determine if
scratches are present.

grinding, scratches will be very evident, but you will not know at this time which grit number made the scratch, and you will be forced, most likely, to start from the beginning again.

The stone has now been sensitized to the reception of your grease drawing. Do not touch the stone face with your hand or any other greasy substance, or these marks will print. If you intend to store the stone at this point, cover it with a fresh piece of newsprint, taping it to the sides of the stone with masking tape. Keep the newsprint on the stone surface until you are ready to draw, to protect it from dust.

Before beginning your drawing, you must place protective borders on the stone. Remove the newsprint, and with your ruler/straight edge and a sanguine (red) conte crayon (which is greaseless and will not print), mark off at least 1 1/2″ margins all the way around the stone (Figure 12-24). Mix one ounce of gum arabic solution to 20 drops of nitric acid (fill your dropper bottle with nitric acid, and, when storing, keep tightly closed) and mix it well with your 1″ to 1 1/2″ watercolor brush (acid brush). Carefully paint this mixture onto the borders, letting it dry naturally (Figure 12-25).

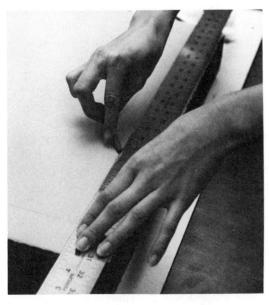

Fig. 12-24 Margins are placed on the stone with sanguine conte and ruler.

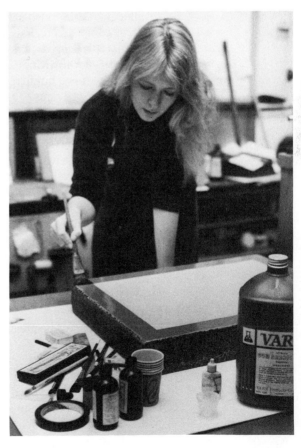

Fig. 12-25 Margins are painted out with a strong etch (20:1).

These margins are now desensitized to the reception of grease. Do not get any of this mixture into the image area, for where it exists the drawing will not take hold and print.

Wash out your measuring cup and brush with plenty of soap and water while waiting for the margins to dry thoroughly. When dry, the stone is ready to receive your drawing.

DIRECT DRAWING ON THE STONE

The items used to draw on sensitized stone consist of lithographic crayon, which comes in pencil form, crayon sticks, and crayon slabs; liquid (water-base) and stick tusche; autographic ink and ink sticks; and transfer ink.

Before working on the stone itself, it may be advisable to work up some paper drawings that simulate the different materials to be used. For lithographic crayon drawings, prepare some preliminary sketches with the very same crayon or with black wax crayons. For tusche, work in India or liquid Sumi ink (straight and mixed with varying degrees of water for tonal changes and washes), using brush and/or pen. India ink, pen, and brush also would be the choice for autographic ink (used straight). The autographic ink sticks (also called rubbing sticks) can be simulated with soft conte or compressed charcoal. And transfer ink, normally used to create large, flat, black areas, can be simulated with solid India ink or black paper glued onto your drawing. The different effects resulting from these items will become more familiar to you as the work progresses.

A drawing previously prepared on paper easily can be transferred by coating the back of a piece of thin tracing paper with sanguine conte and placing it over the sensitized stone, the drawing placed on top of it and taped to the stone sides or margins. Trace the drawing with a 4H pencil that is not excessively sharp, avoiding too much detail.

Another way to begin a drawing on a sensitized stone is to work out the basic drawing with a sanguine conte crayon (which will not print) and then go back into it with your grease drawing items (which are permanent).

Be careful when using either of these procedures not to allow a heavy buildup of conte, or you will not be able to draw through the layer with the grease items, thus producing weak lithographic drawings and prints.

CRAYON DRAWING

Crayons made specifically for lithographic drawing, such as Korn's Brand, will be marked with a number to indicate how much grease they contain. The larger the number, the lower the grease content. Of course, a larger grease content will result in a softer crayon. Accordingly, number 5 crayons will be very hard and will contain the least amount of grease; number 00 crayon will be the softest and very greasy. Lithographic pen-

cils range in number from 1 to 5. The crayon sticks and slabs begin with number 00 and go up to number 5.

Practice with the different crayons on a piece of white textured drawing paper. You will note that the number 5 crayon will result in crisp grey areas and lines. As you move down the scale, darker, softer, and stronger blacks will be the result. However, the results you create on paper will differ slightly on the stone itself. The stone has an intrinsically beautiful surface texture that cannot be duplicated. Additionally, because of the coarseness of the stone, the crayons will wear quickly. When you wish to maintain crisp points and edges, the crayon will have to be sharpened often with a razor blade.

After you have decided on the drawing for the stone, and whether or not you will transfer it by using one of the suggested methods, or draw directly onto the stone with the grease crayon, place the stone in front of you, remove the newsprint cover, place your crayons alongside, and begin. It is recommended that you work from the highest to the lowest numbered crayon. This is the only way to get exact tonal changes and line variety (in terms of light and dark lines overlapping each other). While working, never touch the stone with your hand. If necessary, a simple wooden bridge can be made from 1″ by 3″ clear pine that sits approximately 1/4″ above the surface of the stone; you can rest your hand on it and slide it back and forth as necessary. You may rest your hand on the margins of the stone, as long as the moisture from your skin does not lift the protective gum layer.

It is difficult, if not impossible in most cases, to correct a crayon drawing

Fig. 12-26 Drawing with crayon pencil; note the original drawing alongside used as a guide in completing the stone drawing.

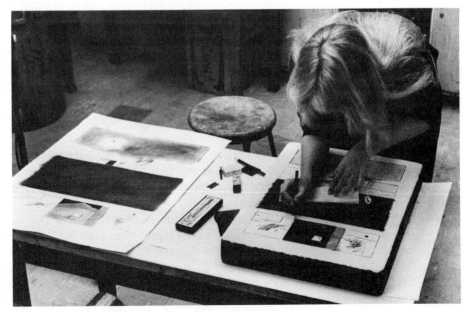

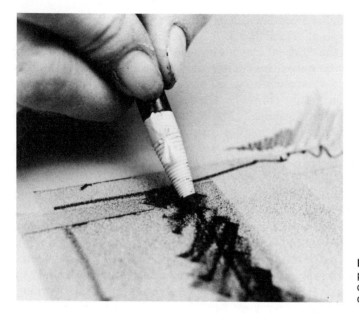

Fig. 12-27 Detail showing the progress of the crayon pencil drawing. Notice the unique textural quality of crayon on stone.

by removing areas and lines at this point. Sometimes, if you have not pressed too hard with the crayon and have not built up heavy areas, the crayon can be removed with a clean cotton cloth dampened with clean water. However, it should be noted that all lithographic drawing items contain both pigment and grease. Accordingly, even though the crayon may appear to have been removed, most likely the grease is still into the sensitized surface of the stone and will print. Corrections should be saved for a later time.

It is recommended that the beginner produce the first drawing in crayon only, and prepare the stone for edition printing at this point. Once proficiency is achieved with the crayon drawings, other items can be added. Each drawing item requires the development of more proficiency, and, usually, this development will be frustrated by trying too much too soon. Figures 12-26 and 12-27 show the process of drawing with crayon pencil.

DRAWING AND PAINTING WITH TUSCHE

Liquid tusche is normally water based. If used straight, it will produce fairly consistent black areas and lines. When mixed in varying degrees with *distilled* water, it will produce varying tones and washes. Shake it thoroughly before use.

Stick tusche (or the French paste tusche) can be mixed with distilled water, but because water-based liquid tusche is available premixed, it normally is used to produce solvent tusche. It is most common to use turpentine when producing solvent tusche. Place a heat-resistant dish on a hot plate set approximately 85° to 90°. Unwrap one-third of the tusche

224 stick and place it on the edge of the dish, allowing it to melt slightly. Add a

few drops of solvent to the melting stick, and mix it by pushing the stick around in the solvent (Figure 12-28). Again, add a few more drops of solvent until you get a mixture of about the same consistency as the straight liquid water tusche, which will flow freely from your brushes. If the mixture dries out, it can be reheated and more solvent can be added at any time. To get varying tones with solvent tusche, add different amounts of solvent.

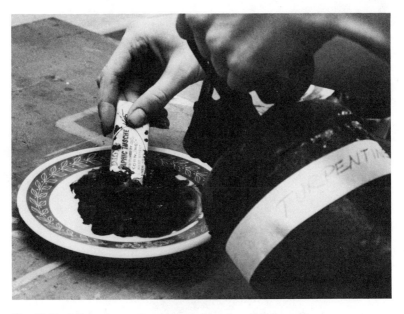

Fig. 12-28 Mixing turpentine to heated tusche stick to create various solvent washes.

There are many ways of working with tusche, and you should experiment as much as possible. To create the intrinsically beautiful and typical lithographic wash common to most wash prints, pour or brush amounts of distilled water onto selected areas of the stone. While these areas remain wet, drop or brush in the water-based liquid tusche either straight or watered down (Figures 12-29 and 12-30). Do not use excessively weak solutions of tusche, or they will not print. Once you have dropped the tusche into the distilled water, leave it alone; do not move it in any way. Let the water evaporate naturally, which will leave fine rings of grease, creating a very interesting and pleasing printed wash.

To create solid areas of "black" and varying "greys," paint the liquid water tusche directly onto the stone. Mix several greys by adding different measured percentages of tusche to distilled water, and place these mixtures, plus a container of straight tusche, next to your stone. Working from light to dark, paint them directly onto the stone sensitized surface (Figure 12-31). Let them dry naturally.

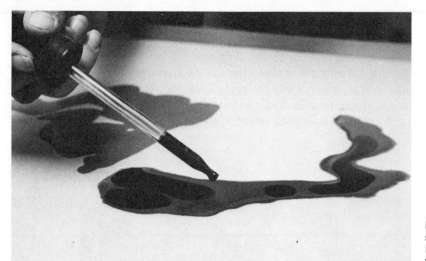

Fig. 12-29 Dropping straight water tusche into a puddle of distilled water on the stone by utilizing an eye dropper.

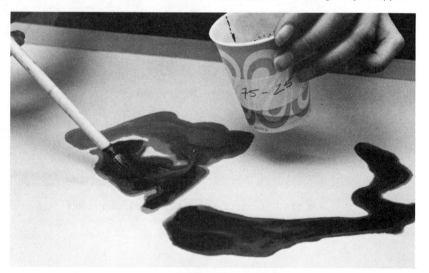

Fig. 12-30 Dropping a 75% tusche to 25% distilled water mixture into a puddle of distilled water utilizing a Japanese brush.

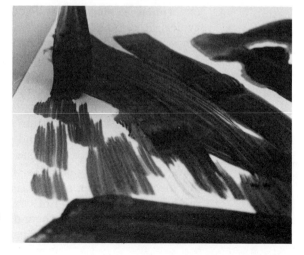

Fig. 12-31 Creating various values with different mixtures of water tusche applied directly to stone with a square watercolor brush. Note the drybrush stokes as well.

Solvent tusche also can be used in the above ways. However, when clear solvent is brushed directly onto a stone, it will spread and not stay in one place as the water will. Accordingly, when you drop in your solvent tusche mixture, it will also spread, limiting your ability to contol the wash (Figure 12-32). However, a solvent wash will print very differently from a water wash, and may be appropriate for certain drawings. Solvent washes print darker than they appear when first drawn or after they have dried. They also print more solid than water tusche washes.

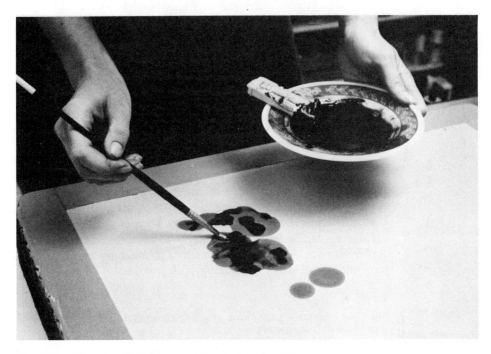

Fig. 12-32 Dropping straight solvent tusche into a puddle of turpentine.

The solid quality of solvent washes can be disturbed in interesting ways by adding water to the solvent wash; utilizing different petroleum solvents such as gasoline or benzine; dropping the solvent wash into areas that contain a layer of alcohol or water; or painting in areas with solvent and water washes simultaneously. You can also create varying "greys" by premixing the solvent with changing percentages of tusche; just remember, they will most likely print slightly darker than they appear in the drawing stage (Figure 12-33).

Tusche also should be experimented with in other ways. You can dip textured cloth into tusche and place the cloth onto a sensitized stone, transferring the texture in interesting ways. You can drop sawdust, salt, sugar, or other absorbent items into a wet tusche wash area, which will

Fig. 12-33 Detail showing a wash area that contains various mixtures of solvent and water tusche running together.

immediately draw up some of the tusche, creating a pebbled surface (Figure 12-34). Straight tusche also can be spattered onto the stone with a bristle brush or toothbrush run through a screen (Figure 12-35). Dry brush techniques can be achieved on a stone using the same methods familiar to watercolorists. And, without a doubt, your experiments will lead you to very individual ways of working with tusche.

Fig. 12-34 Sprinkling salt into a water and solvent tusche area to create a dot pattern.

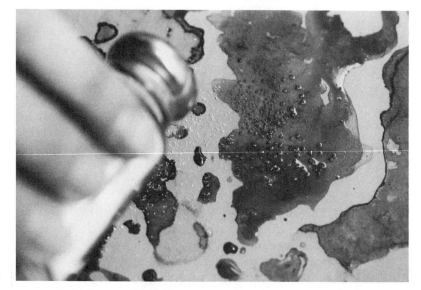

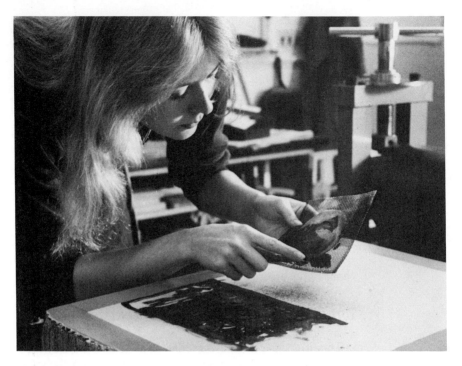

Fig. 12-35 Producing a spattered/spray effect by rubbing a tusche-soaked toothbrush across a piece of screen.

DRAWING WITH AUTOGRAPHIC INK

This item is a form of water-based tusche. However, it is much greasier and produces a very solid line or area. It should not be used for washes.

Unlike tusche, it is transparent brown in color, and therefore may be deceiving. Although the brownness and transparent quality of autographic ink indicate that it will print in light values, this is not the case at all. Think of it as a very black medium.

To work with it in a calligraphic painterly way, use it direct, after shaking the bottle thoroughly, with Japanese and watercolor brushes. It is excellent for pen and ink uses, but it must be slightly thinned with distilled water in this case. Pour a small amount of autographic ink into a separate container, and add, drop by drop, enough water so that it flows evenly from your pen point. Practice with it, using all the different points you have, on a piece of drawing paper, making sure that it is flowing easily and allowing for ultimate flexibility in the drawing. Then work directly onto the stone without pressing too hard with the pen points, or they will wear down very quickly on the coarse stone surface (Figure 12-36).

This item also can be used to spatter or spray, or in other similar ways. It is especially good for producing solid black areas of space by using it straight. However, if the area is very large and you want it very solid, put

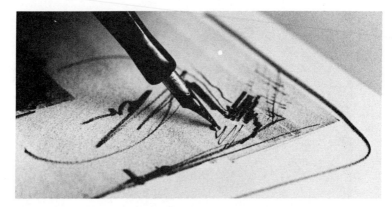

Fig. 12-36 Using pen and autographic ink on stone.

down two or three layers of autographic ink, waiting for each layer to dry thoroughly before placing another layer on top.

DRAWING WITH AUTOGRAPHIC INK STICK

This item is extremely greasy and comes in hard, medium, and soft grades. The hardness or softness does not relate to the grease content, for they all have equal amounts. The varying grades are produced to vary the drawing possibilities. Because it is very greasy, it would normally be used last, over other drawn areas or in distinctly open undrawn areas.

As when working with compressed charcoal, the stick should be rubbed onto a piece of chamois or similar material. This material is wrapped around the finger and rubbed gently onto the stone (Figure 12-37). Slowly

Fig. 12-37 A piece of chamois with autographic rubbing ink applied is then rubbed onto the stone to create a charcoal or graphite effect.

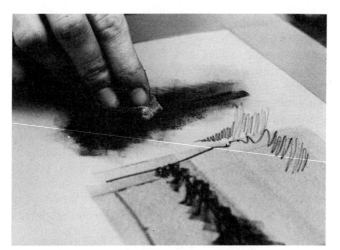

build up the changing rubbed tones; the hard stick will put down a lighter, crisp tone, while the soft will put down a dense, smudged tone.

DRAWING WITH TRANSFER INK

Transfer ink contains an extreme amount of grease and will, therefore, produce the most dense solid. To work with it in this way, designate that specific area requiring the heavy solid, and cut a stencil from a piece of tracing paper that blocks surrounding areas and exposes only the area to receive the transfer ink. Now place a little of the ink onto an inking slab and roll it out onto a small (appropriate size) rubber brayer. Place the tracing paper stencil in place, and roll out the ink onto the exposed stone. Repeat this until an even, heavy layer is apparent.

DEVELOPMENT OF THE DRAWING

All the lithographic drawing items discussed can be used in combination with each other. It was recommended to begin only with a crayon drawing. After mastering the crayon drawing, it is further recommended that you add one item at a time to the list, that is, tusche washes with crayon added; tusche washes, autographic ink solids, and lines, with crayon added; tusche washes, autographic ink, rubbing ink stick, and crayon added; and so on. In this way, after preparing and printing each stone, accurate notes can be kept to aid in a better understanding of the relationship of the drawing to the final print.

It should be noted that normally, within the limitations of the drawing medium, what you see in the final drawing is usually what you will get, if you process and print the stone correctly. As long as you work from light to dark, hard to soft, and take into account the varying values of water tusche, solvent tusche, and autographic ink, the printed edition should be very close to the appearance of the stone when the drawing has been completed.

At this point, you should very carefully study the finished drawing. Take note particularly of the darkest areas (remember that the autographic ink and transfer ink will print the darkest), and then of the lightest areas. You can make a quick simulated paper drawing indicating the tone changes if you do not trust your memory. These notations will become very important in later process stages.

PROTECTING DRAWN IMAGE FROM ETCH MIXTURE

The first step in the processing of any drawing is to protect it from the burn-out possibility created by the acid in the etch mixture. To accomplish this, sprinkle a liberal amount of fine powdered rosin over the surface of the stone, making sure that the drawing is thoroughly dry (Figure 12-38). Take a small piece of pure cotton, roll it into a ball, and very gently push the

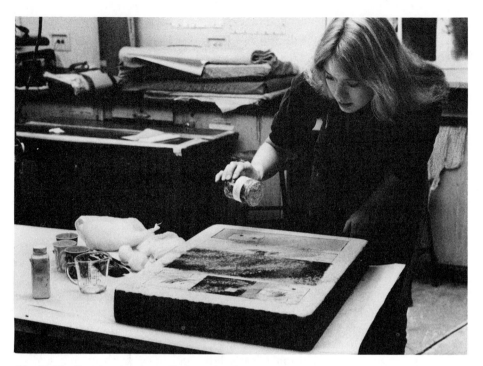

Fig. 12-38 Powdered rosin applied to a drawing on stone after thoroughly dry. The rosin is gently buffed into image with cotton and then the stone is sprinkled with talcum powder.

Fig. 12-39 The talc is also gently buffed into image.

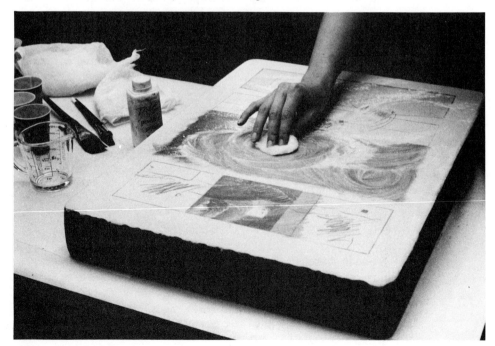

rosin around so that it coats the drawn areas evenly. With equal handling, lightly buff the rosin into the drawing with the cotton, using a circular motion. With a second piece of cotton, brush away the extra rosin laying on the stone surface. Finally, blow the excess away.

Now sprinkle a liberal amount of talcum powder onto the stone surface, and, with another piece of cotton rolled into a ball, gently spread the talc evenly across the drawn areas. Again, lightly buff the talc into the drawing with moderate pressure and a circular motion (Figure 12-39). Take another piece of cotton, brush the extra talc away from the stone, and blow away any excess. The drawing is now ready for the first etch.

THE FIRST ETCH

You must remember that you are not actually "etching" the stone, that is, corroding away stone areas. The acid used in the mixture is the reason for the term, but it is used in very low quantities as a means to set firmly the grease particles into the stone; it does not lower the surface of the stone by corrosive action in any way.

Every drawing, and every drawing material, requires different amounts of acid in the etch mixture. Also pertinent is the hardness (greyness) and softness (yellowness) of the stone. Another consideration is the amount of time the etch should be left on the stone. And the air humidity and temperature play an important role. All of these variables require simple to complicated controls on the part of the printmaker. Some of these controls will be discussed, but it should be noted that once you have acquired a basic understanding of the effects of these variables, your own common sense will determine the proper controls.

An average etch mixture for a crayon drawing is 15 drops of nitric acid to 1 ounce of gum arabic. The gum arabic solution is the prime item in desensitizing the nondrawn areas, while, as stated before, the acid is meant to set the drawing firmly. The gum is extremely attractive to water, and thus aids in fulfilling the basic principle of lithography—water and grease do not mix. One ounce of gum is sufficient for approximately 320 square inches of stone. An average etch for most tusche washes is 20 drops of nitric acid to 1 ounce of gum arabic. For autographic lines and solids, the average is 10:1. For rubbing ink stick, the average is 23:1. For transfer ink solids, 8:1.

The average time that the etch should be left on the stone while constantly being moved is 3 minutes, never less than 1 1/2 minutes and never longer than 5 minutes. It is more efficient to vary the mixture ratios than to vary the time. Remember that these figures are averages. You must pay closer and closer attention to the many variables that affect the etching process. Some basic rules can help.

1. If a stone is very hard (dark grey), it can take stronger etches as long as the drawing itself is not weak. If a stone is soft (yellow), it cannot take strong etches.

2. A low temperature will slow down the etch process. A high temperature will increase the etch process. Also, excessive humidity will overly reduce the chemical reaction; high humidity will increase the action. These factors are difficult to control, but should be considered as much as possible in determining proper etch mixtures and times.

3. If a drawing contains little grease and appears very light, as may be the case when an image is completed with only a number 5 crayon or a very pale wash, the amount of acid to gum arabic must be reduced considerably. It is possible to etch these areas, at least at the first etch stage, with gum arabic only. If a drawing contains excessive amounts of grease, as would be the case if a drawing was completed totally with a number 00 or 1 crayon, the amount of acid to gum arabic should be increased to a suggested maximum of 35:1. Take note, however, that solid lines and areas drawn with autographic or transfer ink require weak etches to maintain solidity.

4. Washes that contain much variation in tone and texture should be treated with ultimate caution. Here it is best to start with a weak etch mixture in the first etch, watch the area closely in the roll-up procedure (see below), and increase the etch accordingly at the second etch stage.

5. Drawings containing all or several of the media variations in the extreme, from heavy grease to light, from fragile washes to solids, and so on, should be area etched. This process will be discussed below.

If the area you are working in is fairly dry and comfortably warm, it is possible to continue with the processing after one hour. However, to be absolutely sure that the etch has taken effect, it is suggested that the stone be left for 24 hours. It should be covered with newsprint and stored in a safe place. This first etch can be left on the stone indefinitely without any harm. Keep the stone from being scratched or exposed to excessive moisture while in storage.

AREA ETCHING

When the drawn image indicates a wide spectrum of tonal values, especially in the case of tusche washes, it will be necessary to apply varying etch mixtures together within the 3-minute timetable. To accomplish this, premix every necessary etch, and place each alongside the stone with a container of 2 ounces of pure gum arabic solution. For as many containers you have premixed, place a Japanese or small watercolor brush alongside. Use your large 1″ brush for the pure gum; for example, you have determined from the drawing that you will need a strong etch (25:1), a medium etch (18:1), a medium-weak etch (13:1), and weak etch (6:1). You will, therefore, have four etches prepared, four small brushes, a container of pure gum, and the 1″ brush. Now follow these procedures:

1. Brush the strong etch onto the margins only.

2. Brush the pure gum onto the very lightest of areas.

3. Check the time (begin the 3 minutes), and within the first 15 seconds, brush the weak etch onto the designated area.

4. Within the next 15 seconds, brush the medium-weak etch onto the designated area.

5. Within the next 15 seconds, brush the medium etch onto the designated area.

6. Within the next 15 seconds, brush the strong etch onto the designated area.

7. Within the next 2 minutes, continuously change etches and brushes, keeping each moving within its designated area as much as possible. You do not have to pay attention to those areas with the pure gum only on them as long as you keep the other etch mixtures away from these puddles.

8. Before buffing down stone, pour the remaining pure gum over the entire stone, and with the 1″ brush move the entire mixture for another 15 seconds.

9. With the cheesecloth, wipe and buff the stone as described for normal etching.

10. Clean cheesecloth, brushes, and such.

APPLYING THE FIRST ETCH (Figures 12-40 and 12-41)

Have in front of you the stone that contains the drawing protected by rosin and talc; two 24″ square pieces of clean cheesecloth; a 1″ soft watercolor brush; container of etch mixture; a hand fan; and a clock for timing. Proceed as follows:

1. Mix etch and stir well with brush.

2. Spread onto margins with 1″ brush; do not touch image area.

3. Check time and begin to spread onto entire stone. (Keep mixture moving with brush, adding more as you need to.)

4. Keep adding to and moving mixture for 3 minutes.

5. Put one piece of cheesecloth into a pad and wipe away excess mixture.

Fig. 12-40 The etch is mixed and applied with a large soft brush; notice the slight effervescence that normally takes place.

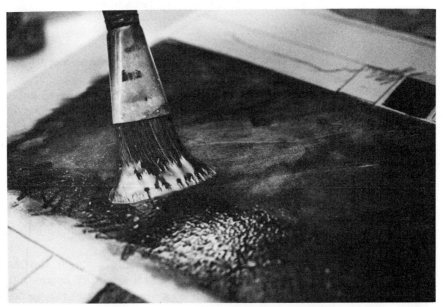

6. Put the other piece of cheesecloth into a pad, buff entire stone using short circular motions and medium pressure. (Do not be alarmed if a small amount of pigment attaches to cloth.)
7. Fan-dry stone until tacky to the touch (check tackiness on one corner of the stone).
8. Continue to fan dry with one hand, and buff the entire stone with the palm of your other hand using tight circular strokes. Buff until stone is completely dry.
9. Let stone sit for 1 to 24 hours.
10. Clean cheesecloth with clean water and hang out to dry for future use. Wash brush in soap and water, removing all gum, and rinse well. Wash out etch container.

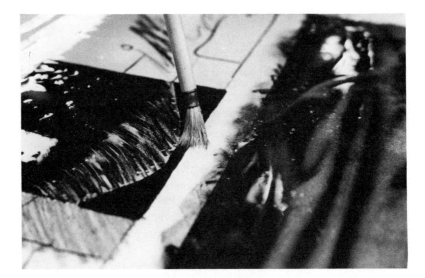

Fig. 12-41 Area etches should be applied with individual small brushes.

It will, at times, be difficult to keep these etches completely separated from each other. Within reason, however, you can always protect those areas not requiring strong etches by creating small pools or outlines of pure gum. Although this method is not absolutely perfect, it will work with more and more practice. Try not to mix too many solutions or you will only cause problems; 3 to 4 mixtures should be more than adequate.

THE SECOND ETCH: INITIAL PREPARATIONS

PRIOR SAFETY PRECAUTION (Figures 12-42 to 12-46)

The stone has been stored for 24 hours or longer; the first etch has completely dried within every pore of the stone. To insure that the gum layer has not been dislodged during storage from moisture or other causes, it is

best to replace the first etch with a new layer of pure gum arabic solution. This is primarily a safety precaution, and it should become habit to accomplish these few procedures after a stone has been stored.

Get ready one bucket of clean water and a clean damp sponge, the bottle of gum arabic solution, two pieces of 24″ square cheesecloth, and a hand fan. Place your uncovered stone in front of you and:

1. Wash old etch from the stone with water and sponge by saturating the stone, wiping up water and loosened gum, wringing out the sponge, and repeating 3 or 4 times.
2. Leave a very thin layer of water on the stone.

Fig. 12-42 Washing the etch off the stone with clean water and washout sponge.

Fig. 12-43 After leaving a thin layer of water on stone, a puddle of gum arabic solution is applied.

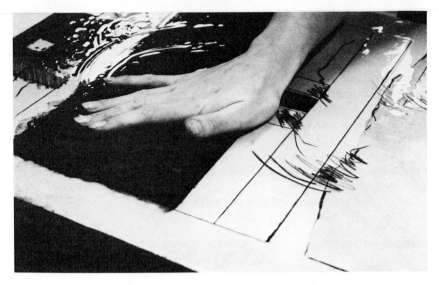

12-44 The gum arabic is carried over entire surface and lightly buffed with hand.

Fig. 12-45 Excess gum arabic is removed with one piece of cheesecloth and a second piece is used to buff the stone lightly.

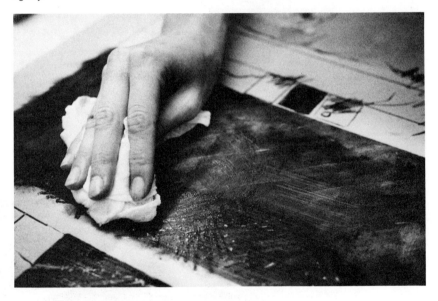

3. Pour a small puddle of pure gum into the center of the stone.

4. With the palm of your hand, carry gum from the center out, covering the entire surface with new gum.

5. With two pieces of cheesecloth, wipe and buff as you did in the first etch procedure.

6. Fan dry and hand buff as you did in the first etch procedure. Buff very tightly, leaving the thinnest of gum layers.

7. Let sit for at least 5 to 15 minutes, insuring that it has dried well. Clean cheesecloth and such, and proceed to roll-up.

Fig. 12-46 The gum arabic is then fan dried while being hand buffed after it becomes tacky to the touch.

THE ROLL-UP

Traditionally, leather rollers were employed for the roll-up of ink and for printing. Eventually, rubber rollers replaced leather for color work. Today, with the perfection of rubber rollers, many shops use them for every type of inking. Accordingly, a good rubber roller that is medium hard (35 durometers) should be employed when available.

The ink used is called roll-up black, which tends to be more greasy than the normal printing ink, is usually stiff (short), and contains no dryers. This ink can be used for normal black and white printing as well as for roll-up procedures.

These procedures result in the replacement of drawing pigment with roll-up black ink. After this is accomplished, the stone receives a second etch, which further secures the drawing and finalizes the nondrawn areas making them highly receptive to water but not to the greasy printing ink. The first step in the roll-up process is to charge the roller and slab with an even coating of roll-up black ink. To accomplish this, you will need alongside your inking slab the rubber roller (which should be cleaned with turpentine) placed in the roller box, a can of roll-up black ink (most lithographic ink is varnish base), a container of magnesium powder, a can of #00 varnish, ink knife (putty knife), a safety can of turpentine, and a few rags. Clean the slab with turpentine and proceed as follows:

1. Open the can of ink and remove paper lid or dried top skin. Be sure that no dried particles of skin remain.

2. Remove a layer of ink and place in one corner of inking slab. (A circle of ink, 2″ in diameter by 1/4″ high, should be more than sufficient for 320 square inches of stone.)

3. Place a thin layer of water or protective spray sealer into ink can to keep it from drying out excessively, and cap it tightly. Place a piece of tape around lid to seal it from the air.

4. Move ink around on slab with ink knife to loosen it up. Place the ink into a small ball, push the ink knife down onto the ball, and lift with the wrist, noticing how high the ink rises with the knife before breaking. It should break at about 2″ to 2 1/2″. If it does, proceed to step 7, for the ink is sufficiently still. If it breaks shorter than 2″, proceed to step 6, and if it breaks longer than 2 1/2″, proceed to step 5.

5. For long ink, add magnesium powder a little at a time until ink breaks at 2″ to 2 1/2″. This may take some time, but it is extremely important to have sufficiently still ink or you will loose the subtlety of your drawn image.

6. For short ink, add #00 varnish a drop at a time, mixing it well into the ink until it draws out and breaks at 2″ to 2 1/2″. (Short ink, when first taken from the can, is usually not a problem.)

7. Place a little of your mixed ink onto the end of the ink knife and spread out a strip evenly the length of the roller.

8. Put ink knife down, pick roller up with both hands from roller box, place it in front of strip of ink, push the roller forward about 16″, and bring it back to the front of the strip.

9. Pick the roller up from the slab about 2″ and rotate it slightly so that when you put it down again, it will pick up ink from the strip in a new area of the roller surface.

10. Again, push the roller forward and bring it back, lifting it and changing position. Continue until the roller is evenly coated with this first strip of ink. (You may change hands, turning the roller completely around, to insure an even application of ink, as often as you think necessary.)

11. Place another strip of ink on the slab, and repeat the procedure. When resting the roller, be sure that you place it back into the roller box; never leave it resting freely on the slab.

12. A roller of 8″ to 10″ in diameter will have a sufficient layer of ink on it by now; larger rollers may require one or two more repetitions of the above.

13. Place the roller in the roller box and clean your hands. Proceed to "Cleaning Pigment Out of Image Area."

Figures 12-47 to 12-53 show the above process.

*CLEANING PIGMENT OUT OF IMAGE AREA
(AND CONTINUED ROLL-UP)*

The drawn image is now ready to be changed from drawing pigment to ink. It must be remembered that you are only removing the drawing pigment while the grease remains on the stone, and, accordingly, as it repels

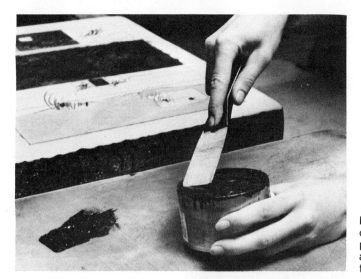

Fig. 12-47 Ink being removed carefully from surface of one-pound can. It is then moved around with ink knife on slab for a few minutes.

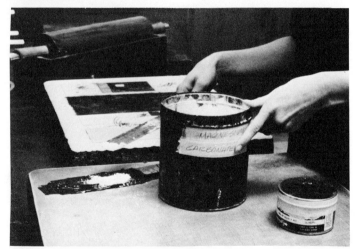

Fig. 12-48 Magnesium carbonate is added to make ink stiff (short). Ink is made long by adding varnish.

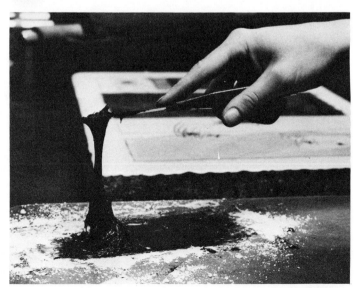

Fig. 12-49 Shortness test indicates ink is still too long. A strip of this short ink is applied evenly to the ink slab.

Fig. 12-50 After more magnesium carbonate is added, ink
tests positively short. Roll-up of roller and slab can begin.

Fig. 12-51 A strip of this short ink
is applied evenly to the ink slab.

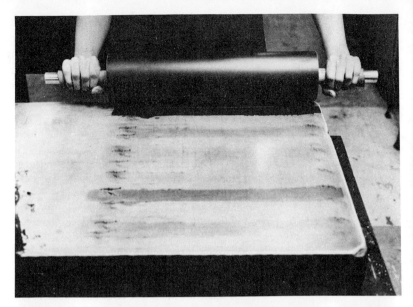

Fig. 12-52 Roller is pushed forward through strip of ink, brought back to start position, flipped slightly to change position, and pushed forward again.

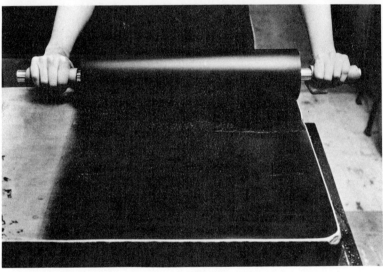

Fig. 12-53 Process is continued, adding more ink strips as necessary, until roller and slab are evenly covered with ink.

water it attracts ink. Therefore, this process requires that you have your stone adjacent to your ink slab and roller (which has already been prepared), plus the following items:

Safety can of turpentine
Clean rags
Two water buckets with clean cold water
Two damp close-pore sponges
One ordinary sponge (wash-out sponge)
One snake slip
Razor blade
Scraping pins or needles

243

Visually take note of your drawing, trying to remember as best as you can what it looks like. Especially notice subtleties and the darkest areas. After you have accomplished the safety precautions described above, and the stone is completely dry, begin as follows:

1. Pour a small puddle of turpentine into center of image area and spread it out with a clean rag.

2. As the black pigment releases from the grease, wipe it up into the rag. Add more turpentine as necessary. Do not overly scrub, but use moderate pressure removing all traces of *black*. The image will still be visual as a "ghost."

3. Continue to wipe until all black pigment is removed. Wipe off entire stone with a clean rag and a little turpentine.

4. Wipe up some ink from a corner of the slab on the last turpentine rag used, and spread it evenly into entire image. Use more ink as necessary until a very thin transparent layer is apparent.

5. Fan dry the stone until any sheen is eliminated from its surface.

6. Wet your wash-out sponge thoroughly and saturate the stone with water. Wipe up this water, which will lift excess blackness.

7. Place a clean bucket of water near you, saturate one close-pore sponge, placing it alongside the stone, and put the second close-pore *damp* sponge on top. (Rotate these sponges often, rewetting as necessary.)

8. Take the top sponge, place it flat against the wet surface of stone, and wipe it across the entire stone. Wring out this sponge in dirty water bucket, redampen with clean water, and rewet stone, placing the sponge on top of the saturated sponge afterward.

9. Pick up the roller with both hands, and, *if the roller will cover the entire image with one roll in any direction*, accomplish this several times, or until the stone appears to lose its thin layer of water. Use minimum arm pressure on the roller. (Never roll ink onto a dry or semidry stone.) Proceed to step number 11.

10. *If the image is larger than the roller*, begin a forward slightly diagonal roll at the bottom left-hand corner, with minimum pressure. When you reach the other side of the stone, turn the roller in an opposite diagonal, overlap the first roll, and pull the roller toward you. Continue across the entire stone until the surface appears to lose its thin layer of water.

11. Hold the roller to one side of the stone so that it is resting on one handle and secured with your hand on the other handle, grab the top sponge with the other hand, and rewet the stone.

12. Place the roller onto the slab and recharge the roller with more ink. (Do not expect to lift more ink onto the rubber until all water marks are rolled away from slab and roller.)

13. Return to the stone, hold the roller to one side, grab the sponge and rewet the stone. Put the sponge back, and make another complete *pass* over the stone, starting at the top left corner this time. A pass is:

depending on the size and shape of the stone.

14. Rewet the stone, recharge the roller with ink, return to the stone, rewet, begin at the top right corner, and make one more complete pass.

15. Continue procedure, keeping the stone wet and recharge the roller between each pass. (When it becomes obvious that more ink is needed on the slab, put a little extra water on the stone, place the roller in the box, put out a strip of ink, take up the roller, and evenly coat roller and slab as before.) Begin at bottom right-hand corner on this pass.

16. Continue procedure, rewetting before and after each pass, recharging roller between each pass, recharging ink slab as necessary, and alternating corners when beginning each pass to insure an even application of ink on the image.

17. You have accomplished a sufficient roll-up when the image is *up full*, that is, the subtlety of the original drawing has completely returned and the darkest areas reflect the same velvet darkness as the original drawing. (Be absolutely sure that the stone is up full; if in doubt, make a few extra passes.)

18. When up full, return the roller to the box and rewet the stone. Take note of any minor errors or blotches of unwanted ink, especially on the edges, and remove them by scraping away lightly with a snake slip, razor, or pin, wiping way the removed ink with the washout sponge. (If you feel it is necessary, you can refile the edges at this time.)

19. When all minor corrections are completed, fan dry the stone. Remove the water buckets and sponges, and proceed to Second Etch.

Figures 12-54 to 12-65 show the above process.

Fig. 12-54 Turpentine is poured onto gummed and dry stone; wiping with soft rag lifts pigment (or old ink) and makes image ready to receive (new) ink.

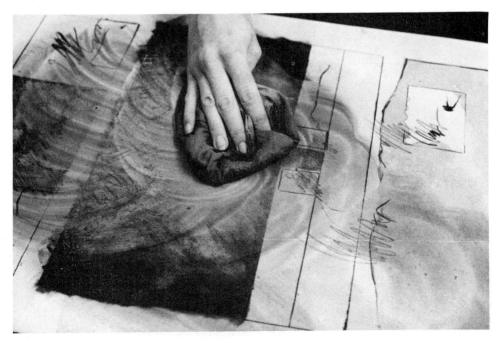

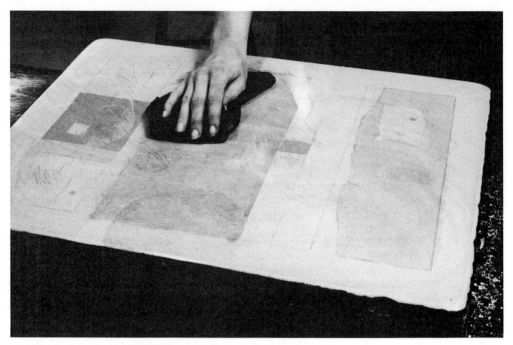

Fig. 12-55 Image should be completely free of old pigment.
Apply more turpentine as necessary.

Fig. 12-56 With clean turps rag, a little ink from slab is wiped
up.

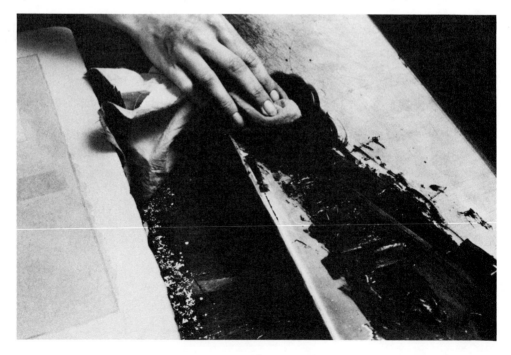

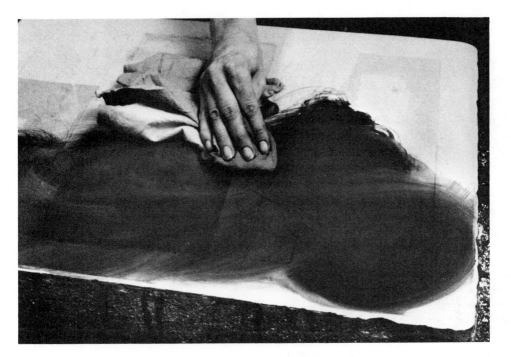

Fig. 12-57 This new ink is rubbed into image to provide a printing base highly receptive to the roll-up. Liquid asphaltum, for a stronger printing base, can be applied in the same way.

Fig. 12-58 The rubbed in new ink is fan dried.

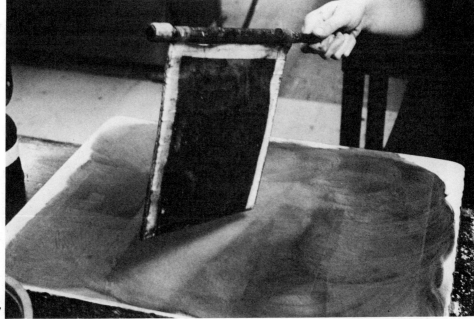

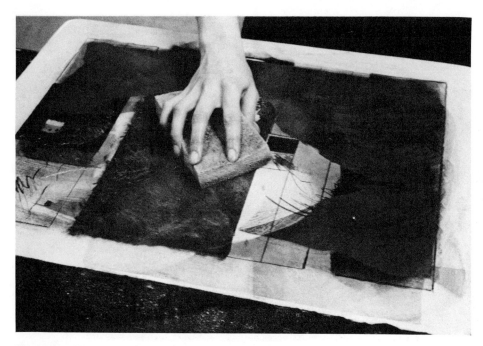

Fig. 12-59 The stone is then *saturated* with water and the washout sponge is used to wipe away the excess rubbed in ink.

Fig. 12-60 The stone is then evenly dampened with clean water and sponges. Note how the roller is held while dampening the stone.

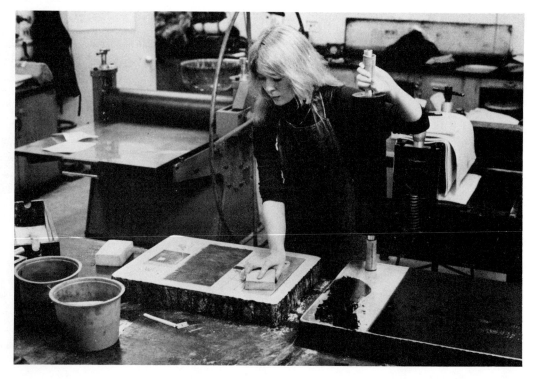

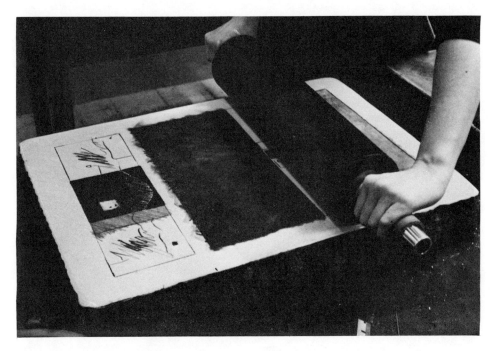

Fig. 12-61 The inked roller is rolled across stone several times covering the entire image with every roll until stone shows signs of drying.

Fig. 12-62 After recharging roller while keeping stone damp, an overlapping pass pattern is begun. The stone must be kept wet throughout the roll-up.

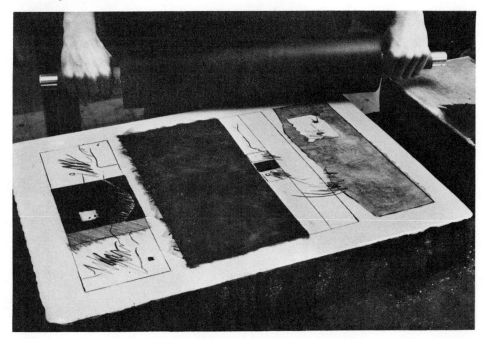

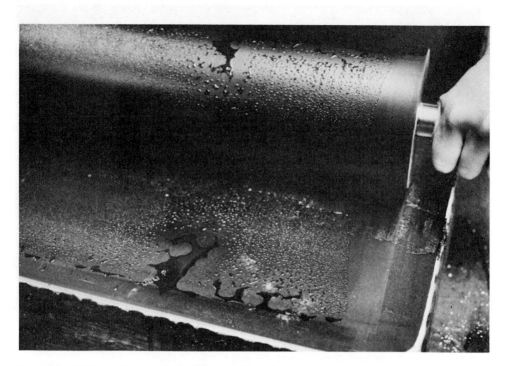

Fig. 12-63 When recharging the roller, insure that all water
has evaporated in the process of rolling up before expecting
ink to adhere to the roller surface.

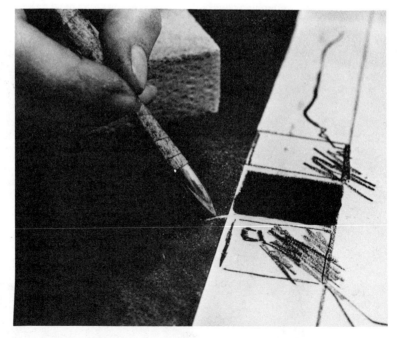

Fig. 12-64 When image
is up full, corrections
can be made before
second etch; a burnisher
point is used in this case
to open a line through a
solid area.

Fig. 12-65 The solid area is lightened slightly by scraping a razor blade across its surface removing some ink/grease. After all corrections are made, the stone must receive another etch.

ROLL-UP PROBLEMS AND SOLUTIONS

Typically, problems arise during the roll-up procedure. Most of them can be solved if you do not panic and do consider possible solutions. These problems, and their solutions, usually consist of the following:

1. When the image is not attracting sufficient ink to come up full, your ink may be too short and require a little varnish. Or you are not recharging the roller and slab often enough, or using too much water and not allowing the ink to adhere properly.

2. If this does not correct the above, chances are that you placed too strong of an etch on the stone, or scrubbed away grease (not only pigment) during the cleaning procedures. It is difficult to completely correct this, but the attempt is usually worthwhile. Try to bring the stone up as full as possible, make any minor corrections including edges, fan dry the stone, and rosin/talc well to protect the image. Place a layer of gum arabic solution on the stone following the Prior Safety Precaution steps above. Go back to step number 1 of Cleaning Pigment Out . . . , and instead of wiping in ink for step 4, wipe into the image with a clean rag that holds a little turpentine, a thin layer of *liquid asphaltum*, which is extremely greasy and should attract the ink for a better roll-up. After accomplishing this, continue through all the steps (5 to 20), and your image should then be up full. (Use a weaker etch mixture for the second etch.) If not, the etch or the scrubbing was too drastic, and the image cannot be saved; if this is the case, you will have to regrind the stone and start again.

3. When the image is extremely receptive to ink, and the roll-up seems to be proceeding too fast, where you begin to notice that subtlety is being lost and solids become dense within one or two passes, your ink may be too long. Stop the roll-up procedure, make any minor corrections you feel necessary, rosin/talc the image, and gum the stone as described above. While the stone is drying, clean off the roller with turpentine or kerosene, scrape up ink from the slab and place it back into a ball, mixing magnesium carbonate into

it until it breaks at 2″, or shorter. Start again with the roll-up procedures and continue until it is properly up full. You also may have recharged the slab and roller too often, or used too little water, or let the stone dry too much. Check out these items if you are sure that the ink was sufficiently short when first mixed.

4. If one of the procedures described in step 3 does not alleviate the extreme receptiveness of the ink, the first etch was probably too weak. Proceed to the second etch after up full and increase the etch mixture accordingly. In this case, you will probably lose some of the subtlety of the original drawing, but you will retain the image.

5. If during the removal of pigment from your image, you inadvertently mixed a large quantity of turpentine with water on the stone, it is likely that you totally or partially sensitized nonimage areas to grease. Accordingly, this will result in a totally or partially black stone obliterating the image completely. If this is apparently the problem, you must regrind the stone and begin again. The rule is to never mix water and turpentine on the stone during the roll-up or printing procedure. Although this rule can be broken for certain reasons, the beginner should consider it "cardinal" until he or she totally understands the medium.

6. Two other possibilities may sometimes occur in the roll-up. The first is *tinting*, which is often difficult to notice without pulling a proof at this point. However, if it appears that the stone is retaining an all-over greyness that does not seem to be attached to the stone but part of the water, simply clean out your sponges and replace the water. Make a few fast passes on the wet stone without recharging the roller with ink, and the tinting should disappear. Another is scumming, where you notice the ink adhering to nonimage areas. If the scumming is not severe and you catch it early enough, simply saturate the stone with clean water and without recharging the roller make very quick, brisk passes across the stone several times (quick passes will lift ink), rewet and continue until nonimage areas clean up. If tinting and scumming persist, more complicated procedures will have to be administered. To do so, refer to the scumming/tinting solutions under Printing Procedures below.

Although this is not a comprehensive list of problems at the roll-up stage, these are the most common. Additionally, they should illustrate the characteristics of the process so that you will better understand how to arrive at corrrective procedures. Considering again the basic principle of lithography—that the grease-drawn areas should only and positively attract grease (ink) and the nondrawn gummed areas should only and positively attract water — and considering that the stabilization of this principle is produced by the chemical sensitizing and desensitizing of the stone, your common sense should lead you back and forth over the procedures to arrive at the proper solution to the problem. This deductive and inductive thought process will produce results as long as you maintain a "coolness" and a perceptive eye throughout the process. When something seems to be going wrong, stop, keep the stone wet, and proceed to arrive at a solution, no matter how long it takes. If you choose not to think out the problem and solution patiently, you will never fully understand lithography, the result of which goes without saying.

THE SECOND ETCH

ETCH MIXTURE

Some of the considerations to be made before deciding on the strength of the second etch have already been pointed out. However, they should be briefly considered at this point.

If you noticed that the roll-up took an excessively long time, or you were required to use excessive arm pressure to force the ink into the image, or had to take corrective actions because the image was not receptive to ink, and you have determined that the possibility exists that these problems were caused by too severe an etch, you should mix an etch that reduces the amount of nitric acid to gum arabic by at least one-third. If the problem was to the extreme, you can cut the ratio of acid to gum by two-thirds. The point is that the strong first etch probably "burnt out" all or sections of the image, and although there still is grease in the image, it is very thin. If the grease layer is too thin, or you completely burnt out some grease areas, it may be necessary to "counteretch" the stone, and redraw (refer to the Major Corrections section of this chapter for counteretching and additions).

If the opposite situation arises, where the image became extremely full very fast, and you noticed a loss of detail and subtlety (which is called "fill in"), or you began to notice and took corrective action for scumming, a stronger second etch mixture should be made. If the problem is only scumming, it would be more advisable to area etch with a strong mixture in the scumming areas only. This stronger area etch also can be applied to any spots you corrected with the snake slip. Be extremely careful to not make the etch too strong or get a strong etch where it does not belong, or you will certainly go to the other extreme and burn out sections.

If the stone rolled-up normally and the result was an inked image that very closely duplicated the drawn image, you should mix an etch that is slightly weaker to insure that no burn out occurs and positive retention of the greasy ink on the stone is the result. In this case, reduce the ratio of acid to gum arabic by aproximately one-fifth. Or retain the same etch, and reduce the time of application to 2 minutes.

If you area etched the stone for the first etch, you should area etch the stone for the second etch, altering your original solutions in accordance with the above information.

APPLYING THE SECOND ETCH

Have in front of you the stone that contains the rolled-up image; containers of powdered rosin and talcum powder; two pieces of cotton; two 24" square pieces of clean, dry cheesecloth; a 1" soft watercolor brush; container of etch mixture; a hand fan; and a clock for timing.

Begin by again protecting the image, which is now rolled up with ink, by first sprinkling powdered rosin onto the surface of the stone and buffing it into the image area with a piece of cotton; using talcum powder, the procedure is repeated. Apply the second etch utilizing the same procedures for applying the first etch. Of course, if it is necessary to area etch the stone for the second etch, use the previous Area Etching procedures. Leave the second etch on the stone for at least one hour, and the stone will be ready for printing. If you choose to store it at this stage, leave the second etch on the stone, cover it with some newsprint, and place it in a safe storage area. The second etch can remain on the stone indefinitely.

PRINTING PROCEDURES

PREPARING THE PAPER

It will be necessary to prepare three different types of paper: a stack of newsprint to pull initial proofs and to use as protective sheets between your prints; a few sheets of proofing paper (Basingwerk Heavy, Arches Lightweight, or Rives Lightweight papers are recommended); and a stack of printing paper, the amount dependent on the chosen edition quantity. Although your stone, theoretically, could be used for as many as 800 prints or more, a reasonable edition size for the beginner is 10 to 15 prints. Professional artists rarely exceed 100 prints in an edition. Recommended for printing is either Rives BFK (an all-white paper) or Arches Cover (available in off-white or buff). Chapter 5 gives you a description of these papers, which are also used for intaglio printing, and Appendix A lists paper distributors.

The paper (newsprint, proofing, and printing) set aside for printing purposes must be torn to the appropriate size taking into cognizance the felt side (printing side) of the paper by reading the watermark normally (left to right) (see Figures 5-3 and 5-4 in Chapter 5). Determine how large your image is and add to this a minimum of 3″ margins all the way around. The beginner may wish to add more than 3″, allowing for irregular placement of paper on the stone, which can be corrected after printing by tearing the paper so that the image is "squared off."

In any case, the paper should all be torn, not cut, using the paper preparation procedures in Chapter 5. When it has all been torn properly, place three sheets of large newsprint on a table facing the front of the press bed. On the first piece of newsprint, place first your stack of printing paper felt side (printing side) down and cover it with another piece of newsprint; then place your proofing paper (either side is good for printing) on top and cover with another piece of newsprint; and, finally, place on top of this the stack of torn newsprint for initial proofing. On the middle sheet of newsprint, place a large stack of clean newsprint, which will be used to place between your prints and as a protective sheet in the print-

ing. The third piece of newsprint will be used to place your prints on, separating them with pieces of newsprint from the middle stack as they are printed.

PREPARING THE PRESS

First insure that the press bed is pulled completely out from underneath the scraper box and locked into that position so that it cannot be moved forward freely without releasing the locking handle on the press bed (used for demonstration purposes, see Figure 12-6, is the Charles Brand lithographic press; modifications to the demonstration will be necessary depending on the press you are using). The press bed should be clear of any debris and covered with a sheet of 1/8″ linoleum or heavy rubber. Carefully place your stone in the center of the press bed on top of the linoleum or rubber, making sure there is nothing attached to the underside of the stone. Select a scraper bar that has a tight leather strip attached and be sure that the width of the bar is wider than the image area but smaller than the width of the stone surface; you may have to turn the stone in another direction to get an appropriate size scraper bar. Check the scraper bar to be sure there are no nicks or gouges in the leather; if there are, the leather strip must be changed. If the leather is in

Fig. 12-66 Scraper bar is pushed into box and holding screw is tightened.

good shape, open the set screw on the scraper box and push the scraper bar all the way up with the leather facing down, and tighten the set screw (Figure 12-66). Now unlock the press bed, and push it forward so that the front edge of the stone sits in front of the scraper bar; be sure the scraper bar is centered in the middle of the stone, making any adjustments as necessary (Figure 12-67). Pull the bed back into a lock position.

Fig. 12-67 Press bed is brought forward to determine if scraper bar is centered.

Place on top of your press table a clean soft, white blotter (Cosmos blotting paper is recommended). Be sure that the blotter has no texture, nicks, folds, or gouges in it. Now check your tympan, insuring the underside is clean and that the surface is free of any nicks or folds. Take a small amount of grease or mutton tallow on the tip of a putty knife and spread it across the front side of the tympan (Figure 12-68). With a paper towel, spread the grease over the entire tympan. Place another small strip of grease on the front of the tympan and put it on top of the blotter. While you have the grease out, place an even layer (not in excess) over the face of the leather strip attached to the scraper bar (Figure 12-69). Be careful not to get grease in areas you do not want it; it should be only on the scraper bar leather and tympan. Clean your hands well after using the grease.

Finally, unlock the press bed and push the bed forward so that the front margin of the stone sits directly under the scraper bar (the pressure

Fig. 12-68 Red press board tympan is properly greased.

Fig. 12-69 Grease is also applied to scraper bar leather.

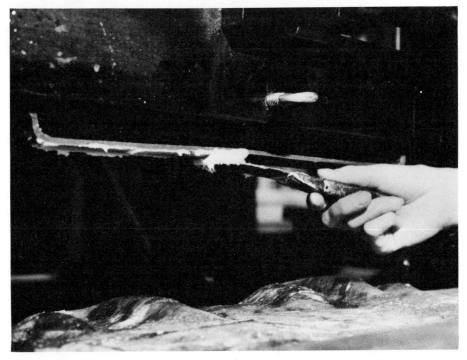

arm should be up and the pressure should be set high to allow the stone to sit under the scraper bar without touching the stone). Place a small piece of 1″ masking tape on the edge of the press bed frame near the frame of the scraper box, and another piece parallel to it on the linoleum of the press bed itself. Push the stone forward some more so that the rear margin of the stone is aligned with the first piece of tape placed on the bed frame, and place another piece of tape parallel to the bed frame piece on the press bed indicating where the rear margin is located. Pull the press bed back to lock position. The tape will tell you where the beginning and ending margins are located without guesswork. These margins will not be readily apparent when the stone is covered with printing paper, protective paper, blotter, and tympan (Figure 12-70).

Fig. 12-70　Tape is applied to press bed and frame to determine beginning and ending margins.

REPEATING THE ROLL-UP

Before rolling up with ink, remove the old etch on the stone by following the Prior Safety Precaution procedures applying a fresh coat of gum arabic to the stone. Besides acting as a safety precaution at this point, the new thin layer of gum will allow for easier washing out of old ink.

Repeat the roll-up procedures on your ink slab, which now should be on the inking table adjacent to the side of the press where the pressure arm is attached. The roll-up procedures are exactly the same, although you may make your ink *slightly* less stiff to assist in an easier roll-up.

Be sure that you have a good even layer of ink on the roller and slab, and clean out the old ink from the image area in the same way you cleaned

out the drawing pigment. Follow the same roll-up procedures exactly. However, you may choose at this point to wipe in liquid asphaltum (slightly diluted with turpentine) instead of ink (step 4 under Cleaning Pigment Out of Image Area), if you noticed that the image took an excessively long time to accomplish the first roll-up or never did come up completely full. This will establish a greasier printing base for the ink to attach itself.

Stop the roll-up procedures when you are sure that the image has come up full with new ink.

PROOFING (FIGURES 12-71 to 12-79)

It is now time to pull your initial proofs to be completely sure that the image is up full and satisfactory. Follow these steps:

1. Keeping the stone wet, recharge the roller and make one more complete pass over the stone. *Do not wet the stone after this pass* or water marks will appear on the proof and you will not get an accurate print reading.
2. Place a sheet of proofing newsprint (from your first stack of paper) on the stone by holding it with cardboard tabs on alternating sides, positioning it over the stone, and gently dropping it onto the stone surface. Do not move it, even if it does not appear to be squarely on the stone. (You can keep your hands from smudging the paper by covering them with talcum powder, away from ink and stone, between printings.)

Fig. 12-71 After roll-up is complete and image indicates it is up full, proofing/printing paper is dropped squarely onto stone using cardboard tabs.

Fig. 12-72 Paper is then covered with newsprint and a clean, untextured blotter is placed over the newsprint.

Fig. 12-73 Greased tympan is then placed over blotter.

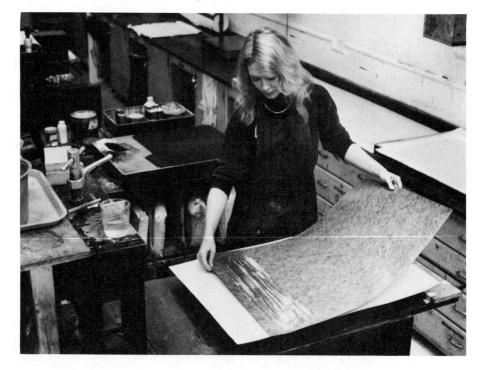

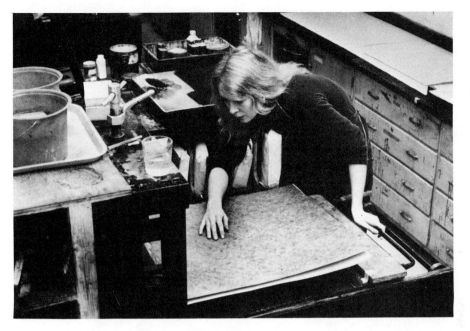

Fig. 12-74 Press bed is unlocked and brought forward so that scraper bar will come down on beginning margin.

3. Cover the sheet of proofing newsprint with another piece of newsprint (from your middle stack).

4. Cover this protective sheet of newsprint with the blotter.

5. Cover the blotter with the tympan, grease side up facing you.

6. Unlock the press bed and push it forward, aligning the first piece of tape on the press bed with the piece on the bed frame. This will place the front margin of the stone directly under the scraper bar. The scraper bar must always begin on the front margin and finish on the rear margin.

7. Pull the pressure arm down, noticing whether or not the scraper bar makes contact with the tympan and a slight resistance occurs. If not, raise the pressure arm and twist the pressure screw (on top of the frame) clockwise a few turns. Bring the pressure arm down again, and continue this procedure until the scraper bar makes contact with the tympan and a slight resistance is noted when dropping the pressure bar in place.

8. Set the clutch (located under the turning handle on the Brand press) by turning it until it snaps into place (a click will be heard). This allows the bed to be evenly and consistently pushed forward under the scraper bar by grinding the crank forward. (When the clutch is set, the press bed is not free to move back and forth by pushing on the bed alone; it must be cranked.)

9. Crank the bed forward until the second piece of tape on the press bed is aligned with the piece on the bed frame, indicating the scraper bar has stopped on the rear margin of the stone. (Never let the scraper bar go past the margin and snap down past the end of the stone; this can crack the stone and damage the press.)

10. Release the clutch by pulling it out and twisting it slightly so that it does not snap down.

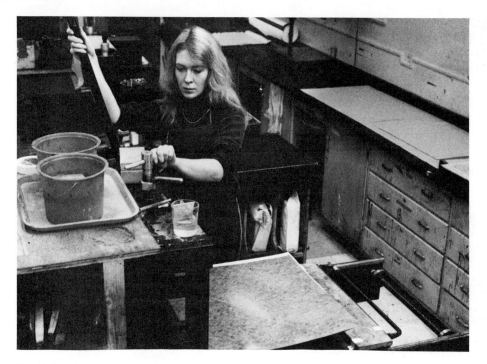

Fig. 12-75 Pressure is adjusted.

Fig. 12-76 After determining proper pressure, pressure arm is brought down, which places scraper bar on beginning margin.

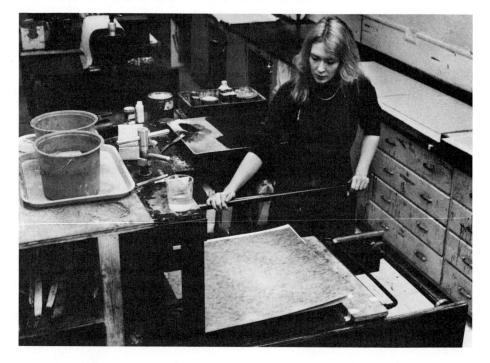

Fig. 12-77 Clutch is turned until it snaps into place. To release clutch, pull it out and turn it a quarter turn.

Fig. 12-78 Stone is pulled through by cranking forward until scraper bar reaches end margin.

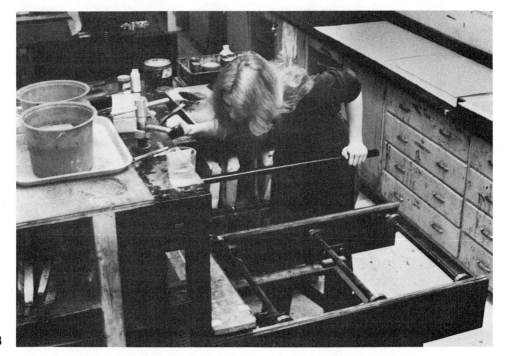

11. Lift the pressure arm all the way up, and pull the press bed back to lock position.

12. Remove the tympan (sometimes the tympan will drop from the surface of the stone and stay in the forward part of the press) and blotter and place them on the press table. Do not get grease on the blotter.

13. Remove the protective newsprint and lay it aside.

14. Remove the initial newsprint proof by grabbing the bottom edge with a cardboard tab and pulling it gently off from left to right.

15. Holding the proof in one hand, dampen the stone with your wet sponge.

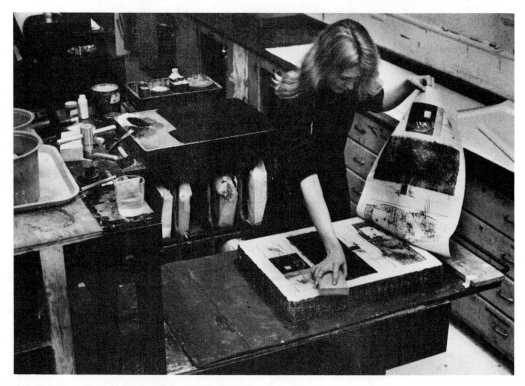

Fig. 12-79 All covering items are removed and print is gently lifted from surface; stone is dampened simultaneously.

16. Lay the newsprint proof on the third piece of newsprint, and check it to see that it is completely up full. You will most likely note that it is not. Recharge your roller (and slab, if necessary) and continue to roll up, increasing your passes accordingly.

17. Continue to pull newsprint proofs following the above procedures until the print indicates it is up full. This should occur in 1 to 4 more initial proofs.

18. When up full on the newsprint proofs, continue proofing procedures on your good proofing paper. Pull one or two of these proofs, establishing that the printing is crisp and clean, that the inking is consistent, and that the image is printing satisfactorily is every way.

After pulling your final proof, check it completely to see that it is perfectly satisfactory. If you notice any scumming (ink adhering to nonimage areas, including the edges), tinting (an overall greyness on the paper), problems in bringing it up full, excessive ink receptivity, and so on, correct these problems before pulling the edition. Many of the problems and their solutions have previously been covered under the roll-up procedures before the second etch. Others, including scumming and tinting, are covered in a following section.

Some problems can be overcome quickly and easily, and the printing of the edition can proceed immediately. Others may require extensive correction, meaning more time and fatigue. If this is the case, do not attempt to proceed to the pulling of the edition at this time. Solve all your problems, and after insuring that the stone is up full, rosin/talc the image, place a gum layer on it, and store it until you can again start the edition printing. When ready to resume printing, wash out the old ink and begin the roll-up again, pulling one or two proofs to be sure that the image is up full and your corrections have solved the problems. Then, proceed to the pulling of the edition. If, at this time, you wish to alter the image completely by either subtracting from it and/or adding to it, proceed to the *Major Corrections* section of this chapter.

Assuming that, after pulling your last good proof, the stone is printing accurately and you are satisfied with the results, it is time to pull your edition of prints. The beginning lithographer will find that 10 to 15 edition prints is the desired maximum. It is possible to pull this amount in one printing session; however, the beginner, not used to the physical as well as emotional energy dissipated during a printing session, may find this attempt overly taxing. The point is, never allow yourself to continue after fatigue has set in, for errors will be the result. At any time you feel tired, bring the image up full, rosin and talc it, gum it following the Prior Safety Precaution procedures, and store the stone until ready to resume the printing. When ready, wash out the old ink, bring it up full, pull a few proofs until it is printing accurately, and resume edition printing.

Following the same printing procedures for proofing, go to good paper and begin pulling your edition. It is recommended before proceeding that you recheck the protective sheet, blotter, tympan, and scraper bar. Regrease the tympan and scraper bar (this may have to be done several times during the printing). Clean your hands, change your water, and wash out your sponges, pin the final proof to the wall near your paper stacks for comparison checking, and you are ready to print the edition.

When using good handmade or mouldmade paper, such as the Rives BFK and Arches Cover, you may find it necessary to increase the pressure of the press *slightly* to compensate for the cushion quality of this thicker paper. Simply turn the pressure screw clockwise a quarter turn. Never use excessive pressure, however, for it will only cause more problems than it might temporarily solve.

After completely pulling the edition, you can leave the stone to dry as is, or wash out both ink and grease with a little gasoline, making it easier to regrind for future use. If you have any intention of reusing the same image, it must be rolled up full (with the same roll-up black ink), rosined and talced, gummed, buffed and fan dried, covered with newsprint, and properly stored.

The prints, stored with newsprint between them in an open space with nothing placed on top, will dry in approximately 24 to 48 hours. You can speed the drying time by pinning them to the wall from one corner of the paper, allowing the flowing air to quicken the speed of drying. After completely dry, they can be torn down to "square off" the image. Measure out the image area, leaving at least 1 1/2" borders, placing pin holes through the paper. Place a sheet of clean newsprint on your worktable, place the print upside down on the newsprint, align a straight edge along the pin holes, and tear the paper straight up to you allowing for an even, deckled edge. The prints then should be stored between sheets of glassine or tissue paper in an appropriate storage cabinet. (See Chapter 5 for edition numbering, titling, and signing of prints.)

PRINTING PROBLEMS AND SOLUTIONS

1. When the image is overreceptive to ink coming up full in one or two passes and beginning to fill in where a loss of subtlety is apparent, fan dry, rosin and talc image, and gum the stone. Check your ink and make sure it is stiff enough. Check the slab and roller to see if you have too much ink built up on both. If you think it is due to a weak second etch, instead of simply gumming the stone, put a 10 to 15 drop etch on the image for 2 to 3 minutes depending on the severity of the fill in. After correcting, remove the old ink and proceed with the roll-up and proofing.

2. When the image is underreceptive to ink where it takes numerous passes to bring it up full, or it seems never to come completely up full, fan dry, rosin and talc image, and gum the stone. Check your ink and make sure it is not overly stiff. Check the slab and roller to see if you have recharged both often enough. Be certain that you have rolled out excessive water on the roller before recharging it with ink. Be certain that you are not using excessive water on the stone; it needs only to be damp with a very thin layer of moisture on its surface. If you think it is due to a strong second etch, remove the old ink and wipe in liquid asphaltum (step 4 of the roll-up) instead of ink, proceeding normally from this point. Continue to roll up until it indicates it is up full on the proofs.

3. When roller marks appear on the image, you have built up too much ink in some areas. Bring image up full, fan dry, rosin and talc, and gum stone. Wash out the ink, and roll up with a thinner layer of ink on the roller, overlapping your strokes more consistently and alternating starting corners with each pass.

4. When scumming appears, where ink is attaching to nonimage areas, it can be corrected if caught soon enough with a scumming solution. Mix 5 drops of phosphoric acid to 1 ounce of gum arabic to 5 ounces of tap water and secure a small piece of undyed cotton felt or several layers of soft undyed cotton cloth. Saturate the felt or cloth, place it around the tip of your index finger,

and, with little pressure, gently wipe away the scum. Wash the stone with clean water and your wash-out sponge and continue to roll up. This scumming solution can be applied at any time during the printing to keep the edges clean and to remove scum. Additionally, if used very carefully, it can restore subtle areas that have slightly filled in. Never, however, overuse the solution, for it can burn out image areas.

5. When scumming has gone too far, and the scumming solution is not working, bring image up full and stop. Keeping the stone wet, clean out scum areas, including the edges, with snake slip. Wash stone, fan dry, rosin and talc image well. Mix a solution of 30 drops of nitric acid to 1 ounce of gum arabic. Pour a puddle of pure gum arabic solution on the stone and wipe it across the entire surface. While this gum layer is wet, brush carefully the strong etch mixture onto those areas where you cleaned the scum away, including the entire margin. Let it sit for two or three minutes, and buff down normally with cheesecloth and hand. Let dry for 15 minutes, and repeat roll-up and proofing. If scumming persists, repeat procedure making sure you stop only after image is up full.

6. When tinting appears, where proofs or prints show an all-over greyness, quickly replace your water, wash out your sponges thoroughly, saturate the stone with this new water, and without recharging your roller make several quick, brisk passes across the stone, rewetting as necessary. Pull a newsprint proof without reinking the image, which should lift leftover dirty water. Continue to roll up the image, recharging roller and slab accordingly. If tinting still appears on the next proof, mix a solution of 6 drops of nitric acid to 1 ounce of gum arabic to 3 ounces of cold water. Pour some of this solution onto the entire stone, keeping it moving with the sponge for 30 seconds, and wipe away with wash-out sponge. Continue to roll up and pull another proof. Tinting should disappear within one or two more proofs; repeat procedure as necessary, but do not overuse.

7. When a vertical mark or line appears on the print, you should check the tympan, blotter, protective sheet, and scraper bar for nicks, gouges, folds, or debris (perhaps imbedded in the grease). If the mark is horizontal on the print, you probably stopped the scraper bar on the image when cranking it through the press; this will sometimes correct itself on successive proofs. If not, bring the image up full, fan dry, rosin and talc, gum, let sit for 5 minutes, and repeat roll-up.

8. When inconsistent printing is apparent, it is probably due to inconsistent inking, overinking, inconsistent water application, uneven arm pressure when rolling up, or inconsistent press pressure (constantly changing the pressure of the press). Try to establish a printing rhythm, counting your passes, counting the amount of rolls necessary to recharge the roller with ink (after removing all water marks), starting and stopping the passes at alternating corners, recharging ink slab evenly and consistently, and maintain an established optimum press pressure (do not use excessive press pressure for this will most certainly destroy your image, break down the desensitized areas, cause unnecessary printing fatigue, and damage press and/or stone).

9. When you notice that the image is inking well but with light or dark areas or spots, your stone is probably uneven, with "hills and valleys" on its surface. This, of course, should have been checked during the grinding procedure. If it is determined that this is the problem at this time, there is nothing you can do but start from the beginning. Putting pieces of paper under the stone to raise it in spots is a precarious procedure not recommended, for it most certainly will result in stone and press damage.

At any time after the first etch, it is possible to alter your drawn image by subtraction or addition, or a combination of both. To subtract imagery, wash off any etch or gum layer. Keep the stone wet, and have available a single edge razor blade, scraping pins of some type, snake slip, and scotch hone, depending on the nature of the subtracting. Keep the stone wet and wipe away removed pigment and grease with a damp sponge. Large areas should be removed first with a scotch hone and gone over with a snake slip, being sure to remove both pigment and grease. Dense areas also can be softened by using the snake slip gently. Sharpen the snake slip with a knife for tight areas. Very tight areas can be removed with a pin or sharp needle (Figure 12-64). The pin also can be used to create negative lines and cross-hatching in solid areas. The razor blade will scrape away the top layer of solids, turning them into varying greys (Figure 12-65).

It is also possible to soften or totally remove areas by mixing a strong etch (40:1 or stronger) and applying it a little at a time to the specified area, washing it away carefully with a sponge after the apparent effervescence stops.

To add to imagery, even in areas that have had imagery removed, you must first counteretch the stone. Mix a solution of 1 ounce of glacial acetic acid to 3 tablespoons of potassium alum (which has been liquified in a little hot water) to 1 gallon of tap water; shake the solution well before using. This mixture can be stored for approximately 4 weeks without losing its counteretch potency. Bring your stone to the sink. If it has a dried gum or etch layer on it, wash it off with a sponge and clean water and follow the next procedures. If it has just been rolled up full with ink (be sure it is up full), fan dry stone, rosin and talc it well, and follow the next procedures.

1. Flood stone with water, tilt off excess.
2. Pour a small puddle of counteretch mixture onto center of stone and carry it across the entire stone with a clean sponge or etch brush for approximately 1 minute.
3. Flood stone with water again, tilt off excess.
4. Repeat steps 2 and 3 at least 2 more times.
5. Wash stone well with clean water and fan dry.
6. Remove stone to drawing table, and add as appropriate with any grease drawing item.

If the stone only has been subtracted from, you should mix an etch of 20:1, fan dry the stone, rosin and talc image, cover the stone with a layer of pure gum, and area etch the subtracted spots for 3 minutes, buffing and fan drying normally. Wait 1 hour, and proof/print.

If the stone has been added to, depending on the drawn additions, rosin and talc, mix up an etch or several area etches, and apply as you would a

first etch. Wait 24 hours, roll-up, and second etch normally. Wait 1 hour, and proof/print.

Treat any typical problems in these subtracted or added areas normally.

CONDENSED PROCEDURES LIST: STONE LITHOGRAPHY

Grinding the Stone

1. Check for level stone.
2. #80 silicon carbide until image disappears.
3. Check for "hills and valleys" on stone surface.
4. #120 silicon carbide, 3 to 4 passes.
5. #180 silicon carbide, 2 to 3 passes.
6. #220 silicon carbide, 2 to 3 passes.
7. #240 and #FF silicon carbide, 2 to 3 passes (as needed for a smoother surface).
8. File, scotch hone, and snake slip edges.
9. Blot with newsprint, fan dry, do not touch surface.
10. Cover with newsprint until ready to draw.

Preparation for Drawing

1. Place 1 1/2" margins on stone with red conte.
2. Mix 20:1 etch; paint onto margins; let dry.
3. Initial drawing very lightly placed on surface with red conte.
4. Drawing worked up with various grease drawing items.
5. Tusche and/or autographic ink allowed to dry thoroughly.

First Etch

1. Rosin and talc image; buff tightly with cotton.
2. Mix appropriate etch(es), stir well with soft brush(es).
3. Spread etch on margins.
4. Start 3-minute timing, spread etch(es) on entire stone; keep moving with soft brush, adding as necessary.
5. Remove excess etch with cheesecloth.
6. Buff remaining etch with another piece of cheesecloth.
7. Fan dry until tacky to the touch.
8. Hand buff, gently at first, then tighter as etch dries.
9. Cover stone and let sit at least 24 hours.

Prior to Second Etch

1. Wash off old etch with clean water and sponge.
2. Leave thin film of water on stone.
3. Pour on puddle of pure gum, spread with palm.

4. Remove excess gum with cheesecloth.

5. Buff remaining gum with another piece of cheesecloth.

6. Fan dry until tacky to the touch.

7. Hand buff, gently at first, then tighter as gum dries.

8. Let sit for at least 5 minutes.

Roll-up

1. Use rubber roller; clean with turps.

2. Take top skin off litho ink.

3. Remove appropriate amount and work it loose on slab.

4. Check ink viscosity; add magnesium carbonate to make ink short; add varnish to make it longer.

5. Lay out strip of ink length of roller; no buildups.

6. Roll up until roller is evenly covered with ink.

Cleaning Pigment from Image

1. Take cognizance of drawing; subtlety and darkest areas.

2. Pour small amount of turps on stone.

3. With soft rag and little pressure, wipe pigment from image.

4. Wipe in new ink or liquid asphaltum on clean turps rag.

5. Fan dry.

6. Saturate clean wash-out sponge with water and apply to stone, edges first, then entire surface.

7. Wipe away excess ink or asphaltum, rinsing sponge often.

8. Change water and sponges; place thin layer of water on stone.

9. Make one roll-up pass on stone.

10. Rewet stone.

11. Recharge roller with ink.

12. Rewet stone.

13. Make another roll-up pass on stone.

14. Continue roll-up until subtlety appears and darkest areas regain same dense value; until up full.

15. Keep stone wet, make any minor subtraction corrections.

16. Wipe stone clean; fan dry.

Second Etch

1. Rosin and talc image; buff tightly with cotton.

2. Mix appropriate etch(es), stir well with soft brush.

3. Spread etch on margins.

4. Start 3-minute timing, spread etch(es) on entire stone; keep moving with soft brush, adding as necessary.

5. Remove excess etch with cheesecloth.

6. Buff remaining etch with another piece of cheesecloth.

7. Fan dry until tacky to the touch.

8. Hand buff, gently at first, then tighter as etch dries.

9. Let stone sit for at least 1 hour.

Proofing/Printing

1. Prepare paper; place into 3 stacks near press.
2. Check press, stone, tympan, blotter, and scraper bar.
3. Grease tympan and scraper bar; clean hands.
4. Repeat Prior to Second Etch procedures.
5. Repeat Roll-up procedures.
6. Repeat Cleaning Pigment from Image procedures to step 14.
7. Do not rewet after last pass; pull initial newsprint proof.
8. Rewet stone, check proof, and continue roll-up accordingly.
9. Continue to pull 2 or 3 more initial newsprint proofs.
10. Continue roll-up and pull 1 or 2 good proofs, or until satisfied with printing results.
11. Continue roll-up and begin to pull edition on good paper.
12. Every third print, do not recharge roller; saturate stone and make several quick passes on surface to keep image clear and consistently sharp.
13. After pulling entire edition, wash image out with gasoline and water; if storing stone for future use, bring up full, fan dry, rosin and talc, and gum stone.
14. After prints dry, tear down; sign, title, number, and date; store between sheets of glassine or tissue paper.

Metal Plate Lithography

INTRODUCTION

Although Senefelder experimented with metal plate lithography, and perfected it to a large extent as pointed out in his book, it did not find exceptional popularity as long as the hand press served as the primary means of pulling a lithograph print. By the turn of the twentieth century, the motorized offset press was perfected, and the metal plate began to supplant the stone for commercial printing. Around the same time, aluminum plates were introduced, which, to some extent, replaced the zinc plate that Senefelder first used.

It is reasonably easy to realize why the metal plate found popularity among commercial lithographers. First, the offset press was designed for metal plates. They were less expensive, easy to obtain, reusable to some extent, easy to handle, quickly processed, and required little storage space. Although the metal plate held some unique aesthetic qualities not possible with stone, artists by far preferred the stone surface for drawing and processing. Although both aluminum and zinc plates are used extensively today, especially when incorporating photolithography

Fig. 13-1 Zinc plate lithograph (crayon, autographic ink, and rubbing ink stick). *Bird at Dawn,* 13″ × 20″, Elaine Wechsler, 1974.

in fine art work, the stone still seems to be the preference of the artist/lithographer.

Stone is porous, retains a unique grain, and is more dependable as a hand printing surface. Yet, because of the advanced technology employed with metal plates in commercial work, they have become very dependable as a hand printing surface, and thus the contemporary artist/printmaker, out of the need for more expedient means to the end and for a more available, flexible, and inexpensive process, turned more and more to metal plates.

For the small lithographic shop, set up individually or as part of the school curriculum, metal plates give the most versatile lithographic surface, both in terms of instruction and application. The basic principles of lithography are equally applicable to metal plates. Although the chemicals used are different, the processing is nearly the same as for stone lithography. Modifications in drawing on metal must be made, but they are few and slight. If you can print a lithographic metal plate, you can print a stone as well, and vice versa.

273

Fig 13-2 Zinc plate lithograph (autographic ink). *Sumac,*
12¾″ × 19½″, Sr. Diane Papp O.P., 1975.

Fig. 13-3 Zinc plate lithograph (*peau de crapaud* wash and autographic ink line). *Untitled,* 11½″ × 18¼″, Alice Kahn, 1973.

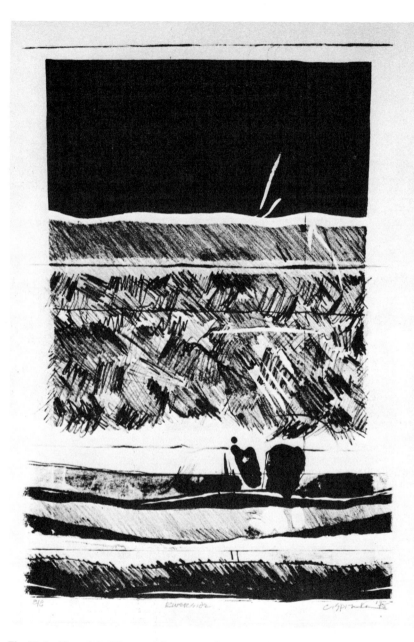

Fig. 13-4 Zinc plate lithograph (crayon and autographic ink).
Riverside, 15″ × 22¼″, Caryl Spinka, 1975.

The equipment and organization of your workshop is almost exactly the same as for stone lithography. Of course, if you do not plan to do any work on stone, the grinding facilities, equipment, and supplies are not needed. Metal plates are ground by commercial lithographic suppliers and delivered ready to use.

It will be necessary to add one item to your press equipment—a 2″ thick metal or hardwood slab used to raise the plate to the appropriate height for hand printing (Figure 13-5). If available, a lithographic stone, 2″ or more thick, perfectly level, and larger than the metal plate being printed, can be used to raise the plate for printing. The slab or stone is placed on the press bed. All other press equipment and procedures are exactly the same as for stone lithography.

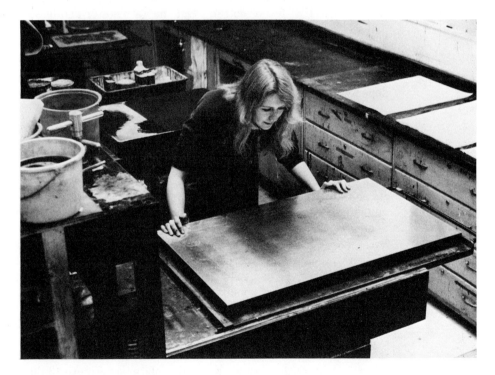

Fig. 13-5 Aluminum slab, 2″ thick, for plate printing, being placed in position on press.

You will have to modify and/or add to your supply list. As pointed out, when not using stone, grinding supplies can be eliminated. Also, you will not need phosphoric acid, scotch hone, snake slip, bubble level, or a rubber apron. You will need 1 pint of nitric acid instead of 1 gallon. Add the following to your supply list:

Weldon Robert's Retouch Stick, 1
Hanco Cellulose Gum Solution, MS-448, 1 gallon (zinc plates)
Hanco Cellulose Gum Solution (acidified), MS-571, 1 gallon (zinc plates)
Hanco Plate Etch, MS-214, 1 gallon (zinc plates)
Polychrome Pro-Sol Fountain Solution #54, 1 gallon (aluminum plates)
Prepared lithographic zinc plates (amount as needed)
Prepared lithographic aluminum plates (amount as needed)
Webril Wipes, 1 package

The Weldon Robert's Retouch Stick will be used to correct metal plates in place of the scotch hone and snake slip. The Hanco solutions are used straight and in combinations with gum arabic solution, as the etch for zinc plates. The Hanco Plate Etch is used as an antiscumming/tinting agent. The Pro-Sol solution serves as an etch and antiscumming/tinting agent for aluminum. Webril Wipes are used with the antiscrumming/tinting agents instead of felt or cotton rags; they are softer and less abrasive.

Plates can be purchased ground specifically for *hand* lithography. This grind approximates a #240 silicon carbide surface on stone and is called a "poster" grind in commercial work. For hand lithography, zinc and aluminum plates should be ordered at .010″ thickness. The overall size is dependent on your press bed and slab (or supporting stone) size (see Appendix A for commercial plate outlets).

CHOICE AND PREPARATION OF PLATE

As pointed out, you have the choice of two different metal plates: zinc or aluminum. Because zinc is more receptive to grease than water, the nonimage areas are much more difficult to stabilize, which causes excessive scumming, loss of subtlety, and increased image fill-in possibilities, difficulties in correcting, and is much easier to add drawing than to subtract. In contrast, aluminum is more receptive to water than grease, creating firm nonimage areas but weak drawings that have a tendency to break down easily, cannot hold extreme subtlety at all, and does not react well to washes. Yet, both do have certain advantages.

Zinc plates can provide very beautiful and unique washes, one of which is called *peau de crapaud* (skin of the toad), caused by the reaction of a water tusche wash on an oxidizing zinc plate (see Figure 13-3); this wash is not possible on either stone or aluminum. Experimental washes using combinations of methyl and denatured alcohol, acetone, kerosene, benzine, and gasoline also are unique to the zinc surface when the plate is slightly heated, allowing for immediate evaporation of the various solvents. A note of caution: using these solvents requires an extreme sense of safety, noting low flash points, toxic fumes, and the possible damages they can cause to human skin. You should only work with them when a fire extinguisher is immediately available, in a well-ventilated and

cool space, and preferably with a vapor mask and rubber gloves. Zinc works quite well with the other drawing materials, staying with high numbered crayons and crayon pencils and using autographic and transfer ink for very beautiful solids, which hold extremely well on this metal surface.

Aluminum is relatively less expensive than zinc, although zinc is usually reground (commercially) two or three times before discarding. The cost of regrinding a plate does not warrant having it done on aluminum. These plates are excellent for quick crayon sketches and do provide a limited amount of intrinsic washes if you wish to experiment. The real value of aluminum lies in photolithography, which, although beyond the scope of this text, can play an important role in advanced work if you wish to incorporate the photographic image into your particular motif.

As one progresses in the medium of lithography, plates in combination with stone will play an ever increasing role. Color lithography, again beyond the major scope of this text, which demands extensive registration of one image over another, makes very extensive use of metal lithography. The ease and speed of handling and its unique qualities provide the artist/lithographer with a wide spectrum of color separation possibilities.

COUNTERETCHING AND SENSITIZING THE PLATE

When purchased, the plate should be kept free of any dirt, moisture, excessive heat, and scratches. Protect the plates with sheets of tissue between, placing them face-to-face in a cardboard box. Store nothing on top of them, and when ready to use, carefully remove them from the storage carton. All metal plates tend to oxidize quickly. This oxidation layer must be removed from the plate before it can be considered sensitized to grease. Accordingly, you will have to mix one or both of the following solutions:

For zinc:
 1/4 ounce of nitric acid
 2 tablespoons of potassium alum, dissolved in one cup of warm water
 32 ounces of tap water

For aluminum:
 1/5 ounce of phosphoric acid (about 25 drops)
 3 tablespoons of potassium alum, dissolved in one cup of warm water
 32 ounces of tap water

Place the solution in a glass or plastic gallon container that can be tightly capped with a plastic top. This solution can be kept for 2 to 3 months before neutralizing. When you are ready to counteretch the plate

before drawing, bring the plate, a plastic or glass tray, and a clean sponge to the sink, and follow this procedure:

1. Place the plate in the tray, ground side up.
2. Wet thoroughly with water and sponge. Pour off excess.
3. Pour in a small puddle of counteretch solution.
4. Tip tray back and forth, covering plate with solution.
5. Scrub the plate surface lightly with sponge.
6. Pour solution out and rewet with tap water.
7. Pour excess water out, and repeat steps 3 to 6 three or four times.
8. Remove plate from tray, blot with a clean piece of newsprint or blotting paper, and fan dry.

Figures 13-6 and 13-7 show the procedure.

Cap your counteretch solution tightly and store with your acids. Clean the sponge and tray well, and put away. Bring your metal plate to your drawing table without touching the surface, which is highly receptive to grease at this point. Place 1 1/2″ margins on the plate with red (sanguine) conte crayon and a very clean straight edge/ruler. Pour into a measuring cup about one ounce of Hanco Cellulose Gum Solution (Acidified) for zinc or one ounce of Pro-Sol Solution #54 for aluminum, and with your soft, flat, watercolor brush, paint the solution onto the borders. Fan dry, wash out your cup, and brush well with water and soap; your plate is now ready to receive the drawing.

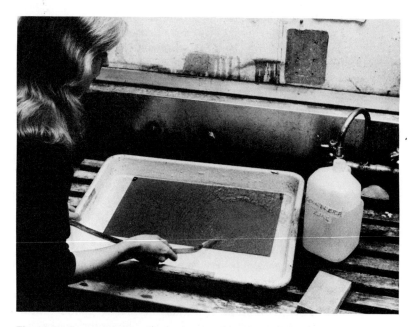

Fig. 13-6 Counteretching begins by covering plate with water and draining.

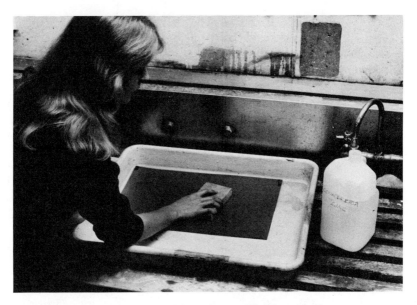

Fig. 13-7 Counteretch is poured onto plate and lightly pushed around with clean sponge. It is then poured out of tray, and the process is repeated a few times.

DRAWING ON METAL PLATES

The intrinsic qualities of the two plates have already been discussed. With this information, choose your drawing materials and place them near the plate at your drawing table. Both plates are usually darker (greyer) in hue than stone; remember this when creating various values. And it should be noted again that zinc is very grease loving and will require little grease buildup relative to stone lithography. Aluminum is exactly the opposite, and will require much more grease buildup in the drawing. In the drawing stage, both plates will accept any of the normal drawing materials used in stone work. However, what you see is usually *not* what you get with metal plates; images on zinc usually will be darker and denser when printed, while aluminum images usually will be lighter, with some loss of very subtle areas when printed.

Both plates require drawing immediately after counteretching and placing of margins. Work from light to dark, and when using washes, place them down first. To get the *peau de crapaud* wash unique to zinc, place a thin puddle of distilled water in the designated area, drop in a slightly thinned mixture of water tusche (90 per cent tusche to 10 per cent distilled water), and *absolutely* do not move the tusche once it has emulsified in the water; let the water evaporate naturally, and the effects of natural zinc oxidation will cause the unique wash as the tusche reaches the plate surface. Other washes on either plate can be created experimentally as you wish, utilizing natural and unnatural (excessive heat)

281

evaporation processes. All other drawing materials should be used in exactly the same way as in stone lithography (see Chapter 12).

PROCESSING METAL PLATES

The processing of metal plates is very nearly the same as stone lithography with the use of different chemical solutions. Therefore, you should refer to the procedures in stone lithography before proceeding. (These procedures will constantly be crossreferenced throughout this section.) The perfectly dry image is protected with rosin and talc, which is separately buffed into the grease with soft cotton, and the appropriate etch or area etches are mixed (according to the chart below) and applied, using the procedure list in the First Etch Roll-up, and Second Etch section of this chapter.

Zinc etches:	
#3, #4, #5 crayon	40% gum arabic solution 60% cellulose gum solution
#00, #1, #2 crayon and rubbing sticks	75% cellulose gum solution 25% cellulose gum solution (acidified)
tusche/autographic ink solids and lines	90% cellulose gum solution 10% cellulose gum solution (acidified)
water tusche washes, light to medium	20% gum arabic solution 80% cellulose gum solution
dark water tusche washes and all solvent tusche washes	60% cellulose gum solution 40% cellulose gum solution (acidified)
Aluminum etches: all crayon and dark water or solvent tusche washes	60% gum arabic solution 40% Pro-Sol Solution #54
light drawings and washes (not recommended on aluminum)	75% gum arabic solution 25% Pro-Sol Solution #54

All etches should be left on the plate, being constantly moved, for 2 minutes. At the second etch stage, depending on how the image rolled up, the time and etch mixture should be increased or decreased as appropriate. It is typical to area etch metal plates (refer to Chapter 12 for these procedures, using the above table for various area etch mixtures).

FIRST ETCH, ROLL-UP, AND SECOND ETCH

You will need all of the materials listed under the equivalent sections for stone lithography. However, you must replace the (phosphoric acid/gum arabic/water) scumming solution with a mixture of 4 ounces of Hanco Plate Etch to 32 ounces of water for zinc, and 2 ounces of Pro-Sol Solution #54 to 32 ounces of water for aluminum. Keep this mixture in a separate

bucket with a separate sponge. You will also replace the snake slip/scotch hone with the Weldon Robert's Retouch Stick. And you will need a few pieces of Webril Wipes.

With all the materials at your work station, make sure that you have applied the rosin and talc on a dry plate correctly and refer back to the appropriate sections in Chapter 12 before taking the following steps:

1. Etch or area etch with a soft brush for 2 minutes on zinc plates; 15 minutes with Pro-Sol Solution #54 on aluminum.
2. Cheesecloth and hand buff; fan dry.
3. Let etch dry thoroughly—5 minutes on zinc, 20 minutes on aluminum.
4. Wash etch off with clear water and wash out sponge. Leave thin film of water on the plate.
5. With pure gum arabic solution, hand gum the plate following safety procedures in Chapter 12.
6. Charge roller and slab with ink, utilizing equivalent stone lithography roll-up procedures. Make ink shorter, breaking between 1″ and 1 1/2″ for zinc plates. Make ink long, breaking between 2 1/2″ and 3″ for aluminum plates.
7. Wash out drawing pigment with turpentine and soft rags as in stone lithography.
8. Take a clean rag with some turpentine on it and rub a thin layer of liquid asphaltum into image. Fan dry.
9. Wash the plate with clean water and wash-out sponge as in stone lithography. Leave a film of water on the plate.
10. With a small piece of Webril Wipe, lift the plate and wipe off surface and rear of plate with wash-out sponge and paper towels.
11. Put a small puddle (about the size of a quarter) of water on the surface where the plate will rest during roll-up, place the center of the rear of the plate over this puddle, and twist the plate back and forth until a suction takes place and the plate seems to adhere to the table surface. This will keep the plate from moving during roll-up.
12. Begin roll-up procedures (as in stone lithography), bringing plate image up full. Make any necessary subtractive corrections with the Weldon Robert's Retouch Stick, using it as a snake slip and keeping the plate wet, making sure that you remove all grease from this area. The stick can be sharpened for close work.
13. Fan dry; rosin and talc image.
14. Mix second etch solution(s):
 For zinc, if image was overreceptive to ink, make the etch stronger by using a slightly larger percentage of cellulose gum solution (acidified) and/or increasing the time by 30 seconds; if image took an excessive amount of time to come up full, decrease the etch by using larger proportions of plain cellulose gum and/or gum arabic solution, decreasing the time by 30 seconds.
 For aluminum, underreceptivity of ink can be corrected by decreasing the etch time alone by 5 to 10 minutes; overreceptive images on aluminum are usually never experienced, but, if it happens, simply increase the Pro-Sol Solution #54 percentage.
 If the image on either plate rolls up satisfactorily, use the same etch solution(s) and time.
15. Repeat steps 1 through 5.

The plate is now ready for printing.

Metal Plate Lithography

The printing of metal plates is equivalent to stone lithography with a few exceptions. Paper should be prepared in exactly the same way, tearing it 1/4" smaller than the plate on all sides. Preparation of the press is the same except for the introduction of the metal or wooden slab, or stone support. The slab or stone should be at least 2" thick, larger than the plate on all sides by at least 1", perfectly level and smooth, and extremely clean top and bottom. Place the slab or stone support on the press bed; it should be centered if it is not exactly the size of the bed. Suction the plate to the slab with a little water in the same way you suctioned it to your table for roll-up. Indicate the plate margins, top and bottom, with pieces of tape that will be visible when tympan is placed over the plate. Again, the scraper bar should be smaller than the plate and larger than the image, and you should be sure that the bar stops and starts on the margins.

Once the proofed image comes up full, change your water and clean your sponges as well (do this often throughout the printing). In addition, you will need less water on the plate during the printing, but be careful not to let the plate dry out.

To remove tinting and scumming, have ready a bucket (gallon) of clean tap water with 4 ounces of Hanco Plate Etch mixed in it for zinc or 2 ounces of Pro-Sol Solution #54 for aluminum. This should be used in two ways: for tinting and very light scumming, simply replace the water with this bucket and wet the entire plate with the mixture, using it as you would water, pulling proofs until you notice the scumming or tinting has been eliminated, then return to using plain water. For heavier scumming, especially on the edges, saturate a piece of Webril Wipe in the solution,

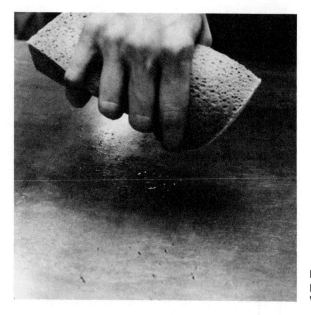

Fig. 13-8 A plate is suctioned to the press bed slab by applying a little water to the slab surface.

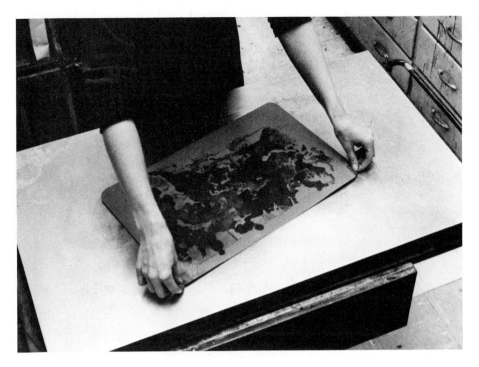

Fig. 13-9 The plate is then twisted back and forth on the
puddle of water until it grabs tightly.

Fig. 13-10 Ink is removed and liquid asphaltum rubbed in as
in stone lithography to obtain a greasy print base.

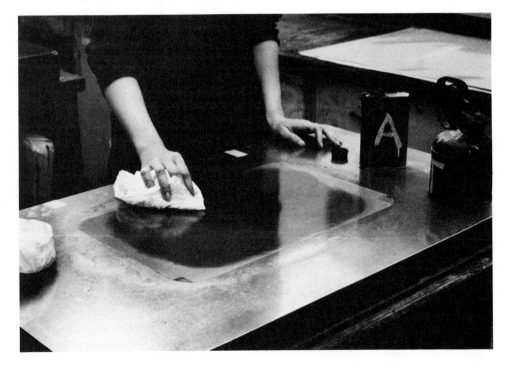

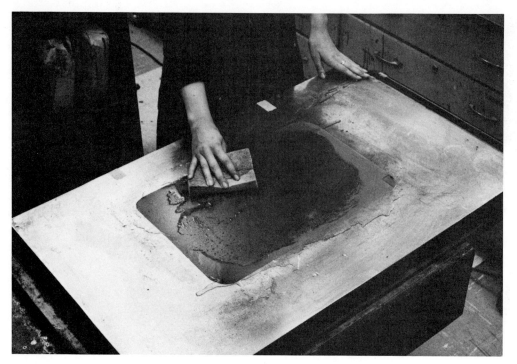

Fig. 13-11 Excess asphaltum removed with water and wash-out sponge.

Fig. 13-12 Plate is lifted, and excess water and turpentine wiped away; plate is then resuctioned to slab.

Fig. 13-13 Roll-up of plate follows the same procedures as for stone lithography.

Fig. 13-14 Proofing and printing of plate follows the same procedures as for stone lithography.

and as you would use the felt with the stone scumming solution, work the scummed ink from the specific area until clean, using little arm pressure and being sure not to break down the image. In either case, do not overuse the solution, or you will surely burn out the image area. If your drawing was particularly frail, mix less plate etch or Pro-Sol, as applicable, to water.

Once you have the image up full, and the printing has begun, do not quit until your entire edition is completed. It is difficult to bring an image on a metal plate back to its original printing state once you have regummed or reetched it.

When the edition is completed, fan dry the zinc plate, clean out the image area with gasoline, and return it to the original vendor, who usually will have it reground for you. Aluminum plates normally are discarded after the edition is completed. The completed prints should be treated as described in stone lithography.

CHANGING AND CORRECTING THE IMAGE ON METAL

As already stated, it is difficult to completely remove image areas from zinc, but adding to it is quite easy. The opposite is true for aluminum—easy to remove, difficult to add. These basic facts should be remembered when considering changes and corrections.

To remove small areas before the first etch (large areas should be removed prior to the second etch), remove the grease and pigment particles with a cotton swab and benzine or gasoline. This solvent will run on the plate, so it must be used with extreme caution or it will surely remove areas you do not want eliminated. Blot the area as you work with it with another piece of clean cotton. Repeat the procedure in one area two or three times, insuring that all grease has been removed. Fan dry the area well, and you can then add to it. If you did not press too hard with the crayon, or allow a wash to adhere thoroughly, the eliminated area should not print.

To remove larger areas or scummed edges prior to the second etch, again clean the designated spots with benzine or gasoline several times. Then work the area well with the Weldon Robert's Retouch Stick, using it as you would snake slip on a stone. If you intend to add to the area removed, in the case of zinc, you must spot counteretch it with a mixture of 15 drops of nitric acid to 4 ounces of water; again, use a cotton swab, working the spot counteretch into the area well, not letting it leak into other image areas, and removing it with another dry piece of cotton after about 2 minutes. You can then add with fairly reliable results. Adding to aluminum is very difficult; the spot counteretch must be much stronger, mixing a solution of 8 drops of nitric acid to 10 drops of phosphoric acid to 20 drops of acetic acid to 1/4 teaspoon of potassium alum to 4 ounces of water. When you redraw on aluminum, the grease content must be much heavier than in the original drawing.

If you decide to remove or lighten areas during the proofing stage, before pulling the edition, you can at this time use razor blades or scratching needles as you would on stone, trying not to score the metal too much (especially in the case of zinc plates, which will be used again). These areas should be carefully etched with a mixture of 50 per cent cellulose gum solution and 50 per cent cellulose gum solution (acidified) for zinc, and 100 per cent Pro-Sol Solution #54 for aluminum, making sure that you have previously rosined and talced the entire image. Let the spot etch dry slightly, then wash it off leaving a thin coat of water on the plate. Hand gum the plate with gum arabic solution, cheesecloth and hand buff, and fan dry, letting it dry thoroughly for approximately 15 minutes before removing the pigment again and returning to roll-up and proofing/printing.

CONDENSED PROCEDURES LIST: METAL PLATE LITHOGRAPHY

Counteretch Plate:

1. Mix up proper formula for zinc and/or aluminum.
2. Place plate in tray, wet, pour out excess.
3. Pour in counteretch, cover plate with it, and scrub with sponge.
4. Pour counteretch out of tray, and repeat steps 2 and 3 four times.
5. Blot and fan dry plate.

Preparation for Drawing:

1. Place 1 1/2" margins on plate with red conte.
2. Paint margins with cellulose gum (acidified) for zinc or Pro-Sol Solution #54 for aluminum; let dry.
3. Initial drawing very lightly placed on surface with red conte.
4. Drawing worked up with various grease drawing items.
5. Tusche and/or autographic ink allowed to dry thoroughly.

First Etch:

1. Rosin and talc image; buff tightly with cotton.
2. Mix appropriate etch(es); stir well with soft brush(es).
3. Spread etch on margins.
4. Start 2 minute timing for zinc and 15 minutes for aluminum, spread etch(es) on entire surface; keep moving with soft brush, adding as necessary.
5. Remove excess etch with cheesecloth; little pressure.
6. Buff remaining etch with another piece of cheesecloth.
7. Fan dry until tacky to the touch.
8. Hand buff, gently at first, then tighter as etch dries.
9. Let zinc sit for 5 minutes; aluminum for 20 minutes.

1. Wash off first etch with clean water and sponge.
2. Leave thin film of water on plate.
3. Pour on a puddle of pure gum, spread with palm.
4. Remove excess gum with cheesecloth.
5. Buff remaining gum with another piece of cheesecloth.
6. Fan dry until tacky to the touch.
7. Hand buff, gently at first, then tighter as gum dries.
8. Let sit at least 5 minutes.

Roll-up:

1. Use rubber roller; clean with turps.
2. Take top skin off litho ink.
3. Remove appropriate amount and work it loose on slab.
4. Check ink viscosity; make extra short for zinc, longer for aluminum.
5. Roll up until roller is evenly covered with ink.

Cleaning Pigment from Image:

1. Take cognizance of drawing; subtlety and darkest areas.
2. Pour small amount of turps on plate.
3. With soft rag and little pressure, wipe pigment from image.
4. Wipe in liquid asphaltum on clean turps rags.
5. Fan dry.
6. Saturate clean wash-out sponge with water and apply to plate, edges first, then entire surface.
7. Wipe away excess asphaltum, rinsing sponge often.
8. Lift plate and wipe table and rear of plate with wash-out spnge.
9. Suction plate to table with a little water.
10. Change water and sponges; place thinnest layer of water on plate.
11. Make one roll-up pass on plate; stop and start on margins.
12. Rewet plate, recharge roller with ink, rewet plate.
13. Make another roll-up pass on plate.
14. Continue roll-up until subtlety appears and darkest areas regain same dense value (zinc will roll up darker).
15. Keep plate wet, make any minor subtractive corrections.
16. Wipe plate clean; fan dry.

Second Etch:

1. Rosin and talc image; buff tightly with cotton.
2. Mix appropriate etch(es), stir well with soft brush(es).
3. Spread etch on margins.
4. Start 2 minute timing for zinc and 15 minutes for aluminum, keep moving with soft brush, adding as necessary.

5. Remove excess etch with cheesecloth; little pressure.
6. Buff remaining etch with another piece of cheesecloth.
7. Fan dry until tacky to the touch.
8. Hand buff, gently at first, then tighter as etch dries.
9. Let zinc sit for 5 minutes; aluminum for 20 minutes.
10. Repeat prior to second etch procedures.

Proofing/printing:

1. Prepare paper; tear 1/4" smaller than plate; 3 stacks.
2. Check press, tympan, blotter, and scraper bar; place slab or stone support on press bed.
3. Grease tympan and scraper bar; clean hands.
4. Repeat "Cleaning Pigment from Image" procedures to step 14.
5. Do not rewet after last pass; pull initial newsprint proof; insure that you place paper squarely within the plate.
6. Rewet plate, check proof, and continue to roll up accordingly.
7. Continue to pull 2 or 3 more initial newsprint proofs, or until satisfied with proofing results.
8. Continue roll-up and pull 1 or 2 good proofs.
9. Continue roll-up and begin to pull entire edition on good paper.
10. Every other print, do not recharge roller; saturate plate and make several quick passes on surface to keep image clear.
11. After pulling entire edition, wash zinc plate with gasoline or discard aluminum plate.
12. After prints dry, sign, title, number and date; store between sheets of glassine or tissue paper.

Transfer Lithography

INTRODUCTION

As discussed in the opening section of Part III, Senefelder used transfer methods to arrive at "chemical lithography" processes. Accordingly, the method of transfer lithography was instantly used by lithographers, finding its popularity mainly among commercial printers involved in poster and illustration art. The convenient nature of the process, allowing an artist easily to carry a piece of transfer paper and work on a drawing at his or her convenience without concern for heavy equipment or extensive supplies, consistently increased its popularity, especially in Europe.

With the increased interest in lithography in the United States over the last 25 years, many contemporary artists began to experiment and exploit the possibilities inherent in transfer methods, utilizing collage, montage, monoprint, and frottage techniques. Because of these explorations, promoted by Tamarind and Universal Limited Art Editions among other major fine art printmaking workshops, today's artist has gained a body of almost infinite possibilities with transfer lithographic techniques in combination with many other fine art media and processes.

292

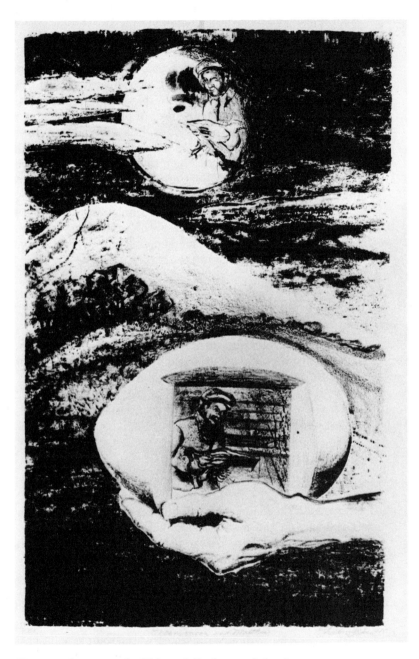

Fig. 14-1 Stone transfer lithograph (frottage and direct drawing). *Man, Moon and Malthus,* 15″ × 23¾″, Sheldon Strober, 1975.

Transfer lithography allows the artist to draw or create directly onto a piece of paper. Because the paper is reversed in the transfer process, the image appears on the printing paper in exactly the same position as it was drawn. All drawing methods suitable for stone or metal plate lithography can be used on transfer paper except water tusche washes. Although this chapter deals specifically with precoated transfer papers, if necessary it is possible to transfer an image from an ordinary piece of drawing paper once one understands the basic principle behind the process.

Once an image is placed on a sheet of precoated transfer paper using the multitude of drawing possibilities, it is adhered face down to a stone or metal lithographic plate, run through the press until the image is transferred, and then processed on that surface in very much the same way you would process a direct drawing. It is not a difficult procedure, but it does take a little practice and experimentation to achieve expertise with the transfer paper, the drawing techniques, the technical aspects of the transfer itself, and the finesse of printing a transferred image. Patient exploration with this medium will surely result in very positive additions to your printmaking repertoire.

ADDITIONAL SUPPLIES REQUIRED

Of course, you will make use of all of the supplies and equipment listed in stone and/or metal plate lithography. Depending on the approach you take with the transfer paper, you will need the following:

> Charbonnel (or other similar) precoated transfer paper (amount as needed)
> Wheat paste (1 lb.)
> White gouache (small tube)
> Glycerine (1 pint)
> Aluminum foil (wide roll)

Besides the recommended all-purpose transfer paper, there are many other types on the market, each with its own advantages and disadvantages. In fact, there are so many different types available that it is beyond the scope of this text to discuss each individually. Once you achieve expertise with the recommended precoated paper, you may wish to experiment with other types.

Basically, precoated transfer papers are made from a base paper usually very thin, sometimes with an intrinsic texture but usually fairly smooth, covered with a coating of a water-soluble solution usually consisting of gelatine, flour, starch, and dental plaster. The coating allows you to draw on it with any grease drawing item except water tusche (because the coating is water soluble). When the paper is properly dampened, the coating releases from the paper and transfers the drawn image to your lithographic surface.

DRAWING ON PRECOATED TRANSFER PAPER

The drawing can take the shape of a directly placed image utilizing lithographic crayon, solvent tusche, and autographic rubbing ink stick (autographic ink is a form of water-based tusche and also should be avoided). You can use these items in exactly the same way you used them for direct drawing on stone or metal plate. However, the true value of transfer paper drawing lies in more experimental methods.

Frottage concepts, where a textural surface is transferred to another surface by means of rubbing with a drawing tool, can be employed with very interesting and exciting results on transfer paper. Take a piece of all-purpose transfer paper and, working with low number (heavy grease) crayons, crayon pencils, or crayon slabs, place the paper over heavy textural surfaces, coated side facing you. Simply rub the crayon across the surface, transferring the raised textures and negative (incised) space to the paper. Textures from gravestones, rocks, shells, cement, slate, cloth, stained glass windows, wooden floors and cabinets, tapestries, relief plates, and the like will all produce beautiful textures not possible to duplicate in the same way with any other method. After you have accumulated your textures on the paper surface, you can draw directly on it with more crayon or other items, pulling the textural drawing together with line and contour (Figure 14-2).

Fig. 14-2 Creating a frottage drawing on precoated transfer paper from photoengraving plates used in commercial printing.

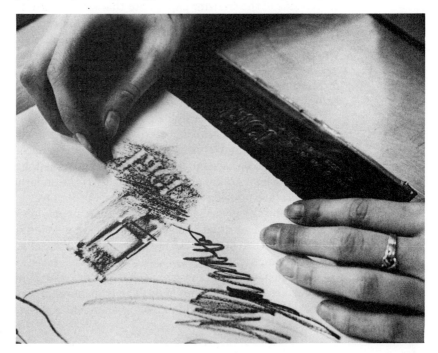

296

*Transfer
Lithography*

Collage methods that employ the gluing to a surface of many different types of items can be very effective in transfer drawings. By accumulating many frottage textures with the above method, you can create a collage on another sheet of precoated transfer paper by cutting or tearing them up and reassembling the pieces to create a total motif. To do so, mix a paste solution from equal parts wheat paste and water, adding to it a little glycerine (1 teaspoon to 1 pint of paste), spread a thin coat of it on the back of each piece of cut or torn transfer paper, and adhere it to the precoated side of another piece of transfer paper. Build your collage continuously in this way until you are satisfied with the results. You can then directly draw or paint on top of the collage.

The process of montage, where a composite is produced from several pictures or photographs, can be used effectively as well. By placing the all-purpose transfer paper, coated side down, over newspaper or magazine photographs or prints (or over other similar offset printed publications including posters) and rubbing with a plastic hone, pencil, or wooden spoon, the image will be transferred to the coated side of the paper. The transfer usually contains enough grease from the offset ink for transferring to the stone or metal plate. You can further dislodge the printed material (if necessary) by first coating it lightly with a layer of paint thinner, alcohol, or nail polish remover. It may be necessary to place a protective sheet of tracing paper between the rubbing instrument and the back of the transfer paper so that the paper does not tear.

Another interesting method is monoprinting on transfer paper. By applying solvent tusche or thinned (with turpentine) transfer ink to a glass surface with a brush or more explorative printing items, and pushing the coated side of the transfer paper onto this wet surface, the painted image will appear as a monoprint on the transfer paper, which can then be transferred to the stone or plate after drying. This method also can be employed to transfer images from other printing surfaces such as collagraphs, woodcuts, linocuts, etchings, and so on. After the image is transferred to the paper, it can be directly drawn on further, or added to after being transferred.

Very interesting white on black drawings can be made by rolling out a layer of transfer ink onto the coated side of the transfer paper, letting it set for about 1 hour, and working over it with white gouache and brush. The gouache should be used fairly thick, but can be thinned slightly with water. When the transfer takes place, the gouache will lie underneath the transfer ink; therefore, during normal wash-out procedures, the ink will be removed and the gouache will lift, revealing a very interesting painterly image that will print as a negative "white" in a solid field of black. This resist method can be used further on your frottage, collage, montage, and other drawings.

Once you have begun these experimental drawing approaches, you will discover very individual methods. The transfer approach is wide open to exploration, and you should exploit it as much as you see fit.

Again, the image can be transferred to stone or plate (Figures 14-3 to 14-9). It is recommended that you use zinc plates instead of aluminum because of zinc's high receptivity to grease, making the transfer much simpler. In transferring to either stone or metal plate, the process is exactly the same. First, be sure that everything has dried thoroughly on your transfer drawing. Next, prepare your stone (grinding it to #240) or your plate (counteretching it) as described in Chapters 12 and 13. Place your margins on the surface with red conte only; do not etch them. These margins will indicate the proper placement of the transfer paper. If the image for transfer is larger than the designated image area on the stone or plate, cut the transfer paper down so that it will lie evenly within the margins. In any case, the paper should be about 1/4″ smaller on all sides than the stone or plate surface. Place the stone in the center of the lithographic press bed, sensitized side facing up. In the case of a plate, suction it properly to the press slab or support stone, which has been centered on the press bed. Identify the margins of the stone or plate with tape on the press bed, and proceed as follows:

1. Dampen the stone or plate with clean water and sponge.
2. Place the transfer drawing, coated side down, on the stone or plate, centering it within the image area.

Fig. 14-3 Wetting a zinc plate for reception of a frottage/collage transfer drawing.

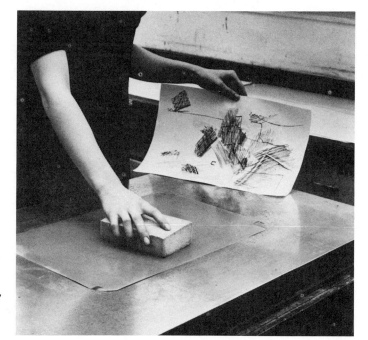

3. Place a sheet of smooth newsprint over the transfer paper; place a blotter (Cosmos blotting paper) over the newsprint.

4. Grease your tympan and place it over the blotter, grease side up.

5. Place appropriate sized scraper bar (larger than image, smaller than stone or plate) in place and grease it.

6. Place stone or plate margin (use tape markings) under scraper bar, bring pressure arm down. Adjust pressure slightly lighter than normal printing.

7. Engage clutch, and crank press bed through until you reach rear margin, and without disengagement of clutch, crank the press counterclockwise, returning the stone or plate to the starting position.

8. Repeat step 7.

9. Disengage clutch, release pressure arm, and bring press bed to lock position. Remove tympan, blotter, and newsprint (discard newsprint) without disturbing the transfer paper.

10. Carefully dampen the back of the transfer paper with clean water and sponge.

11. Place a sheet of smooth aluminum foil, larger than stone or plate over transfer paper to keep water from spreading.

12. Place another sheet of newsprint over the aluminum foil; blotter and greased tympan over the newsprint.

13. Bring press bed forward again so that margin of stone or plate is under scraper bar, and pull pressure arm down.

14. Repeat step 7 four more times.

Fig. 14-4 Transfer drawing is adhered to wet zinc plate.

Fig. 14-5 Plate and drawing are covered with newsprint, blotter, and tympan, and pulled back and forth through press 2 to 3 times at light pressure.

Fig. 14-6 Covering package is removed, transfer paper dampened, and a piece of aluminum foil placed over it.

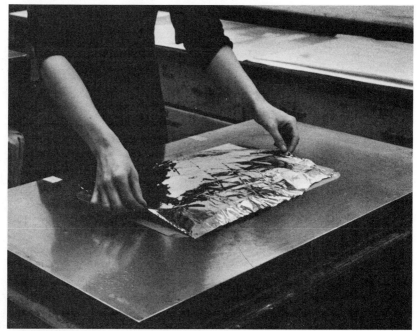

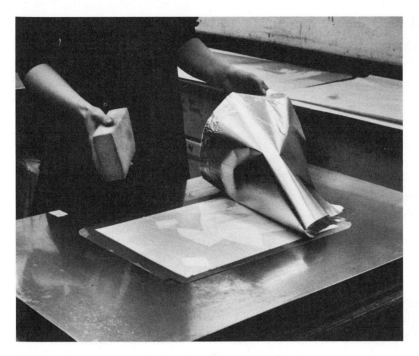

Fig. 14-7 Covering package placed over aluminum foil and pulled through press four more times; covering package removed and transfer checked, redampened, and pulled through press again as needed.

Fig. 14-8 Once transfer paper becomes transparent and drawing appears to have transferred, paper is carefully removed.

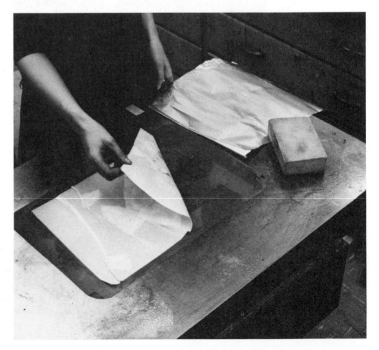

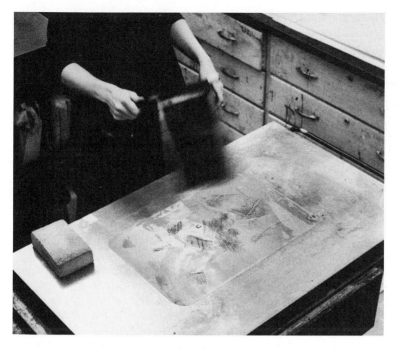

Fig. 14-9 Plate is fan dried after all collage pieces are removed.

15. Disengage clutch, release pressure arm, and bring press bed to lock position. Remove tympan, blotter, newsprint, and aluminum foil carefully. When the transfer paper has become very transparent, so that you can see the image, the transfer is usually complete. To check, lift a corner of the transfer paper, noting whether or not the drawing is now on the stone.

16. If it has transferred, dampen the paper lightly with warm water, and slowly lift it from the stone or plate. It should lift in one motion; if it sticks, wet it again with warm water and peel the pieces carefully from the surface.

17. If it has not yet transferred, repeat the procedures from step 10 to 15 until it has transferred. You should be careful not to overdo it, or use excesssive pressure, or the transfer will be destroyed. Have patience, work slowly, and check as often as you wish to see if the image has transferred.

18. Once transferred, do not touch the stone or plate with anything. Fan dry it only.

PROCESSING TRANSFERRED DRAWINGS
(Figures 14-10 to 14-15)

On stone:

1. Make no corrections at this point. After stone is completely dry, apply a coat of talcum powder only, working very gently with a large piece of soft cotton.

2. Mix four drops of nitric acid to 1 ounce of gum arabic and apply it as your first etch for 2 minutes. Normal first etch procedures.

3. Let stone dry thoroughly for 24 hours.

4. Roll up in normal way for stone lithography.

5. Clean pigment from image in normal way and rub in layer of liquid asphaltum instead of roll-up ink. Bring image up full. Make normal corrections.

6. Rosin and talc, and apply a normal second etch. If the image requires it, area etch the stone. Apply a 20:1 etch to the margins.

7. Process and print the stone normally from this step on.

On metal:

1. Make no corrections at this point. After plate is completely dry, apply a coat of talcum powder only, working very gently with a large piece of soft cotton.

2. For zinc: the first etch should be 100 per cent cellulose gum solution. For aluminum: the first etch should be 25 per cent Pro-Sol Solution #54 to 75 per cent gum arabic. Apply normally for 2 minutes.

3. Let zinc plate dry thoroughly for 5 minutes; aluminum for 20 minutes.

4. Roll up with extra stiff (short) ink.

5. Clean pigment from image in normal way and rub in normal layer of liquid asphaltum.

6. Bring image up full. Be extremely careful of unusual scumming with transferred images on zinc; use normal corrective scumming procedures. Make any necessary corrections with Weldon Robert's Retouch stick.

7. Rosin and talc, and apply the second etch using normal metal plate second etch procedures.

8. Process and print the plate normally from this step on.

Fig. 14-10 After thoroughly dry, talcum powder is gently buffed into image.

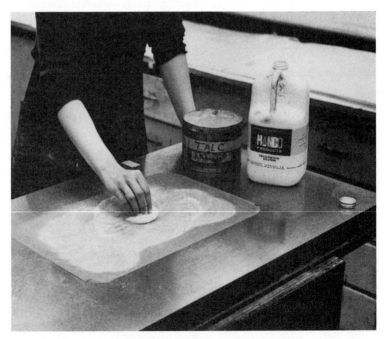

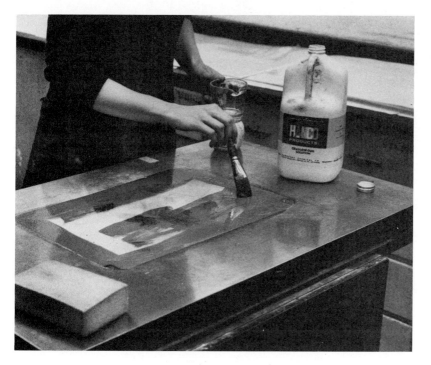

Fig. 14-11 Straight cellulose gum being applied to zinc plate
for 2 minutes.

Fig. 14-12 Plate is then gently cheesecloth and hand buffed.

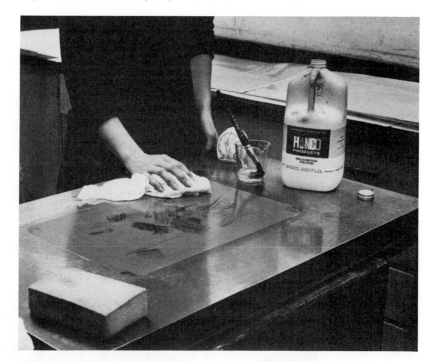

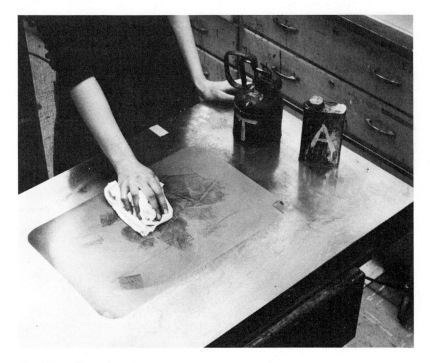

Fig. 14-13 Normal wash out ensues.

Fig. 14-14 Normal roll-up ensues. After up full, plate is rosined, talced, and counteretched lightly so that it will accept further direct drawing.

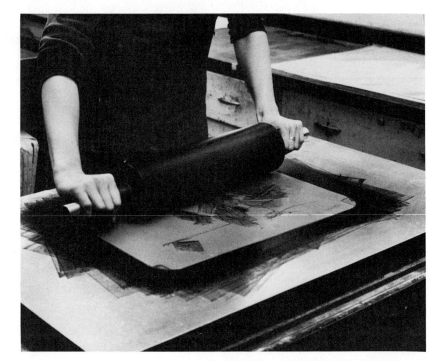

304

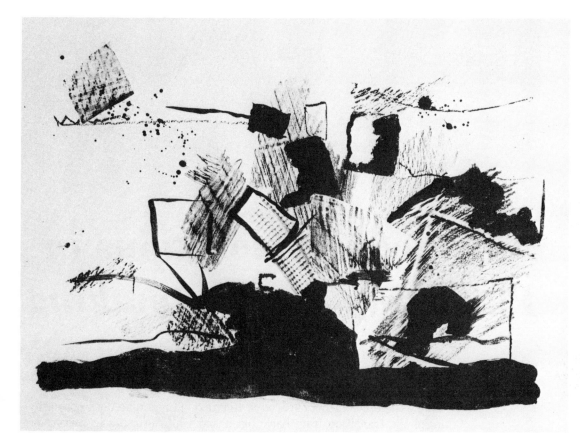

Fig. 14-15 Final transfer lithograph print with direct drawing, by Caryl Spinka.

Advanced Explorations in Planographic Printmaking

COLOR

Unlike the other media covered in this text, lithography does not easily make the transition from basic black and white printing to multicolor printing. This is due to the mass of technical complications that arise with the transition. Accordingly, it is extremely important that the student of this medium research more advanced literature on the subject before proceeding. However, to make you aware of the possibilities that do exist, a brief summary follows.

Colored ink for hand lithography is available from many suppliers, such as Handschy Chemical (see Appendix A). They are usually mixed for commercial lithographic purposes, and when ordered for hand lithography you must state this stipulation. Commercial inks usually contain strong amounts of driers and are usually very long; both of these facts can cause severe printing problems for the hand lithographer.

A plate or stone being prepared for color work is processed exactly the same as for black and white printing. However, when the image is washed out before printing and is ready to receive a rubbing of roll-up ink or liquid

306 asphaltum {step 4 under the Condensed Metal Plate list (Chapter 13) and

step 6 under the Condensed Stone list (Chapter 12)}, replace the roll-up ink/liquid asphaltum with the selected colored ink straight from the can (no additives in it). The colored ink is rolled up stiff as usual and applied to the plate or stone until up full. The proofing and printing proceeds normally, but before the plate or stone is stored (if it is going to be printed again), it must be rolled up in black (roll-up) ink again. To accomplish this:

1. Bring image up full in color.
2. Fan dry the stone or plate.
3. Talc the stone or plate.
4. Apply a coat of gum arabic solution using the hand application method, and buff down tight.
5. Let stone or plate sit for 5 minutes.
6. Roll up slab and roller in roll-up black ink.
7. Wash out colored ink in normal way.
8. Rub in roll-up black ink, wash and wet plate or stone, and bring completely up full. Fan dry.
9. Rosin and talc image and hand apply another coat of gum arabic solution, buffing tight.
10. Let sit for 5 minutes, cover, and store in safe area.

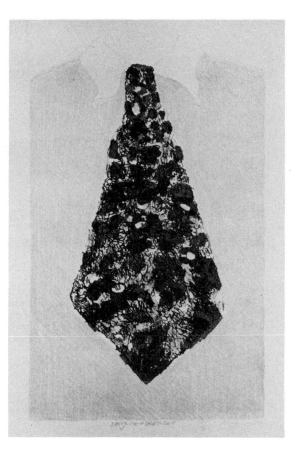

Fig. 15-1 Three stone, three primary colored lithograph. *Nasty-Tie and Shirt Set,* 16½" × 22½", Michael Haynes, 1973.

Fig. 15-2 Stone and plate lithograph, 2 colors. *Untitled,*
19¾" × 27", Caryl Spinka, 1975. (First drawing on stone
consisted of applying a 20:1 etch with pieces of sponge, letting
it dry, and drawing through the open areas with crayon. Second
drawing on aluminum plate consisted of autographic ink and
crayon.)

Fig. 15-3 Stone transposition lithograph, 7 colors. *Process II,*
16″ × 20″, William C. Maxwell, 1972. (A transposition consists
of printing the positive (originally drawn) image first; then
changing the stone surface chemically so that the negative, or
background, areas print.)

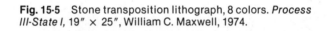

Fig. 15-4 Stone transposition lithograph, 8 colors. *Process 48,*
20″ × 26″, William C. Maxwell, 1973.

Fig. 15-5 Stone transposition lithograph, 8 colors. *Process
III-State I,* 19″ × 25″, William C. Maxwell, 1974.

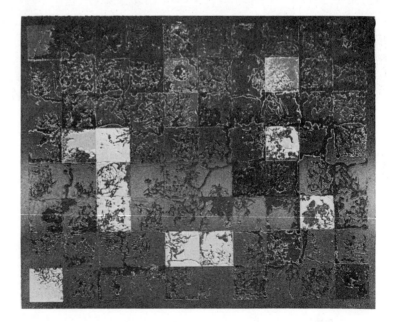

310

Fig. 15-6 Stone transposition lithograph, 7 colors. *Process: 48-State II*, 20″ × 26″, William C. Maxwell, 1973.

The point is, the image can never be left for any length of time with colored ink in it. Once dried, it is almost impossible to remove without destroying the grease receptiveness of the image.

REGISTRATION

A lithographic print requiring several colors either needs a subtractive/additive change on the original stone or plate, or another drawn stone and/or plate for every color. To register multicolored prints properly, a system of placement must be established. Although there are many different systems available, one seems to work in most every case—pinpoint registration.

Before the stone or plate margins are etched, you must draw carefully, on opposite borders (usually the short sides of the surface) 3/4″ of an inch from the edge and centered between the left and right margins, a cross (+) with autographic ink and crow-quill pen (Figure 15-7). The lines of the cross must be very thin, allowing for the smallest of points where the lines cross each other. These autographic ink crosses should be allowed to dry, then rosined and talced before applying the margin etch. When printing your edition in the first color (the entire edition should be totally printed), be sure that the crosses are printing as well.

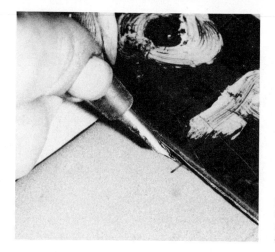

Fig. 15-7 Detail showing the drawing of registration marks using a raised straight edge and crow quill pen point.

When preparing the following plates or stones, first make a tracing of the registration marks and an outline of your image from one of the edition prints. Place a thin layer of red conte on the back of the tracing paper where the traced lines appear, and place the paper over the new surface. With a hard pencil, transfer the conte lines, remove the tracing, place the registration marks onto the surface with autographic ink and crow-quill pen, rosin and talc them, and etch the margins. Use the red conte outline of your original image to determine where to place the next drawing, which can be in separated areas or superimposed (which allows for further color possibilities when working with transparent inks that allow one color to be seen under the superimposed color), or both. It is sometimes advisable to prethink the process and prepare a simulated key drawing before attacking a multicolored lithograph.

To print the new image in the proper place on the original edition, push a small pin (dissecting pins are excellent) through the two printed cross points on each print. On the new plate or stone, place the pin in the cross point gently, and rotate it slightly to create a tiny groove. When ready to apply the printed edition, print by print, to the newly prepared surface in another color, push two dissecting pins through each hole from the back of the paper, lift the paper and pins simultaneously by putting the paper between your middle fingers and holding the pin handle with your thumb and index fingers. Carry everything to the new surface, place the one pin in a groove made at one end of the plate or stone and the other pin in the groove made in the other end of the plate or stone, being aware of the appropriate top and bottom of print and new image area. Hold the pins perfectly perpendicular to the surface, and gently drop the paper onto the plate or stone (it should ride down the pin, falling in exactly the right place). Carefully remove the pins, and print (Figures 15-8 to 15-11).

The procedure will be cumbersome at first, but with practice you will attain perfect registration every time. As long as your draw very thin registration crosses and push through holes in exactly the right place (and do not allow the holes to tear or become larger), there should be no problem

312 in registering every print correctly.

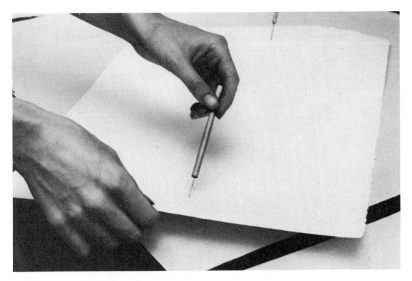

Fig. 15-8 Inserting pins and pin holes through previously
printed image.

Fig. 15-9 Creating a tiny groove in plate by turning pin firmly
within the center of the cross.

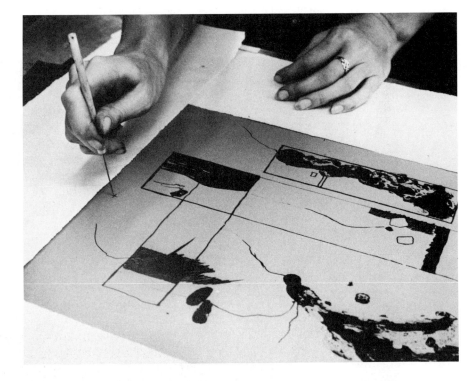

Fig. 15-10 Lining up the pins and paper with the next image on the plate.

Fig. 15-11 Paper is carefully dropped onto plate by letting it slide down pins; pins are then carefully removed without moving paper.

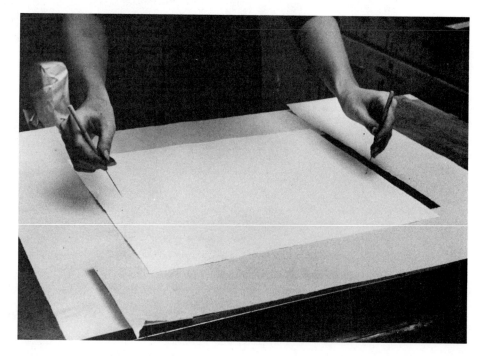

The combinations of possibilities, from stone to stone, stone to plate, plate to plate, and plate to stone, are almost infinite, each having its own intrinsic properties, which can be exploited as much as the image dictates. Further, by working with transparent and opaque inks in combination with each other, color possibilities become almost infinite. To understand such possibilities, a thorough research of color should be undertaken. Then, your first color print should involve the three primary colors only, yellow, red, and blue, in that order. If you print the yellow opaquely, the red very transparently, and the blue semitransparently (your image allowing for overlapping forms), it is possible to obtain the entire spectrum in three printings. After accomplishing this problem, a foundational understanding of lithographic color printing will be formed. From this understanding, the more advanced approaches, such as transpositions, rainbow rolling, stenciling, bleeded images, and so on, will be possible.

IV

PRODUCING AN EXPERIMENTAL PRINT

The exploration and experimentation in printmaking today, as exemplified by the destruction of restrictive boundaries since the early 1950s, has created a new vitality among artists/printmakers. Coupled with a sense of commitment to the production of a fine art image as a first priority and the achievement of ultimate process proficiency as the second priority, this vitality has resulted in many new advances.

The creative mentality that has fostered the new growth in experimental print production, however, is not a new phenomenon. The brief histories of printmaking processes outlined in this text have consistently heralded the admittedly slow development of exploratory approaches. In the early stages, these approaches were considered to be "violent" changes that "necessarily [involved] the destruction of what was valued in the past."[1] Today, however, old values in the arts are being reconsidered, and, rather than rejected, are eclectically applied to new methods and processes of fine art production.

The acceptance on the part of the dealer, critic, and curator of experimentation in the arts without rejecting the past has further fostered the boundaries of imagination and artistic expression. Dedicated artists, new

[1]Minna Citron, "In Deep Relief," *Artist's Proof*, VI (Greenwich, Conn.: New York Graphic Society, 1966), 30.

and old, as well as the fine arts student, now welcome this relatively new climate, and the results have been increasingly dynamic and impressive. Perhaps in no other fine art medium is this more apparent than in print-making. The introduction of new materials and supplies, new and better presses for print production, new processes and techniques both compli-cated and simple, new flexible print reproduction standards, and new inventive challenges for the artist has created monumental interests in a medium that for too long remained latently creative.

The new processes are vast in number and their permanency is yet to be defined. They include such things as plastic printing, vacuum forming multiples, video and computer reproductions, total three-dimensional multiples, photographic combined methods, mixed media, and collagraph printing. All of these innovations employ extensive use of color, break the restrictive size boundaries of past prints, and move the realm of printmaking into extensive self-imaginative images never before realized.

Collagraph

INTRODUCTION

As stated in the introduction to Part IV, experimentation and exploration in printmaking are the "name of the game" today. Many of the discoveries resulting from these very varied approaches are quite ephemeral and ultimately depend on their temporary uses as they meet the aesthetic needs of individual artist/printmakers. However, this innovative approach, every once in a while, results in a discovery that lasts and permanently becomes part of the printmaker's repertoire, not only as a medium to be used in combination with others but as a unique process in and of itself, retaining its own intrinsic values. Collagraph printmaking has become such a medium.

Its history is very recent, and its development and growth seem to have occurred simultaneously in many parts of the world, especially in many parts of the United States. Because the contemporary artist was demanding and creating boundless and borderless demarcations between aesthetic expressions, as well as discovering new ones, media became more and more intertwined. Collage, a French word from *coller*, to glue, became a

very important part of the artist's vocabulary during the twentieth century. Rather than being a medium unto itself, it merged with the concepts and methods of painting, drawing, photography, printing, and sculpture. It was inevitable that collage methods would find their way into the work of printmakers, and by the late 1950s this was very evident in the United States. Much of the credit for its early development belongs to Glen Alps of the University of Washington in Seattle,[1] and later the extensive and very exciting work of John Ross and Clare Romano of the New York City area, both of whom were prominent in introducing the medium to central Europe (Yugoslavia and Romania) as artists-in-residence with the United States Information Agency.[2] (This author is personally indebted to these two very important artist/printmakers for my initial introduction to the medium.)

The collagraph involves materials and supplies that are readily available, and it can be taught in the classroom or individual workshop not

Fig. 16-1 Color collagraph. *Red House,* 14″ × 20½″, Janice Rogers, 1974. (This plate was made from a 1-ply cardboard base, which was incised as well as having pieces of thin paper glued down in "tile" fashion, using modeling paste for texture. Printed in intaglio only.)

[1]Herbert Joseph Appleson, *Developments in Contemporary Printmaking 1950-1970,* unpublished Ed.D. dissertation. Teachers College, Columbia University, 1972, pp. 68-73.
[2]John Ross and Clare Romano, *The Complete Intaglio Print* (New York: The Free Press, 1974), p. vii.

Fig. 16-2 Collagraph embossement with collage. *Untitled,*
16″ × 19¼″, Pat Jobling, 1975.

equipped for major print production. It makes use of both intaglio and
relief methods of printing and incorporates them in a unique and varied
way. It is a very direct method of creating a print, for the production of the
plate is equivalent to the production of a collage painting or constructed
sculpture. Because it makes use of the simplest materials and requires
little technical expertise, collagraph printmaking is the most flexible,
accessible, and feasible of all printmaking processes. The intrinsic possi-
bilities of the medium, which demand more in terms of imagination versus
technique, are sure to excite the novice and professional artist alike.

WORKSHOP, EQUIPMENT, AND SUPPLIES: INITIAL PREPARATIONS

As with etching, a large workshop is not necessary. If you intend to print
your collagraph plates utilizing intaglio methods, a double cylinder press
will be necessary (refer to Chapter 1). However, it is possible to print
321 collagraphs with relief printing methods only (see Chapter 10). That which

is special to the collagraph in utilizing these two methods, **either** independently or in combination, will be discussed in the following sections.

In your workshop storage cabinet, you will need the following supplies (Figure 16-3):

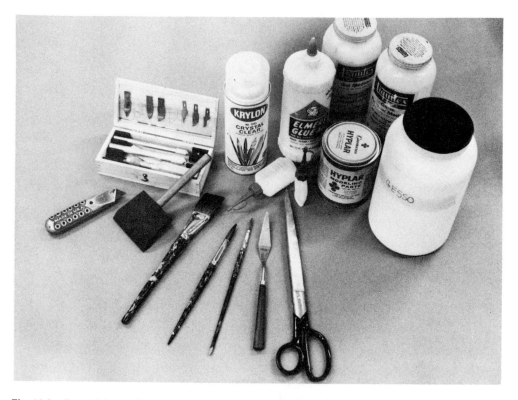

Fig. 16-3 Essential supplies necessary to create a collagraph plate.

Cardboard, index board, or chip board (1/16″ thick)
Masking tape
Pencil
Mat knife
No. 1 X-acto knife, with several no. 11 blades
Scissors
White glue (preferably Elmer's), 1 quart
Polymer acrylic gesso, 1 pint
Polymer acrylic modeling paste, 1 pint
Polymer acrylic medium (gloss medium/gel medium), amount as needed
Liquid plastic spray (preferably Krylon), 1 pint
Bulletin board, or other drying surface

Push pins, no. 5, aluminum

Foam brush (1″ wide)

Nylon painter's brush (½″ wide)

Artist brushes (amount as needed)

Acetate or mylar sheet (amount as needed)

Talcum powder (small container), (asbestos free)

Palette knife (bent blade type)

Stencil brushes (a variety of sizes, as needed)

Brayers (a variety of sizes, as needed)

Inking slab (16″ × 20″ piece of plate glass)

Paint thinner (1 gallon)

Kerosene (amount as needed)

Rubber gloves (should be used with kerosene)

#00 burnt plate oil or raw linseed oil, 1 pint

Ink, oil base (as recommended in the following paragraphs)

Whiting or French chalk

Tarlatan (as needed)

Magnesium carbonate (as needed)

Items to be glued (as recommended)

Newsprint (larger than your plate, as needed)

Printing paper (Rives BFK or Arches Cover Buff or White)

Foam rubber, close pore (as large as press blankets, ½″ thick)

Most of these supplies can be purchased in any art supply store. Some, such as the kerosene, glass slab, foam and painter's brush, and linseed oil can be obtained from a hardware store. The recommended ink may have to be ordered through the mail if not available in your area.

A sturdy working table is an essential part of the shop. If you do not want the table top to be full of cutting marks, you should provide for a cutting surface, either double thick cardboard or masonite.

As with every process, you will need to designate a separate, ventilated area for solvent cleanup. Kerosene, or its equivalent, will be used for cleanup on collograph plates. It is a low volatile solvent that does not break down the glues and polymers used in making the collograph plate. Rubber gloves should be used when handling kerosene, and it should be used only in a well ventilated area. A metal container with a metal cover should be used for discarding solvent-soaked rags, newspapers, and paper towels. Printing paper should be stored flat, if possible, in a clean, well-ventilated area that is not exposed to sunlight or moisture. You will need a source of running water; it does not have to be in the immediate workshop area, but should be easily accessible.

Of course, all the rules for organization of a workshop discussed in Chapter 1 are pertinent to this section as well. Remember to find a working structure and system that are efficient and effective, adapting them to your particular needs, and sticking to them.

The essential advantage of the collagraph base is that it can be made from cardboard, which can be cut into any shape or size very easily and is inexpensive. A single ply, 1/16" thick, cardboard will work quite well. It does not have to be white, and is usually purchased grey or biege in 30" x 40" sheets. Also adequate, but a little more expensive, is index board or chip board, which usually comes with a white, slick face. Old pieces of mat board will work; however, mat board is made from layers of paper that can come apart in the cutting and gluing processes. At times, a firmer base will be necessary; untempered masonite, 1/8" thick, can be used for this purpose, but will require cutting by a jigsaw or sabre saw. Do not use extremely thin cardboard, poster board, or corregated cardboard as a base However, thin pieces of cardboard and paper can be used to build up layers on an already cut base, 1/16" or 1/8" thick.

You can cut the base to any shape or size. It does not have to be cut into a rectangle or square, which are the basic shapes typical of other print-making processes such as etching. Additionally, you do not have to cut out only one shape. Several shapes can be cut and put together for printing in jigsaw puzzle fashion. This allows you to ink the several pieces in several colors without any difficulty. A registration plate (to be discussed later) is made to assemble the pieces properly from print to print. The jigsaw puzzle possibility is another big advantage to collagraphs. Initially, it is recommended that you keep your basic design simple, utilizing two or three shapes as your base. More complicated additions can be made at a later time after fully understanding the possibilities and procedures of the process.

Before cutting the base, you may wish to make a few quick drawings to determine how the design will take shape. By reading this chapter fully before doing anything, a basic understanding should evolve to allow you to plan the drawing, and final platemaking with little difficulty. It is not necessary, at this point, to think about color. The evolution of color choices should be left to the printing process itself.

After deciding on the form of your motif, draw the shapes to be cut directly onto the cardboard with a pencil. For angular shapes, use a ruler (Figure 16-4); for circles, use a compass; for curves, use French curves or draw them freehand, and so on. After drawing out the shapes, place the cardboard sheet on your cutting surface (thick piece of cardboard or masonite), and score the drawn lines lightly with your mat knife (Figure 16-5). Do not undercut the edges, but cut them on an angle so that they leave a slight outward bevel. After scoring the lines lightly, repeat the cutting using a little more pressure; do not try to cut the cardboard completely through with one motion. Change your mat knife blades or sharpen them on an oil/Arkansas stone as necessary. After cutting out your base pieces, check them to see if they are fairly clean on all edges.

To firm up the collagraph base, you may wish to coat it with a thin layer of glue or polymer acrylic gloss medium. This is not absolutely necessary,

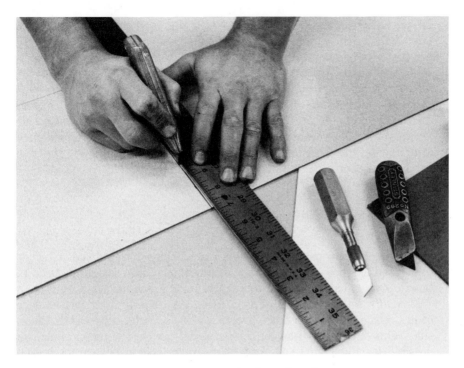

Fig. 16-4 Cutting straight or angular pieces of 1-ply cardboard.

Fig. 16-5 Cutting out curved shapes from 1-ply cardboard.

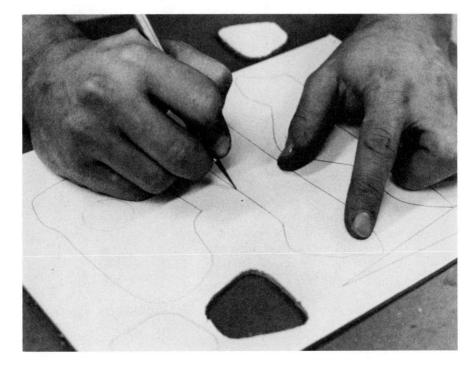

for the entire collage will be covered with glue later on. If you choose to begin with a firmer base, however, mix the glue or acrylic with water (75 per cent glue or acrylic to 25 per cent water), being sure that the water is well distributed. Spread the mixture over the surface of the plate with the foam brush and let it dry thoroughly. Turn the plate over and coat the back and sides with the mixture, letting it dry thoroughly. Do not let any excess mixture build up on the plate, and insure that you have created no air pockets or left open areas on the plate. If you notice any unwanted buildups after drying, you can sand them lightly with some fine sandpaper. The base is now ready for collage building.

SELECTION OF COLLAGE MATERIALS FOR GLUING

Depending on your particular design, you will have to select the materials to be used for the collage. There are numerous items that can be used to build up your plate in terms of texture, tonal areas, and flat areas.

Most any cloth will provide a certain texture. Cheesecloth, tarlatan, lace of all kinds, embroidered cloth, burlap, nylon stockings, terry cloth, linen, silk, items of clothing (gloves, shirts, pants), and crocheted cloth are all possibilities (Figure 16-6). Other textural items include, but are not limited

Fig. 16-6 An accumulation of cloth and string textures.

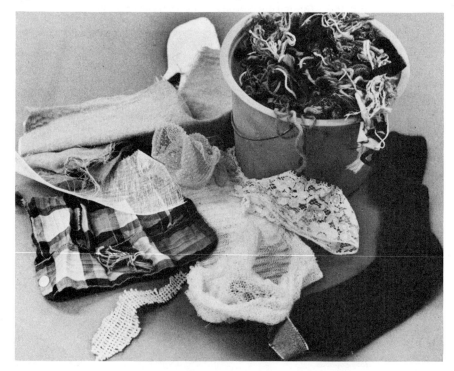

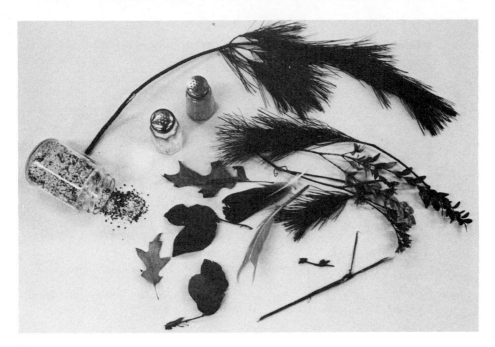

Fig. 16-7 An accumulation of organic textures.

Fig. 16-8 An accumulation of miscellaneous textures.

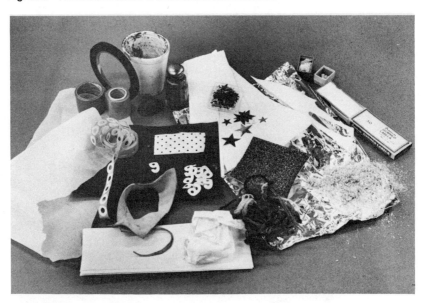

to, tin foil, string, thread, different types of paper, leaves, grass, flower petals, grit, sand, feathers, leather, suede, different tapes, modeling foils, and gummed labels (alphabet letters, numbers, stars, designed shapes, and such) (Figures 16-7 and 16-8).

327

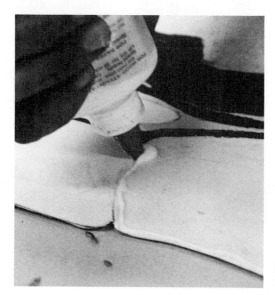

Fig. 16-9 Drawing with Elmer's glue.

Painterly textures can be created with the liquid mediums at hand, such as the gesso or modeling paste, which can be applied with brush or palette knife, or the polymer acrylic gel medium, which can give an impasto appearance. The white glue can be "drawn" onto the plate with the squeeze bottles to form lines, dots, and closed or open contours (Figure 16-9).

Fig. 16-10 Applying oil to a key that will be pressed into modeling paste.

Additionally, the modeling paste can be placed on the plate, and embossed or imprinted with an item such as a key that has been coated with a thin coat of oil or petroleum jelly; when the modeling paste dries, the item easily can be lifted out, leaving the embossed area to catch ink and print its pattern into the paper (Figures 16-10 to 16-13). Food items can also be used, such as coffee grounds, alphabet noodles, or cereals of all kinds.

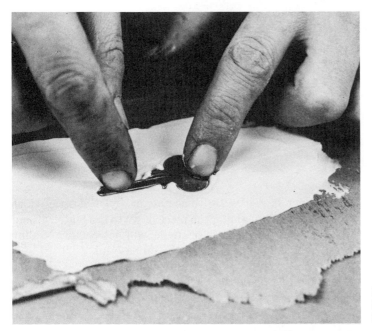

Fig. 16-11 The key being firmly pressed into modeling paste.

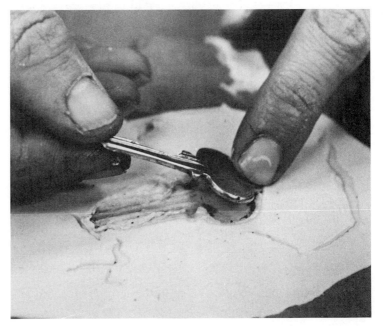

Fig. 16-12 After modeling paste has dried, the key is removed.

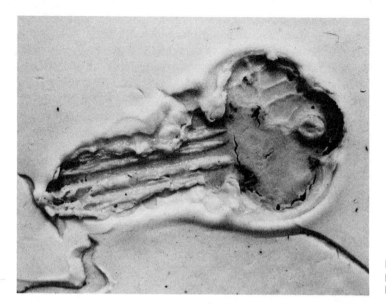

Fig. 16-13 The imprinted key in modeling paste.

Flat areas of space can be created with acetate or mylar sheets, which are glued in place as a final step, gluing the piece down to the plate without applying anything on top. The acetate or mylar will not require sealing with glue or acrylic for it will not soak up the oil-base ink.

Lines and areas can be directly incised into the cardboard. Using the X-acto no. 1 knife and no. 11 blades, cut a line into the cardboard, deciding how thick you want the line to appear in the final print, and cut another line parallel to the first. These lines can be straight or curved. At the ends of

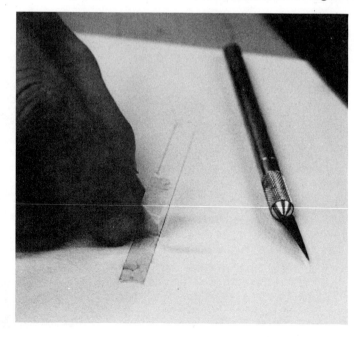

Fig. 16-14 Incising lines and areas in 1-ply cardboard.

the two lines, make another cut, connecting the lines closing the inner area. Now lift a layer of cardboard starting at one end of the closed line completely out of the base (Figure 16-14). Smooth the line out slightly with the X-acto knife. Do the same thing for a large area, such as a circle. Just remember not to cut too deeply, approximately 1/32 " deep is more than sufficient. Additionally, lines can be incised into the glue, medium, or modeling paste with sharp-pointed instruments, such as nails, pins, or etching needles.

Your sense of exploration is essential in the selection of items to be collaged onto your plate. The main things to remember in the selection is that no item should be more than 1/16" to 1/8" thick, should not have sharp surfaces or edges (items can be filed down), surfaces should not erratically change within the same immediate area (with regard to thickness), the final surface should not be more than 1/4" thick, and the plate should be kept fairly simple (explore the many different possibilities in other plates).

GLUING OF MATERIALS

You have properly prepared your collage base, chosen the collage materials to be used, and have completed any line or area incising directly into the base per your initial design. It is now time to finalize the collage by gluing down collage items, further incising into cardboard and/or glue or mediums, creating painterly areas with glue or mediums, and, finally, sealing the entire plate for oil-base ink printing.

If you are planning to glue on pieces of cardboard over the base, you should use straight white glue. The recommended white glue for all purposes is Elmer's. It is a polyvinyl acetate resin emulsion in water, dries fairly rapidly when used in thin layers, is of an opaque white color when used but dries transparently, is extremely durable, and takes very heavy pressure without breaking down. Other makers of this "white" glue are Weldwood and Sobo, plus numerous other minor brands; Elmer's is the main choice because it seems to dry faster and holds up longer. Spread the glue over the back of the piece of cardboard to be applied to the base, and push it tightly into place, wiping excess glue from the edges. The cardboard pieces to be glued onto the base should be cut so that they are beveled slightly outward. These pieces of cardboard can be incised also, before or after gluing down.

Pieces of paper can be torn or cut with scissors to create clean edges and glued down, using a mixture of 75 per cent white glue and 25 per cent water. Paper can be overlapped when glued down to create abstract tilelike patterns.

All cloth and string should be soaked in a bath of 75 per cent white glue and 25 per cent water. When ready to be put into place, wring out the excess glue and push material into the base, stretching it down tightly. String also should be forced to adhere tightly to the base (Figures 16-15 and 16-16).

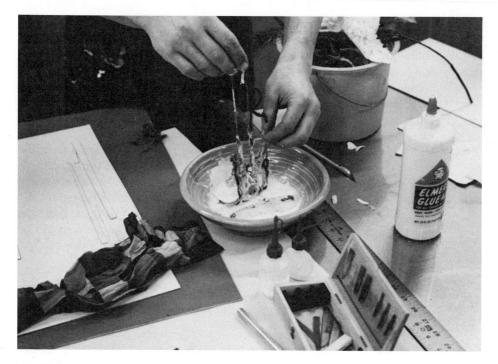

Fig. 16-15 Soaking string and cloth in Elmer's glue.

Fig. 16-16 The soaked items are removed and adhered to the collagraph base.

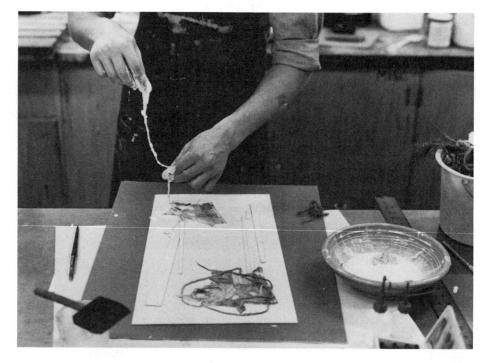

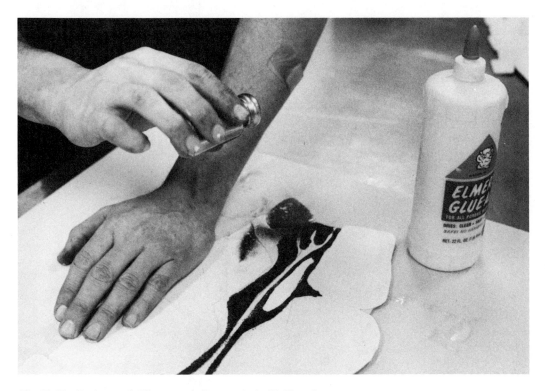

Fig. 16-17 Dark aquatintlike areas being created with Elmer's glue and fine grit.

To create tonal areas, brush onto the plate a thin coat of 75 per cent white glue and 25 per cent water mixture in the designated spot, and sprinkle the glue with a layer of sand (rough, dark tones), grit (finer, dark tones), or coffee grounds (rough, open, lighter tones) (Figure 16-17). If you wish to cover a large area with a tone made from one of the above, brush the glue mixture on a few inches at a time, or it will dry out before you can sprinkle the substance into it. After sprinkling is complete, and glue has had a chance to set the substance into it, blow off any excess particles that accumulated from the sprinkling procedure. Sandpaper and carbon paper can be glued down as well to create dark tone areas. Heavy or thick items, such as rubber gaskets or leather and suede pieces, should be glued down with straight white glue.

Tapes of all kinds can be used, such as aluminum tape, masking tape, linen tape, vinyl tape, and transparent tape. They can be applied directly without glue. Also, gummed items of all kinds (numerous types can be found in any stationery store or department store) can be directly applied without glue.

After gluing everything you intend to apply to the base, you may wish to create painterly textures in certain areas of the plate. To do this, use various brushes and/or palette knives, building areas with modeling paste, polymer acrylic gloss or gel medium, polymer acrylic gesso, and/or

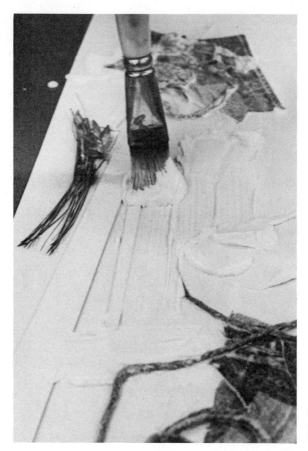

Fig. 16-18 Applying modeling paste in a painterly way.

the white glue (Figure 16-18). You must wait for each layer to dry before applying a second layer, if a second layer is desired. You can also draw with the glue or modeling paste by putting it into a squeeze bottle, such as a mustard or ketchup plastic container, and forcing it out of the tip as you guide your hand along to create linear patterns (see Figure 16-9). When doing this, be sure that the base areas are perfectly dry before applying, or it will run and not hold the line.

After finalizing the design of your collage, let the plate dry thoroughly. This can take anywhere from 24 to 48 hours. When dry, the white glue will be completely transparent; to test underneath areas, squeeze them tightly to see if the glue runs or squeezes out.

After the plate is completely dry, you should cover its entire surface with a thinned coat of polymer acrylic gesso. Mix approximately 60 per cent gesso to 40 per cent water (depending on the thickness of the gesso), making sure the water is well distributed. Brush (or, if possible, spray) this mixture onto the plate using a foam brush (Figure 16-19). Brush it on evenly, allowing absolutely no buildup in critical texture and incised areas. You simply need a thin white coat over the entire collage. This white

surface will allow you best to judge the application and wiping of ink. If you are not too concerned with this judgment (basically for intaglio printing) or intend only to relief print the collagraph, the gesso procedure is not necessary.

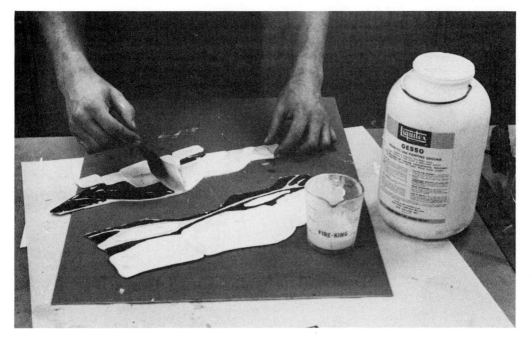

Fig. 16-19 Covering entire plate with gesso using a foam brush.

The gesso should dry quite rapidly. After it is completely dry, a final coating of 75 per cent white glue to 25 per cent water mixture should be applied over the entire plate: top, bottom, sides, crevices, incisions, textures, and so on (Figure 16-20). Be extremely careful not to allow excessive buildups of gesso or final glue, especially in those areas where you want to retain dark tones. The textures here must be quite apparent, quite rough to the touch, to hold ink and print dark. With experience, you can apply one to several different layers of final glue to textured areas to create different tones, from dark to light. Simply remember that the more texture you block out with glue, the lighter that texture will print. Be sure that all joining crevices are filled with glue so that the ink will not leak underneath, making contact with the cardboard and, accordingly, slowly destroying it or oozing ink and/or solvent onto your prints when making contact with the extreme pressure of the press.

Note should be made for those interested in working in relief with only water-base inks (such as elementary schools). Instead of using white glue for all gluing procedures, use only polymer acrylic gloss medium, mixing it in the same ratios as you would the glue. You do not need to apply the gesso

in this case, but do insure that the plate is thoroughly sealed out with a final coating of medium. You do not want the ink or water (when cleaning the plate) to leak underneath, for it will run and breakdown the cardboard as well. You cannot intaglio print with water base-inks. Before proceeding, be sure that the plate is completely dry.

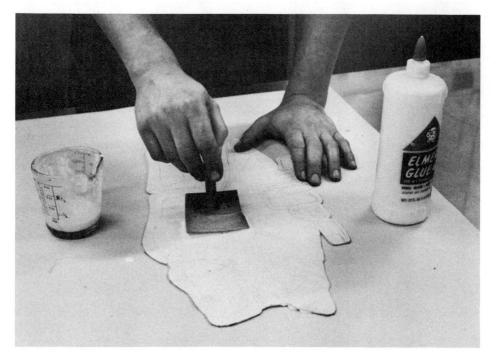

Fig. 16-20 Covering entire plate with Elmer's glue.

FINAL PLATE PREPARATION

After the plate has dried completely, check it to see if you wish to make any modifications or correct it in any way. Modifications and corrections are difficult after the plate has made contact with oil-base inks and solvents, so they should be made at this point. You can remove sections, cut away complete plate pieces, sand down areas, add more items or textures, and paint additional mediums onto the surface. Also check to see that all holes and crevices are fully filled.

When all corrections and/or modifications are complete, and everything has dried thoroughly, the plate should be sprayed with a couple of thin coats of liquid plastic. Recommended is Krylon Crystal Clear Brand. Place your plate against a protected wall, and spray one thin coat over its surface. It should completely dry in about 3 to 5 minutes; then spray another thin coat. Repeat this procedure for the back and sides (Figure 16-21).

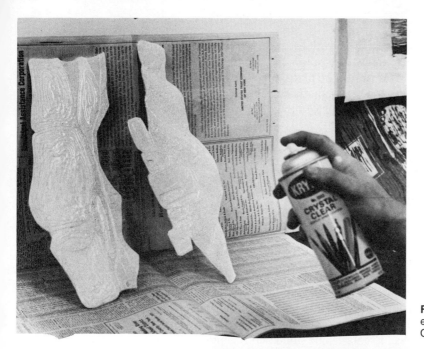

Fig. 16-21 Covering entire plate with Krylon Crystal Clear spray.

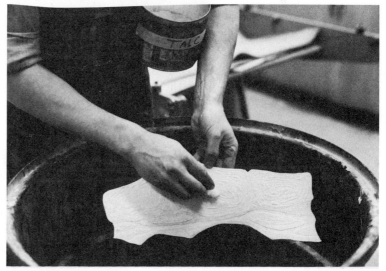

Fig. 16-22 Dusting entire plate with talcum powder.

After the plastic spray has dried, you may wish to create some areas that will retain no ink in the intaglio stage, or will retain a very flat area of color from the relief stage of inking. If this is so, cut that area of space out with a scissor from a piece of heavy acetate or mylar. This piece of acetate or mylar can be glued in place, or can be kept separate, relief inked, and placed into position on the plate before printing. It will not shift or move once your printing paper is placed over the plate, and it will print as a perfectly flat, colored area, or "white" space, depending on your choice.

The plate is ready for inking after one more small, but important, step. It **337** must be lightly brushed all over with talcum powder. This takes the

tackiness out of the glues and mediums, allows the plate to be inked smoothly, and will not allow the printing paper to stick to the plate. Brush the talc over the entire plate, top, bottom, and sides, with a soft brush or piece of cotton. Take another brush or piece of cotton and brush away any excess powder (Figure 16-22). The plate is now ready for printing.

PRINTING A COLLAGRAPH

IN RELIEF ONLY

If you are going to print *only* in relief with no press, Chapter 10 is applicable, with some additions and/or modifications. A lighter paper than is used for intaglio work will be required, such as a Japanese rice paper, which is somewhat stronger than that used for other forms of relief printing. Okawara and Torinoko Japanese papers have proven excellent for relief printing from highly textured collagraph plates. If a smoother, more opaque paper is desirable, Rives Heavyweight (not Rives BFK) should be the choice. Proofs can be pulled on Basingwerk paper, or a smooth, light, good quality drawing paper.

You should begin by first proofing the collagraph plate in relief. Roll out an even layer of semistiff, black, oil-base ink with a soft rubber roller 4″ to 6″ in length. The amount of pressure to be used when applying the ink to the plate is up to you, but make sure that it is consistent pressure throughout the inking process, applying an even layer of ink over the entire plate relief surface (Figure 16-23). Do not force ink into incised areas, crevices, or textures, but keep the ink only on the raised or open surface areas.

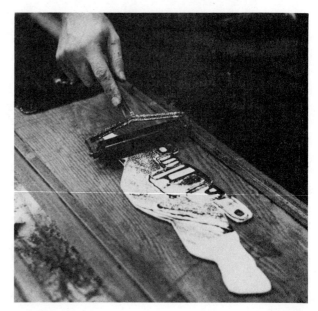

Fig. 16-23 Applying one relief color to plate for hand printing.

After applying the ink to the plate, place it on a clean surface and drop a piece of dry proofing paper over it. You can tape the paper down on one edge to keep it from moving. Using the same relief procedures discussed in Chapter 10, transfer the inked image from the plate to the plate with a baren or a wooden rice spoon (Figure 16-24). You can flip the paper back occasionally to check how the transfer is taking (Figure 16-25).

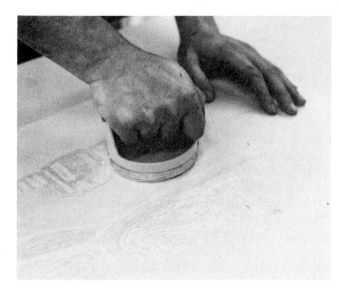

Fig. 16-24 Using a Speedball baren to hand print.

Fig. 16-25 The print is lifted and checked for accurate relief printing.

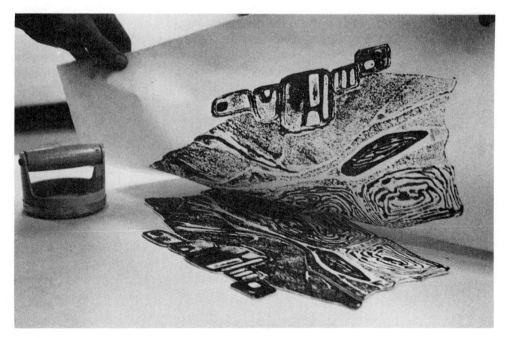

After removing the paper from the plate, attach it to a wall in front of your inking area. Looking at your proof in relief, decide whether or not you wish to print it in colored inks. To do so, you will have to purchase an assortment of colored, oil-base inks. Recommended are Graphic Chemical Brand Perfection Palette inks. Lithographic and offset inks, which are varnish base and can be cleaned with kerosene, also can be used, but they are usually more expensive. By purchasing the three primary colors, red, yellow, and blue, plus a transpertizing body such as Graphic Chemical's Extender or Transparent White and an opaque tinting body such as Graphic Chemical's Mixing White, you can create quite an assortment of colors. Specialty and earth colors will have to be purchased premixed. If you wish simply to experiment in color before making large purchases of ink, a good quality oil paint will work.

Mix your colors according to a standard color chart, such as Grumbacher's color computer (available in most art stores). If you wish the ink to print more transparently than would be normal, you must add a transpertizer to it. Number 00 burnt plate oil or raw linseed oil (#00 varnish in the case of lithographic or offset inks) will transpertize the ink to some extent and should be used to soften very short (stiff) ink, but if used in excess, it will make the ink much too long (soft). Accordingly, the Graphic Chemical Brand Transparent White should be added to the ink, remembering that the more you add, the more transparent the ink will get.

After mixing the colors you wish to roll onto the plate, they should be fairly stiff, at least as stiff as the etching ink. To stiffen the mixed colors, add magnesium carbonate powder a little at a time until the ink reaches the desired viscosity (see Chapter 12).

After the ink is brought to its proper viscosity, roll out the ink on the appropriate size rubber brayers as your plate dictates. Several colors can be rolled on at the same time, but do not get overly complicated or it will be difficult to repeat the same color areas. After cleaning the plate with kerosene to remove the black ink and drying it well, roll the colored ink in the same way that you rolled the black ink onto the plate. Place your plate on a clean base, put a sheet of proofing paper over it, tape it down, and pull the print as you did before.

After insuring that the transfer has taken place adequately, take the proofing paper from the plate and place it alongside the black proof. After studying it, make any modifications in color you feel are necessary and pull another proof(s). Once you have finalized the color selection, ink the plate accordingly, and pull a print on your selected good paper. You can pull your entire edition at this time. You do not need to clean the plate between each printing; this will assist you in applying the colors in the same place each time.

After pulling your edition, clean the plate thoroughly with kerosene (use rubber gloves) and dry it well with a clean soft rag. The plate can be stored as is, or it can be carried to another state in the future by altering the image (adding or subtracting), or by printing it in intaglio or intaglio/relief.

Collagraph If you intend to print the collagraph as an intaglio plate, or in combination with relief printing, a double cylinder press is needed. The presses discussed in Chapter 5 are applicable. Additionally, the procedures for intaglio inking in Chapter 5 are applicable to the collagraph, with some additions and/or modifications.

The plate first should be run through the press to determine the pressure. Again, be sure the plate has been brushed with talcum powder before proceeding. Set the pressure high on your press. If it is equipped with micrometer dials, as in the one illustrated, set the dials to "0 over 4" (see Figure 5-17, Chapter 5). Place the blankets in order (cushion 1/4' on top, pusher 1/8" in middle, sizing catcher 1/16" on bottom) and squarely on the press bed. Underneath the sizing catcher, place a piece of close-pore foam rubber as big as the blankets (or at least as large as the printing paper used) (Figure 16-26). Flip the blankets and foam back over the cylinder with the press bed all the way to one side. Place a piece of newsprint on the press bed, then your plate(s) properly brushed with talcum powder (see Figure 16-22), and another piece of newsprint on top. Place the foam and blankets over the newsprint and run the plate through the press. When it reaches the other side, lift the blankets slightly from the press and check to see if the newsprint is ripping evenly from the set pressure. You will

Fig. 16-26 Preparing the blankets and foam for press printing of the collagraph.

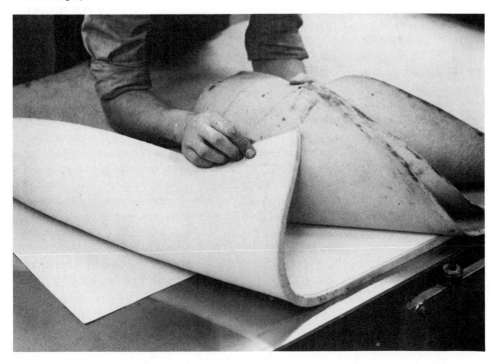

probably discover that it is not, and, accordingly, you should bring the dials down clockwise one notch at a time, checking to see if the paper is ripping evenly each time you run the plate through the cylinders. You do not have to change newsprint paper each time. Once you determine that the paper is ripping evenly all the way around, record this pressure on the back of the plate or in a notebook. This is not a foolproof method of finding the *exact* pressure, but it will provide a starting point; modifications should be made in the proofing stage to be sure that you find *optimum* pressure.

Before proceeding to color printing, you should first pull a proof in black. Following the intaglio inking and printing procedures in Chapter 5, ink the plate with a medium-sized stencil brush, forcing the ink into all crevices, incisions, textures, and so on, without creating an excessive ink buildup. It is very easy to overink a collagraph plate for intaglio printing because of the many surface variations created; therefore, you should be extremely careful not to use too much ink. The indentations and textures must have ink on their deep surfaces, but they do not require inking so that they are filled to the relief surfaces of the plate. As with any other intaglio plate, the areas must be first tarlatan wiped and then hand wiped. Because the surface is gesso white, you can judge how the ink is taking on the plate and how it will print. Usually, what you see is what you will get. If the plate looks underwiped, it will print dark and the ink will ooze in spots. If the plate looks overwiped, that is pale and without tonal changes, it will print that way, usually leaving white spots. After expertise is achieved with collagraph plates, controlling optimum press pressure and inking, you can control the printing quite well, maintaining consistent inking from print to print simply by watching the wiped surfaces of the plate and comparing them to a final proof.

You will have to proof print on a heavy good quality paper, such as Rives BFK or Arches Cover. A lighter proofing paper, such as Basingwerk, will usually tear in intaglio printing of a collagraph. Use the foam as described above, and print the proof on soaked, evenly blotted paper (normal intaglio printing).

Attach the proof to a bulletin-type board with push pins, letting it dry thoroughly. Check to determine if any areas are tearing the paper, and, if so, modify your press pressure. If the print is pale and the plate indicates that it is still holding quite a bit of ink, and you are sure of not overwiping the plate, increase the pressure slightly.

If everything is not yet perfect, or you need further practice in printing a collagraph, continue to pull more proofs. It is not necessary to clean the plate between each printing at this stage.

Figures 16-27 and 16-28 show the pulling of a relief, inked (black) print being taken from an etching press and attached to the wall for drying; note the added piece of mylar (sky) inked in relief with a roller, which was later eliminated for the color printing of the edition.

After the proofing stage is complete, clean the plate well with kerosene and dry it thoroughly with a soft, clean rag.

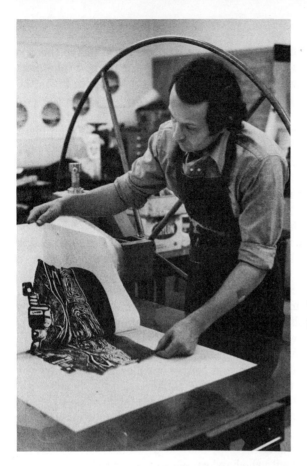

Fig. 16-27 The print is relief rolled in one color and printed on an etching press; the deep areas print as strong convex embossements.

Fig. 16-28 The relief proof printed on an etching press; note the flat color of the sky produced by cutting out a piece of mylar and relief rolling it.

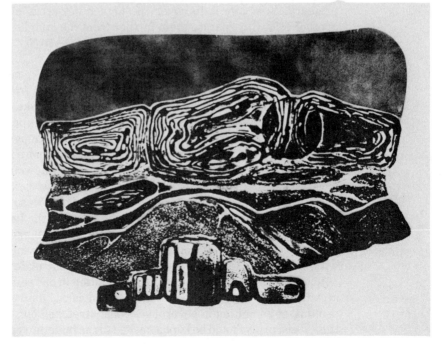

Now that you have made all necessary printing alterations in the one color proofing stage, you can prepare your colored intaglio and relief inks for multicolored proofing and printing. Decide on two colors in the initial stage, an intaglio color and a relief color. After working with the two colors, you can increase the palette as you wish.

The intaglio color should be mixed to the same viscosity as the black etching ink used in the intaglio work for the proof. The choice of inks here again is Graphic Chemical Brand Perfection Palette, and the instructions for mixing are exactly the same as described under the Relief Only section of this chapter. However, you should avoid using too much transparent white in your intaglio ink, and you cannot use lithographic or offset inks for this step, but they can be used for the next (relief) step, which will be applied over the intaglio ink. After mixing your intaglio color, set it aside on your inking station. Remember to put in a few drops of oil of clove to keep it moist longer.

Now mix up one relief color. It should be mixed, as previously described, to a semisoft viscosity. Roll the color out evenly onto a hard, rubber brayer (a large, hard, rubber roller, as used for these illustrations, will work best, if available, because it will not leave roller or offset marks on the plate; these are, however, usually too expensive for the beginner). Be sure that you have an even, full coat of ink on your brayer or roller. Lay the brayer or roller aside so that it is not resting on the rubber.

Using a medium-sized stencil brush, apply the intaglio color over the entire plate in the same way that you applied the black intaglio ink used for proofing. Wipe it clean with tarlatan and hand wiping, and lay it on a flat, clean surface for relief rolling.

Roll out the relief color with the hard rubber brayer or roller using little pressure. Your aim is to cover the high relief areas of the plate with another color, to separate them further from the intaglio areas. You may have to recharge your brayer or roller a few times to coat the plate evenly with the relief color.

Now set it on a piece of newsprint, which has been placed on the press bed, and print it as you did the proof. Remove the print from the plate, and pin it alongside the black proof. You may wish to make modifications in color and application before finalizing an edition. At this point, you will also need to make a registration template if you are using a jigsaw puzzle plate (see the following section). Remember, you can add more than one color in the relief stage, over the intaglio ink, in the same way you may have used several colors in the printing of a relief collagraph with no press. Figures 16-29 to 16-37 show the complete relief/intaglio process described.

To keep perfect consistency from print to print, the brayers or rollers and plate should be cleaned with kerosene between each printing, and dried thoroughly. When you are finished printing, clean everything well with kerosene (use rubber gloves), and store your plate in a safe area.

It is not necessary to print your entire edition in one session. By keeping accurate notes and samples of the colored inks, you can complete the printing of an edition in several sessions, stretched out over a period of time. Each print should be kept attached to the bulletin-type board until all

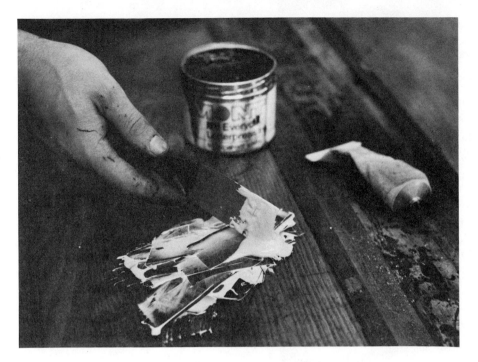

Fig. 16-29 Making the ink transparent by adding IPI Transparent White.

Fig. 16-30 Making the relief ink stiff (short) with magnesium carbonate.

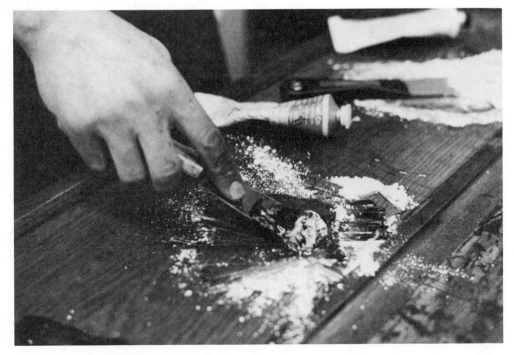

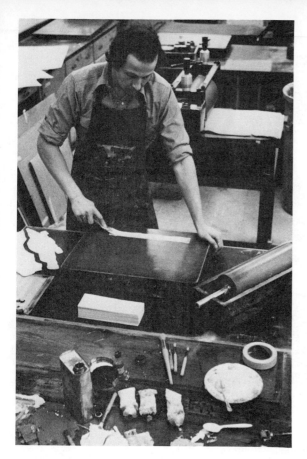

Fig. 16-31 Laying out an even strip of ink to be rolled out with large roller.

Fig. 16-32 Continue the roll-up until roller and slab contains an even thin layer of ink.

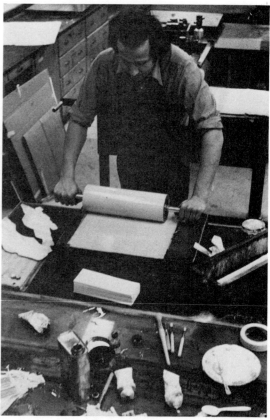

346

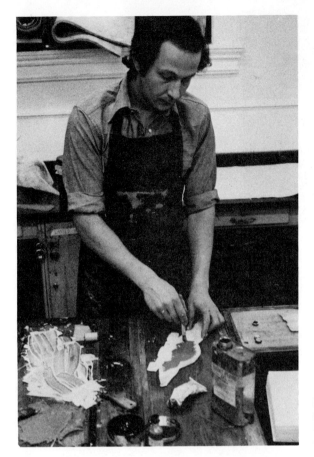

Fig. 16-33 Intaglio ink applied with a stencil brush to the collagraph plate. Plate is then tarlatan and hand wiped as in Chapter 5.

Fig. 16-34 Relief color applied over the wiped intaglio color.

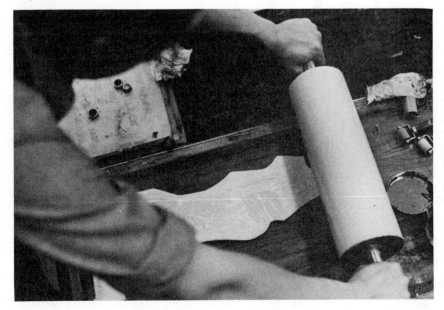

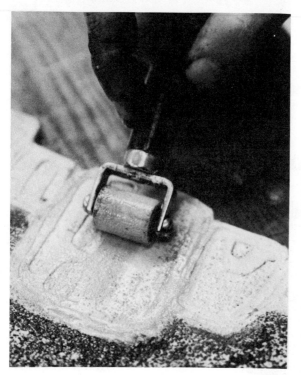

Fig. 16-35 Detail showing the application of one color relief rolled over another intaglio color with a small brayer.

Fig. 16-36 Dampened paper being carefully dropped over inked collagraph plates on the press bed.

Fig. 16-37 Print being pulled from plates [Plate 13 (color plate) shows the final print by Sheldon Strober.]

moisture has evaporated. The prints can then be removed, and placed face up on a flat, clean table, separated from each other until the ink is perfectly dry (24 to 48 hours). They then should be torn down (see Chapter 5) and stored between tissue or glassine paper. For exhibiting information, including signing, dating, numbering, and lettering, refer to Part V.

REGISTRATION OF A JIGSAW COLLAGRAPH PLATE

In suggesting that you employ one of the biggest advantages of a collagraph, that is, multiplates or jigsaw plates, it was pointed out that you will have to create a registration system so that the plates are placed in the same place each time for consistent printing of the edition. A simple system is described here.

When the plates are clean (have no ink on them), place them on a sheet of clean newsprint (larger than printing paper) in the position and order you wish them to print. With a soft pencil, trace the position of each plate onto the newsprint. Remove the plates, and place the newsprint onto the press bed, attaching it with a small piece of masking tape on the top edge. Now take a sheet of acetate that is larger than the traced paper and place it over this newsprint, taping it down to the press bed with a small piece of tape on each corner. After inking the plates, place each directly in its designated

spot (do not cover the acetate with another piece of newsprint), and print normally. After removing the print, and removing the plates for cleaning, wipe off the ink left on the acetate with a cloth that has a small amount of paint thinner on it. When placing the plates into their designated spot, try not to get finger marks on the acetate, or they will print; if this happens, remove them carefully with a rag that has a small amount of paint thinner on it, without moving the plate.

The printing paper used with this method should be quite large, leaving at least 6″ margins all the way around, so that the paper can be torn down consistently, leaving the image in exactly the same place each time and providing for even borders from print to print.

Combining Processes
And Other Possibilities

ADVANTAGES AND DISADVANTAGES TO COMBINED MEDIA PRINTS

The tradition of printmaking prior to the 1960s allowed for little diversity. Prints were kept "pure," the resulting image displaying an individual process of platemaking and reproduction. The "preciousness" of prints was determined by how well the printmaker maintained that sense of purity from conception of image to the pulling of an edition. An etching was an etching; further, a line etching should not depend on an aquatint to "pull it together." An etcher would never think of producing a lithograph. Under these confining dictates, the idea of combining printmaking media in one print was not heard.

With the new interest in prints produced by the innovative workshops of Stanley William Hayter in the '40s and '50s and of June Wayne and Tatyana Grosman among others in the '60s the restrictive boundaries and definitions so long apparent in the world of printmakers became meaningless. Like painting and sculpture, fine art print images exploded with diversity, evolving a viable process sensibility based on experimentation and explor-
351 ation. This inevitable evolution is far from over, and old conservatisms are

Fig. 17-1 Photo-montage lithograph, separate stone lithograph, collagraph, collage, and hand coloring. *Metaphysical Graffiti or In One Ear and Out the Other*, 22″ × 28″, Janet Hughes, 1975.

Fig. 17-2 Two plate viscosity etching with collagraph in two colors. *Untitled,* 18″ × 30″, Virginia Evans Smit, 1976.

Fig. 17-3 Black multiprocess etching with air brush and linear hand coloring. *Process: One to One to II*, 29″ × 41″, William C. Maxwell, 1976.

no longer held and quoted by the contemporary artist/printmarker; the resulting prints clearly evidence a liberal energy releasing new ideas and concepts every year.

Yet, it should be noted that traditions are far from lost. They still exist as the basis for producing a fine art print. Without this basis, as is clear to every artist who has participated in printmaking media, contemporary fine art prints would never be made. It is the starting point; today clearly de-mystified and simplified, but still the place where the student of the various processes must begin. For many, this beginning point will be sufficient. Black and white prints, kept within the bounds of one or two methods and produced with commitment and sophistication, are still as beautiful as they were in the seventeenth and eighteenth centuries. The removal of restrictive boundaries should not result in the establishment of new constrictions that devalue development within a traditional approach of print production.

The artist who chooses to experiment and innovate should do so only if his or her temperament and aesthetic considerations determine this path. Remaining open to every possibility, the printmaking student should be ready to *try* anything, using a process as it relates to his or her individual approach to image. But it is the individual image that should determine the ultimate utilization. Everything should be tried, if just simply to acquire an understanding for the inventive approach and result. Nothing can be rejected honestly until one absorbs the necessary understanding of a particular process, whether new or old. But it can and should be rejected once understood, if one cannot at a particular time see it in relation to a personal development of image.

The explorations into combined media prints will tax the student's imagination considerably. Those working already as painters, sculptors, photographers, conceptualists, and so on will immediately want to relate printmaking to their fine art preferences, incorporating the various associated aesthetics, approaches, and processes into their prints. Those that have never worked in other fine art media will want to explore these paths to grow properly in the process of image development.

Today, there is no reason why a print cannot contain hand coloring, collage materials, or a hand-drawn line. There is no reason why a print cannot retain the sculptured look, with heavy embossing, vacuum forming, or paper casting. And a traditional printmaking approach can be very effectively combined with photographic techniques. These realizations will become more and more apparent as the student of printmaking begins to explore contemporary prints in galleries and museums throughout the world as will be *inevitably* necessary.

And this research will also prove that the student of printmaking can very effectively participate by choosing to grow and develop within a single medium, for there will be as many examples of the "conservative" approach as there will be of the "liberal" approach.

As pointed out, it is the image that should determine the choice of combined approaches. Further, it is the image that will determine what the combinations will be. If hard ground line etching calls for one or two flat colors in one area, it would probably be more sensible to apply these colors to the edition by hand. If a collagraph image is improved by the application of a "collage" item that cannot be applied with normal printing methods, such as the application of stitching or the placement of a coin in a particular area, then it must be done by other means. If a lithograph would be more dynamic embossed with a collagraph plate, it should be done.

Of course, it will be difficult to make these choices if you are not familiar with various processes, both in printmaking and fine art in general. The point is, you should continuously seek to add to your repertoire of possibilities. At every point in the production of a print, ask yourself whether or not the image could be improved with the incorporation of another medium. If the answer is yes, determine what that medium (media) will be. If you have a working knowledge of the medium, it will be a simple matter of trial and error to combine it until reaching satisfying results. If you have no knowledge of the other medium you would like to incorporate in your print, but are aware that this other medium exists, you will have to research your choice, develop an understanding of it through the process of *doing*, and then relate it to your particular print. In either case, you may discover that the choice was not a viable one, and the combination does not work; however, your direct involvement in this new experience will build up your repertoire so that a more calculated choice can be made with future prints. No exposure to or expansion of a medium will be in vain.

Besides the galleries and museums, there are numerous publications to help you gain this exposure. You must be willing to visit the library and bookstore often. Do not research prints, printmaking processes, or printmaking books *only*; get to see as much art and method as you can, including commercial art processes. Everything can be related as long as the need to relate and a sense of determination coexist.

HAND COLORING

Any print can be hand colored. The only thing to remember is that if you want to maintain the traditional principle of consistency within the multiple image, you must maintain a consistent process of hand coloring. This principle may be pertinent, however, only if you wish to exhibit at certain places or sell your prints through certain dealers who wish to maintain that particular tradition. For your own purposes, it may be totally irrelevant. Yet, determining relevancy should not be done carelessly, for consistency still has its importance within the concept of a multiple original image.

If you choose to hand color, the coloring item should be very carefully chosen. Some prints can be hand colored satisfactorily with a good quality ink. The inks work best when transparent solids and colored pen line is desired. Another viable choice for hand coloring is watercolor, but again it should be of the finest quality, paying close attention to permanency of pigment. Watercolor works best where transparent color washes that reveal tonal gradations are desired.

High quality, permanent, felt tip pens can be used effectively for linear work and very small area coloring. The permanency of pigment should be thoroughly determined here, for it fluctuates excessively among the various pens on the market. Colored pencils can work quite effectively along these same lines. Good quality chalk pastels also can be effective when combined with any printmaking process. However, maintaining consistency (if desired) with this item is extremely difficult if not impossible.

Acrylic paints are excellent for hand coloring. Because they are pliable when dry and completely permanent (they will not dissolve in water once dry), they can be applied to the paper before the print is pulled. By carefully following an individualized stencil method of application, the colors can be rolled or carefully brushed onto particular areas of a sheet of printing paper. The paint is then allowed to dry, which takes a very short time. The sheets can then be soaked (in the case of intaglio printing) or printed dry. A simple method of registration can be accomplished by following Chapter 10 (relief printing) or Chapter 16 (collagraph printing).

COLLAGE

The methods of collage can be very effectively utilized on prints. If careful selection and control is maintained, consistency can be accomplished. However, it may be desirable to vary the theme from print to print, using the basic print only as a beginning to further explorations.

Most items can be glued to a print with a mixture of 80 per cent Elmer's glue and 20 per cent water. At times, it may be necessary to use the glue straight, but it usually is too thick for most collage printing when a smooth, neat surface is desired.

In the case of intaglio printing, a particular method of collage has been employed, called *chine collé*. Here the collage item is applied during the printing, allowing it to be printed on as well as adhered to the actual printing paper. Permanent colored papers, Japanese papers, newspaper cuttings, magazine cuttings, thin cheesecloth or tarlatan, old photographs, and similar items can be used. For this process, place the inked intaglio plate on the press bed, apply a thin coat of a mixture of wheat paste and water to the back of the collage item, position it on the plate (in the predesignated area you wish to have it attached) glue side up, place your printing paper over it, and print normally (Figures 17-4 to 17-6). When you remove the print from the plate, it will have adhered to the printing paper,

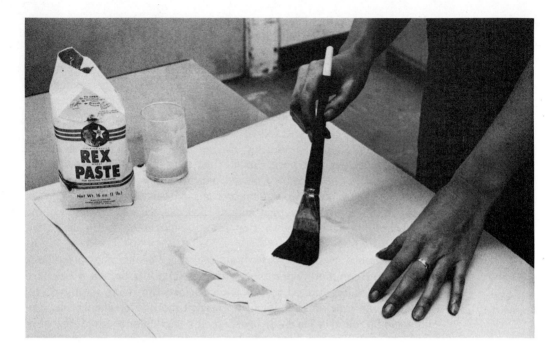

Fig. 17-4 Applying wheat paste to a precut piece of Arches
Cover buff paper to be used for the *chine collé process.*

Fig. 17-5 Placing the precut paper in place, glue side up, on the
intaglio inked plate.

Fig. 17-6 The dampened printing paper, white Rives BFK, is dropped onto the plate/precut paper and pulled through the press; it laminates itself to the precut paper, both receiving the inked intaglio image.

and the intaglio image will have transferred to the collage piece as well as the printing paper wherever the collage piece did not exist (Figure 17-7). The consistency of the edition easily can be maintained by having all collage pieces the same, cut out before the printing begins, and placed in exactly the same place each time. Lithography printing also can employ chine collé methods.

It is also possible to punch holes through a print, leaving them open or threading pieces of cord or ribbon through them. Cord and ribbon can be glued in place. Direct hand or machine sewing can be done on a print as well.

Large or somewhat heavier items should be glued to the print with a 5-minute epoxy. Keys, metal strips, pieces of light wood, heavy, colored acetate, mylar, plastic items, and the like should all be glued on with **359** epoxy.

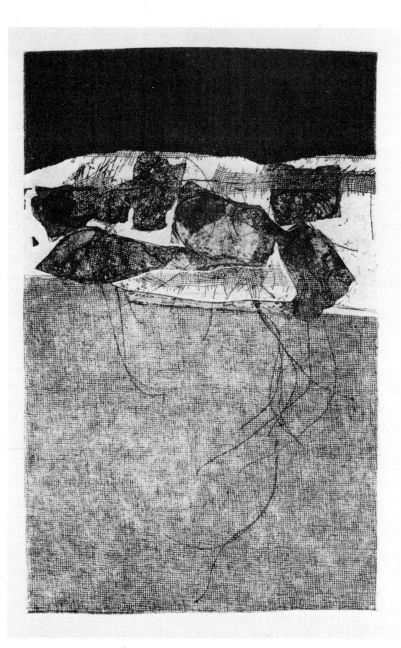

Fig. 17-7 The *chine collé* print by Caryl Spinka.

EMBOSSING

Any intaglio plate, collagraph, and unmounted linoleum block can be printed without inking to create an embossed print. However, the result will be more effective when some rules are followed.

In the case of an etching, the intaglio image must have deeply bitten areas with clearly defined edges. Collagraphs should be fairly crisp also, with no areas containing excessive collage buildup. Engravings and drypoint plates usually will not work as embossings, for they consist mainly of line that is too fine to show up without inking. Because you are not inking the plate, pieces of cardboard can be glued together to form a relief plate for embossed prints; the cardboard need not be excessively sealed—a light spraying of Krylon Crystal Clear is sufficient to protect the plate from the damp paper. And, of course, any item that is not excessively thick (1/8″ or thinner) can be embossed, such as keys, paper clips, thick tapes, coins, and gaskets.

An embossing must be printed on a double cylinder etching press. The paper must be of the highest quality, capable of taking the embossment without tearing; Arches Cover and Rives BFK will work for most low relief embossments, but thicker, heavier paper may be necessary for very heavy embossing. The paper should be soaked for a longer period than for normal printing (1 to 2 hours longer). The blankets are set up in a normal way, but a piece of 1/2″ thick close-pore polyurethane foam is placed between the plate and the blankets before the plate is run through the press. The piece of foam must be larger than the printing paper being used and should be placed squarely on the press bed. The pressure setting of the press will be determined by the thickness of the embossing item; start with high pressure and come down slowly until you reach an optimum point where you are getting very clear and precise images without tearing the paper.

You can also emboss prints that have already been printed from another inked plate, relief block, or lithographic stone. After the ink has dried on the particular print to be embossed, place the paper in the water for soaking or resoaking. (In the case of relief prints on a very light paper, such as Japanese papers, it will not be possible to get an embossing.) Set up your embossing item or plate on the press, properly register the dampened and blotted paper over it, and with the foam between the blankets and press bed (which is holding the embossing item/plate on it), run it through the press.

Attach any embossed prints to a bulletin-type wall with push pins placed 2″ apart and 1/4″ in from the paper edge, and let them dry naturally until all water has evaporated. Store these prints with nothing on top of them.

MONOPRINTS (MONOTYPES)

The methods of monoprinting are usually considered the bridge between printmaking and painting. As the word implies, you are dealing with *one* print production; it is not a method of consistent reproduction, and,

therefore, does not totally come under the realm of printmaking. Yet it utilizes the methods and tools of printmakers, as well as the tools of the painter.

Any painting pigment that does not dry quickly can be used—oil colors, watercolors, inks, temperas, and ordinary house paints. The wet color is brushed, rolled, wiped, or finger-painted onto a nonabsorbent base, usually glass. Colors can be intermixed directly onto the base or premixed and brushed carefully onto specific areas of the base. Color can be pushed around in any way you wish; it can be blotted, "scratched" away with a clean brush or your finger, piled in an impasto with a palette knife, thinned before or after it is on the glass base with turpentine or water, splattered with a stiff toothbrush, or any other such process.

Any paper will work, and you should try various types. The paper can be used dry or dampened. It is carefully placed over the wet and manipulated pigment, and lightly pushed into the base with your hand. It can then be rubbed with a baren (see Chapter 10), a spoon, your finger(s), a brayer, or any other item that will transfer the paint to the paper. The paper is then carefully removed and another sheet is placed over the drying pigment, or new pigment is applied and transferred. The process (Figures 17-8 to 17-12) is immediate and should be accomplished with the spontaneity of a drawing or painting. As you work through the process, you will develop a better sense of control and intent.

Fig. 17-8 Detail showing the application of inks and solvents to a glass slab.

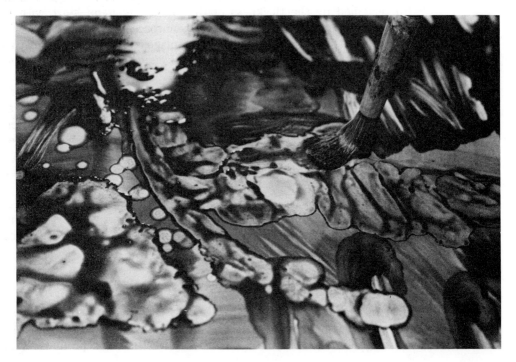

Fig. 17-9 Dropping the printing paper over the prepared slab.

Fig. 17-10 Using a Japanese baren to transfer the monoprint image.

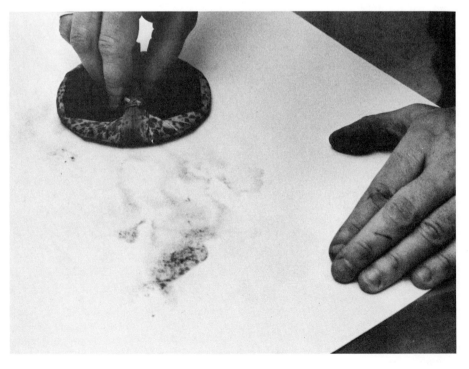

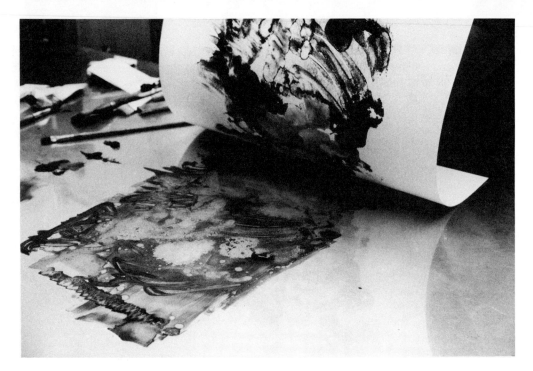

Fig. 17-11 Pulling the monoprint from the slab.

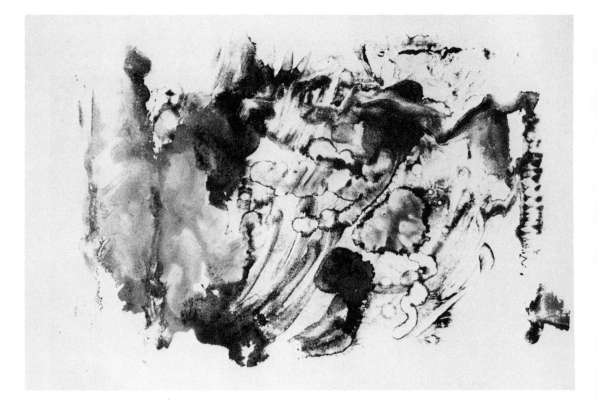

Fig. 17-12 The final monoprint.

The dried prints can be monoprinted again, creating transparent layers of pigment on top of each other. Or the monoprints can be torn or cut up and glued to another sheet to create very interesting collage monotypes. Or they can be drawn into with pencil, charcoal, pastel, or more paint, and further developed to the creator's satisfaction.

Monotypes also can be created with old etching or lithographic plates. The plates can be inked or left dry; pigment of any type is then applied to the plate surface as one chooses, the paper placed over the plate, a couple of sheets of clean newsprint over the paper to protect the blankets from oozing pigment, and printed through the press normally or with less pressure.

Remember, you are creating one of a kind, and technically the monotype is not considered a print. But you should explore the process, for the results can be quite effective and will certainly broaden your repertoire of possibilities. Many significant artists have used and do use the monoprint process in their own work, and its importance as a medium within itself is becoming more and more apparent.

SELF-IMAGINATIVE PRINTMAKING

It should be apparent that your *own* particular inventions within the realm of printmaking are encouraged. This very exciting period in contemporary art, where processes become more and more intertwined, where eclectic approaches are the name-of-the-game, should be an endorsement of individual imaginative endeavors. By exploring the many processes covered in this text, by carrying your explorations into advanced approaches, by experimenting with various combined processes, you will inevitably discover individual methods and approaches. You will ultimately find yourself in the artist/printmaker's pool of discovery, not through deliberate intent but out of your own aesthetic need.

V

THE
EXHIBITED
PRINT

It is inevitable that the beginning printmaker will want to display prints, either for professional or personal reasons. Therefore, you should be familiar with the more standardized requirements for exhibiting prints. These requirements determine what an original fine art print is; how it is numbered consecutively, titled, signed, and dated; how and whether or not it should be matted or framed; how edition copies should be stored; where and how it will be exhibited; and the development of a personal printmaking aesthetic.

The Print Council of America, in 1961, defined the original print by stating:

1. The artist alone has created the master image in or upon the plate, stone wood block, or other material, for the purpose of creating the print.
2. The print is made from the said material, by the artist or pursuant to his [or her] directions.
3. The finished print is approved by the artist.[1]

This very broad and generalized definition allows the artist/printmaker wide flexibility in determining whether or not a particular multiple image is an original work of art. Recognizing this fact, individual ethical standards play

[1]Joshua B. Cahn, *What is an Original Print?* (New York: Print Council of America, 1961), p. 9.

an important role, and the beginning student of printmaking should develop personal standards, taking into account the recognized contemporary requirements within professional printmaking circles. They will become readily apparent as the student researches further literature on prints, sees prints in galleries and museums, and begins to display prints in open exhibitions. It is the purpose here to present the beginner with a foundation for the personal development of standards that will be open to modification as the scope of the multiple image expands and the individual aesthetic progresses.

18

Preparing the Print
For Display

NUMBERING, TITLING, SIGNING, AND DATING

After your entire edition is pulled, no matter in what medium, the prints should be stored temporarily with newsprint between every proof and print, allowing the ink to dry thoroughly. This could take a week or more, depending on how much air the prints get. Do not try to speed the drying time by placing the prints near or on a heated surface, exposing them to direct sunlight or excessive blotting of the drying ink. Any of these things will most certainly damage the inked image and/or paper, and your printing work will be in vain. Do not put heavy weights on the prints while the ink is drying, or the newsprint will certainly stick to the image. As an added protection, especially if the prints cannot be stored in a proper print cabinet or box, you can place the pile on a heavy piece of chip board and cover it with another piece.

Once the ink has dried, the prints should be interleafed with tissue or glassine paper. They should never be stored for long periods in newsprint, for this paper will certainly discolor your prints. When you are interleafing the proofs and edition, it is time to tear down each print to "square off" the image and properly number, title, sign, and date the work.

369

First, go through the entire edition, determining that is completely consistent in every way. You can do this by comparing each print to the first copy of the edition. Any prints that are weak or inconsistent in other ways should be put in a separate pile. All working proofs should be placed in a second pile (those proofs pulled before finalization of the image), all newsprint proofs destroyed, and all proofs pulled on a good quality proofing paper before pulling the edition (artist's proofs) in another pile. Working proofs can be simply marked as such in the lower left-hand corner and stored with the edition for feedback information, or they can be destroyed. Prints pulled from the edition because of inconsistency are usually destroyed. However, many artists choose to use these prints for individual hand coloring, marking them as "Artist's Proof, Hand Colored" in the appropriate space described below. If these inconsistent proofs are not drastically different from the edition, many artists will mark and deal with them as proofs even though this process is not considered ethical in professional workshops.

If you have not already torn down the prints so that the image is properly "squared off" within the paper, do so at this point. Mark where you want to tear by pushing pin holes through the paper (two holes per torn edge is sufficient), turn the print over (image side down on a clean sheet of newsprint), place the straight edge along the holes, and tear straight up to you. Do not try to tear less than 1/2″ inch of paper.

Artist's proofs are marked with an "A/P," or "Proof," or "Artist's Proof," approximately 1/4″ below the image blocked with the left-hand corner of the image area. Artist's proofs usually carry no number.

Edition prints are numbered consecutively; for example, an edition of 10 will be marked 1/10, 2/10, 3/10, through 10/10. This numbering system has nothing to do with the order of the pulling of the entire edition, but simply identifies each print as part of an edition of 10.

At times a particular image will be altered in some significant way after a large body of prints have been pulled. The alteration could be a change in color, a change in stenciling, a change in paper, or a change in the drawing. After pulling another large body of prints from the altered surface, the image may again be changed, and another body of prints pulled. At this point, you will have three different *state* changes within the entire edition. (Technically, these changes can go on indefinitely, but the artist/printmaker usually keeps them to a minimum.) If the entire body consists of 30 prints, 10 of which belong to the first state, 10 to the second state, and 10 to the third state, the edition will be marked: 1/30-State I through 10/30-State I, 11/30-State II through 20/30-State II, and 21/30-State III through 30/30-State III. The marking of the edition number is done in exactly the same place that the artist's proof designation would appear.

A print can be titled or untitled, as the artist chooses. If a title is chosen, it is placed 1/4″ below the image, centered between the edition or artist's proof designation and the signature. The title can be enclosed with quotation marks if desired. An untitled print can be marked "Untitled" or the center left blank.

The signature is usually followed with the date, which can be the year; the month and year; or the day, month and year the edition was completed. The signature and date is placed 1/4″ below the image blocked with the right-hand corner of the image area. The signature can be the entire name of the artist, the initials only, initials and surname, or a logo-type signature. The manner in which an individual signs is personal, but should be decided on and kept consistent from edition to edition. If the signature is very long, it is recommended that the date be placed directly below it.

Numbering, titling, signing, and dating should be done with a medium-soft pencil of a standard graphite grey. It should be done naturally, in the artist's usual handwriting.

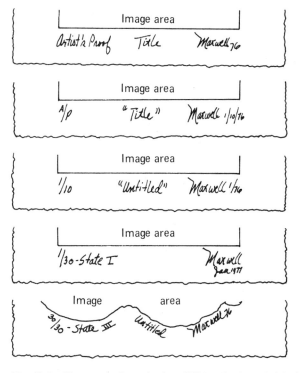

Fig. 18-1 Five ways of numbering, titling, signing, and dating prints.

Sometimes a particular edition does not allow for the above, because of an irregular image, a jigsaw type motif, irregular paper or designated mat/frame, or a bleeded image (running to the edges of the paper with no margins). In such a case, you may have to follow the shape of the image, follow the shape of the mat, or number, title, sign, and date on the back of the print. (Figure 18-1 shows five numbering, titling, signing, and dating possibilities.)

A print being prepared for display should be properly matted, mat-backed, and framed. Many professional exhibitions do not require framing, but they usually do require some form of matting. The traditional hinge mat is still the most efficient way to prepare a print for display. Modifications to the basic hinge mat design can be made as the beginner attains a better understanding of display procedures and requirements.

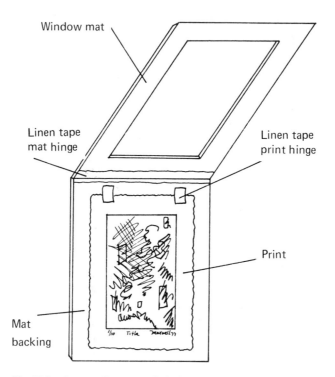

Window mat

Linen tape
mat hinge

Linen tape
print hinge

Print

Mat
backing

Fig. 18-2 A properly prepared window mat.

A hinge mat is made with 100 per cent rag-fiber mat board. The print is measured and a determination made as to whether or not the paper edge will show after the matting is accomplished. This can be done on any print with a well-torn margin that has been kept perfectly clean, and especially in the case of a bleeded image. If the paper edge is to show, the inside or "window" of the mat should be cut approximately 1/4" larger than the *image area*. The window mat should have 2″ margins as a minimum. It is cut with a standard mat knife or specially designed mat cutter (which usually allows for beveled cuts if desired).

A base mat or mat-backing is cut the size of the outer edge of the window mat from 100 per cent rag-fiber mat board that is usually heavier than the window mat. The print is hinged to the mat-backing with a 2″ strip of linen

tape (1" to 2" thick). The tape is folded in half, glue side facing out. The top edge of the print is adhered to one side of the folded tape, and the other side is placed on the mat-backing in the appropriate area (so that the window mat will center the print when it is adhered to the mat-backing). If the window mat is going to cover the print edge, the tape can be applied normally to the top of the print (Figure 18-2).

Another strip of linen tape is applied to the top edge of the mat-backing so that half of the tape strip is hanging off the edge of the mat (the tape strip should be the length of the mat width). The tape is then folded back, revealing the glue side of the top half, and the window mat is carefully aligned and adhered to the tape. When finished, the mat and print easily can be lifted without disturbing the print.

Never use any tapes (which can seriously damage a print) other than linen framing tape, usually available from an expert commercial framer. If preferred, a piece of clear acetate or Mylar can be adhered to the inside of the window with linen tape, to protect the print while being displayed if the hinge mat is not going to be placed into a frame. (Figure 18-12 shows a diagram of the matting procedure.)

FRAMING

The framing of a print can be an expensive, cumbersome, and boring project. It is suggested that the student of printmaking find a good commercial framer who meets particular needs and guarantees expert framing quality. There are many unethical and untrained commercial framers; you must ascertain the quality of materials and workmanship before entrusting your prints to a framer. It is too easy to hide damaging methods and materials in the confines of a frame; the damage may not appear for many years, when it is too late. Most expert framers will give sizable discounts to students and professional artists who have large quantities of work framed (see Appendix A).

It is possible to frame prints yourself, but a few rules are necessary. Never place glass directly against the print surface—captured moisture can damage the paper and image. A hinge mat, placed within a frame, will keep the print away from the glass. Some artists prefer to have their work framed with no window mat surrounding the print. This is possible, but the glass must be kept from the print surface by inserting a "fillet" (made from a thin piece of wood or plastic) between the glass and the matbacking (hidden from view along the inside of the frame), which will have the print hinged onto its surface with linen tape. The thickness of the fillet is up to you, as is the width of the frame molding; it usually ranges between 1/8" to 1/2" (Figure 18-3). Plexiglass can be used in place of glass, but it scratches easily and can warp with exposure to extremes of heat.

The easily assembled metal section frames are excellent for those who desire simple and relatively inexpensive methods of framing. These frames allow for quick disassembling and are, therefore, excellent for

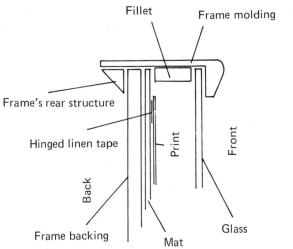

Fillet

Frame molding

Frame's rear structure

Hinged linen tape

Back

Print

Front

Frame backing

Mat

Glass

Fig. 18-3 A properly prepared fillet frame.

temporary exhibiting. However, they come in standard sizes, and although there is a wide variety, the standards may not be appropriate for your particular print.

The number of framing possibilities is immense, and you should explore the market extensively until you become familiar with the variety. Not all frames work in all situations, and you must be aware of how a frame changes an image. The wrong frame could destroy a successful image, and the right frame could very effectively compliment and sometimes improve an image.

Developing
A Printmaking Aesthetic

EXHIBITING

The student of printmaking eventually may try to get prints into exhibitions. There are many local, regional, and national juried open shows that invite prints of every category. These shows sometimes include other fine art mediums, as well as the crafts, and sometimes are designated as solely printmaking exhibitions. There is no comprehensive listing of shows available to the public. Anyone interested in exhibiting prints, therefore, must do some "leg work." Sometimes there are monthly listings in art periodicals of shows throughout the country. Arts sections of newspapers may give listings. Prospective brochures for exhibitions are usually sent to art departments of colleges and universities, where they are placed on bulletin boards.

Many communities have their own art centers or museums that hold exhibitions throughout the year. Local communities also establish art associations that are open to membership on many levels, including exhibiting membership. These associations are usually listed in the local telephone directly; they should be contacted for requirements and procedures. Membership in a local art center, museum, or art association

usually increases the availability of exhibition literature from other localities as well. Art departments of colleges and universities also sometimes hold open exhibitions.

Local communities throughout the country may have commercial galleries that handle prints. Although the very established large commercial gallery is meant specifically for the more established professional artist, smaller galleries are a real possibility. Prints are usually accepted on consignment from the artist, and after a sale is made, the money is usually divided as preagreed by artist and dealer.

As one becomes more proficient as an artist/printmaker, further exhibition possibilities can be explored. These include the major museums, larger commercial galleries, national art organizations, and artist-run "cooperative" galleries.

Although the beginner will probably be somewhat timid about public exhibitions of his or her work, they help one to become as "professional" as possible. Although the feedback can be very negative at times, it is the most effective way to grow in your work. A determined individual will weigh every negative occurrence or criticism within the proper context and continue to pursue the development of a chosen art form. To assist in this pursuit, the evolution of art history and criticism will be an inevitable course of action.

It is quite possible that many will never wish to go beyond the point of making prints for personal satisfaction and distribution. But it should be noted that proper growth in the various media eventually will lead to *some* basic printing research, both on historical and critical levels. The growth is aesthetic, and the making of any art insists that the individual maker manifest an appreciation and responsiveness to the artistic image. This manifestation can only lead to a better understanding of one's personal place within the wide spectrum of fine art printmaking.

CONCLUSION

TOWARD THE DEVELOPMENT OF A PERSONAL PRINTMAKING AESTHETIC

As the introduction to this book indicated, the scope is primarily technical in nature. Therefore, questions of craft have been the prime consideration. Instructions in creating image have been hinted at but not explored in any definitive way. A book of this type could not do justice to the "art" of developing a personal sophisticated visual statement. In this regard, no one piece of literature would ever dogmatically insist that it has revealed the absolute process by which an artist develops an image. Yet, some consideration of the process should be made.

If there is any so-called absolute in the process of image development, its title should be *relativity*. Such a concept (creative rather than academic in nature) allows the student of printmaking a fundamental sense of security

without destroying the necessary artistic flexibility required. Close definitions are all too often limitations; "fixed" and "determined" are terms expressive of growth stoppage.

Relativity seeks adjustment. The evolution of a plate, block, or stone constantly requires modification, alteration, and permutation. The creator consistently remains extremely aware of the changing and developing image, holding a continuous dialogue with the work from conception of idea to completion of edition. Of course, any decision to preplan the progression of an image depends on the personal need of the creator, taking into account individual personality and experience. But even with an advanced plan, the creator must never fall victim to a monologue situation, for it inevitably casts the attention to the ego alone, causing halting, inconsistent, and sporadic steps to an end that will reveal a static attitude and a labored image. The preplanner, as well as intuitive creator, should feel continuously free to modify, expand, delight in his or her tools, and change his or her approach. The artist must be ready to see anew, be open to accident, take risks, and be responsive to his or her own subjectivity. In this sense, the *open* definition declares that the process of printmaking is one of constant adjustment and readjustment.

To remain flexible and open enough to this concept of adjustment, a basic attitude toward the making must be present. Stanley William Hayter's approach, by means of play versus work, is a paramount concept in the progress of a print.[1] This is not the frivolous passive attitude toward play, but a serious, deliberate, and committed freedom from mechanized habits that climax in artistic frustration. Serious play requires the meditative concentration of a chess game, where for one to become a winner, moves must be made with attention to technical data as well as imagination. One may be an expert at knowing all the correct and plausible moves, but if he or she does not have a conscious awareness and responsiveness to an ever changing game board, accompanied by flexible, adjusting, and risk-taking abilities, losing will be the final result.

Like chess, printmaking also has its "moves." These are attention and concern for the elements and concepts of design, which include practical theory with regard to line, form, texture, color, value, space, balance, and continuity. The student of printmaking should become as familiar with design theory as with technical processes. Many fundamental design texts are available and should be explored continuously as a means to broaden the base of attack and analyze your particular problem, reducing the image development to essentials so that relationships are better understood both visually and verbally.[2] These are concepts used or rejected as need arises and imagery dictates.

Unlike other fine art forms, printmaking allows for thorough evaluation of image through design understandings because of the nature of the

[1]Stanley William Hayter, *New Ways of Gravure*. (2nd ed.) (Fair Lawn, N.J.: Oxford University Press, 1961), pp. 270-272.

[2]Otto G. Ocvirk, Robert O. Bone, Roert E. Stinson, and Phillip R. Wigg, *Art Fundamentals: Theory and Practice* (Dubuque, Iowa: William C. Brown Company), 1968.

medium. Prints are done in stages. Proofing allows for a complete visual record and evaluation of successive stages. At any time along the way, the printmaker can choose to pull an "edition," then carrying the plate to later stages without the fear that something has been destroyed. These later stages allow for the element of surprise, the unexpected result, and clarity of expression, increasing the dialogue possibilities and extending the perceptions of the creator. As one advances into color, the possibilities of modification increase rapidly, just as the plates allow for constant rearrangement of form and effect. The visual statement is no longer monographic in nature.

The rules or "moves" of technical process are also open to flexible responses. This book has attempted to provide a distinctively basic approach to tools and materials without the burden of traditional wrongs and rights, which provide only mechanized uses of process. This is not a tool in printmaking but a hindrance. Treat technical process as part of the total act, and you will soon discover that skill proficiency is only important when it serves the need for aesthetic expression, increasing the imaginative abilities of the individual. Treat it as an end in itself and your imagery will never progress, but is more likely to retrogress. The eventual relationship of the creator to his or her materials and procedures should become intuitive in nature, enabling you to concentrate completely on the evolving visual.

That particular visual statement has two equal aspects. On the one side, it is a record of personal experience. This aspect does not need elaboration. However, the other side that declares the statement to be just that, a form of communication that opens to the spectator the chance for involvement, is too often neglected by the beginner. If you establish no invitation, no one will look, no one will really *see*. To understand this, the concept of a vacuum should be considered. The reality of a room is found in the vacant space enclosed by the roof and walls, not in the roof and walls themselves. The usefulness of a water pitcher is in the emptiness where water might be put, not in the form of the pitcher or the materials it was made from. In the development of an image, the vacuum is illustrated by the value of suggestion. In leaving something unsaid, the viewer is given the chance to complete the idea, and thus the image will rivet attention until the viewer unavoidably becomes part of it. The image is then *seen*.

You must also learn to *see*. Response and appreciation of prints, as well as other fine art forms, by others broadens the individual's insights, strengthens critical judgement, enriches ideas, and develops image integrity. A sensitive response to a work of art provides insight with respect to the elusive factors of quality. Beyond the pleasures of viewing other prints, these insights provide a means toward legitimate acceptance or rejection of particular viewpoints, and the ultimate development of personal ones. Viewing a work of art from various bases opens one to new experiences, and perfects a deepened aesthetic awareness.

It has been the intent of this text to provide the student of printmaking with the necessary foundations in technical process. Further, the attempt

has been to do so without adding to the technical myths that have for too long kept interested persons away from printmaking. Methods have been simplified in the hope of providing a basic understanding of technique so that the primary consideration—image development—can progress in a contemporary fine arts medium that very definitely bridges the space between craft and art.

Appendix A

Appendix A

LIST OF SUPPLIERS

In general, most well-stocked retail art supply outlets will handle a wide variety of printmaking materials. Specialized items are sometimes more difficult to obtain, especially if you are not in or near a large city. However, most suppliers will take mail orders. Specific retailers and wholesalers of art supplies should be individually contacted for catalogs and ordering procedures. Of course, the local telephone directory, specifically the "Yellow Pages," is invaluable when trying to locate workshop equipment and materials. The following listing should help the beginner in locating specific outlets:

General art supplies, including printmaking materials:

Dick Blick
P. O. Box 1267
Galesburg, Ill. 61401
800-447-8192

Fine Art Materials, Inc.
539 La Guardia Pl.
New York, N. Y. 10012
212-982-7100

N.Y. Central Supply Co.
62 Third Ave.
New York, N. Y. 10003
212-473-7705

Pearl Paint Co., Inc. (3 locations)
308 Canal St.
New York, N. Y. 10013
212-431-7932

2411 Hempstead Turnpike
East Meadow, L. I., N. Y. 11554
516-731-3700

800 Route 17
Paramus, N. J. 07652
201-447-0300

Sam Flax, Inc. (3 locations)
25 E. 28th St.
New York, N. Y. 10016
212-889-2666

511 Madison Ave.
New York, N. Y. 10022
212-889-2666

15 Park Row
New York, N. Y. 10038
212-791-1230

Metal plates (etching, engraving, and lithographic):

National Steel and Copper Plate Co.
543 W. 43rd St.
New York, N. Y. 10036
212-245-9922

Revere Copper and Brass Inc.
Edes Manufacturing Division
P. O. Box 477
Plymouth, Mass. 02360
617-746-1000

T. E. Conklin Brass and Copper Co., Inc.
324 W. 23rd St.
New York, N. Y. 10011
212-691-5100

Presses and miscellaneous heavy equipment:

American French Tool Co.
Route 117
Coventry, R. I. 02816
401-821-0452

Charles Brand Machinery Inc.
84 E. 10th St.
New York, N. Y. 10003
212-473-3661

Graphic Chemical and Ink Co.
(see *General Printmaking Supplies*.)

The Griffin Company
1745 E. 14th St.
Oakland, Calif. 94606
415-533-0600

Rembrandt Graphic Arts Co.
Stockton, N. J. 08559
609-397-0413

Showcard Machine Co. (2 locations)
Showcard Proofing Presses
320 W. Ohio St.
Chicago, Ill. 60610
312-944-3830

Eastern Representative
60 E. 42nd St.
New York, N.Y. 10017
212-867-3223

Vandersons Corp.
Vandercook Press
7101 N. Capital Drive
Chicago, Ill. 60645
800-323-7648

General printmaking supplies (including fine paper):

Aiko's Art Materials Import, Inc.
715 N. Wabash Ave.
Chicago, Ill. 60611
312-943-0745

Andrews/Nelson/Whitehead
31-10 48th Ave.
Long Island City, N. Y. 11101
212-937-7100

Crestwood Paper Co.
263 Ninth Ave.
New York, N. Y. 10001
212-255-5522

The Cronite Co. Inc. (2 locations)
1 Beekman St.
New York, N. Y. 10038
212-233-3210

Kennedy Blvd. at 88th St.
North Bergen, N. J. 07047
201-869-4000

Fine Arts
Wheaton Plaza
Wheaton, Maryland 20902
202-363-6619

Graphic Chemical and Ink Co.
P. O. Box 27
728 N. Yale Ave.
Villa Park, Ill. 60181
312-832-6004

Guy T. Kuhn
P. O. Box 166
Keddysville, Md. 21756
301-432-8148

Rembrandt Graphic Arts Co.
(see under *Presses* etc.)

Yasutomo and Co.
Dept. AA-4
24 California St.
San Francisco, Calif. 74111
415-981-4326

General lithographic supplies:

Handschy Chemical Co.
2525 N. Elston Ave.
Chicago, Ill. 60647
312-276-6400

Harold Pitman
515 Secaucus Rd.
Secaucus, N. J. 07094
201-865-8300
212-244-6820

J. H. and G. B. Siebold, Inc.
150 Varick St.
New York, N. Y. 10013
212-675-7650

Litho-Plate Co.
5200 East Valley Blvd.
Los Angeles, Calif. 90032
213-221-1145

Polychrome Corp.
920 Broadway
New York, N. Y. 10013
212-254-1670

Sinclair and Valentine (2 locations)
Secaucus Rd.
Secaucus, N. J. 07094
212-227-5984
201-866-3710

Santa Fé Springs, Calif.
213-921-3493

William Korn (lithographic drawing supplies)
111 Eighth Ave.
New York, N. Y. 10011
212-242-3317

Chemicals and acids:

City Chemical Co.
132 W. 22nd St.
New York, N. Y. 10011
212-929-2723

Philip Hunt
707 Army St.
San Francisco, Calif. 94124
415-285-1700

Varn Products Co., Inc.
175 State Highway
Oakland, N. J. 07436
201-337-3600

Solvents:

Union Amsco (2 locations)
Division of Union Oil Co. of Calif.
350 Roosevelt Ave.
Carteret, N. J. 07008
201-541-4224

P. O. Box 8320
New York, N. Y. 10008
212-964-0772

Varn Products Co., Inc.
(see under *Chemicals* etc.)

Lithographic, offset, and letterpress inks:

General Printing Ink Co. (2 locations)
Division of Sun Chemical Corp.
390 Central Ave.
East Rutherford, N. J. 07073
212-695-3858
201-438-4040

2458 Hunter Street
Los Angeles, Calif. 90021
213-627-1401

Handschy Chemical Co.
(see under *General lithographic*)

Inmont Corporation (2 locations)
1133 Avenue of the Americas
New York, N. Y. 10011
212-765-1100

1255 Broad St.
Clifton, N. J. 07015
212-244-5757
201-773-8200

IPI Printing Inks
423 Broome St.
New York, N. Y. 10013
212-431-5780

J. H. and G. B. Siebold, Inc.
(see under *General lithographic*)

Sinclair and Valentine
(see under *General lithographic*)

Superior Printing Ink Co., Inc.
295 Lafayette St.
New York, N. Y. 10013
212-226-1276

Dry pigments and pigment mixing supplies:

Fezandie and Sperrle Inc.
Subsidiary of Leeben Color and Chemical Co., Inc.
103 Lafayette St.
New York, N. Y. 10013
212-226-7653

Steel facing:

Anderson and Lamb
46 Cadman Plaza West
Brooklyn, N. Y. 11201
212-624-2181

Felt blankets:

Continental Felt Co.
22 W. 15th St.
New York, N. Y. 10011
212-929-5262

Pacific States Felt and Mfg. Co.
23850 Clawiter Rd.
Hayward, Calif. 94545
415-783-0277

Plastic supplies, including plastic and epoxy tympans:

Amplast Inc.
359 Canal St.
New York, N. Y. 10013
212-966-3822

Commercial Plastics and Supply Corp.
630 Broadway
New York, N. Y. 10013
212-477-5000

Industrial Plastic Supply Co.
309 Canal St.
New York, N. Y. 10013
212-226-2010

Plank grain wood blocks:

American Printing Equipment and Supply Co.
42-25 9th St.
Long Island City, N. Y. 11101
212-729-5779

Endgrain wood blocks:

Reliance Wood Co.
9419 Railroad Ave.
N. Bergen, N. J. 07047
201-869-1230

Cylinder rubber, rubber padding and bases, and foam rubber:

Canal Rubber Supply Co.
329 Canal St.
New York, N. Y. 10013
212-226-7339

Rollers:

Apex Printers and Roller Co.
1541 N. 16th St.
St. Louis, Missouri 63106
314-231-9752

Charles Brand Machinery Co.
(see under *Presses* etc.)

Tarlatan:

Beckman, Inc.
120 Baxter St.
New York, N. Y. 10013
212-226-8400

Carborundum:

King and Malcomn Co., Inc.
57-10 Grand Ave.
Maspeth, L. I., N. Y. 11378
212-386-4900

General wood engraving supplies:

J. Johnson and Co.
33 Matinecock Rd.
Port Washington, N. Y. 11050
516-883-5608

The Sander Wood Engraving Co., Inc.
117 W. Harrison
Chicago, Ill. 60605
312-427-2204

Engraving and etching tools:

E. C. Lyons
16 West 22nd St.
New York, N. Y. 10011
212-691-1974

Edward C. Muller
3646 White Plains Rd.
Bronx, N. Y. 10467
212-881-7270

Sculpture Associates Ltd.
114 E. 25th St.
New York, N. Y. 10010
212-777-2400

Vapor, gas and dust respirators:

Pulmosan Safety Equipment Corp.
30-48 Linden Pl.
Flushing, N. Y. 11354
212-939-3200

Framing and frame molding:

Kulicke Frames Inc. (2 locations)
43 E. 78th St.
New York, N. Y. 10021
212-254-0140

636 Broadway
New York, N. Y. 10013
212-673-1564

Mark LV Frames and Poster Originals, Ltd. (3 locations)
386 West Broadway
New York, N. Y. 10012
212-226-7720

924 Madison Ave.
New York, N. Y. 10021
212-861-0422

19 Main St.
East Hampton, L. I., N. Y. 11937
516-324-6356

Vadley Art Co.
816 Broadway
New York, N. Y. 10013
212-254-9190

Yale Picture Frame and Molding Corp.
700 Broadway
New York, N. Y. 10013
212-777-0840

Appendix B

Appendix B

GLOSSARY

À la poupée The application of several colors to a plate simultaneously for single (one-step), multicolor intaglio printing.

Abstraction The rearrangement or simplification of objects observed for purposes of organization and personal artistic expression.

Acetic acid Colorless, pungent, water-miscible liquid (CH_3COOH), which is the essential constituent of vinegar used for certain lithographic and etching purposes.

Acid resist A liquid or solid material that cannot be affected by the corrosive factors of acids.

Aesthetics Traditionally concerned with a sense of the beautiful as well as pure emotion and sensation (as opposed to pure intellectuality). Contemporary uses include concern for artistic qualities that attempts to discover the origins and relationships of art forms isolated and in combination with philosophy, psychology, sociology, religion, and other studies and aspects of life.

Analogous colors Closely related colors that neighbor each other on the color wheel, such as red and red-orange.

Angle tint tool A wood engraving tool similar to the burin that contains a flat-sided rod and sloped cutting tip used for single nonvarying line cutting.

392

Aquatint A method of etching that produces value tones on a metal plate through the application of dusting or spraying acid-resist substances on the plate surface.

Area etch A method of applying a lithographic etch mixture to particular areas or spots on a plate or stone.

Artist's proof A reserved number of prints out of the edition so marked with "A/P," Proof," or "Artist's Proof." They bear no numbering system and are usually the same as the edition prints. Many artists will mark trial or working proofs as artists proofs, and these will usually differ from the edition.

Asphaltum A bituminous liquid substance and by-product of petroleum, of high grease content used in etching grounds and as a printing base in lithography. In powdered form, can be used for dusting fine aquatints.

Autographic ink A very greasy liquid water tusche used to create solids and pen lines for lithography.

Autographic ink stick A very greasy stick used for rubbing gradation tones on a lithographic printing surface.

Balance The visual effect of equality throughout a composition that attempts to accomplish integration and unity.

Baren A tool used to transfer ink from a relief block or plate to a piece of paper without the aid of a press.

Bench hook A holding device for blocks to avoid slipping of block or cutting tools.

Bevel The filed, angled edge of a stone or plate.

Bite The corrosive action of acid on a metal plate to create an etching (intaglio image).

Blankets Woven or pressed surgical felt used on an etching press for intaglio printing.

Bleeded image A printed image that extends to the edges of the printing paper.

Block The relief printing surface, usually 3/4" to 15/16" thick wood or mounted linoleum.

Brayer A small one-hand roller used to apply inks and grounds to various printing surfaces, and for printing in relief without the aid of a press.

Bridge A hand-resting device placed over a plate, block, or stone for simplified drawing without touching the image surface.

Burin A tempered steel rod with a handle and lozenge or square cutting point used for engraving furrows in a metal or wood surface.

Burnisher A tool with an oval rod or convex tip, highly polished and kept perfectly smooth, used in various plate making and printing processes.

Burnt plate oil Raw linseed oil burnt to certain temperatures used in mixing inks, and changing ink viscosity.

Calligraphy Reminiscent of the flowing lines of handwriting, drawn as a non-objective or objective motif.

Cancelled plate The process by which a stone, block, or plate is defaced by some form of line strike on its surface after the completion of edition printing.

Carborundum Silicon carbide abrasive powders used to grind a lithographic stone, and for various experimental printmaking processes.

Cellulose gum A gum solution made from inert carbohydrates, the chief con-

stituent of cell walls of plants, used in metal plate lithography as an etch solution.

Chaos The unrelated parts of a whole, which present a feeling or visual sense of confusion or disorder.

Charcoal block A rectangular piece of solid hand charcoal used with water as a polishing agent on metal or stone.

Chiaroscuro The illusionistic creation of space by visual concentration of light and shade on an image, and the intermediary blends developed.

Chine collé A method of laminating various papers to a printing paper surface simultaneously as the inked print is being pulled.

Chisels Wood sculpture tools similar in shape and construction to woodcutting tools, but much larger and more diverse in assortment, used for various woodcutting purposes.

Collage A technique of composing a work of art by pasting on a single surface various materials. In printmaking, it includes the process of chine collé and is part of transfer lithography.

Collagraph A plate produced by collage techniques used for intaglio and/or relief printing. The print from said plate(s).

Color The quality of an object or subject with respect to wavelengths of light reflected, which create variance and quality of hue.

Complementary colors The opposite colors on a color wheel, for example, blue and orange, red and green, violet and yellow.

Composition The organization of artistic elements in the attempt to create a unified whole through interesting and dynamic rearrangements of the parts.

Continuity A state of flow between connected visual elements.

Contour Line that creates boundaries or closed shapes in space.

Counteretch The process by which a surface is sensitized to the reception of a lithographic grease drawing.

Criblé A method of engraving tiny holes into a plate utilizing punches, a stippling engraver, or a burin.

Deckled edge The typical edge of handmade papers that are left irregular. This edge can be simulated by proper tearing.

Desensitize To treat a stone or plate surface chemically so that it will no longer be receptive to lithographic grease drawing.

Design The arrangement of artistic elements into a formal organization; the classification of these elements.

Diamond point A drypoint needle containing a ruby, sapphire, or diamond chip point for sharp smooth cutting in metal.

Draw tool An angled cutting rod and tip with handle used to hand cut metal and plastic plates by pulling the tool toward you, scoring the plate surface so that it can be easily separated by snapping.

Drypoint An intaglio method of direct incising with a needle to create a burr that prints a raised, velvet line. The print from said plate.

Durometer A mathematical measurement for determining the hardness or softness of rubber rollers.

Edition The total number of prints with a particular single image pulled from a single or multicombination of plates, blocks, or stones. Numbered consecutively with the number of a particular print above the number of the total edition, such as 1/10.

Elliptic tint tool A wood-engraving tool similar to the burin that contains a curved sided rod and curved cutting tip that produces variable changing lines and curves.

Embossement The raised area of a print produced by inked or uninked intaglio or collagraph plates. The print from said plate(s).

Emphasis The importance or significance laid upon certain visual elements of a composition.

Endgrain Wood cut across the grain used for wood blocks in wood engraving.

Engraver's chisel A wood engraving tool similar to the burin that contains a wide square rod and cutting tip used to remove large areas of wood.

Engraver's knife A wood engraving tool similar to the burin that contains a very sharp triangular rod and cutting tip used for outlining and very fine lines and textures.

Engraver's pad A circular leather sand or grit-filled bag used to make circular or curved cuts in metal and wood engraving.

Engraving An incising method that utilizes burins and similar push-cutting tools on endgrain wood blocks and metal plates. The print from said block or plate.

Etch The method and acid mixture for biting metal in etching. In lithography, it refers to the chemical mixture for desensitizing a plate or stone.

Etching An incising method that utilizes the corrosive factors of acids on metal. The print from said metal plate.

Etching needle Any type needle used to scratch through an etching ground to create a drawing that will be etched.

Extender An opaque or transparent medium added to ink to increase coverage, thin out pigment quality, or as a transparency for color overlays.

Felt side The printing side of paper that reveals a nap on the surface.

Form An expressive, inventive, classical, or arbitrary arrangement of artistic elements with respect to design principles to create a harmonious or chaotic unity.

Foul bite The accidental, uncontrolled biting of a metal plate.

French chalk A refined talcum powder used to talc a lithographic image or as a replacement for whiting in intaglio processes.

Frottage A technique of creating a visual image by transferring textural items to paper by rubbing methods.

Glycerine A colorless, odorless, syrupy, sweet liquid ($HOCH_2CHOHCH_2OH$) obtained by saponification of natural fats and oils used in lithography for various purposes.

Gouache Opaque watercolor pigment.

Gouges Various half-round concave tools used in woodcutting and linocutting.

Ground An acid-resist substance in liquid, paste, or solid made from wax, resin, and asphaltum (and solvent in liquid form) placed on a plate for etching processes. Petroleum jelly added to create soft ground.

Gum Gum arabic solution used to desensitize a stone or plate to grease and make it receptive to water for lithographic printing. Also used in lift ground-etching formulas.

Harmony The visual creation and feeling of a compositional unity produced by the arrangement of design elements.

Hue The common name of particular colors signifying the measurement of a specific wavelength of light, such as red.

Illusion Imitation of visual reality.

Image The artistic playful presentation of an aesthetic vision giving off a concrete definite appearance.

Impression The inked transferred image on a piece of printing paper.

Intagliate The incised areas of a particular plate.

Intaglio The process of incising a plate by various methods for printing in a double cylinder press. Refers to the printing process as well.

Intuitive The reliance on instincts whether learned or innate through natural sensing and feeling, rather than a reliance on exact rule structures or procedures.

Jeweler's rouge The brownish-red oxide of iron that remains after heating ferrous sulfate (colcothar) used to polish metal and stone.

Knife A sharp cutting tool of various designs used to cut lines and edges in woodcuts and linocuts.

Letterpress A relief printing press used in commercial printing. Used in the printing of type-high woodcut, wood engraving, and linocut blocks.

Levigator A heavy, metal, circular, hand-grinding tool used to remove an old image from a stone surface and make it highly sensitive to a grease drawing.

Lift ground A direct etching method that utilizes a sugar mixture that lifts through a ground or stop-out varnish when the plate is submerged in water. Also called sugar-lift and sugar-lift aquatint. The print from said lift ground plate.

Line A mark or stroke long in proportion to its breadth made between two points with a drawing instrument.

Liner A multiple lining tool used in metal and wood engraving.

Linocut The process of cutting a relief image from linoleum. The print from said linoleum block or plate.

Lithography A planographic process of producing a print from a grease drawing on stone or zinc and aluminum plates, based on the principle that water and grease do not mix.

Lithotine A derivative substitute for turpentine that is safer and less irritable to skin.

Magnesium carbonate A chemical powder used to stiffen (make short) printer's inks.

Medium (media) The reference to particular materials, supplies, equipment, and processes used by an artist to attain certain effects and results.

Mezzotint An anachronistic intaglio plate-making method that produces a white image from a blackened plate. The process is experiencing a small revival, especially when used in combinations with other media.

Mixed media The combination of printmaking and other artistic visual production methods simultaneously on one print or multiple.

Monotype (monoprint) A single print made by transferring a "painted" image from a smooth surface such as glass.

Montage The technique of combining in a single composition photographic elements from various sources in collage and frottage fashion.

Mordant The acid bath mixture used for etch biting.

Motif A recurring subject, theme, idea, or visual element in a composition that is the dominant feature.

Multiple The repeated or duplicated work of art considered, when properly signed and authenticated, as an original.

Neutrals Tone that does not reflect wavelengths of light. Refers to black, white, and tonal greys.

Nitric acid Colorless caustic water-soluble liquid (HNO_3) having powerful corrosive and oxidizing properties used in etching and lithography.

Nonobjective A visual presentation that has no reference to reality whatsoever, relying on the artistic imagination of the creator only.

Numbering The method of identifying the entire edition of prints.

Objective The attempt to present a visual that is an exact rendering of visual reality.

Offset The transference of an image from one surface to another, and then to the printing paper surface. In commercial print, the most common method of image and type duplication by means of automatic offset presses, and photographic reproduction.

Oil/Arkansas stone Rough and fine oil stones used to sharpen tools.

Oil of clove Clove oil, traditionally used by pharmacists for toothaches, placed in oil-based inks in small quantities to keep the ink moist longer for easy intaglio printing.

Pattern The decorative or visual design forming a consistent or characteristic arrangement usually accomplished through repetition.

Phosphoric acid Any of three acids: orthophosphoric (H_3PO_4), metaphosphoric (HPO_3), or pyrophosphoric ($H_4P_2O_7$) derived from phosphorus pentoxide and water. Used in syrupy state in lithography.

Plank grain Wood that is cut parallel to the grain, exposing the natural grain, used for woodcut printing blocks.

Planographic A printing method that transfers an image from the surface (not in relief or incised) of a plate or stone.

Plate A surface made from various materials (including metal, wood, plastic, linoleum, plaster, cardboard, masonite) for the reception of a printmaking image.

Potassim alum A colorless, odorless, crystalline, water-soluble solid or power ($K_2AO_4 \bullet A1_2(SO_4)_3 \bullet 24H_2O$) used in counteretch formulas for lithography.

Primary colors The colors of the spectrum that cannot be mixed from other pigment hues—red, yellow and blue.

Pull The process of producing a print by various printing methods. The pulled edition refers to the entire printed body of prints containing a particular, unique image.

Pumice A powdered volcanic glass used as a polishing and correcting agent in intaglio and lithographic plate-making processes. In stick form, it is referred to as snake slip.

Register A process by which succeeding images are properly placed in a correct relationship to one another by use of registration markers, templates, and registration frames.

Relief Various methods of producing a raised image on different surfaces. The method of printing from said raised surfaces. A print from said raised surfaces.

Resensitize A chemical process by which a lithographic surface is made sensitive to grease drawing without grinding procedures employed.

Roller Large "rolling-pin" type printing mechanisms covered with rubber, polyurethane, leather, gelatine, or other various materials.

Roll-up The process by which a slab, roller, and printing surface is inked.

Rosin (resin) Translucent resin left after distilling the oil of turpentine from the crude oleoresin of the pine. Used as an acid-resist substance in etching and lithography, and in some printing inks.

Roulette A wheel tool that contains a particular pattern engraved into a metal plate.

Scorper An engraving tool similar to the burin that contains a rectangular rod and cutting point, which is usually rounded or flat. Sometimes referred to as a graver.

Scotch hone A stone hone in stick form used as an abrasive for correcting images on metal and stone, and for initial polishing.

Scraper A three-sided, sharp-edged tool used in various intaglio plate-making processes and corrections.

Scumming In lithography, the unwanted adherence of ink in nondrawn image areas of a stone or plate, caused by the breakdown of the desensitizing etch in most cases.

Shape Area of space characterized by a specific outline, formed color, value, or texture.

Solvent Various substances used to dissolve other substances. In printmaking, the most common solvents are kerosene, turpentine, paint thinner (mineral spirits), lacquer thinner, gasoline, and denatured alcohol.

Snake slip Pumice in stick form used for correcting and polishing printing surfaces of stone and metal.

Space The real or illusionistic sense of three-dimensional expanse in which all material objects and events exist. In contemporary art, space also refers to the nonordinary fantasy expanse, whether three or two-dimensional in quality, created by the artist's imaginative use of visual and time relationships.

Spitsticker A wood-engraving tool similar to the burin that contains a triangular rod and cutting point, which is usually flat or slightly rounded at the tip. Is the most used of all wood-engraving tools.

State Variants of a basic printed image from the same single or multiple plate(s), stone(s), or block(s). Various states within an edition are identified by Roman numerals following the title "State" after the edition number, such as 1/10-State I.

Steel facing The process by which a thin coat of steel is placed on a copper or copper-faced plate electronically to reinforce the intagliate for multiple printing.

Stippling graver A burin-like engraving tool used to create dot patterns (criblé effects) on metal plates.

Stop-out varnish An acid-resist liquid usually made from rosin and denatured alcohol used in etching.

Tactile Refers to the sense of touch.

Talcum powder Powdered hydrous magnesium silicate used as an acid-resist material in lithography, and other miscellaneous printmaking processes.

Tarlatan A stiff "cheesecloth"-like material used for wiping inked plates in intaglio printing.

Technique The craft or skill with which one employs particular tools and processes to achieve a desired result.

Texture The real or illusionistic presentation of tactile surfaces.

Tinting In lithography, the unwanted overall light tone effect printed over and through an image usually caused by dirty water and sponges.

Tone The particular character of change in color or value determined by quality of light reflection.

Transfer paper Precoated paper used in lithography to receive a grease drawing, which is chemically transferred and processed for normal lithographic printing.

Tusche A grease substance in liquid, paste, or stick form used with water or solvents for lithographic drawings.

Tympan A sheet of pressboard, plastic, or thin metal used as a cover sheet between the printing paper and scraper bar in lithographic printing.

Tympan grease Usually mutton tallow, the fatty tissue, or suet of sheep. Commercial grease of certain consistencies also can be used. Applied to tympan and scraper bar leather for smooth lithographic printing.

Type-high blocks Blocks prepared in exact thicknesses (.918 inches) for letterpress relief printing.

Unity The oneness of a complex organic whole or of an interconnected combination of parts, harmonic or chaotic in nature.

Value The quality of lightness or darkness of color or neutrals.

Varnish In lithography, refers to various varnishes used to change viscosity of lithographic inks. In etching, refers to stop-out varnish.

Viener A cutting tool for wood or linoleum blocks that consists of a metal rod with a "V" or "U" cutting tip and a pushing handle.

Viscosity The glutinous nature of inks; high viscosity refers to very stiff (short) ink and low viscosity refers to very oily (long) ink. Refers also to the particular processes of simultaneous color application to deep-etched plates.

Weldon Robert's Retouch Stick A rubber hone used for correcting and cleaning areas of metal lithographic plates.

Whiting Pure white calcium carbonate chalk that has been ground and washed, used in various intaglio processes.

Woodcut A relief printing surface cut from the plank grain wood block. The print from said block.

Wood engraving A relief printing surface engraved into the endgrain wood block. The print from said block.

Working proof The artist's proof containing changes in the form of additions and subtractions. Not part of the edition and usually destroyed or kept by the artist or printer for feedback information only. Also referred to as trial proofs.

Xylography The craft and art of wood engraving and woodcutting.

Bibliography

Bibliography

Adhémar, Jean, *Twentieth-Century Graphics*, trans. Eveline Hart. New York: Praeger Publications, 1971.

Andrews, Michael P., *Creative Printmaking*. Englewood Cliffs, N. J. : Prentice-Hall, Inc. 1964.

Anonymous, "A New Direction in Intaglio," *The Work of Mauricio Lasansky and His Students*. Exhibition Catalog. Minneapolis: Walker Art Center, 1949.

_____, *1800 Woodcuts by Thomas Bewick and His School*. New York: Dover Publications, Inc., 1962.

_____, *Modern Masters of Etching*, vols. 1-28. Introductions by Malcom C. Salaman. New York: William Edwin Rudge, 1920-1933.

Antreasian, Garo, and Clinton Adams, *The Tamarind Book of Lithography: Art and Techniques*. New York: Harry Abrams, Inc., 1971.

Appleson, Herbert Joseph, *Developments in Contemparary Printmaking 1950-1970*, Unpublished Ed.D. dissertation. Teachers College, Columbia University, 1972.

Arnold, Grant, *Creative Lithography and How to Do It*. New York: Harper and Brothers, 1941.

Banister, Manly, *Etching and Other Intaglio Techniques*. New York: Sterling Publishing, 1969.

Bewick, Thomas, *Memoirs of Thomas Bewick.* New York: Lincoln McVeagh, The Dial Press, 1925.

403

Bibliography

Blum, André, *The Origins of Printing and Engraving.* New York: Charles Scribner's Sons, 1940.

Brommer, Gerald F., *Relief Printmaking.* Worcester, Mass.: Davis Publications, Inc., 1970.

Brown, Bolton, *Lithography for Artists.* Chicago: University of Chicago, 1930.

Brundson, John, *The Technique of Etching and Engraving.* New York: Reinhold Publishing Corp., 1965.

Brunner, Felix. *A Handbook of Graphic Reproduction Processes* (3rd ed.). New York: Hastings House, Publishers, Inc., 1968.

Cahn, Joshua Binion, ed., *What is an Original Print?* New York: Print Council of America, 1961.

Carrington, Fitzroy, *Engravers and Etchers.* Chicago: The Art Institute of Chicago, 1917.

Carter, Thomas Francis, rev. by Goodrich L. Carrington, *The Invention of Printing in China and Its Spread Westward.* New York: The Ronald Press Co., 1955.

Chamberlain, Walter, *Etching and Engraving.* New York: The Viking Press, 1972.

Chatto, W. A., *A Treatise on Wood Engraving.* London: Charles Knight and Co., 1839.

Chesney, Lee, "Printmaking Today," *College Art Journal,* XIX (Winter 1959-60), 158-165.

Citron, Minna, "In Deep Relief," *Artist's Proof,* VI (1966), 30-37.

Cundall, Joseph, *A Brief History of Wood Engraving.* London: Sampson Low, Marston & Company, Ltd., 1895.

Dodson, Austin, *Thomas Bewick and His Pupils.* Boston: James R. Osgood and Co., 1884.

Edmondson, Leonard, *Etching.* New York: Van Nostrand Reinhold Co., 1973.

Eichenberg, Fritz, ed., *Artist's Proofs; the Annual of Prints and Printmaking.* New York: Pratt Graphics Center in association with New York Graphic Society, Ltd., 1961-1971.

Ficke, Arthur Davison, *Chats on Japanese Prints.* London: T. Fisher Unwin Ltd., 1915.

Foight, Claude, *Lino-Cuts.* London: John Lane, The Bodley Head Ltd., 1927.

Furst, Herbert, *The Modern Woodcut.* London: John Lane, The Bodley Head Ltd., 1924.

Goldman, Judith, "Print Criteria," *Art News,* 70:19 (January 1972), 48, 65.

Green, Peter, *New Creative Print Making.* New York: Watson-Guptill Publications, Inc., 1969.

————, *Surface Printing.* New York: Watson-Guptill Publications, Inc., 1968.

Greenburg, Samuel, *Making Linoleum Cuts.* New York: Stephen Daye Press, 1947.

Gross, Anthony, *Etching, Engraving and Intaglio Printmaking.* London: Oxford University Press, 1970.

Hayter, Stanley William, *About Prints.* London: Oxford University Press, 1962.

————, *New Ways of Gravure* (2nd ed.). Fair Lawn, N. J.: Oxford University Press, 1962.

Heller, Jules, *Printmaking Today* (2nd ed.). New York: Holt, Rinehart and Winston, 1972.

Hess, Thomas B., "Prints: Where History, Style and Money Meet," *Art News*, 70:19 (January 1972), 29, 66-67.

Hind, Arthur M., *A History of Engraving and Etching from the 15th Century to the Year 1914.* London: Constable and Company, Ltd., 1923.

_____, *A Short History of Engraving and Etching.* London: Constable and Company, Ltd., 1908.

Ivins, William M., Jr., *How Prints Look.* Boston: Beacon Hill Press, 1958.

_____, *Notes on Prints.* New York: DeCapo Press, 1967.

_____, *Prints and Visual Communication*, reprint, New York: DeCapo Press, 1969.

_____, *Prints and Books*, reprint. New York: DeCapo Press, 1969.

Keynes, Geoffrey, *William Blake's Engravings.* London: Faber and Faber, 1950.

Kosloff, Albert, *Celluloid Etching.* Chicago: Chicago Book Company, 1940.

Kurth, Willi, *The Complete Woodcuts of Albrecht Dürer.* New York: Arden Book Co., 1940.

Loche, Renée, *Lithography.* Geneva: Les Editions de Bonvent, 1971.

Lumsden, E. S., *The Art of Etching.* Philadelphia: J. B. Lippincott Company, 1924.

Marsh, Roger, *Monoprints for the Artist.* London: Alectiranti, 1969.

Mayer, Ralph, *The Artist's Handbook of Materials and Techniques.* New York: The Viking Press, 1967.

Mendelowitz, Daniel M., *A Guide to Drawing.* New York: Holt, Rinehart and Winston, 1976.

Munro, Thomas, *The Arts and Their Interrelations.* New York: The Liberal Arts Press, 1951.

Oevirk, Otto G. et al., *Art Fundamentals: Theory and Practice* (2nd ed.). Dubuque, Iowa: Wm. C. Brown Co., 1968.

Pennell, Joseph, *Etchers and Etching* (4th ed.). New York: The MacMillan Company, 1925.

Pennell, Joseph, and Elizabeth Robbins Pennell, *Lithography and Lithographers: Some Chapters in the History of the Art.* New York: The Century Co., 1898.

Peterdi, Gabor, *Printmaking, Metholds Old and New.* New York: The Macmillan Company, 1971.

Petit, Gaston, *44 Modern Japanese Print Artists*, vols. I & II. New York: Kodansha International Ltd., 1973.

Platt, John, *Colour Woodcuts.* London: Sir Isaac Pitman and Sons, Ltd., 1938.

Plowman, George T., *Etching and Other Graphic Arts.* New York: Dodd, Mead and Company, 1929.

Polk, Ralph W., *Essentials of Linoleum-Block Printing.* Peoria, Ill.: The Manual Arts Press, 1927.

Pyle, Clifford, *Etching Principles and Methods.* New York: Harper and Brothers, 1941.

Rasmusen, Henry, *Printmaking with Monotype.* New York: Chilton Company, 1960.

Read, Herbert, et al., *Atelier 17 Group.* Exhibition Catalog. New York: Wittenborn, Schultz, Inc., 1949.

Ross, John, and Clare Romano, *The Complete Intaglio Print.* New York: The Free Press, 1974.

Rothenstein, Michael, *Linocuts and Woodcuts.* New York: Watson-Guptill Publications, Inc., 1962.

Rothenstein, Michael, *Relief Printmaking.* New York: Watson-Guptill Publications, Inc., 1970.

Sachs, Paul J., *Modern Prints & Drawings.* New York: Alfred A. Knopf, 1954.

Salaman, Malcolm Charles, *The New Woodcut.* London: The Studio Ltd., 1930.

Senefelder, Alois, *A Complete Course of Lithography,* reprint, New York: DeCapo Press, 1969.

Sotriffer, Kristian, *Printmaking History and Technique.* New York: McGraw-Hill Book Co., 1968.

Statler, Oliver, *Modern Japanese Prints.* Rutland, Vt.: Charles E. Tuttle Company, 1956.

Sternberg, Harry, *Modern Methods and Materials of Etching.* New York: McGraw-Hill Book Co., 1949.

Strang, David, *The Printing of Etchings and Engravings.* London: Ernest Benn Ltd., 1930.

Takahashi, Sellchiro, *Traditional Woodblock Prints of Japan,* trans. Richard Stanley-Baker. New York: Weatherhill/Heibonsha, 1972.

Weitenkampf, F., *American Graphic Art.* New York: The MacMillan Company, 1924.

West, Levon, *Making an Etching.* London: The Studio Ltd., 1932.

Zigrosser, Carl, *The Appeal of Prints.* Greenwich, Conn.: New York Graphic Society, 1970.

_____, *The Artist in America: Twenty-Four Close-Ups of Contemporary Printmakers.* New York: Alfred A. Knopf, 1942.

_____, *Book of Fine Prints.* New York: Crown Publishers Inc., 1956.

_____, *Prints. Thirteen Illustrated Essays on the Art of the Print.* New York: The Print Council of America, 1962.

_____, *Six Centuries of Fine Prints.* New York: Covici Friede, 1937.